Nov. 30, 1987.

To LOTFI & MIDGE.

WITH WARMEST

LOVE.

Joey & Roby

The Other Nineteenth Century

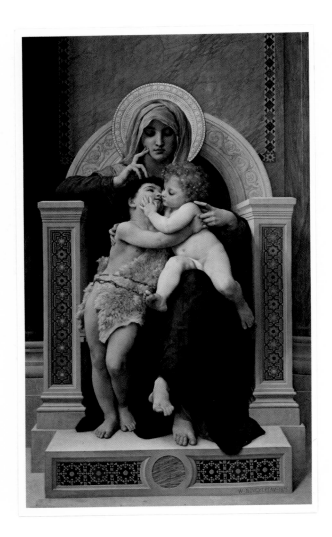

The Other Nineteenth Century

Paintings and Sculpture in the Collection of Mr and Mrs Joseph M. Tanenbaum

ORGANIZED AND EDITED BY LOUISE d'ARGENCOURT AND DOUGLAS DRUICK

THE NATIONAL GALLERY OF CANADA, OTTAWA · NATIONAL MUSEUMS OF CANADA · 1978

ISBN 0-88884-348-8

FRONTISPIECE
William Adolphe Bouguereau
*The Virgin, the Infant Jesus,
and Saint John the Baptist* 1875
Oil on canvas, 1.97 x 1.18 m

COVER
Théodule Augustin Ribot
The Mandolin Player 1862
Oil on canvas, 73 x 60 cm

PRINTED IN CANADA
Obtainable from National Museums of Canada
Mail Order
Ottawa, Canada K1A 0M8

Aussi publié sous le titre
Un autre XIX^e siècle:
Peintures et sculptures de
la collection de M. et Mme Joseph M. Tanenbaum

CONTENTS

9 ACKNOWLEDGEMENTS

11 PREFACE

13 FOREWORD

15 CONTRIBUTORS

21 GENERAL INTRODUCTION

31 NOTES

PAINTERS

33 Lawrence Alma-Tadema

38 Albert Aublet

40 Charles Bargue

44 Giovanni Boldini

48 François Bonvin

54 William Bouguereau

60 Félix Bracquemond

63 Eugène Carrière

72 Théodore Chassériau

75 Thomas Couture

82 Alexandre Decamps

85 Gustave Doré

90 Henri Fantin-Latour

97 Jean-Louis Forain

102 Jean-Léon Gérôme

120 Edward John Gregory

123 Jean-Jacques Henner

127 Eugène Isabey

130 Johan Jongkind

133 Jean-Paul Laurens

136 Frederic Lord Leighton

145 John Martin

148 Ernest Meissonier

CONTENTS

151 Georges Michel

154 Albert Moore

157 Théodule Ribot

176 Ferdinand Roybet

182 Alfred Stevens

184 James Tissot

194 Antoine Vollon

SCULPTORS

198 INTRODUCTION TO SCULPTURE

202 Antoine Louis Barye

204 Rembrandt Bugatti

206 Jean-Baptiste Carpeaux

214 Jules Dalou

220 Alexandre Falguière

222 Emmanuel Frémiet

224 Jean-Léon Gérôme

226 Max Klinger

228 Constantin Meunier

230 George Minne

232 Aimé-Nicolas Morot

234 Medardo Rosso

236 INDEX OF ARTISTS

238 INDEX OF TITLES

WE WOULD LIKE TO EXPRESS our gratitude to Jean Sutherland Boggs who, while she was director of the National Gallery of Canada, first conceived this project. In the same spirit, Hsio-Yen Shih, Director of the National Gallery, continued to offer us every assistance and kindly placed at our disposal the Conservation and Restoration Laboratory.

Our thanks go to the European, American, and Canadian specialists who wrote the catalogue entries; to Mario Amaya, Guillemette Cottin, Jeremy Mass, and Juanita Toupin; and to the art dealers Charles Jerdein, Robert Kashey, Norman Leitman, Georges Martin du Nord, Herman Shickman, and André Watteau, all of whom gave generously of their time and advice. We thank also those members of the Gallery staff who assisted us in the many stages of this project: our editors, Jean-Claude Champenois and Julia Findlay, who worked so effectively within a tight schedule; Ian Hodkinson and Stewart Meese, of the Conservation and Restoration Laboratory, for their invaluable expertise; Helen Clark, who organized the illustrations; C. Ellis Kerr, Claude Lupien, and Ab Wellard, who responded so efficiently to our request for additional photography; Brian Stewart and Maija Vilcins for their diligent research; and Sylvia Gellman who so thoroughly kept track of all of the documentation.

Lastly, we express our deep appreciation to Mr and Mrs Joseph M. Tanenbaum without whose patience and steady support this exhibition could not have been realized.

As BEFITS ONE of the primary expressions of human creativity, art is constantly self-renewing, whether in taste or in knowledge. A quarter of a century ago, interest in nineteenth-century art was almost exclusively focused on French Impressionism and its immediate stylistic successors. Then, about fifteen years ago, the importance of Romanticism (whether in England, France, or Germany) began to be re-examined. Even more recently, Neo-classicism and the effects of the French Revolution have enjoyed a fresh look. Two curators of the National Gallery of Canada, Louise d'Argencourt and Douglas Druick, have profited by the intellectual and visual stimuli that these revivals have presented. In organizing *The Other Nineteenth Century*, they have undertaken to open vistas of even more riches from an extraordinarily fertile period.

The studies published in this catalogue have drawn upon the best talents available to art historical scholarship, in specialists from many countries and institutions. The National Gallery of Canada thanks all of these contributors who have made the ideals of international cooperation a reality.

Our greatest gratitude is directed, however, to the two collectors who have made this exhibition and these studies possible. Mr and Mrs Joseph M. Tanenbaum represent a new phenomenon in Canadian cultural life, the serious yet generous acquisitor, the amateur but studious connoisseur. Their willingness to share their collection with others and their recognition that art should be the domain of all people will serve as an example to many.

HSIO-YEN SHIH
DIRECTOR OF
THE NATIONAL GALLERY OF CANADA

ONE OF THE MOST IMPORTANT PRECEPTS of being successful, whether in business or art collecting, was taught to me by my father Max, who always used to tell me that "one can be forgiven for making a mistake once, but never for making the same mistake twice." Of course, my dear wife Toby and I have made some very costly mistakes in the process of assembling our collection. This is not really surprising, since in retrospect it seems as though we began collecting not by design but almost accidentally. Nevertheless, armed with my father's basic philosophy, we quickly learned that we had to approach only the best art dealers and that we must also take full advantage of the research and knowledge made available by specialists. Early in our collecting, an important influence was Mario Amaya, chief curator of the Art Gallery of Ontario, appointed in the spring of 1968. Under his guidance and with our own developing taste and willingness to listen and read, we gradually turned from painting of the Victorian era and turned to French art of the same period. By the fall of 1970, we were firmly committed to the so-called "neglected" French artists of the nineteenth century. We could not understand why these artists, some of whom had taught the Impressionists, and who were so influential in the nineteenth century, had been forgotten. For example, Manet studied under Thomas Couture and learned from him much of his craft. In addition, on the practical side, in the early 1970s fine works by Couture could be purchased for a fraction of the price of a Manet.

It was really through the process of learning about an artist, after having bought one of his works and then searching for more, that we met a number of stimulating individuals who were always ready to help us. We established what we believe will be lasting relationships with art dealers Norman Leitman, Herman Schickman, Meyer Schweitzer, Robert Kashey, Charles Jerdein, and André Watteau; and with art historians David Brooke, Mario Amaya, Gerald M. Ackerman, Gabriel P. Weisberg, Myron Laskin Jr., and Pierre Rosenberg.

We are particularly indebted to Jean Sutherland Boggs, former director of the National Gallery of Canada, who has given us unfailing support, and who initiated the idea of this exhibition. We are also grateful to Hsio-Yen Shih, Director of the National Gallery, for her enthusiastic guidance in bringing this exhibition to its conclusion. We would like to thank the contributors to the catalogue and, in particular, Louise d'Argencourt and Douglas Druick, for their outstanding organization.

All of these people and others have helped to make our collection a unique and, we would like to believe, valuable contribution to the culture of Canada. We are proud to live in this country, which has given such generous opportunities to my beloved late grand-parents Abraham and Chippa Tanenbaum and to my dear parents Max and

Anne. It is in appreciation of this that we have arranged that our collection be bequeathed to the National Gallery of Canada.

JOSEPH M. TANENBAUM

GERALD M. ACKERMAN G.M.A. Gerald M. Ackerman, Chairman, Art Department, Pomona College, Claremont, California, has published articles in such periodicals as the *Art Bulletin* and the *Gazette des Beaux-Arts*. He organized the 1972 exhibition on Gérôme and has written a book on this artist (in press).

LOUISE D'ARGENCOURT L. d'A. Louise d'Argencourt, Assistant Research Curator of European Art, National Gallery of Canada, has, in collaboration with the Louvre, organized a major exhibition on Puvis de Chavannes and written the accompanying catalogue.

ROBERT J. BANTENS R.J.B. Robert Bantens, Assistant Professor of Art History, Department of Art, University of South Alabama, has published articles on Carrière, Gauguin, and Delacroix.

PIERRE BAZIN P.B. Pierre Bazin, Director, Musée de Dieppe, Dieppe, France, organized an exhibition on Eugène Isabey and wrote the accompanying catalogue.

ALBERT BOIME A.B. Albert Boime, Professor of Art History, State University of New York at Binghamton, New York, has written extensively on nineteenth-century French art. His many publications include *The Academy and French Painting in the Nineteenth Century* and he is currently working on a monograph, "Thomas Couture and the Eclectic Vision" (to be published in 1979).

JEAN-PAUL BOUILLON J.-P.B. Jean-Paul Bouillon, Professor of Art History, Department of Archaeology and History of Art, University of Clermont-Ferrand, Clermont-Ferrand, France, has published works on artists (Kandinsky and Bracquemond) and literary figures (the Goncourt brothers, Zola). He has also organized conferences whose material has been published (*Le Cubisme*, 1973; *Les Années 1919–1925, 1975*, and *Les Années 1945–1950* (in preparation).

PIERRE W. DESJARDINS P. W. D. Pierre W. Desjardins, Lecturer, Department of Art History, University of Montreal, specializes in nineteenth-century French art. He is doing research for his dissertation on French portraiture of the Second Empire for the Courtauld Institute, London.

DOUGLAS DRUICK D.D. Douglas Druick, Curator of European and American Prints, National Gallery of Canada, has published articles on Puvis de Chavannes and Cézanne. He is currently writing a book on French lithographs from 1850 to 1900, and a monograph on Fantin-Latour.

CONTRIBUTORS

ALICIA C. FAXON **A.C.F.**

Alicia C. Faxon is studying at Boston University. She has written two books, *Women and Jesus* and *Collecting Art on a Shoestring*, as well as several articles. She is currently preparing a catalogue raisonné on Forain's late prints.

WILLIAM FEAVER **W.F.**

William Feaver is the art critic for *The Observer* and a member of the Arts Council of Great Britain. He wrote *The Art of John Martin* and is organizing an exhibition of British art and design in the thirties.

ANNA GRUETZNER **A.G.**

Anna Gruetzner is studying at the Courtauld Institute, London, England, and is co-author of *The Dictionary of British Artists 1880–1940*. She has organized exhibitions for the British Council and for the Arts Council of Great Britain.

GREGORY HEDBERG **G.H.**

Gregory Hedberg, Curator of Paintings, Minneapolis Institute of Arts, Minnesota, has published articles in *Marsyas* and the *Minneapolis Institute of Arts Bulletin*. He is currently organizing an exhibition on the Victorian High Renaissance.

CONSTANCE CAIN HUNGERFORD **C.C.H.**

Constance Cain Hungerford is Assistant Professor, Department of Art, Swarthmore College, Swarthmore, Pennsylvania. She is preparing a monograph and catalogue raisonné on Meissonier.

HORST W. JANSON **H.W.J.**

Horst W. Janson, Professor, Department of Fine Arts, New York University, New York, was chairman of that department for twenty-five years. His many publications include *The Sculpture of Donatello* and *The History of Art*. He has just finished a book on nineteenth-century sculpture, soon to be published.

ALAIN KLEPPER **A.K.**

Alain Klepper is doing research for his dissertation on Laurens for the Sorbonne.

WILLARD E. MISFELDT **W.E.M.**

Willard E. Misfeldt, Associate Professor of Art, Bowling Green State University, Bowling Green, Ohio, is an artist himself. He has published articles in various periodicals, and is currently working on a monograph on Tissot.

PETER MITCHELL **P.M.**

Peter Mitchell has published several catalogues, including *Alfred Émile Léopold Stevens, 1823–1906*, which accompanied an exhibition on Stevens.

DEWEY F. MOSBY **D.F.M.**

Dewey F. Mosby, Curator of European Art, The Detroit Institute of Arts, Detroit, Michigan, has

organized exhibitions on Degas and on French painting, 1774–1830. He has published his dissertation on Decamps, and is contributing to a book commemorating Professor Horst Janson's contributions to the field of art history.

LEONÉE ORMOND **L.O.**

Leonée Ormond is a lecturer at the Department of English, University of London, London. In addition to articles on both literature and painting, she has written a book on writer George Du Maurier and, with her husband, a book on Frederic Lord Leighton.

RICHARD ORMOND **R.O.**

Richard Ormond, Deputy Keeper at the National Portrait Gallery, London, has published several books, including one on John Singer Sargent and a two-volume catalogue of the collection of the National Portrait Gallery.

MICHAEL PANTAZZI **M.P.**

Michael Pantazzi, who formerly taught art history at York University, Toronto, is now head of Education Services, National Gallery of Canada.

MARC SANDOZ **M.S.**

Marc Sandoz, former curator of the Musée des Beaux-Arts de Poitiers, is a specialist in French history painting of the eighteenth century and romantic painting. He is the author of several books, including a catalogue raisonné of the work of Théodore Chassériau. He is, at the moment, writing a book on Louis Lagrenée *dit* l'Ainé, 1725–1805.

VERN SWANSON **V.S.**

Vern Swanson, formerly assistant professor at Auburn University, Provost, Utah, has recently published *Alma-Tadema: The Painter of the Victorian Vision of the Ancient World*, and is preparing a catalogue raisonné of this artist's works.

GABRIEL P. WEISBERG **G.P.W.**

Gabriel P. Weisberg, Curator of Art History and Education, Cleveland Museum of Art, has contributed many articles to such periodicals as the *Art Bulletin, Gazette des Beaux-Arts*, and *Apollo.* He has worked extensively on the Japanese influence on French art from 1854 to 1910, organized several exhibitions of nineteenth-century prints, and has just finished a monograph on Bonvin.

The Other Nineteenth Century

FROM GEORGES MICHEL TO CARRIÈRE, by way of Gérôme, Ribot, Doré, and Stevens, and from John Martin to Tissot, by way of Leighton and Alma-Tadema, the main trends in French and English painting in the second half of the nineteenth century are illustrated here in their complex ramifications. The diversity of styles and subjects is surprising, but in fact the apparent eclecticism of this collection reflects the state of art during the period in which these works were done.

The Paris Universal Exhibition of 1855 was an important indication for France that a new era was beginning. It is well known that the governments of participating countries attached considerable importance to these international gatherings. They provided a place where the countries competed with one another in technological and art displays and where official recognition could be given for progress. Despite the distinction apparently made in the *Rapport sur l'exposition universelle de 1855* between art and the other products displayed, art was basically presented as a consumer item in the same way as were industrial products; and what the report says on the technical section could just as well apply to art: "The real promoter of industrial progress and the best judge of it is the consumer. The creation of a clientele is the recompense for any progress that is achieved."[1] In this atmosphere of competition created by the new capitalist society, it was no surprise that the rules governing the production and sale of everyday consumer goods also governed the field of art. In his assessment of the 1875 Salon, Anatole de Montaiglon lamented this new tendency: "The exhibition is leaning increasingly towards commercial exploitation: instead of being almost a competition it is becoming a market place."[2] Since art was now required to meet the demands of a broader and more capricious clientele, it was forced to become increasingly diversified in both subject matter and techniques adopted.

This proliferation of genres and styles disturbed the critics, who began to question the reason for art and to wonder where it was headed. In their account of the 1855 Universal Exhibition, the Goncourts had considered the problem of the functions of art: "Is a painting a book. . ., an idea. . ., a visible voice, a language painted and derived from thought? does it appeal to the intellect? . . . Is painting, in a word, a spiritualistic art form? – Is its purpose and destiny not, rather, to appeal to the eye and be the embodiment of a fact, the representation of a thing, and not to aspire far beyond providing recreation for the optic nerve? Is painting not, rather, a materialistic art form, giving life to form by means of colour? . . ."[3] In his review of the 1863

[1] Prince Napoleon, *Rapport sur l'Exposition universelle de 1855 présenté à l'Empereur* (Paris, 1857), p. 149

[2] Anatole de Montaiglon, "*Le Salon de 1875*," *Gazette des Beaux-Arts* (June 1875), pp. 489–490.

[3] Edmond and Jules de Goncourt, *La peinture à l'Exposition universelle de 1855* (Paris: Denon, 1855), pp. 5–6.

Salon, the critic Jules Castagnary proposed as the supreme purpose of art the expression of an individual consciousness in a given society. A new and extremely mobile concept of beauty had thus appeared, which by definition disregarded all the prejudices engendered by the notion of ideal beauty, and which ultimately opened the door to a wide variety of experiments.

The 1850s, therefore, witnessed the beginning of two debates which followed a parallel course throughout the second half of the nineteenth century. The first was concerned with subject matter, a problem already debated at length by the critics Thoré, Champfleury, and Proudhon at the time of the controversy brought about by Courbet's work. Should the artist look to the past for historical or mythic events to stimulate his imagination and help him enlighten the masses, or should he look to an immediate reality for ideas which would equally benefit human progress? While some wanted to maintain the traditional categories of art (historical, religious, and allegorical painting), other critics and men of letters, including Castagnary, Alexandre Dumas fils, and Émile Zola, resolutely opted for "modernity" and predicted a stylistic revolution – the decline of painting in the grand manner and the demise of religious and historical themes. At the same time, they declared the advent of the small genre picture as the "triumph of the nineteenth century," and landscape painting, the "victory of modern art." These men of letters welcomed the fall of the *peintre-littérateur* and the rise of the pure painter.

The second debate was essentially concerned with techniques: freedom of invention did not mean freedom from discipline. In his "Programme de critique" (1864) the painter Eugène Fromentin (1820–1874) attributed the obviously unhealthy state of contemporary painting to the artists' lack of instruction and education. Later, in his book *Les Maîtres d'autrefois*, a compendium of Dutch and Flemish painting in the seventeenth century, he continued to discuss this view. Placing technical training above all, he spoke against the laxity and incoherence which then characterized such training: "Today in fact, one finds only artists who, more or less adventurous in the exercise of their talent, have no fixed beliefs."[4] He complained that, "Everyone has his own style and his own formula concerning drawing and colour. . . ."[5] Fromentin used his comparative analyses of past and present practices to suggest to his contemporaries a course of action that they might follow in their search for new directions. His proposal was "to create a beautiful work embodying everything from the past in combination with the modern spirit of nineteenth-century France, resembling a Metsu in every respect but with no trace of imitation."[6] The work of such artists as Decamps, Meissonier, Michel,

[4]Eugène Fromentin, *Les Maîtres d'autrefois* (Paris: Livre de poche, 1965), p. 98.
[5]*Ibid.*, p. 233.
[6]*Ibid.*, p. 240.

Ribot, and Roybet is proof that the great tradition of Dutch painting of the "Golden Age" still prevailed in contemporary critical thought.

In reading the critics of the time, one senses that painting was also being threatened from another quarter. Fromentin wrote that, "The influence of photography in determining the appearances of objects and of the photographic study as a basis for the effects of light have changed most ways of seeing, feeling, and painting. At the present moment, painting is never clear enough, sharp enough, explicit enough, or stark enough. Today, apparently, the mechanical reduction of reality is the last word as far as experience and knowledge are concerned, and talent consists of struggling to match the accuracy and imitative power of an instrument."[7] Certainly, in this context, one thinks of Gérôme, Aublet, and particularly Bouguereau, whose plastic conception was conditioned by the view of reality provided by the photograph.

Confronted with paintings as stylistically varied as those in this exhibition, one attempts to identify the principle which governed the Tanenbaums' approach to collecting, to determine what qualities a Bouguereau and a Forain or a Martin and an Alma-Tadema might have in common.

Underlying the apparent eclecticism of subjects and styles, there appears to be a certain affinity between artists often far removed from one another in time and place: for example, whether dealing with the Middle East or Ancient Greece, both Gérôme and Alma-Tadema painted with a suppleness and technical perfection that has seldom been equalled. Similarly, there is a shared sensibility in the paintings of Tissot and Stevens. On the other hand, it is interesting to see how two pupils of Gérôme – Aublet and Forain – went on to evolve their own very different personal styles.

Besides the canvases that display a high degree of finish and a porcelain-smooth surface, there are others on which the paint has been heavily applied and which appear relatively "unfinished." Most notable in this respect are Bouguereau's *Virgin, Christ, and Saint John the Baptist* (cat. no. 12) and Vollon's *The Pig* (cat. no. 70). These totally dissimilar works were shown at the Salon of 1875 where they were both equally acclaimed.

All of the traditional categories are represented in this collection – history painting by Laurens and Leighton; allegorical painting by Carrière; religious painting by Chassériau, Bouguereau, and Henner; portraiture by Bracquemond, Fantin, and Boldini; landscape by Decamps, Isabey, Jongkind, and Doré; still life by Bonvin, Ribot, and Vollon. However, genre pictures with anecdotal themes set in the past or present (the specialty of Ribot, Tissot, Alma-Tadema, Gérôme,

[7] *Ibid.*, p. 274.

and Forain) are the most numerous. It thus becomes evident that the narrative content of a picture is an important criterion in the Tanenbaums' approach to collecting.

The collection does not represent the traditional view of painting of this period. It is, rather, a reflection of a personal approach to nineteenth-century art. There are, for example, no Corots, but landscape painting of the same period is represented by Michel and Decamps. Neither are there paintings by Ingres, but there are major works by Bouguereau, Gérôme, and Meissonier who, inspired by the same ideal, dominated the official Salon for more than twenty years, eclipsing Manet, Cézanne, and the Impressionists. The romantic spirit is represented, not by Delacroix, but by Chassériau, Isabey, and Doré. There are no Manets, but there are works by his friends Ribot, Vollon, and Fantin; no Géricaults, but Coutures and Bonvins. The social commentary one might look for in Daumier is found in the works of Forain. It is this approach which makes the Tanenbaum collection virtually unique.

Much of the nineteenth-century French art which has been most admired in the twentieth century does not interest the Tanenbaums. While they greatly admire certain paintings by Delacroix, Manet, and Gauguin, the works of Monet, Pissarro, Mary Cassat, Renoir, Cézanne, and the bulk of the paintings by Degas fail to strike a responsive chord. Rather, in collecting, they were not drawn to what was considered fashionable, but to artists who had been "forgotten" by the twentieth century, and whose work has only recently been reevaluated, a process in which the Tanenbaums have played a part. In this sense the Tanenbaums must be seen as daring collectors, standing behind their convictions at a time when these convictions had little support. Interestingly enough, however, when considered in terms of nineteenth-century taste, their collection takes on a rather different complexion. For if in the twentieth century a collector's importance has often been calculated in terms of the number of important Impressionist pictures he owns, in the nineteenth century, paintings by Meissonier provided a yardstick with which to measure a collector's taste and means. In Zola's novel *L'Argent* (1891), one character stands before a picture by Meisonnier "whose work he estimated to be one hundred thousand francs," an astounding sum for the period. Boldini (cat. nos 6, 7) commanded during his lifetime fees which neither Manet, Degas, nor any Impressionist did during his. But not all those represented here were so fortunate. While Chassériau, Bouguereau, and Moore had sufficient prestige to obtain commissions, and Roybet, Vollon, Tissot, and Stevens were great commercial successes, Ribot, Bonvin, and Fantin, were rejected several times by the Salon jury, had great difficulty becoming established, and lived for long periods in a state bordering on destitution.

Indeed, then, even in nineteenth-century terms, this collection

would have been considered somewhat of an anomaly. Those collectors who were attracted to the colour sense, high degree of finish, and subject matter found in paintings by Bouguereau, Meissonier, and Gérôme, very seldom felt an affinity for the work of such artists as Ribot, Fantin, Henner, and Carrière. Similarly, critics who admired the work of the latter generally found the paintings of Bouguereau, Meissonier, and Gérôme hollow displays of virtuosity.

The artists themselves were perhaps somewhat more eclectic in their tastes than either the collectors or critics. We know, for example, that both Gérôme and Fantin, in their formative years, admired the work of Decamps. Similarly, the work of Bonvin was held in esteem by Bouguereau, Fantin, Whistler, and, it would seem, Albert Moore. Yet shared admirations did not necessarily imply mutual admiration. Thus Fantin, for example, felt both Gérôme and Bouguereau were adept technicians rather than artists.

But beyond these similarities and differences there were also natural affinities arising from the fact that the artists lived in the same era and most took part in the political dramas which unfolded between 1848 and 1870–1871, and up until the last years of the century – those years marked by the troubled political climate precipitated by the Dreyfus affair. In certain cases, the lives of the artists were as unsettled as the times in which they lived. Friendships and coteries often enabled some of them to find the courage to continue in the face of rejection by the critics. Jongkind and Isabey, for example, shared for a time the same studio and the same views on painting. In 1859 Bonvin held in his atelier an exhibition of works by his friends Ribot, Fantin, Whistler, and Vollon – all paintings which had been rejected by the Salon jury. Three years later, these artists, along with Bracquemond, Jongkind, and Roybet, and others, formed the Société des Aquafortistes, devoted to the promotion of contemporary art. In 1860, with the assistance of other artists, Isabey and Bonvin had organized a sale to assist the poverty-stricken Jongkind. Such camaraderie continued and even ten years later Fantin, Bracquemond, Stevens, and Henner met regularly at the Café Guerbois; in discussions centred around Manet and Zola, they exchanged views on art and planned strategy to counter the opposition of those who represented the status quo in art and politics.

THE TANENBAUMS DID NOT SET OUT to become collectors. As in the case of many amateurs, their appreciation of art followed a logical but somewhat unconventional progression from relative naïveté to critical expertise. The course of this development reveals a single-mindedness and self-reliance which was as bold as it was incautious. Like many, they were, initially, only able to say that while they knew little about art they knew what they

liked. But unlike most, they refused to remain complacent; they felt compelled to know more about what they liked – and why.

In 1964 the Tanenbaums acquired their first paintings, motivated solely by the desire to decorate the English-style house in Toronto into which they had just moved. Their first purchase was a painting by an unknown English artist, for which they paid one hundred dollars: "We remembered not sleeping for a whole night," Tanenbaum recalled, "worrying because we had spent so much money on a little square of canvas."[8]

Soon after, on the advice of friends, they began to attend local auctions. Within a three-month period in the fall of 1964, they acquired thirty-five paintings, mostly by unknown English artists. Their manner of proceeding reflected the self-reliance which was to characterize their serious collecting later on. They would visit the auction preview, and solely on the basis of what interested them and without any advice, they would decide on the works on which they would bid. Joey Tanenbaum, who attended the auctions himself, worked out a number of complicated stratagems which indicate that he was instinctively drawn to the aspect of gamesmanship in collecting.

Each acquisition fostered the desire for more paintings. This growing interest did not, however, lead them to the art museums. "Our attitude to museum art was that it's untouchable. We believed that the prices for museum paintings were so high that they were out of reach for the average person and so were not something to aspire to." It was through periodicals rather than art museums that the Tanenbaums entered on the next state of their development as collectors. Friends advised them to subscribe to *Apollo* magazine which has reproductions of paintings available on the market. It was through *Apollo* and *Connoisseur* that the Tanenbaums began to appreciate qualitative differences in paintings. Their reaction was immediate – and basically sound: "In 1965 there were two pictures by Abraham Solomon in *Apollo* advertised for sale in London – *Awaiting the Verdict* and *The Acquittal*. We were so excited by the reproductions that I picked up the phone and called England to find out how much they cost." Astonished by the price which was much higher than they had anticipated, they nevertheless decided to go ahead and purchase them.

Their interest in Solomon was logical, given their taste for English narrative pictures. The departure from their previous approach lay in their new perception of the quality of these particular paintings, both of which had enjoyed considerable renown in the nineteenth century. The Solomons changed the Tanenbaums' approach to collecting: "They so outshone everything else we had that we realized that it was art of this quality we wanted. . . . We took great pleas-

[8]All subsequent quotations are taken from an interview with Mr Tanenbaum, June 1977.

ure in looking at them. It was at this point that we stopped regarding pictures as simply decoration."

The discovery of the relative lack of quality of their previous acquisitions and the delight with the Solomons made the Tanenbaums curious about the works they owned, and they began to do more research. But their peace of mind had been disturbed. They were now determined to be surrounded by works that better answered their newly developed tastes. In fact, the Tanenbaums were becoming collectors.

More knowledgeable in their approach, they began to consult and to buy from a local art dealer. Over the next few years they acquired about fifty pictures – primarily English; in the process they traded every painting they owned – with the exception of the two Solomons.

Despite this intensive activity, the collection as it now stands only began to take shape in late 1967. It was then that the Tanenbaums saw Alma-Tadema's *An Apodyterium* (cat. no. 1) reproduced in *Apollo*, and there followed a sequence of events comparable to that surrounding the acquisition of the Solomons in 1965. *An Apodyterium* was an important acquisition – a major painting by a once internationally celebrated artist whose work was soon to enjoy a revival of interest.

Shortly after, the Tanenbaums were advised by a friend that in order to give their collecting greater direction, they should contact the chief curator of the Art Gallery of Ontario, David Brooke. The first meeting proved eventful. Brooke was at the time working on a retrospective exhibition of the works of James Tissot. After looking at the Tanenbaums' paintings, he showed them a photograph of a Tissot available in New York which he recommended that they acquire. Characteristically, Tanenbaum phoned the dealer the next morning and purchased *The Staircase* (cat. no. 65). Since the picture was included in the travelling Tissot retrospective, it was not until July that Tanenbaum could go to New York to pick it up. This trip opened up new horizons, for he ended up by purchasing two additional paintings – both on impulse.

I flew to New York and met the dealer. There was a picture lying on a table. It was a Gérôme – the *Arnaute fumant* [cat. no. 35]. I didn't know who Gérôme was at the time, but of all the pictures, it was the one I liked best. I bought it. . .and that was that. Since I had nothing to do before my plane left, I wandered around for about an hour. Finally I saw, in a display window, two pictures which reminded me of those I had seen in Toronto. I asked the owner if he had any nineteenth-century paintings and that's when I came across the *Mme Carrière* [cat. no. 15]. I bought it and left.

The trip to New York had been an initiation of sorts. First of all, it became clear that much of what was being sold on the Toronto market was coming from New York. Since the local mark-up was significant, it was obvious to the Tanenbaums that in future it would be wiser to visit more dealers and to go directly to the source. Moreover, although the Tanenbaums had been collecting mostly English art, this trip had resulted in an introduction to works of several nineteenth-century French artists. They were now intrigued by French painting, and they acquired more works by both Carrière and Gérôme in the next months (cat. nos 17, 38).

Early in 1969 a situation arose which was to test their daring and, in the process, further refine their approach to art. The London dealer from whom they had purchased the Alma-Tadema sent them a transparency of *The Levite of Ephraim and His Dead Wife* (cat. no. 40). Henner's large and celebrated painting shown at the Salon of 1898. But while the painting was fine, the subject matter was macabre. Until now, the Tanenbaums had agreed on all purchases. Subject matter had – in certain instances – posed problems, in particular, Gérôme's *Prayer in the Mosque of Quat-Bey Cairo* (cat. no. 38), but they had been easily resolved. However, with the Henner the problem was more acute, for although Tanenbaum thought it a remarkable painting, his wife disagreed. But Joey Tanenbaum, possessed of the true collector's drive, had to have it. Understandably its arrival at their house caused certain repercussions within the family. However, on his first visit to the Tanenbaums, Mario Amaya, then chief curator of the Art Gallery of Ontario, argued persuasively – and successfully – that the Henner was a major work and that on purely aesthetic grounds it belonged in their collection. Amaya also encouraged the Tanenbaums to pursue their interest in nineteenth-century artists whose reputations had yet to be fully revived. Fruitful, too, was his introduction of the Tanenbaums to art historians; this exposure to various experts became an important stimulus to their collecting.

As a result of the purchases made since late 1967, the Tanenbaums had, by 1969, the core of a serious collection. Their interest had now developed into a passion. They were encouraged to see their taste vindicated when works from their collection were borrowed for museum exhibitions, and some of these displays sparked, in turn, new interests and new acquisitions. When in 1969 the Art Gallery of Ontario held the exhibition *The Sacred and Profane in Symbolist Art* the Tanenbaums lent a number of their paintings (see cat. nos 15, 17, 51). When they visited the exhibition, they were confronted with art of a type they had not seen before. Yet they were immediately overwhelmed by Leighton's masterpiece *Hercules Wrestling with Death for the Body of Alcestis* (cat. no. 45). Amaya supported their decision to buy it, and the work was acquired. A second picture which they admired

and later regretted not pursuing was Gustav Klimt's *Hope I*, subsequently acquired by the National Gallery of Canada.

But not everyone shared the Tanenbaums' enthusiasm. The family regarded their collecting as somewhat foolish, somewhat extravagant. Joey Tanenbaum remembers that once in 1970, "my father had dinner with a good friend of mine. My friend said, 'You know, Max, I'm going over to your son's home tomorrow night.' My father replied, 'You know, Rudy, tomorrow night you're going to see the most expensive goddam wallpaper in the world.'"

Undeterred by such objections, the Tanenbaums purchased works by Doré, Isabey, Tissot, Forain, Vollon, Couture, and Ribot during the period 1970–1971. Once again their recent acquisitions led to dissatisfaction with the bulk of their collection, and once again they embarked on a process of "weeding out." This was to become a characteristic of their collecting – a testimony to their flexibility, and to their willingness to learn.

Since Victorian art had by then become fashionable, the Tanenbaums easily disposed of the bulk of their paintings by English artists. Even the Solomons, which they felt they had outgrown, were sold. They now moved into the relatively less fashionable market for the "forgotten" nineteenth-century French artists. Soon the only English artists represented in the collection were Alma-Tadema, Moore, and Leighton. With the exception of works by these artists, the concentration shifted entirely to French painting.

While Mario Amaya and other scholars whom they had met could now be sought for advice, the Tanenbaums continued to rely on their own reactions. In the case of Tissot's *Woman of Fashion* (cat. no. 68), for instance, they ignored the opinion of professionals who advised against purchase on the basis of the then very high asking price. Believing in the painting's quality, the Tanenbaums acquired it at a price which represented commitment and daring at the time, but which by today's market standards is unthinkably inexpensive. For many years they were to proceed in this fashion, at once naïve and courageous, interested above all in the work of art. But in recent years, the market has become so prohibitively expensive that more and more they have begun to seek the advice of the experts.

By 1971, the Tanenbaums felt sure of the path they were following and accelerated the pace of their collecting: they felt that they had to act quickly because the type of art they admired would be increasingly sought after and more and more difficult to obtain. In some instances their appreciation of a painting was not immediate. They have described the acquisition of the Chassériau (cat. no. 19) as a "traumatic jump." Sometimes, in their first response to a painting, they have not been prepared to meet this challenge. This was the case with John Martin's *Deluge* (1834): "We just weren't prepared to buy

it at the time; we simply couldn't make the commitment. We have regretted this ever since."

But this openness to what is new and different is far from being uncritical. At the centre of their approach to collecting are very firm personal ideas regarding quality. The preponderance of works in the collection by Gérôme and Ribot obviously reflects the admiration the Tanenbaums have for both artists. Yet it is not fair to assume that these are their favourite painters: "It has always been the quality – or what we thought was quality – of what has been available on the market which has served as the determining factor. Take, for example, Tissot. We were offered a lot of Tissots during the period 1967–1968, but we didn't feel that they were comparable in quality to what we have today. The same goes for Henner. There have been lots of Henners available on the market. But I think Henner is a mindless artist in most cases. But when he's good – which is very seldom – he's great. Gérôme can be bad – but he can also be consistently fine."

Exposure to new material continues to come through art periodicals and extensive contact with dealers rather than as a result of visiting museums. The reason for this stems from the private collector's compulsion. Once a painting is in a museum it is forever lost to the private collector.

While they are no longer acquiring works with the same frequency as they were several years ago, the Tanenbaums are still very active, as the number of recent acquisitions (cat. nos 19, 23, 48, 66) attests. At this point, collecting has become part of their way of life. "The excitement of finding a work and trying to obtain it will never wear off. Even if we are not always successful, we still enjoy the challenge."

The Tanenbaums have been surprisingly open in their approach to art. Perhaps it is the very fact that they are essentially self-taught – that their taste in art has resulted from a personal evolution rather than an unquestioning acceptance of established attitudes regarding nineteenth-century painting – that has allowed them to be so free from critical preconceptions. Their development into important collectors over such a short space of time is remarkable, a tribute to their desire to learn and their willingness to take risks in order to do so.

L. d'A./D.D.

The entries are arranged in alphabetical order. Initials appearing at the end of each biography are those of the contributing author, who also wrote the individual entries on that artist, unless otherwise indicated. The opinions and comments expressed are those of the authors.

Professor Horst W. Janson has written both the introduction and the entries of the sculpture section.

In most cases, where the title of a work is official, the original title and the English translation have been given when that work is first mentioned.

After the first full reference is given in the general bibliography, all subsequent references to that work are abridged.

Each general bibliography is in alphabetical order; the specific bibliography of each entry is in chronological order.

In measurements, height precedes width and refers to the support of the painting.

SIR LAWRENCE ALMA-TADEMA

Dronrijp (Holland) 1836 –
Wiesbaden (Germany) 1912

ONE OF THE MOST SUCCESSFUL ARTISTS of the nineteenth century, Alma-Tadema began life modestly in the Frisian village of Dronrijp, near Leeuwarden. His widowed mother worked to support her son, first to become a lawyer and eventually an artist. He studied at the Antwerp Academy under Dyckmans (1811–1888) and, in 1859, in the studio of Hendrick Leys (1815–1869). In 1863 the artist visited Naples and Pompeii for the first time. This journey proved to be crucial for his artistic development, for, whereas he had previously restricted his subjects to mostly Merovingian and Egyptian themes, he now devoted himself to painting archaelogically accurate reconstructions of bourgeois life in classical antiquity.

Alma-Tadema won a Gold Medal at the 1864 Salon; this, in addition to the commissions of Ernest Gambart and his exhibition of twelve pictures at the 1867 Salon, indicated his increasing recognition by the art world. After the death of his wife Pauline in 1869 and with the approach of the Franco-Prussian War, Alma-Tadema and his two daughters took up residence in London. Unlike most of the artists who fled the Continent at this time, Alma-Tadema became an English citizen, a move which facilitated his entry into the Royal Academy in 1879. His arrival on the London art scene coincided with the resurgence of classical painting, championed by Frederic Lord Leighton (cat. nos 44–47) and Sir Edward John Poynter (1836–1919).

Alma-Tadema's work immediately became popular and he soon could command extravagant prices for his paintings. (So wealthy did he become, in fact, that by 1883 he bought a mansion in St John's Wood which was to become one of the most palatial homes in London.) So much was his painting quintessentially "Late Victorian" that he was alternately criticized and praised for painting "Victorians in togas." More than anyone else he flattered the new rich of England and America by depicting them as Imperial Romans.

A large exhibition of his work in 1883 at the Grosvenor Gallery and another after his death in 1913 at the Royal Academy chronicled his career and confirmed his reputation as a brilliant technician, erudite archaeologist,

and painter of great talent. He invariably painted pictures of lanquid Roman patricians of the late Empire beside the blue Mediterranean, in marble baths, or in Pompeian villas. As his career progressed through the 1880s and into the 1900s, his work exhibited a greater concern for genteel and domestic sentimentality than for classic heroism.

Eventually his obsequiousness to English tastes won him a knighthood and the Order of Merit. But by 1905 critics had already begun to disclaim his artist merit. Roger Fry protested vehemently against Alma-Tadema's winning the Order of Merit, saying that the medal now needed to be disinfected and that Tadema's art had the quality of "scented soap." By the time of his death in 1912, the market value of his pictures had already begun to drop, and would continue to do so until the mid-1960s.

Now the artist's delicately coloured and minutely painted Romans in marble interiors again command respect. Sir Lawrence may justly be considered as a painter of great beauty and charm. His epithet describes him most effectively: Sir Lawrence Alma-Tadema: GREAT PAINTER, BRAVE WORKER, STRONG FRIEND.

EXHIBITIONS
Antwerp, 1861. Amsterdam, 1862. Ghent, 1865. London, French Gallery, 1865–1867. Paris Salons of 1864, 1865, 1874. Paris Universal Exhibitions, 1867, 1878, 1889. London, Royal Academy, 1869–1871, 1874, 1875, 1881, 1883–1885, 1889, 1894, 1896, 1901, 1904. Berlin and Brussels, 1874. Munich, 1879. London, Grosvenor Gallery, 1881–1884.

AWARDS AND HONOURS
Gold Medal, Amsterdam, 1862. Medal, Paris Salon of 1864. Knight of the Order of Leopold of Belgium, 1866. Second-Class Medal, Paris Exhibition, 1867. Knight of the Lion of the Netherlands, 1868. Chevalier of the *Légion d'Honneur*, 1873. Gold Medal, Berlin, 1874. Medal, Philadelphia International Exhibition, 1876. Medal, Royal Scottish Academy, 1877. Gold Medal, Paris Universal Exhibition, 1878. Officer of the *Légion d'Honneur*, 1879. Gold Medal, Melbourne Universal Exhibition, 1880. Prussian Order of Merit, 1881. Order of Frederick the Great, 1881. Gold Medal, Paris Universal Exhibition, 1889. Gold Medal, Chicago International Exhibition, 1893. Gold Medal, Academy of Saint Luke, Rome, 1893. Gold Medal, Vienna, 1894. Gold Medal, Brussels Exhibition, 1898. Knighted, 1899. Order of Merit, 1905.

BIBLIOGRAPHY
Russell J. Ash, *Alma-Tadema*, London: Shire Publications, 1973. Rudolph Dircks, *The Later Works of Sir Lawrence Alma-Tadema O.M., R.A.*, London: Virtue, 1910. Georg Moritz Ebers, *Lorenz Alma-Tadema: His Life and Works*, translated by Mary J. Safford, New York: Gottsberger Publishing, 1886. Edmund Gosse, *Lawrence Alma-Tadema, R.A.*

Edited by Dumas, London: J. S. Virtue, 1882. Percy Cross Standing, *Sir Lawrence Alma-Tadema O.M., R.A.*, London: Cassell, 1905. F.G. Stephens, *Selected Works of Sir Lawrence Alma-Tadema O.M., R.A.*, London: Virtue, 1901. Helen Zimmern, *The Life and Work of L. Alma-Tadema*, special supplement to *Art Journal*, London: Art Journal Office, 1888; Zimmern, *Sir Lawrence Alma-Tadema R.A.*, London: George Bell & Sons, 1902.

V.S.

1

An Apodyterium (*Opus CCLXXIV*) 1886

Oil on panel

45.3 x 60.9 cm

INSCRIPTION

Signed u. r. centre on wall, *OP CCLXXIV/ L Alma Tadema.*

PROVENANCE

S. Joshua by 1887; Christie's, London, 21 January 1921, cat. no. 25 (sold to W.W. Sampson, London); W.A. Cargill; Sotheby's, London, Cargill sale, 29 May 1963, cat. no. 42 (sold to Charles Jerdein, London). Acquired January 1968.

EXHIBITIONS

1886, London, Royal Academy, *Royal Academy Illustrated Catalogue*, cat. no. 285. 1887, Manchester, Royal Jubilee Exhibition, cat. no. 312. 1888, Melbourne, Exhibition of Melbourne. 1913, London, *Royal Academy Winter Exhibition Catalogue*, cat. no. 169. 1913, Liverpool, Walker Art Gallery, cat. no. 1041. April 1968, Toronto, Art Gallery of Ontario. December 1968–March 1969, London, Royal Academy of the Arts Bicentenary Exhibition, cat. no. 57.

BIBLIOGRAPHY

Art Journal, 1886, repr. p. 186. *Illustrated London News*, 8 May 1886, repr. p. 490. M.H. Bell, 1886, repr. and sketch, p. 13. *Pall Mall Gazette*, 1886, repr. "extra," p. 22. Maurice Rheims, *The Age of Art Nouveau*, London: Thames & Hudson, 1966, pl. 209. Graham Reynolds, *Victorian Painting*, London: Studio Vista, 1966, p. 134, repr. *Apollo*, June 1967, repr. p. XXXVII. Mario Amaya, *Sunday Times Magazine*, 18 February 1968, repr. p. 50. Tom Prideaux, *The World of Whistler*, New York: Time-Life Books, 1970, pp. 56-57, repr. col. Mario Amaya, "Alma-Tadema," *The Victorians – A World Built to Last*, edited by George Perry and Nicholas Mason, New York: Viking Press, 1974, repr. p. 88.

RELATED WORKS

Composition sketch for *An Apodyterium*, pencil, location unknown. *Nude Girl Untying Her Sandals* (study for *An Apodyterium*), pencil, location unknown, repr. in Zimmern, *The Life and Works of Alma-Tadema*, p. 28.

"APODYTERIUM" means the dressing-room of a ladies' bath. The painting depicts a red-haired lady in the dressing-room, looking shyly towards the spectators as she loosens (or ties) a golden girdle around her purple- and cream-coloured gown. It is quite possible that this is a picture of Tadema's eldest daughter Laurence, who was twenty-one at the time, red-haired, and always available to model for her father. No known study remains for this lovely figure, but there is a drawing for the nude woman sitting behind her (see Related Works). This dark-haired beauty sits upon a purple blanket which lies on a marble bench that runs diagonally along the wall at the right. On the upper portions of this wall are recesses for the ladies' apparel. The nude woman is loosening the blue bands on her sandals as she prepares to bathe.

Paintings of nudes are extremely rare in Alma-Tadema's work, and only nine oils are known to exist. *After the Dance* (*Opus CLVII*, 1875, private collection, Japan), *The Sculptor's Model* (*Opus CLXXIX*, 1877, formerly Hon. John Collier), *In the Tepidarium* (*Opus CCXXIX*, 1881, Lady Lever Art Gallery, Port Sunlight, Cheshire, England), and *A Favourite Custom* (*Opus CCCXCI*, 1909, The Tate Gallery, London) are among the most famous examples. Although the artist was not known for his ability to render flesh, in these paintings and in *An Apodyterium* his depiction of the human figure is satisfying.

Within the vestibule in the middle-ground, balneators (attendants of the bath) carry bundles of towels and other equipment (probably sponges, oils, and strigils) for the bath. They follow a half-nude bather as she ascends a flight of stairs to the right. The stair leads, according to the *Royal Winter Exhibition Catalogue* (1913, p. 45), to the upper apartments used for giving massages and for resting (tepidarium). Alma-Tadema often incorporated balneatrix figures in his work, especially in the late 1870s.

In the background, two balneators close the large wooden doors which lead to a wrestling court, as other ladies and children pass through the court. A painted fresco on the far side of the court catches the brilliant sunlight and adds a splash of colour to the picture's otherwise limited, chromatic harmonies. Alma-Tadema was fond of arranging figures intimately close to the picture plane, then neutralizing the middle-ground (done here through darker tonalities), then drawing the viewer quickly into the background with a bright glint of sunlight on landscape, architecture, or figures. These

"glimpses" become a standard device in such paintings as *Welcome Footsteps* (*Opus CCLVII*, 1883; formerly Scott & Fowles, New York) which opens into a garden, and *The Oleander* (*Opus CCXLV*, 1882; Dr Jackson, Oregon) with its view of the sea. These glimpses serve to activate the picture's surface and give an accent to the entire composition.

Another aspect of Alma-Tadema's work during the 1880s was his experiments with deeper tonalities and warmer colours. *An Apodyterium* and *The Parting Kiss* (*Opus CCXL*, 1882; Private Collection, Japan) both exhibit Alma-Tadema's desire to enrich his canvases with tones and colours. His marble is more golden and mellow, especially along the seams, than in his later pictures such as *The Voice of Spring* (cat. no. 2) and *Under the Roof of Blue Ionian Weather* (*Opus CCCLXII*, 1901; formerly Kock Collection, Amsterdam). In these later pictures the marble is scintillatingly white. Gone are the effects of antiquation; everything seems fresh, sparkling, and bright.

The painting was well received in the Royal Academy exhibition of 1886. The *Pall Mall Gazette* named it the "picture of the year" (1886, p. 22). The *Art Journal* compared *An Apodyterium* with *The Way to the Temple* (*Opus CCXXXIX*, 1882; The Royal Academy of the Arts, London) which was Alma-Tadema's Royal Academy diploma painting of 1883, and found *An Apodyterium* superior in lighting, colour, drawing, and interest to the diploma picture (1886, p. 186). Even adverse critics of Alma-Tadema have always admired this work.

An Apodyterium includes all the elements of Alma-Tadema's art that his admirers have come to expect and love. The picture remains one of the artist's finest works.

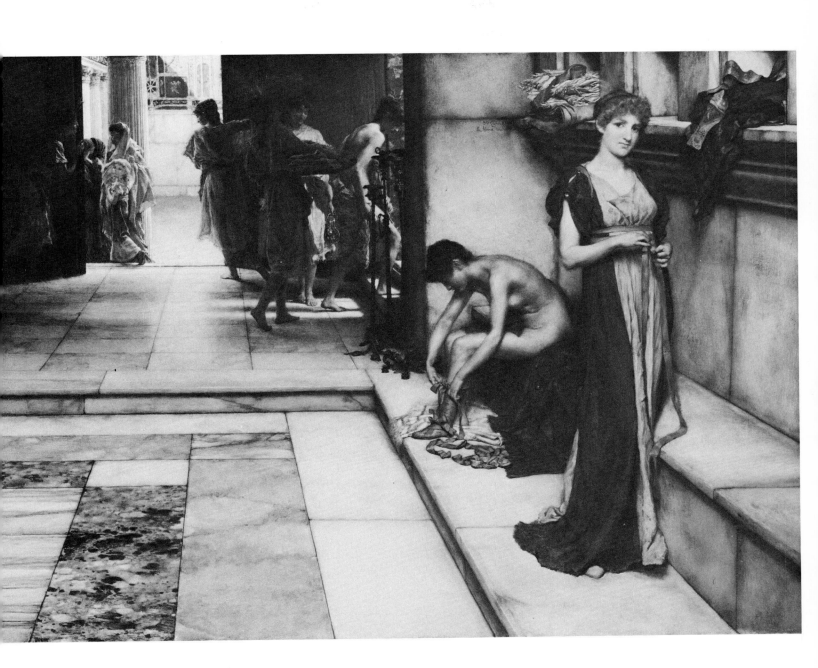

2

The Voice of Spring
(*Opus CCCXCVII*) 1910
Oil on panel
48.9 x 115.7 cm

INSCRIPTION
Signed on step l.c., *L. Alma Tadema* OP
CCCXCVII.

PROVENANCE
Tooth & Sons, London, by 1913; Colnaghi,
London; Christie's, London, 23 June 1961
(sold to Leger Galleries, London); James
Coats, New York, 25 August 1961–1967;
Allen Funt, New York, 1967–1973;
Sotheby's Belgravia, London, 6 November
1973, cat. no. 35 (sold to Charles Jerdein,
London); Mrs Alan Clark, Hythe, Kent;
Charles Jerdein, London. Acquired February 1977.

EXHIBITIONS
1910, London, Royal Academy, cat. no. 184.
1913, London, *Royal Academy Winter Exhibition Catalogue*, p. 44, cat. no. 163. April–May
1962, New York, Robert Isaacson Gallery,
cat no. 12. March–April 1973, New York,
The Metropolitan Museum of Art, *Painting
by Sir Lawrence Alma-Tadema from the Allen
Funt Collection*, cat. no. 35. May–June 1974,
Rotterdam Art Foundation. August–
September 1974, Leeuwarden (The Netherlands), Museum Princessehof, cat. no. 36.
June 1975, Sydney, Art Gallery of New
South Wales, cat. no. 9.

BIBLIOGRAPHY
Dircks, *The Later Works*, p. 32.

RELATED WORKS
*Woman Dancing with Two Girls (study for The
Voice of Spring)*, pencil, 36.8 x 14 cm, signed
and dedicated to David Murray, repr. in
Sotheby's Belgravia catalogue, May 1974, p.
133. *Seated Woman* (study for principal figure
for *The Voice of Spring*), pencil, location
unknown.

THE VOICE OF SPRING depicts a young
woman seated on a marble exedra
which forms a part of a shrine dedicated
to an unidentified deity. She seems to be
a variation in both pose and theme of
Alma-Tadema's earlier picture, *The
Year's at the Spring: All's Right with the
World (Opus CCCLXLX*, 1902; Private Collection, England), which was inspired
by a poem by Robert Browning. The
use of imagery involving spring is found
quite often in Alma-Tadema's work;
between 1874 and 1910 he painted no
fewer than sixteen paintings specifically
depicting that season.

The woman gazes dreamily as she
meditates upon the voices of spring –
the children's laughter and the playing
of a lyre in the distance. The crackle
and scent of a burning offering of pine
cones, which were sacred to Bacchus,
upon an altar revives pleasant memories. It must be a cool day in early
spring for she, like all the figures in the
painting, is dressed warmly, and the
anemone flowers in the meadow are
among the first to bloom after the winter.

The marble statue has not yet been
identified, although Dr Cooney, of the
Cleveland Museum of Art, believes that
Alma-Tadema's source was a statue on
the eastern pediment of the Parthenon.
Seventeen years earlier, Alma-Tadema
had incorporated this same statue in his
Unconscious Rivals (Opus CCCXXI, 1893;
City Art Museum, Bristol). In the distance, across the meadow, children are
playing, and people mingle beside the
Mediterranean. The figures to the far
right are like those represented in a
series of four versions of *Spring in the Garden of the Villa Borghese* (all painted in
1877), in which they pick flowers and
relax in the meadow. It was not until
1874 that Tadema began to concern
himself with landscape, but from then
on it played an important role in more
than twenty-five per cent of his paintings.

The Voice of Spring was owned by
Arthur Tooth & Sons, London, in 1913,
but then dropped out of sight until 1961
(see Provenance). Unfortunately, no
contemporary literature in the early
century mentions this picture, nor have
any letters surfaced that could shed further light upon the painting. If any
other painter had done this picture, it
would be considered enigmatic, but this
is not so with Alma-Tadema, who seldom presents us with any latent symbolism. The picture must be taken at face
value. What Alma-Tadema has given
us is a delightful picture, with overtones
of loneliness. Perhaps Mary Howitt's
poem entitled *The Voice of Spring* (1890)
was the source of inspiration:

Turn thine eyes to Earth and Heaven:
God for thee the Spring has given,
Clothed the Earth, and cleared the
 skies,
For thy pleasure or thy food:
Pour thy soul in gratitude.

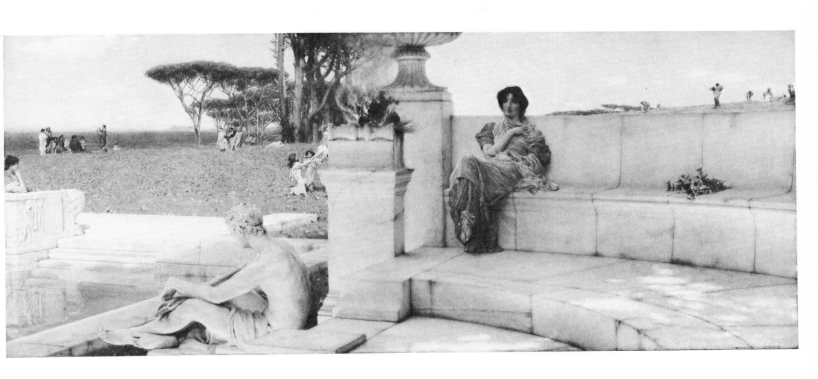

ALBERT AUBLET

Paris 1851 – Paris 1938

AUBLET ENTERED THE STUDIO of Claude Jacquand (1804–1878) in the late eighteen sixties; then, in 1870–1874 he studied at the studio of Jean-Léon Gérôme (cat. nos 30–38, 83). By the 1880s he was exhibiting regularly in the Salon and in the Munich Secession exhibitions. In 1883 he travelled through Spain to Algiers with Gérôme and Alberto Pasini (1826–1899). He painted genre, Tunisian subjects, histories, and portraits. After 1920, he turned to sculpture. He continued to exhibit until his death in 1938.

EXHIBITIONS
Paris Salons of 1880–1882, 1883, 1887–1889, 1906–1937. Paris Universal Exhibition, 1889.

AWARDS AND HONOURS
Third-Class Medal, Paris, 1880. Third-Class Medal, Munich, 1883. Gold Medal, Paris Universal Exhibition, 1889. Chevalier of the *Légion d'Honneur,* 1890.

BIBLIOGRAPHY
Charles Moreau-Vauthier, *Gérôme; peintre et sculpteur, l'homme et l'artiste, d'après sa correspondance, ses notes, les souvenirs de ses élèves et de ses amis,* Paris: Hachette, 1906, pp. 114–271, *passim.*

G.M.A.

Ceremony of the Howling Dervishes of Scutari
1882
(*Cérémonie des Derviches hurleurs de Scutari*)

Oil on canvas

111 x 146.3 cm

INSCRIPTION
Signed and dated l.l., *Albert Aublet, 1882.*

PROVENANCE
Mario Amaya, New York; Charles Jerdein, London. Acquired January 1976.

EXHIBITION
Paris Salon of 1882.

BIBLIOGRAPHY
Philippe Burty et. al., *L'exposition des beaux-arts (Salon de 1882),* Paris: Librairie d'art, 1882, p. 185, repr. p. 187.

IN A CROWDED, Turkish mosque, an Imam is performing a treading ceremony, probably a Dervish initiation rite. The Imam is walking gingerly, aided by an assistant, over the backs of a row of young boys, prostrate upon a bear rug, a symbol of authority. Among the spectators, mostly old men, a younger boy looks on with some envy.

This Turkish subject represents a departure for Aublet, whose oriental scenes usually depict the life of Algiers. It seems, however, that prior to the trip to that city with Gérôme in 1883, he visited Scutari, a quarter of Asiatic Constantinople, for the illustrated Salon catalogue of 1882 notes that, "M. Aublet has crossed the Bosphorous and disembarked at Scutari. He has brought back from there a *Ceremony of the Howling Dervishes of Scutari,* in which one sees the firm and precise technique of Gérôme" (Burty et. al., *L'exposition des beaux-arts,* p. 185). It is quite likely that this trip was also made in the company of Gérôme, who visited Turkey and Constantinople in 1881.

Although Aublet exhibited frequently at the Salon, his paintings are now virtually unknown. This picture is, then, of great interest as an example of a student of Gérôme, who was also a follower.

Aublet does not have the same strong sense of structure of his master. He gives more attention to the decoration of the mosque than to its architecture, and the bodies of figures seem lost in their bright costumes. But he does have a fine eye for detail, as the precise rendering of the artifacts in this painting reveals.

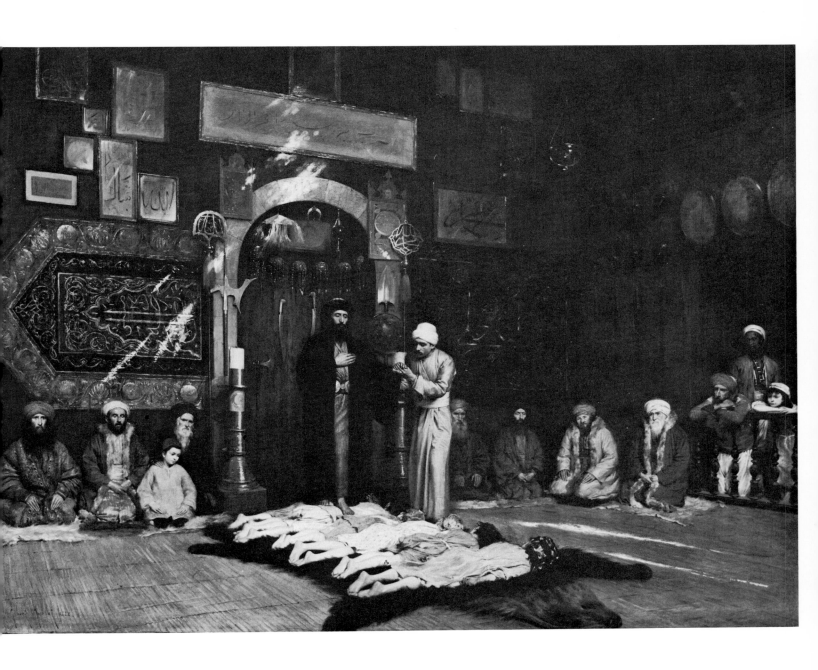

CHARLES BARGUE

Paris c. 1825 – Paris 1883

A FABLED PAINTER AND LITHOGRAPHER, Bargue is often called a pupil of Jean-Léon Gérôme (cat. nos 30–38, 83). This is most unlikely, for he was the same age as Gérôme. He might have been his studio assistant for some time, but there is no record of this. Bargue published several popular sets of lithographic prints, some of a commercial nature and others of an erotic nature, and three volumes of a *Cours de Dessin* (Paris: Goupil, 1868–1870), collaborating with Gérôme for the first two volumes. It is not known whether he travelled to the Middle East, whose citizens he often depicted, but it seems unnecessary to postulate such a trip, for his oriental scenes all smack of the studio.

It is said that Bargue finished less than twenty paintings in his life. C.H. Stranahan tells a curious story that Bargue died of want: "After being refused when in ill health an allowance by a dealer who had profited greatly by his works, he fell in a fit at his door and was removed to a charitable institution where he died" (*History of French Painting*, p. 331). The anecdote is repeated, almost word for word, in every biography of the artist, and we are not to be outdone. The incident – if it is true – makes it even more unlikely that Bargue was Gérôme's student, for Gérôme looked after his old students. It is also often said that Bargue borrowed costumes and props for his oriental scenes from Gérôme, but the costumes and artifacts used in Bargue's oils are never seen in Gérôme's works.

EXHIBITIONS
Lithographs at Paris Salons of 1867 and 1868.

AWARDS
Medals for printmaking at the Paris Salons of 1867, 1868.

BIBLIOGRAPHY
Shepherd Gallery, *Ingres and Delacroix through Degas and Puvis de Chavannes: The Figure in French Art, 1800–1870*, New York, 1975, pp. 273–275. Charles Sterling, *French Paintings in the Metropolitan Museum*, vol. 2, New York: Harvard University Press, 1966, p. 175ff. "A Group of Drawings by Charles Bargue," *International Studio*, vol. 84 (1926), pp. 45–49. C.H. Stranahan, *History of French Painting*, New York: Scribners, 1897, p. 331.

G.M.A.

4

Seated Bashi-Bouzouk
(Bashi-Bouzouk assis)

Oil on canvas

47.2 x 33.5 cm

PROVENANCE
Schweitzer Gallery, New York. Acquired May 1972.

EXHIBITION
October–December 1974, Hempstead, N.Y., Emily Lowe Gallery, Hofstra University, *Art Pompier: Anti-Impressionism*, cat. no. 2, repr.

BIBLIOGRAPHY
Apollo magazine, June 1972, repr. p. 107.

RELATED WORKS
Bargue did several finished paintings of single Bashi-Bazouks. The most famous is in the Metropolitan Museum, New York.

THIS OIL is a preparatory sketch or *ébauche*. The works of Bargue are known for their high and exquisite finish, but his paintings are so rare, and so difficult to trace, that the connoisseur who appreciates his work will be delighted at the chance of seeing the unfinished paintings.

The few drawings in private and public collections and his lithographic copies after old master drawings, as well as the finished oils themselves, reveal Bargue to be a strong draughtsman. Like Gérôme, he could reduce a figure to its essentials and present the anatomical structure with just a few strokes. Unlike Gérôme, he found drawing exciting as well as exacting, and passion seems to lurk behind the varied lines of his chalk or pencil; he was observing the drawings as well as nature.

It is said that Bargue painted less than twenty pictures. So few have been located that they can be listed here: three are in the Sordoni Collection in Wilkes-Barre, Pennsylvania (one a watercolour); two are in the Metropolitan Museum in New York; and one each is in the Boston Museum of Fine Arts, the Malden (Massachusetts) Public Library, the Arnot Art Gallery in Elmira, New York (a sketch), and the Payne Art Center in Oshkosh, Wisconsin. With these two sketches, the total of known works is eleven. The finished works, including the watercolour *The Algerian Guard (La sentinelle algérienne)* in the Sordoni Collection, show him to be a great technician in every sense.

Bargue has fine brush technique. The pleated Arnaut skirt in the picture in the Boston Museum outdoes Gérôme in meticulousness. He was also a master of male anatomy; his depiction of legs, arms, and hands can hardly be surpas-

sed. His anatomy is even convincing in distortion, as the squashed calf and thigh of the Metropolitan Bashi-Bazouk show.

Overall, Bargue develops a rich, sonorous colour scheme of deep, merging tones. So refined is the colouring that his works would make Gérôme's seem strident and bright, except for the care with which Gérôme integrates his colours compositionally. Bargue's colouring centres on his figures, for although his poses and gestures are convincing, he is weak in composition. His greatest picture, *The Chess Game (La partie d'échecs*, Sordoni Collection), although animated by four splendid figures, a dog, and a parrot, could, compositionally, really be two pictures.

In Bashi-Bazouks the artist found a subject well suited to his style of painting and choice of rich colour schemes. The Bashi-Bazouks were irregular troops attached to the Ottoman army, and were much feared for their ferocity. As irregular troops, they could dress as they pleased – usually gaudily.

Most of his paintings are of seated single figures in costume, either eighteenth-century or oriental. Bargue seems to be in the territory of both Gérôme and Jean-Louis-Ernest Meissonier (cat. no. 49). Although his single figures remind us immediately of Gérôme's, his contemporaries compared him to Eugène Delacroix (1798–1863) and Eugène Fromentin (1820–1876). Looking at this sketch and the following one (cat. no. 5), we can understand this comparison. The sketches reveal the colouristic thought that underlay his compositions. The body of the *Seated Bashi-Bazouk* seems to be drawn by the brush, in colour. The analytical treatment of the legs, recognizable at once as Bargue's manner of depicting anatomy, and the painterly buildup of the shawl promise a sumptuous, meticulous surface with a fine sense of structure underneath.

Like Gerôme, Bargue admired the muscular and bony type of Arabian men, but for him, who had probably never been to North Africa, their culture was unimportant. He thought of them simply as well-built human beings who wore rich and beautiful costumes. Although he had a command of gesture and movement that would have allowed him to present psychological situations, his lack of actual experience in North Africa probably hid from him the psychological possibilities which Gérôme, with his sure knowledge of the Middle East, could evoke even with a single figure. But in a painting by Bargue the drama of the picture lies in the rendering.

Interesting as a document of how a minor master thought and worked, this

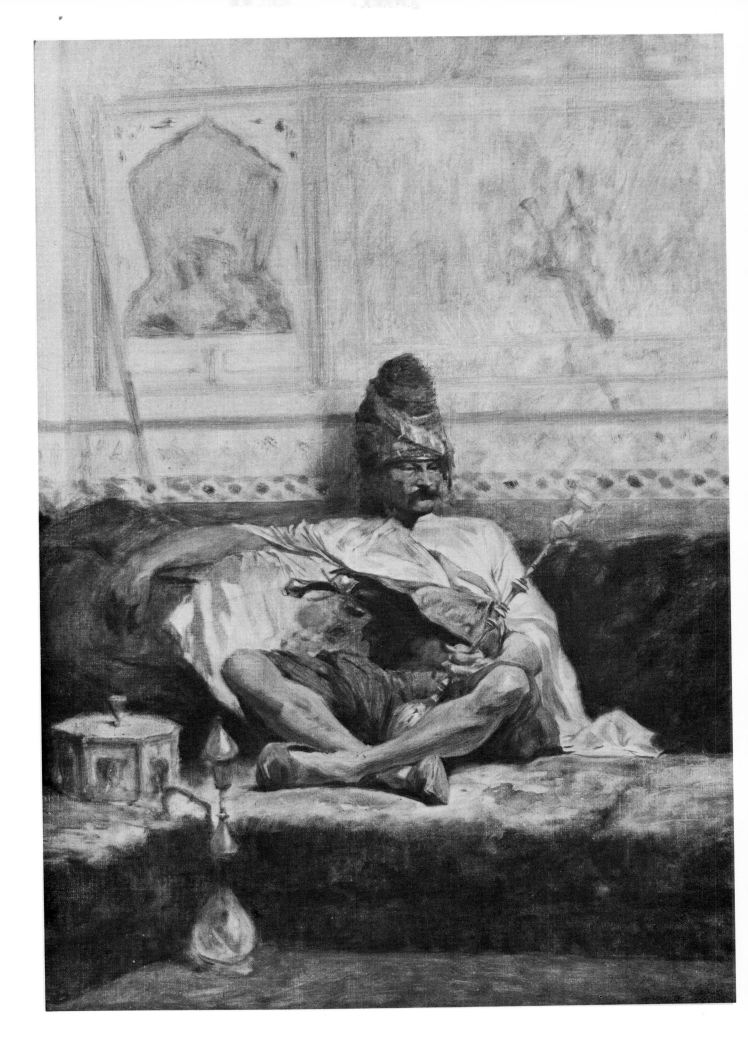

sketch also has great charm. The *Seated Bashi-Bazouk* was left in an even state of finish that makes it pleasing to the eye.

5

Prayer in a Mosque
(*Prière dans la mosquée*)
Oil on panel
35.6 x 27.4 cm

PROVENANCE
Schweitzer Gallery, New York, 1972.
Acquired May 1972.

BIBLIOGRAPHY
Apollo, June 1972, repr. p. 107.

RELATED WORKS
Preparatory drawings for the two foremost figures are in the Walters Art Collection in Baltimore, Maryland.

LIKE *SEATED BASHI-BOUZOUK*, this oil is another preparatory sketch, and documents how a minor master thought and worked. However, unlike *Seated Bashi-Bouzouk*, which looks relatively finished, *Prayer in a Mosque* has been slightly more worked up in some areas, as if it were in some ugly-duckling stage between the preparatory *ébauche* and the final refinements. One can be sure that the colour scheme of the *Seated Bashi-Bazouk* would have darkened, as has happened in this painting, had it gone through similar stages.

Two of the praying men have bare shoulders. The basic planes of their anatomy have been simplified in preparation for coats of glaze. As a result, some areas are exquisitely finished, others rough.

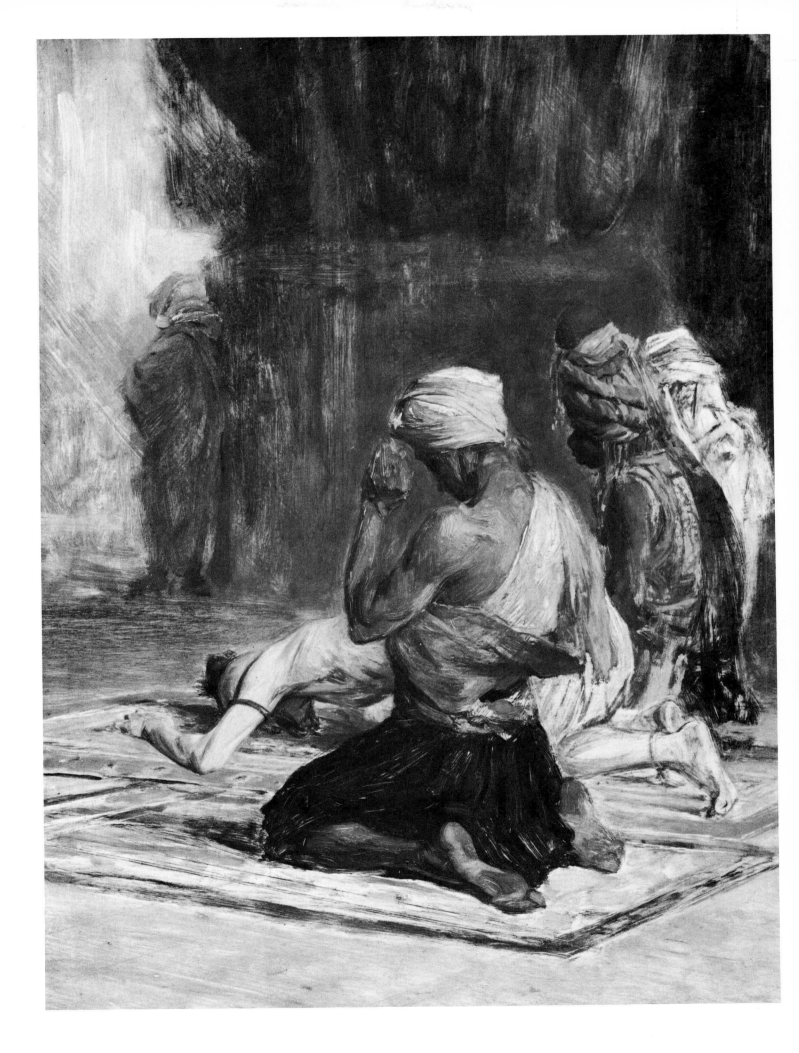

GIOVANNI BOLDINI

Ferrara 1842 – Paris 1931

BOLDINI, "THIS MONSTER OF TALENT" as Degas described him, was with Paul Helleu (1859–1927) and Antonio de la Gandara (1862–1917), the chronicler of the Parisian and international beau monde at the end of the nineteenth century. His portraits of the Italian Marquesa Casati, the Roumanian-born Princess Marthe Bibesco, the Anglo-American Duchess of Marlborough, renowned actresses and demimondaines Réjane, Cécile Sorel, Céline de Monthalant, are brushed with verve and panache; they bring back to life a universe minutely described by Marcel Proust in *À la Recherche du temps perdu*. Less well known, his male portraits are more poised, less exhuberant, and also less mannered. They have better resisted the passing of a fashion.

The eighth child of a family of thirteen, Giovanni Boldini was born in Ferrara on 31 December 1842. His father Antonio was a painter of religious subjects and copyist of works by the old masters, and two of his brothers, Giuseppe and Pietro, also worked as painters. One of Boldini's first known pictures is an oval self-portrait, painted in 1858 when he was sixteen (Baldi Collection, Ferrara). His talent as painter and portraitist soon became evident and before he settled in Florence in 1862, he had already begun to paint portraits of his Ferrarese compatriots. In Florence, he studied first at the Academy of Fine Arts with Stefano Ussi (1822–1901) and Enrico Pollastrini (1817–1876), but disappointed with this academic teaching, he began working on his own.

Michele Gordigiani (1830–1909), a studio neighbour, introduced him to a group of friends that met regularly at Caffè Michelangiolo: Telemaco Signorini, Cristiano Banti, Vincenzo Cabianca, Odoardo Borrani, Giovanni Fattori, and painters of the Macchiaioli circle. Through Banti, an illegitimate son of the Marquesa Vettori, Boldini was introduced to society and began to associate with several of the great Russian and English families that lived in Florence. In this way, he was able to see the collection of Dutch and contemporary French paintings in Prince Anatole Demidoff's villa at San Donato. He also had a close relationship with the Laskaraki family and painted a triple portrait of the sisters Laskaraki (Boldini Museum, Ferrara).

In 1867 he visited the Universal Exhibition in Paris with the family of Sir Walter Falconer and their friends. During a stopover in Monte Carlo, he painted the portrait of General Spagnolo, a resident of that city. At the Paris Salon, he was drawn to the work of Gérôme (cat. nos 30–38, 83) and Meissonier (cat. no. 49), but he also admired the paintings of Courbet and Manet exhibited in nearby pavilions. During the same visit, he met Alfred Sisley (1839–1899), Gustave Caillebotte (1848–1894), and Edgar Degas (1834–1917) who was to become one of his close friends (they travelled together and painted at least two portraits of each other between 1880 and 1890).

After he returned to Florence, between 1867 and 1870, Boldini painted small landscapes and numerous portraits of artistic and society personalities. He also decorated the dining room walls of "La Falconiera," Lady Falconer's villa in Pistoia, where he spent the summer of 1870. In the fall, he accompanied his English friends to London where Sir P. Cornwallis-West lent him his own studio near Hyde Park and introduced him to London society. In spite of his limited knowledge of the English language, Boldini enjoyed great social success and his small portraits became very sought after. At the end of the year, he returned briefly to Italy. After the Franco-Prussian war ended in the spring of 1871, he went back to Paris rather than London and settled in Montmartre at 12 avenue Frochot. In 1872 he moved to 11 Place Pigalle where Puvis de Chavannes (1824–1898) and Henner (cat. no. 40) also had their studios.

A series of landscapes and genre pictures date from this period. Eclectic in his tastes, Boldini was interested in the work of Watteau, Ingres, and Corot. In 1876 he travelled in Holland where he studied the work of Frans Hals (1581/85–1666), his favourite portrait painter, and in Germany where he did a portrait of the artist Adolph Menzel (1815–1905) (Neue Berliner Galerie, East Berlin). Beginning in the 1880s he made increasing use of pastel and experimented with etching.

In 1886 he rented a large house previously occupied by Alfred Stevens (cat. no. 64) and then by John Singer Sargent (1856–1925) at 41 Boulevard Berthier, on the Plaine Monceau. In this district favoured by fashionable artists and intellectuals, he had such neighbours as Sarah Bernhardt, Puvis de Chavannes, Meissonier, Madeleine Lemaire, Yvette Guilbert, Alexandre Dumas fils, and poet Georges Rodenbach whose portrait he painted and etched on several occasions. In 1889, he was named Commissioner of Fine Arts for Italy at the Universal Exhibition in Paris. In September of the same year, he travelled to Spain with Degas, returning to Paris by Tangiers. His international reputation was now firmly established and he exhibited widely in Europe and in America which he visited in 1897.

At eighty-seven, after a long and tumultuous bachelorhood, eighteen months before he died he married Emilia Cardona, a young journalist from Turin. In 1932, with the generous donation of his widow, a Boldini museum was established in the Palazzo dei Diamanti in Ferrara. Six years later, after much research, Emilia finally located "La Falconiera" and its frescoes, restored it, and settled there to write numerous books on her husband.

EXHIBITIONS
Paris Salon beginning in 1874. Salon of the Société Nationale des Beaux-Arts, 1889. Exhibits regularly at various exhibitions in London between 1870 and 1893. Venice Biennale beginning in 1901. Retrospective at the XVIII Venice Biennale in 1932.

AWARDS AND HONOURS
Grand Prix, Paris Universal Exhibition of 1889, 1900. Chevalier of the *Légion d'Honneur*, 1919.

BIBLIOGRAPHY
Emilia Cardona, *Vie de Jean Boldini*, Eugène Figuière, Paris, 1931; Cardona, *Boldini parisien d'Italie*, Paris: Librairie Grund, and Milan: Edizioni Daria Guarnati, 1932. Emilia Cardona Boldini and Enrico Piceni, *Boldini (1842–1931)*, exhibition catalogue, Musée Jacquemart-André, Paris, March–May 1963. Dario Cecchi, *Giovanni Boldini*, vol. 3, *La vita sociale della nuova Italia*, Turin: Unione Tipographico-Editrice Torinese, 1962. Dino Prandi, *Giovanni Boldini, l'opera incisa*, Reggio Emilia: Prandi, 1970. Carlo L. Ragghianti, *L'opera completa di Boldini*, vol. 37, *Classici dell'Arte*, Milan: Rizzoli Editore, 1979.

P.-W.D.

6

Portrait of Pedro and Luis Subercaseaux
1887

Oil on canvas

134.8 x 125.8 cm

INSCRIPTION
Signed and dated l.r., *Boldini 1887*.

PROVENANCE
Ramon Subercaseaux; Luis Subercaseaux; Christie's, London, 11 April 1972, cat. no. 45; Christopher Gibbs, London; H. Shickman Gallery, New York. Acquired September 1975.

BIBLIOGRAPHY
Ragghianti, *Boldini*, cat. no. 156, p. 103, repr. p. 102. Reproduced in *Apollo*, vol. XCV (June 1972), p. 189.

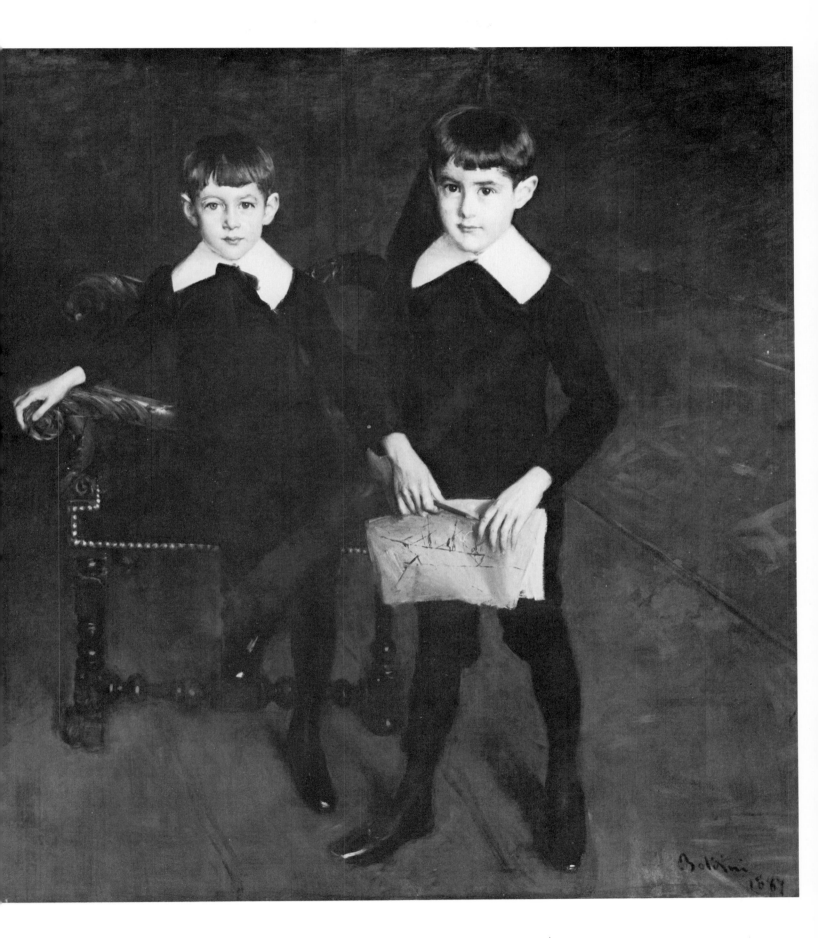

GIOVANNI BOLDINI

THIS PICTURE IS ONE of three portraits of members of the Subercaseaux family which Boldini, a family friend, painted in 1887. The second portrait is of Amalia Subercaseaux and the third, her husband Ramon, a writer, painter, minister of External Affairs for Chile and ambassador to Paris, Berlin, and the Holy See. This painting shows Ramon's two sons Pedro and Luis. Pedro, the elder, was born in Rome in 1881 and eventually became a painter and a Benedictine monk. After staying at Quarr Abbey on the Isle of Wight, he returned to Chile and founded a monastery in Santiago, where some of his paintings still hang in the Hall of Congress. Luis, the younger son, became a diplomat like his father and was, at various times, Chilean ambassador to Lima, Rome, and Madrid. This portrait, which had been in the family collections, was finally sold.

This is an excellent example of Boldini's male portraits done in the middle years of his long career. Less impetuous and mannered than many of his female portraits, it manifests a greater psychological insight in the representation of the two boys, whose respective personalities are easily discernable through their posture and gaze. They are shown in a vast but undefined room, in front of an imposing arm-chair, the back of which is visible above Pedro's head. The boy is holding in his hands a drawing of a three-masted ship, a sign perhaps of his early predisposition to art. The raised perspective may well indicate that the picture was intended to be hung quite high (perhaps over a mantelpiece). The background, very freely brushed in, discloses a few changes of position for Pedro's left arm and shoulder. The bold brushwork in the clothes and background emphasizes the fineness of the hands. The marked contrast of the black costumes and white collars enhances the subtlety of the flesh tones and recalls Boldini's interest in Frans Hals. The relatively sober treatment and the perceptive insight remind us that this was a portrait of friends rather than one of the innumerable and often rather superficial society commissions with which Boldini is often exclusively identified.

7

Portrait of a Young Man
Oil on canvas
56 x 48 cm

INSCRIPTION
Signed, l.l., *Boldini;* on the back of the frame in another hand, *Portrait of sculpteur* [sic] *Rinaldo Carnielo.*

PROVENANCE
Baron von Kassel; Sotheby's, London, 5 December 1962, cat. no. 117 (as *Rittrato di Rinaldo Carnielo*); Charles Jerdein, London, 1962; H. Shickman Gallery, New York. Acquired September 1975.

THE DATE OF THIS PORTRAIT and the identity of the sitter are problematic. With its restrained handling, rather tight brushwork, and dark background, the portrait seems close to Boldini's early work. It must have been painted before the portrait of General Spagnolo (Marzotto Collection, Valdagno, Venetia) which, although it incorporates a similar pose and a uniform background, displays freer handling and a more fluid brushwork. The modelling of the figure is less dramatic, yet is not dissimilar to that in this work, and the white collars are similarly contrasted with the dark background.

However this *Portrait of a Young Man* is more closely related to Dutch and French sources: one immediately thinks of the portrait of a man (previously thought to be Delacroix) by Géricault (Musée des Beaux-Arts, Rouen). Prior to his trip to Paris, Boldini could have seen numerous examples of French contemporary painting and Dutch portraiture in the Demidoff collections in Florence. (Bol, Coques, Dou, De Keyser, Mierevelt, Mieris, and Verspronck were all represented in Prince Demidoff's collection, dispersed at a sale in his residence on rue Jean-Goujon in Paris, 1–3 April 1869).

It seems reasonable to assume that this portrait was executed before 1867, the date of the portrait of General Spagnolo. It also shows some affinity with the portrait of Giovanni Paganuci, signed and dated 1865. This would suggest that this *Portrait of a Young Man* was painted between 1865 and 1867.

However, the signature is closer in style to that used by Boldini from about 1878. As this picture could hardly have been painted at that time (unless one accepts a sudden return to a more restrained style), it may be assumed that the signature was added a few years later, as was often the case for his early unsigned work. Scientific analysis tends to confirm this hypothesis and eliminates the possibility of a much later signature. Radiography also reveals some broad strokes which do not correspond to the finished image; they indicate that the artist probably began with a different subject, now impossible to identify clearly, which he subsequently abandoned for this portrait.

According to a historical interpretation that seems to date from the presence of the picture in the von Kassel collection and which is recorded in a manuscript inscription affixed to the back of the frame, the sitter is the sculptor Rinaldo Carnielo (1853–1910), a pupil of Aristodesno Costoli (1803–1871) at the Florence Academy of Fine Art. However, Carnielo, born in 1853, would have been too young in 1865–1867 to be the sitter represented here. While a precise identification is impossible, the youth and costume of the sitter may suggest a young colleague of Boldini during the artist's student years in Florence. With its psychological and dramatic intensity, its assured and fluid handling, this work remains one of the most attractive examples of Boldini's early portraiture.

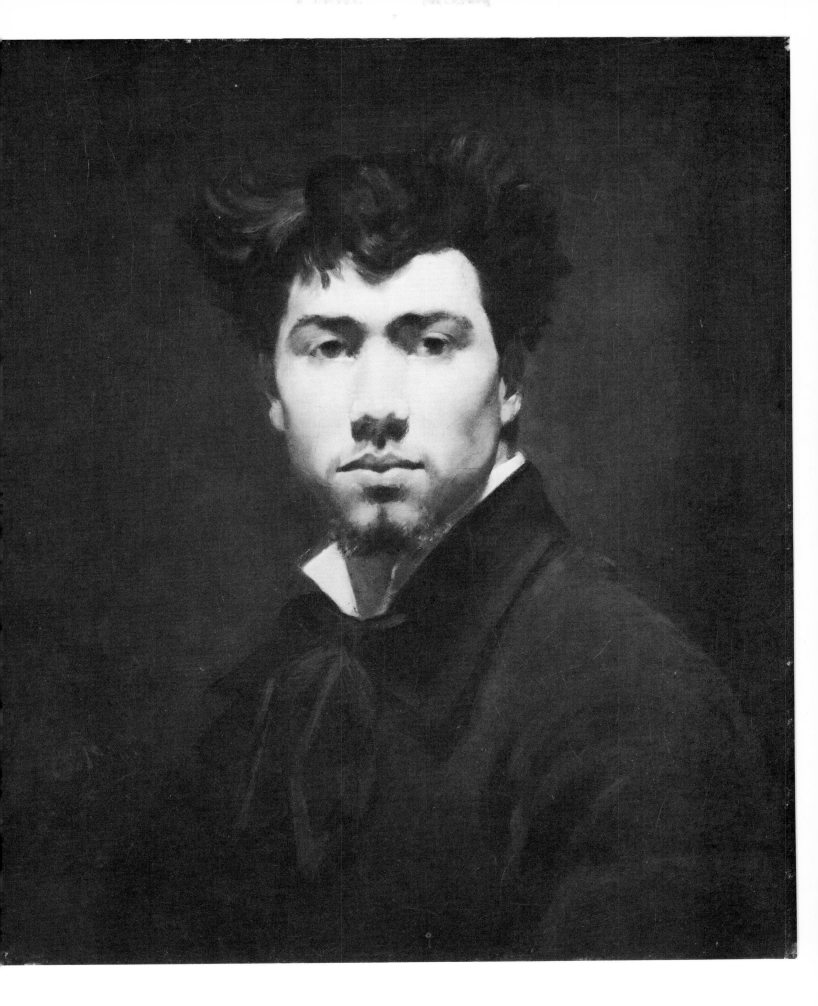

FRANÇOIS SAINT BONVIN

Vaugirard (Paris) 1817 –
Saint-Germain-en-Laye 1887

FRANÇOIS SAINT BONVIN was a self-taught artist. His earliest known oil painting (1839) foreshadows a lifelong dedication to still life. Since at that time he was working for the Paris Préfecture de Police, one can assume that this panel was completed at night, after the day's responsibilities. What little training Bonvin did obtain, first as a printer, and later on his own, at the Gobelins and the Académie Suisse, was augmented by contact with François-Marius Granet (1775–1849), the artist Bonvin considered his master. During the early 1840s, Bonvin advocated themes drawn from everyday life, especially scenes inspired by family and close friends.

In an effort to win recognition, Bonvin exhibited drawings and watercolours under the arcades of the Institut de France from 1844 to 1846, when his first patron, Laurent Laperlier, purchased some drawings. He first showed at the Paris Salon in 1847, when he exhibited a portrait.

Involved in the Realist camp, Bonvin met, among others, the novelist and critic Champfleury and Gustave Courbet (1819–1877), with whom he developed a fruitful relationship which was to last until the mid-1860s. They used to meet in Parisian cafés to discuss the course of French painting. Champfleury championed Bonvin's still lifes; and at the Salon of 1849 he singled out *The Cook (La Cuisinière)* as sharing affinities with the work of Jean-Baptiste Chardin (1699–1779), a master whose works Bonvin admired at the Louvre and in private collections in Paris. This painting received a third-class medal, and the artist was awarded 250 francs which helped alleviate his poverty.

Bonvin's small compositions never generated the heated critical attacks by conservative critics against Courbet who was then developing a new realist imagery. For this reason Bonvin received an official state commission to complete *The School for Orphan Girls (L'École des Orphelines,* Salon, 1851) which received a second-class medal – the highest award Bonvin ever received.

During the Second Empire, Bonvin obtained considerable support. Commissions and purchases of his paintings helped establish him as a key figure in the emergence of Naturalism with images of contemporary themes. These works were completed without the harsh stylistic changes advocated by Courbet. In 1859, when a number of young painters were rejected at the Salon, Bonvin exhibited their works in his own studio, thereby actively supporting Alphonse Legros (1837–1911), Henri Fantin-Latour (cat. nos 26, 27), James McNeill Whistler (1834–1903), and Théodule Ribot (cat. nos 52–60) in spite of conservative opposition to increasingly naturalistic images.

Bonvin had a sympathetic understanding of painters from former times, especially the Dutch masters of the seventeenth century. His examination of their themes helped provide a foundation for French advocacy of a similar practical aesthetic. In 1866, following the suicide of his artistically talented stepbrother Léon, Bonvin made his first trip to the Low Countries, visiting Holland in 1867, to fulfill a lifelong admiration for those painters he had first studied in the Louvre.

At the time of the Franco-Prussian War, Bonvin travelled to London in the company of Louison Köhler (1850–1935; see cat. no. 9). During the year he remained there his financial problems increased. Returning to France in 1871, he settled in Saint-Germain-en-Laye (a small village outside Paris) and continued to submit paintings to the Salons, often using Louison as model. Failing health eventually forced him to curtail his travels – he made one last trip to Holland in 1873 – although he still painted what he saw around him. Even though he had received official recognition in 1870, and continued to receive support from the young art dealer Gustave Tempelaere, his works in the 1880s were increasingly ignored except by the most fervent advocates of the pioneers of the realist aesthetic. Bonvin's friends only belatedly recognized his deplorable financial and physical condition: a special charity exhibition and sale was organized and held a few months before his death in 1887.

EXHIBITIONS
Salons of 1847 to 1880.

AWARDS AND HONOURS
Third-Class Medal (genre), Salon of 1849.
Second-Class Medal (genre), 1850–1851
Salon. Chevalier of the *Légion d'Honneur,*
1870.

BIBLIOGRAPHY
Étienne Moreau-Nélaton, *Bonvin raconté par lui-même,* Paris: H. Laurens, 1927.
Gabriel P. Weisberg, "François Bonvin and an Interest in Several Painters of the Seventeenth and Eighteenth Centuries," *Gazette des Beaux-Arts,* vol. 76 (December 1970), pp. 357–366. Weisberg, "François Bonvin and The Critics of His Art," *Apollo,* vol. 100 (October 1974), pp. 306-311. Weisberg, *François Bonvin: Sa Vie et l'Œuvre,* Paris: Éditions Geoffroy Dechaume (in press).

G.P.W.

8

Still Life with Lemon and Oysters 1858
Oil on canvas
75.0 x 83.8 cm

INSCRIPTION
Signed and dated l.r., *F. Bonvin 1858.*

PROVENANCE
Kunsthandel Huinck and Scheijon NJ., no. 1019, Amsterdam; Sotheby's, London, 13 April 1972, cat. no. 6, repr.; Galerie André Watteau, Paris; H. Shickman Gallery, New York. Acquired November 1972.

BIBLIOGRAPHY
Weisberg, *François Bonvin,* fig. 181.

RELATED WORKS
Other still lifes with oyster are in the Rijksmuseum Kröller-Muller, Otterlo (1858); Yale University Art Gallery (1860); Musée des Beaux-Arts, Saint Denis, Reims (1861); and the Burrell Collection, Glasgow Art Gallery and Museum (1876).

BY THE 1850S, Bonvin was a well-established painter who enjoyed a rapport with the government of the Second Empire. Some of his genre canvases were purchased by the State (*The Blacksmiths [Les Forgerons], A Remembrance of Treport [Souvenirs du Treport],* 1857), and his still lifes were sought after. Bonvin also completed larger canvases which suggest an assimilation of compositional devices that he had learned from the Dutch and from Chardin.

In this painting, Bonvin organized his objects on a white tablecloth – a device used by the artist in many of his compositions. The container of oysters becomes the focal point of a composition which Bonvin was to use several times in the following decade. The inclusion of the knife, placed precariously near the edge of the table, recalls Dutch motifs as well as the influence of Chardin, and directs the viewer's gaze towards the focal point of the composition.

A painting such as this could have been used as a decorative piece in a dining room or as part of a series of similar arrangements, grouped with examples by other still-life painters of the time. Bonvin was not alone in championing the still life as a theme for Salon exhibition. Other painters, among them such younger artists as Antoine Vollon (cat. nos 70, 71) and Théodule Ribot, demonstrated how effective a tool the still

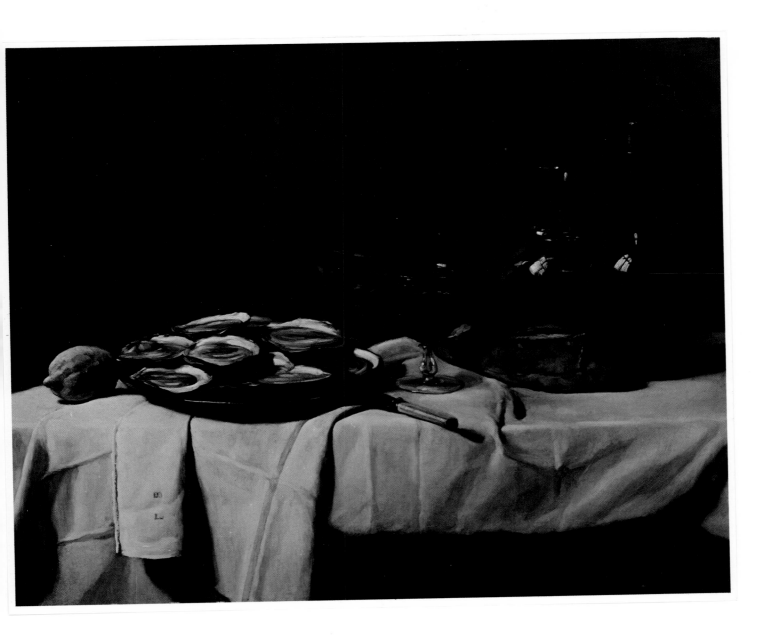

life was in training an artist's visual perception to light and shade. By the early 1860s the still-life revival reached such heights that the painters of still life rivalled the more conservative artists in number, thereby threatening the foundation of the entire academic painting system. Bonvin was seen as a leader in this movement and had been caricatured by Nadar for his emphasis on sensations observed solely by the eye (*Journal pour rire*, 1852).

Bonvin's genre and still-life compositions were also of importance to less traditional artists such as Edgar Degas (1834–1917), and Édouard Manet (1832–1883). His use of the theme of the ironer (1857; Philadelphia Museum of Art) may have influenced Degas's images of the same subject during the 1870s. Similarly, the still-life arrangements of Bonvin interested Manet, who was, in turn, to affect the way in which Bonvin used colour in the 1870s. The extent of the relationship between Bonvin and Manet cannot be determined, although both men exhibited in Louis Martinet's gallery during the mid-1860s.

Beginning in the late 1850s, Bonvin's large-scale still lifes display other aspects of his style that are worth noting. Several of these canvases (notably a large canvas in the Burrell Collection, Glasgow, *Still Life with Game*, dated 1874) display a careful painting technique in keeping with the demands of a highly finished Salon entry intended to appeal to middle-class tastes. Bonvin's still lifes for Salon exhibition, to which *Still Life with Lemon and Oysters* can be compared, often show a carefully modulated colour scheme in tones of brown, ochre, and black, consistent with the traditional tones of still-life painting. The highlights on the jug and wine bottle, entering from a light source at the left, reveal how Bonvin incorporated Dutch compositional devices. The total harmony of these muted colours is subtle and sensitively reflects the nuances of light and atmosphere.

Unlike some of his smaller still lifes, particularly those completed for his own pleasure or for private collectors, this painting exhibits a smooth surface. The tactile sense in the smaller canvases, where spontaneous paint application is evident, shows that Bonvin could challenge the art establishment with a freer use of pigment. When he chose to follow

Salon practice and to limit his personal freedom, however, Bonvin demonstrated a perfected Realism made palatable for the Second Empire.

A curious aspect of this painting is the fact that Bonvin signed it twice, once with a signature and date in the lower left, and a second time in a monogram embroidered into the white tablecloth. Bonvin's sense of humour is evident in other compositions where, for example, he includes an anglicized version of his last name on a poster on the back wall of an inn (*Flemish Cabaret*, 1867, the Walters Art Gallery, Baltimore). Only an artist sure of his following and his stature would be able to amuse himself in this fashion, thus adding further support to the contention that, during the Second Empire, Bonvin's type of Naturalism – and his majestic still lifes – were appreciated by the State and private patrons alike.

9

The Indiscreet Servant 1871
(*La Servante indiscrète*)

Oil on canvas

53.5 x 36 cm

INSCRIPTION
Signed and dated l.r., *F. Bonvin, 1871, London.*

PROVENANCE
Alexandre Blanc sale, Georges Petit Gallery, Paris, 3, 4 December 1906; Hôtel Drouot, Paris, 30 June 1950; Sotheby's, London, 19 June 1963; Sotheby's, London, 2 December 1971; Charles Jerdein, London. Acquired March 1976.

BIOGRAPHY
Moreau-Nélaton, *Bonvin raconté par lui-même*, p. 28. Weisberg, *François Bonvin*, fig. 128.

RELATED WORKS
A watercolour in a missing sketchbook (Moreau-Nélaton, fig. 57) is the preliminary study for the painting. A missing painting of a servant reading a letter (1870) is the only other work by Bonvin which is thematically similar.

THE THEME OF THE CONTEMPLATIVE SERVANT was uncommon in Bonvin's work until he met Louison Köhler in 1870. One version was completed depicting a maid reading a book near an open window in an elegant middle-class interior (location unknown); a second representation is this painting completed in January 1871 during Bonvin's stay in London (November 1870–November 1871).

Bonvin was in London not only to escape from the misfortunes of war and the Commune but also to join a growing colony of French painters, including Charles Daubigny (1817–1879) and

Jean-Léon Gérôme, (cat. nos 30–38, 83), who were living in exile until events improved in Paris. In a letter dated 12 November 1870 to Hector Brame, who had been acting unofficially as his art dealer, Bonvin noted that he would be in London for no more than one month; he anticipated joining Brame soon for a trip in the Low Countries. Bonvin's decision to remain longer in London may have been necessitated by his developing relationship with Durand-Ruel, to whom he was able to sell some canvases while he was there. This London sojourn also enabled him to continue studying the old masters; he examined works by Dutch seventeenth-century painters and Jan Van Eyck (*c.* 1385/90–1441).

The theme of the servant in an interior is derived, in part, from Bonvin's study of Dutch painting – including the then newly rediscovered works by Jan Vermeer (1623–1675) – and from a use of images which had a deeper, personal connotation. During his London stay Bonvin was ministered to by Louison Köhler, who was to remain his companion throughout the later years of his life, and who looked after him with compassion and devotion, alleviating the sadness caused by the death of his first wife, Elisabeth Dios, and the separation from his second wife, Céline Prunaire. As companion and housekeeper, Louison became much more than a servant, and modelled for many of Bonvin's late genre paintings. Bonvin depicted her reading his mail – as shown here – or playing the guitar (a version *c.* 1874; Cleveland Museum of Art), or preparing food in their kitchen in Saint-Germain-en-Laye.

In this painting, Louison is dressed for housework, wearing a red petticoat and black skirt. Bonvin's early genre paintings from the 1850s used a limited tonal colour range in keeping with the dull, earth tones of the other Realists. Beginning with the Salons of the late 1840s, Realists (including Édouard Frère, 1819–1886, and Adolphe Leleux, 1812–1891) used minimal colour when painting scenes of everyday life. Bonvin was no different; his images of women washing clothes or sewing are depicted in these tones. Only occasionally was a richer tone used, as in the red dress of Bonvin's *Cook* (*c.* 1846; Musée de Mulhouse). *The Indiscreet Servant*, with its heightened colour, thus represents Bonvin's transition to intensified tones. Having seen works by Manet and other young painters, Vollon and Whistler, for instance, Bonvin may have realized that brighter colours were being used in scenes drawn from contemporary life, and although he continued to use realist themes, his colour contrasts became

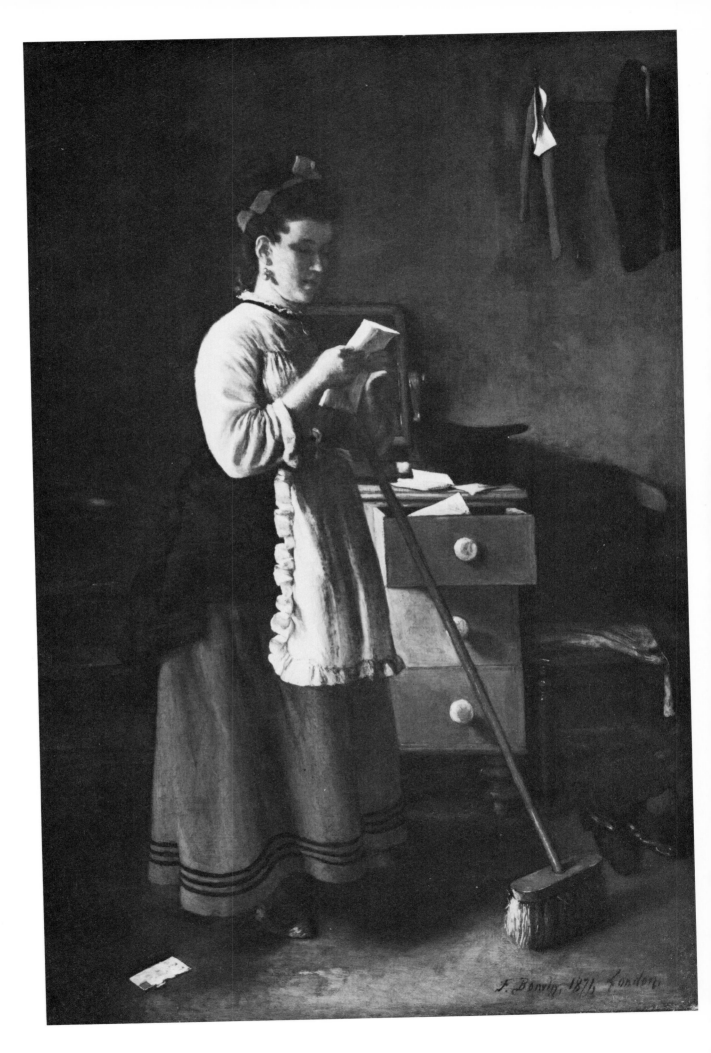

FRANÇOIS SAINT BONVIN

sharper, even somewhat abrupt.

Preliminary watercolours and finished charcoal drawings were an important aspect of Bonvin's working method, especially in regard to figural studies. For *The Indiscreet Servant,* a watercolour was prepared in a sketchbook Bonvin used in London (Moreau-Nélaton, *Bonvin raconté,* fig. 57). Bonvin placed Louison, attentively reading a letter, in a room containing the artist's scattered garments. Little change was made between the watercolour study and the finished oil, thus indicating the careful way in which Bonvin developed images – unlike other Realists, like Ribot, who often did not work in such a methodical, traditional manner.

In both the watercolour and the painting, however, the narrative element is stressed, emphasizing the personal significance of receiving a letter during that uncertain period when Bonvin and Louison were waiting impatiently to return to France.

Still Life with Jar of Cherries 1871
(Nature morte à la bouteille)

Oil on wood

47.5 x 31.5 cm

INSCRIPTION
Signed and dated l.r., *F. Bonvin, 1871, London.*

PROVENANCE
Brame Archives, no. 3863, 26 October 1925, from Tempelaere; public sale, Frederik Muller, Amsterdam, 16 April 1929; Christie's, London, 12 December 1969, cat. no. 183 (sold to Mr Pierpont); Sotheby's, London, 29 March 1973 Part II, cat. no. 106, repr. p. 12; H. Shickman Gallery, New York. Acquired February 1975.

BIBLIOGRAPHY
Moreau-Nélaton, *Bonvin raconté,* p. 78. Weisberg, *François Bonvin,* fig. 212.

RELATED WORKS
There is a preliminary watercolour for this painting (Moreau-Nélaton, fig. 59) in a lost sketchbook; other paintings with a similar theme include *Still Life with Oranges and Hazelnuts (Nature morte avec oranges et noisettes,* 1871; Private Collection, New York); and *Still Life: Jar of Cherries and a Glass of Wine (Nature morte: pot de cerises et verre de vin,* Private Collection, The Netherlands).

DURING HIS STAY IN LONDON, Bonvin did still lifes on panel and canvas. Working from preliminary watercolour sketches (Moreau-Nélaton, fig. 59), Bonvin also developed other versions of an after-dinner delicacy he particularly enjoyed – cherries in wine.

The simplicity of the composition, where a few objects have been placed on a spare shelf, is in keeping with Bonvin's appreciation of Chardin. As a key figure in the Chardin revival, Bonvin had examined the eighteenth-century painter's canvases in private collections and used similar compositional arrangements in still lifes and genre scenes throughout his own career. Occasionally seen by art historians as a *pasticheur* of Chardin's style, Bonvin actually adapted the earlier painter's emphasis on simple design in his tactile examination of a few objects. He advised painters to study the objects directly (as Chardin had done), thereby encouraging interest in observation of objects that could be arranged within a studio to capture nuances of light.

It is not known how many of these still-life compositions Bonvin completed in London (others are in the Rijksmuseum, Amsterdam, and in private collections in the United States), but he gave genre and still-life images to the dealer Durand-Ruel for potential sale. Some panels, possibly this one, he may have kept in his possession until late in his career; the panel bears the stamp of Gustave Tempelaere on the reverse, suggesting it was sold through Bonvin's connection with this dealer that began in 1880.

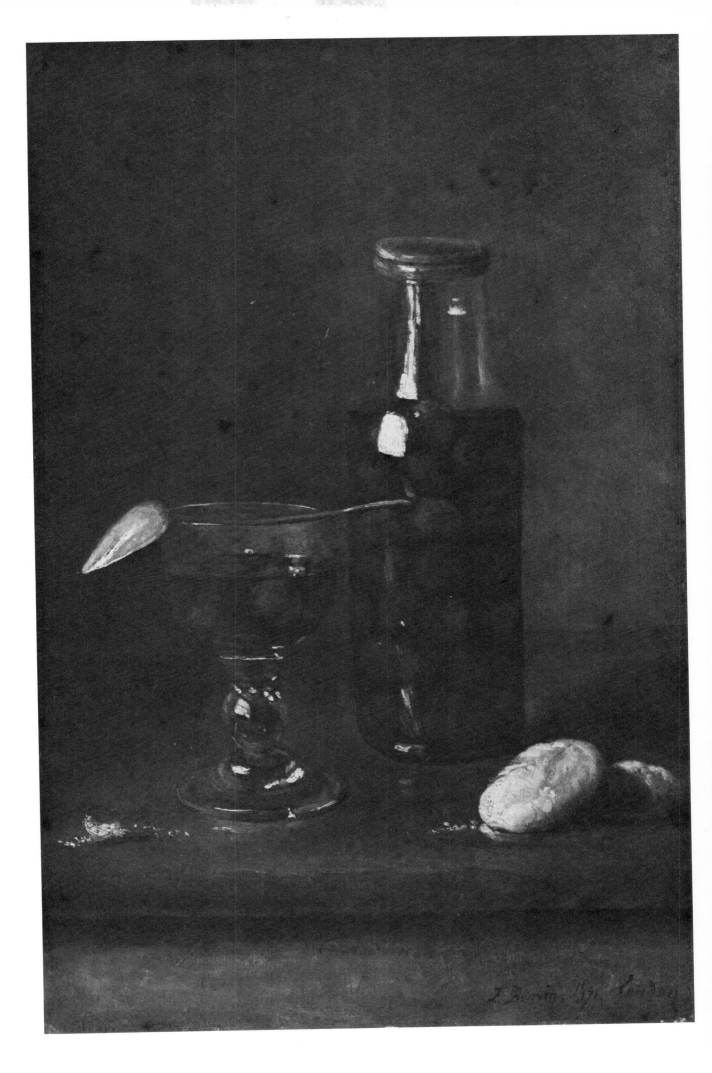

WILLIAM ADOLPHE BOUGUEREAU

La Rochelle 1825 – Paris 1905

BOUGUEREAU WAS BORN of a Catholic father and a Protestant mother in La Rochelle, a former Huguenot stronghold, in 1825. He received his first drawing lessons at the Collège de Pons (near Saintes), and at the age of sixteen enrolled in the École des Beaux-Arts de Bordeaux. In 1846 he went to Paris, where he pursued his training as a painter in the atelier of Picot (1768–1860). In 1850 his canvas *Zenobia Found by the Shepherds on the Shores of the Araxes (Zénobie retrouvée par les bergers sur les bords de l'Araxe)* earned him the *Prix de Rome*. He then left for Italy, where he spent four years copying Giotto and Raphael, the great masters of the Renaissance he most revered.

Much of Bouguereau's career was devoted to secular and religious mural paintings. The churches of Sainte-Clothilde and Saint-Augustin and the Bartholony and Pereire mansions in Paris, the concert hall of the Grand Théâtre in Bordeaux, the cathedral and the residence of a wealthy patron of the arts in La Rochelle were all enhanced by his great compositions with their simple arrangements and subdued colour schemes.

In the Salons between 1854 and 1905, Bouguereau's madonnas and satyrs rubbed elbows in an ethereal atmosphere, like creatures from a world in which good and evil had been reconciled. "Mr Bouguereau's imperturbable fecundity always brings him success," wrote Arthur Baignères. "With its mixture of the sacred and the profane, his work touches the pious soul and easily catches the eye of the heathen. Each year he combines perfect skill, polish, and gracious academic figures to produce, like flowers on a tree, work made to appeal to the upper classes" (quoted in Baschet, *Œuvres de W. Bouguereau*, p. 56).

EXHIBITIONS
Salons of 1849 to 1905.

AWARDS AND HONOURS
Prix de Rome, 1850. Second-Class Medal, Paris Universal Exhibition, 1855. First-Class Medal, Salon of 1857. Third-Class Medal, Paris Universal Exhibition, 1867. Member of the Institut de France, 1876. Medal of Honour, Paris Universal Exhibition, 1878. Knight of the Order of Leopold, 1881. Grand Medal of Honour, Salon of 1885. Medal of Honour, Antwerp, 1885. Chevalier (1859); Officer (1876); Commander (1885); Grand Officer (1903) of the *Légion d'Honneur*.

BIBLIOGRAPHY
Ludovic Baschet, editor, *Catalogue illustré des œuvres de W. Bouguereau,* in Series Artistes modernes, Paris, 1885. Robert Isaacson, *William-Adolphe Bouguereau,* exhibition catalogue, The New York Cultural Center and California Palace of the Legion of Honor, San Francisco, 1974–1975. René Ménard, "W. Bouguereau," *Grands peintres français et étrangers,* Paris: Launette and Goupil, 1884. Marius Vachon, *W. Bouguereau,* Paris: A. Lahure, 1900.

L. d'A.

11

Slumber
(*Le Sommeil*)

Oil on canvas

61.5 x 51.3 cm

INSCRIPTION
Signed l.r., *W. Bouguereau.*

PROVENANCE
Christie's, London, sale of 12 March 1880, cat. no. 109 (purchased by Agnew & Sons, London); S.P. Avery, New York, 1880; Mrs Mary Radcliffe, sale of her collection, Christie's, London, 22 February 1908 (as *An Italian Mother and Boys,* 23½ in. x 19½ in., purchased by Bernheim, Paris); Bernheim-Jeune, Paris (as *Maternité*); collection of Mrs Escudero, Buenos Aires; Adolfo Bullrich y Cia Ltda, S.A. (associated with Sotheby's, Buenos Aires), sale 14 November 1973, cat. no. 20 (as *Maternidad*), repr.; Hammer Galleries, New York. Acquired January 1975.

EXHIBITIONS
22 October–15 December 1974, Hempstead (Long Island), N.Y. Hofstra University, The Emily Lowe Gallery, *Art Pompier: Anti-Impressionism, 19th-Century French Salon Painting,* cat. no. 14, repr.

RELATED WORKS
Slumber, 1864 Salon, oil on canvas, 1.57 x 1.22 m, signed u.l., and dated 1864 (location unknown). Sketch, oil on canvas, for the *Slumber* of the 1864 Salon, oil on canvas, approximately 1.35 x 1.05 m (the artist's heirs). Drawing for overall composition, black pencil on buff paper, 32 x 24.2 cm (the artist's heirs).

THIS PAINTING is a smaller and modified version of the *Slumber (Sommeil)* which was shown at the Salon of 1864. While the grouping of the mother and children exactly reproduces the Salon painting, the artist has changed the setting of this intimate family scene. In the 1864 picture, the group, placed in what seems to be an exterior courtyard, stands out against a white wall. Through an opening on the right we can glimpse part of the wall of a house, relieved by dark vegetation, the only element to enliven the classical gravity of this scene.

In the version exhibited here, the setting is a rustic interior furnished with only a few familiar objects. The right leg of the chair against which the standing child is silhouetted coincides with the line of the wall in the 1864 version. The woman is wearing an Italian peasant costume, but the affected grace of her pose and that of the eldest child have nothing in common with the simple gestures of the countryfolk represented in the contemporary paintings of artists such as Jean-François Millet (1814–1875). Sugar-coated, polite images of rural life were in fact intended for a bourgeois public which loved to look beyond the anecdote depicted and recognize the eternally recurring gestures of humanity incarnate in noble forms arranged in a manner not too far removed from the proven formulas of the grand tradition. "This sort of madonna is reminiscent of all the paintings that young students plagiarize from the Italian masters and send off to the exhibitions of the École des Beaux-Arts," wrote Bürger (Baschet, *Œuvres de W. Bouguereau,* p. 28).

The figure of the standing child with brown hair had already appeared, reversed, in *Brotherly Love (L'Amour fraternel)* of 1851, and again, with the arms in a different position, in the *Holy Family (Sainte Famille)* from the 1863 Salon. This *Holy Family* certainly influenced the *Slumber* of 1864, which seems to be a secular version of the 1863 work (see also *The Virgin, the Infant Jesus, and Saint John the Baptist,* cat. no. 12). The critics recognized this. Gautier noted that, "There is a great deal of charm in this maternal grouping, which could easily become a *Holy Family*" (Baschet, p. 28) and Paul de Saint-Victor referred to "These three white figures, composed and grouped like a working-class Holy Family . . ." (Baschet, p. 28).

It is difficult to date with precision the small-scale replicas Bouguereau made of his large Salon paintings. Here, too, we are dealing with a rare instance where the reduced version does not conform exactly to the prototype. According to Baschet and Vachon, the replicas were often done for purposes of engraved reproduction and were made immediately after the parent Salon paintings, but it is also probable that some of them were done several years later. In this instance, the oil lamp on the buffet at the left, appears in another painting, *Bunch of Grapes (La grappe de raisin)* of 1868, but this is not sufficient reason to suggest the same date for *Slumber.* Still, it is reasonable to think it was painted before 1870.

The subtle colour scheme (predominantly blue and white, with accents of

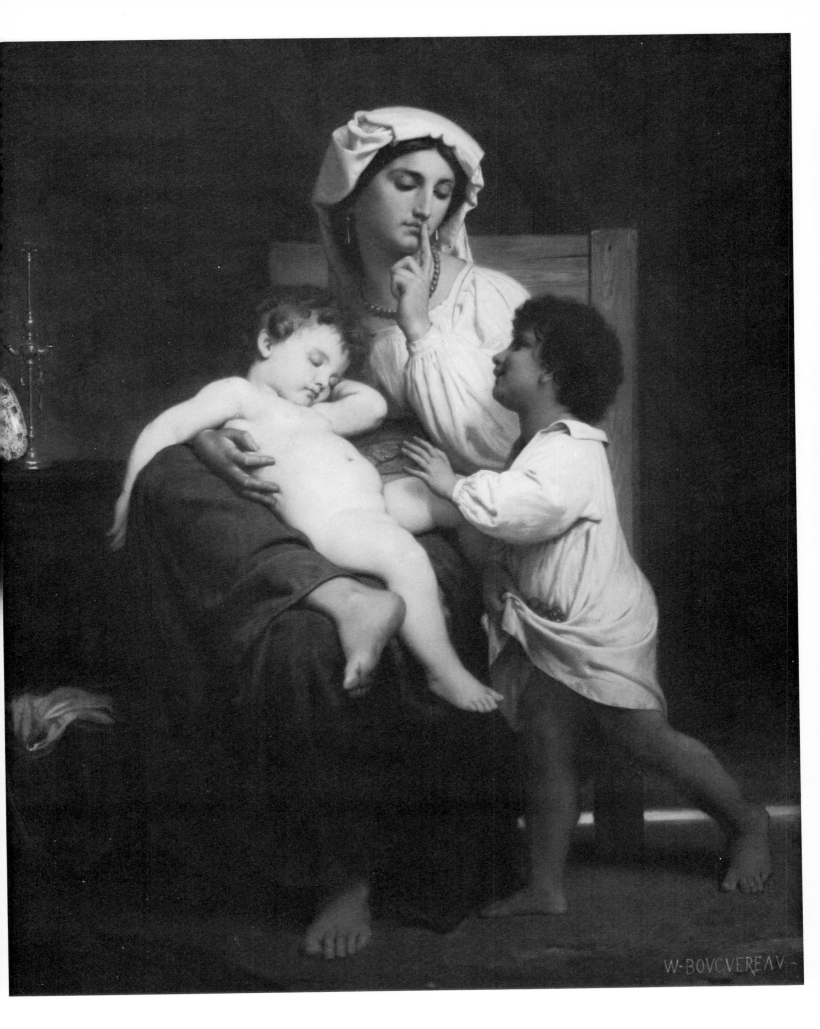

red), and the skillful rendering of the various textures (the wood seat, the heavy cloth of the skirt, and the linen bodice) bear witness to the exceptional gifts of an artist who, unfortunately, often lacked imagination and failed to seek fresh approaches to his work.

12

The Virgin, the Infant Jesus, and Saint John the Baptist 1875

Oil on canvas

1.97 x 1.18 m

INSCRIPTION

Signed and dated l.r., *W. Bouguereau – 1875.*

PROVENANCE

Collection of Aristide Boucicaut, Paris; Mrs Aristide Boucicaut, 1878; Hôtel Drouot, Paris, sale 9 February 1976; Galerie Félix Marcilhac, Paris; Charles Jerdein, London. Acquired June 1976.

EXHIBITIONS

Salon of 1875, cat. no. 272 (belonging to Mr Boucicaut). Paris Universal Exhibition of 1878, cat. no. 95 (lent by Mrs Boucicaut).

BIBLIOGRAPHY

Anatole de Montaiglon, "Salon de 1875," *Gazette des Beaux-Arts,* vol. 1 (1875), p. 506, repr. with Bouguereau's sketch after his own painting. Émile Zola, "Exposition de tableaux à Paris" [1875], in *Mon Salon – Manet, Écrits sur l'art,* compiled by Antoinette Ehrard, Paris: Garnier-Flammarion, 1970, p. 229. "International Art at the Universal Exhibition, Paris," *The Art Journal,* 1878, p. 197. Reproduced in *The Graphic,* Christmas 1879. Ménard, "W. Bouguereau," vol. I, p. 7, repr. p. 9. Baschet, ed., *Catalogue illustré des œuvres de W. Bouguereau,* pp. 51–52. Vachon, *Bouguereau,* photogravure repr. by Dujardin, p. 93. Reproduced in *Burr-McIntosh Monthly,* December 1907.

RELATED WORKS

Smaller-scale replica made for engraving, mentioned in the *Catalogue illustré des œuvres de W. Bouguereau,* 1885, p. 51. Preparatory sketch, oil on canvas, approximately 1.35 x 1.05 m (the artist's heirs). Drawing for the overall composition, black pencil on beige paper, 32.7 x 25.3 cm (the artist's heirs). *Same subject with variations* Canvas entitled *The Holy Family* (1863 Salon, cat. no. 226), 1.37 x 1.08 m, signed and dated 1862, purchased by Napoleon III, later in the collection of the Empress Eugénie (see sale of her collection, Christie's, London, 1 July 1927, as *The Madonna and Child, with the Infant St John).* Painting with the same title as this one mentioned in 1881 by Vachon (1900) in his catalogue of Bouguereau's works, p. 154.

Canvas, 1.88 x 1.09 m, signed and dated 1882, in the Mary J. Morgan sale, American Art Gallery, New York, 8 March 1886, cat. no. 238, and Samuel B. Sexton sale, American Art Association, 10 February 1905, cat. no. 188, as *Madonna, Infant Saviour and St John.* The Tanenbaum picture was engraved by Gustave Bertinot.

EXHIBITED AT THE 1875 SALON, this painting is the first in a series of large religious works (*Pietà,* 1876; *Virgin as Consoler [Vierge consolatrice],* 1877, *Charity,* 1878), which are among the artist's most famous and which reveal the full maturity of his talent. Various characteristics – the absolute frontality of the elements that make up the setting, the placing of the main subject on the vertical axis of the composition, the monumental simplicity of the figures in contrast with the preciosity evident in the architectural detail – set these works apart from the rest of the artist's production.

Numerous elements in this painting bring to mind the great tradition of Italian art: the abstract treatment of the mosaic decoration of the throne on which the Virgin is seated is reminiscent of the work of the Cosmati family (Rome XIII–XIV centuries); the curve of the back of the throne with its foliated scroll suggests a fifteenth-century Venetian architectural motif; and the grouping of the Virgin, the Infant Jesus, and Saint John, whose noble simplicity appears to be inspired by Raphael (the Infant Saint John is based on the portrayal of Jesus in *La belle jardinière* in the Louvre). Yet in spite of these allusions to the past, the work is wholly original.

The same subject, The Virgin, the Infant Jesus and Saint John the Baptist, had been treated by Gérôme (cat. nos 30–38), and had earned him a second-class medal in the 1848 Salon. Bouguereau, who had been studying painting in Paris since 1846, undoubtedly saw his young rival's painting, in which the dependency on Raphael is so evident that it verges on plagiarism. Although the influence of Andrea del Sarto (1486–1550) or Raphael can be detected in Bouguereau's painting of almost twenty years later, one can see that the artist has fully assimilated the tradition from which he drew his inspiration, producing a work that is both personal and representative of a certain trend in art of the second half of the nineteenth century.

The theme of the 1875 canvas can be traced back to 1851 when, in his painting entitled *Brotherly Love (L'amour fraternel;* 1854 Salon and 1855 Universal Exhibition), Bouguereau explored the motif of a mother and two children. In

this picture, which could have been done as a tondo, the woman is seated on the ground, with her arms around two children who are embracing each other in a pose analogous to that in the Tanenbaum picture. Théophile Gautier's comments on *Brotherly Love* emphasize the ambiguous nature of the subject: "A beautiful young woman whom one would take for the Virgin Mary. . .bends in motherly fashion over two children who are embracing each other, like the Infant Saint John and the Infant Jesus in paintings of the Holy Family" (Baschet, *Œuvres de W. Bouguereau,* p. 8).

In 1862 Bouguereau painted a *Holy Family* which at one time belonged to the Imperial Family and hung in the Palais des Tuileries (see catalogue for the sale of the Empress Eugénie's collection in 1927, which contains this title: *The Madonna and Child, with the Infant St John).* This composition varies only slightly from the other subjects mentioned. After this came *Slumber* (1864 Salon) which is essentially a secular version of the theme of *The Virgin, the Infant Jesus, and Saint John the Baptist* (see cat. no. 11).

A large oil sketch for the 1875 canvas (collection of the heirs of the artist) shows the group set in a landscape and to the right of centre. The two boys are in the same pose as in the Tanenbaum picture, but the Virgin is seated in three-quarters profile and holds a distaff in her right hand. In the left foreground is a woven basket; here the influence of Leonardo da Vinci (1452–1519) seems to predominate.

In the final version, Bouguereau opted for a more severe grouping, with the figures contained in a perfectly symmetrical architectural setting. The rigour of the composition and the hieratic pose of the Virgin make the painting a sort of modern icon but one which would be more appropriate in a boudoir than a church (Zola, in *Manet,* p. 229). While the bourgeois public, "society people with an eye for pretty things," regarded with delight these images of worldly piety, the critics were very severe in their judgement of this painting which they saw as lacking in conviction and having no depth whatsoever. Jules Clarétie wrote that, "Nothing could be more elegant, more charming or more tender than Mr Bouguereau's *The Virgin, the Infant Jesus and Saint John the Baptist. . . ,* a work overly polished and overly finished, exuding unctuous grace and finicky perfection. . . . All this plus a deft hand enables him to make a colossal fortune by producing for export alternately Virgins and Bathers, Madonnas and Floras and Zephyrs, John the Baptists and frolicking Fauns.

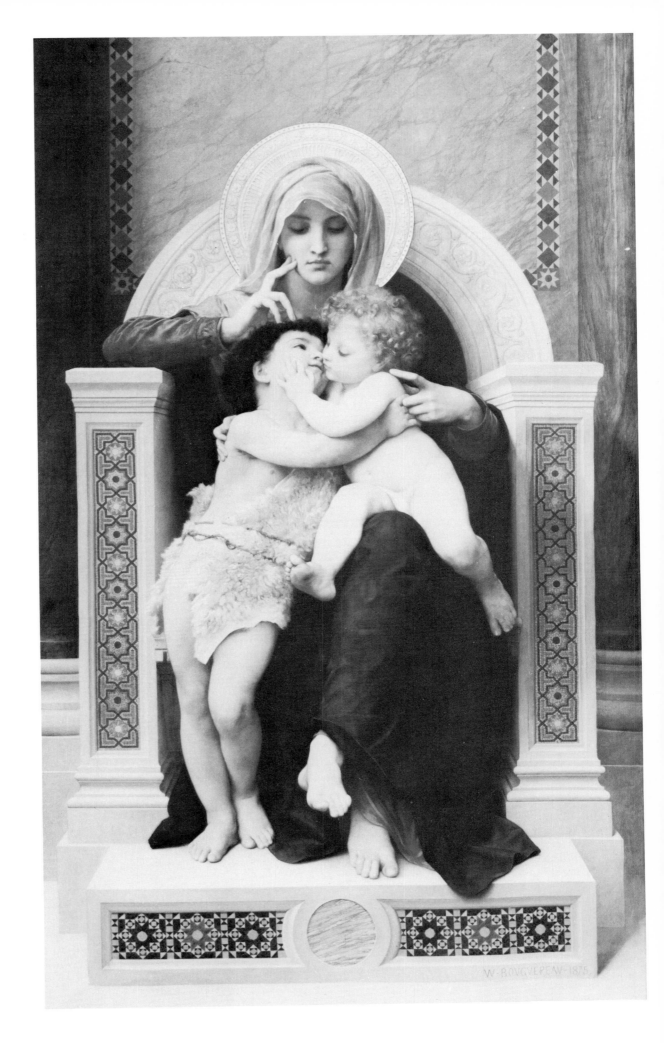

Mythology and Catholicism are mixed, for Mr Bouguereau is an eclectic" (in Baschet, *Œuvres de W. Bouguereau*, p. 52). No better summary could be made of the points on which the critics attacked the artist at the annual Salons – the affected treatment of subject, academic draughtsmanship, photographic realism which destroys any mystery, and above all, confusion of genres, which results in a blurring of the sacred and the profane.

The theme of *The Virgin, the Infant Jesus and Saint John the Baptist* was to undergo subsequent development in Bouguereau's work. Vachon mentions a version done about 1881 (p. 154, same title, location unknown), and the catalogues for the successive sales of the Mary J. Morgan collection (between 1884 and 1886; see Related Works) indicate that there was another canvas dated 1882 quite close in size to the Tanenbaum picture. In the 1882 version, the Infant Jesus, sitting on his mother's lap, has his arms outstretched in the form of a cross and is looking tenderly at the Infant Saint John, who is stretching clasped hands towards him in a gesture of adoration.

These different versions and interpretations of *The Virgin, the Infant Jesus, and Saint John the Baptist* demonstrate the interest of the art-buying public in a motif which could be interpreted either profanely, as an expression of brotherly love, or religiously, as a divine pact prefiguring Christ's Passion, the reason for the Virgin's melancholic gaze.

It was apparently in response to the enthusiasm of the American collectors who commissioned them that Bouguereau so frequently painted these sentimental subjects which, in France, appealed to only part of the Salon-going public. "This particular brand of art had great appeal on the other side of the Atlantic, and Mr Bouguereau's adorable sweetmeats are the rage in America," wrote Jules Clarétie à propos *The Virgin, the Infant Jesus, and Saint John the Baptist* in the Tanenbaum collection (in Baschet, *Œuvres de W. Bouguereau*, p. 51).

It seems that those who liked this type of art were attracted less by the subjects depicted than by the quality of execution, the high degree of finish, the perfection of the drawing, the finesse of the modelling, and the very subtle light effects which, applied to the various textures (marble, fur, skin, hair, clothing), give them a sort of tactile presence which appeals immediately to the senses while also satisfying the criteria for material verisimilitude of the subject portrayed. The physical presence of figurative elements is reinforced by the three-dimensional effects obtained by an extremely skillful utilization of light and shade which causes certain parts to stand out – notably, the foot of the Virgin, which seems to protrude from the canvas. The colour scheme consists essentially of primaries – red and blue – softened by lightly tinted whites, which serve to unify the parts of the painting. Finally, it is important to note the distortion of the horizontal lines of the pedestal and the architectural elements to the right; this was undoubtedly introduced to animate, albeit imperceptibly, a composition which would otherwise be too perfectly symmetrical.

13

Self-Portrait 1886

Oil on canvas

47 x 38.5 cm

INSCRIPTION
Signed and dated u.r., *W. Bouguereau/1886.* Dedication in block letters, u.l., *A mon cher professeur et ami/Mr–Sage.*

PROVENANCE
Hôtel Drouot, Paris, sale 3 March 1976, no. 29; Georges Martin du Nord, Paris. Acquired February 1977.

RELATED WORKS
In addition to the self-portrait in the Tanenbaum Collection, there are six other self-portraits known. Of the two done in oil on canvas during Bouguereau's sojourn in Italy, one portrays the artist in a bust length, three-quarter view and remains in the sketch stage; the other, signed and dated, was reproduced in the catalogue for the exhibition *Bouguereau en Italie*, Lyon, Musée des Beaux-Arts, 1948, cat. no. 8, fig. 1 (both belong to the artist's heirs.) Another, signed and dated 1854, is in the Villa Medici in Rome (Manuel Gasser, "Pensionäre von Pensionären Gemalt," *Du*, vol. 32 [September 1972], p. 652, repr. col. p. 653). One canvas, 93 x 61 cm, signed and dated 1888, in which the painter is visible to his hips, was reproduced as an engraving by Charles Baude in the *Monde illustré*, 30 April 1889 (it belongs to the artist's heirs) and there is a copy of this portrait in the same size by Charles-Amable Lenoir (Bouguereau's heirs). A canvas, 53 x 46 cm, signed and dated 1895, is in the Uffizzi, Florence, Portrait Gallery (repr. in the catalogue of the exhibition *Pitture francese nelle collezioni pubbliche fiorentine*, 1977, cat. no. 45, p. 80). Another, 1.63 x .98 m, signed and dated 1895, is in Antwerp, Musée Royal des Beaux-Arts, Galerie des Académiciens (repr. in Vachon, *W. Bouguereau*, 1900, frontis.).

THIS PORTRAIT was painted when the artist was at the peak of his career. A professor at the École des Beaux-Arts since 1875 and a member of the Institute the following year, he had just received the Grand Medal of Honour at the 1885 Salon in acknowledgement of past achievements and had been made a Commander of the *Légion d'Honneur*, a coveted title which gave official recognition to his talents.

The portrait is dedicated to Mr Sage, a student of Ingres (1780–1867) and drawing instructor at the college in Pons, from whom Bouguereau took his first drawing lessons at the age of thirteen (Vachon, *W. Bouguereau*, p. 7). There is no known document which sheds light on the relationship between teacher and pupil after Bouguereau left his home province to enter the Paris atelier of François-Edouard Picot (1786–1868) in 1846. A painter named Auguste Jules Sage (1829–1908) also attended Picot's atelier at the École des Beaux-Arts and could, if he were related to the enigmatic Mr Sage, have been a connection between Bouguereau and his former teacher. In any event, this dedicated portrait suggests that the contact between the two men remained unbroken during the years between Bouguereau's college days and the period when he received official recognition. It is also possible, however, that at the time when he was so highly honoured – the portrait shows him wearing his decoration – Bouguereau remembered with emotion and gratitude the man who had started him on his career.

The painter's image of himself is simple and direct. His dress may appear formal, but if one looks at contemporary photographs of the artist it seems that this was the way he dressed every day, even for painting. The focal point is the face, where the furrowed brows express concentration and application. The presence of two warts on his right cheek indicates that the painter did not want to hide anything of his physical appearance and did not try to project an idealized image of himself. The subtle modelling, the confident execution, and the lightness of touch which draws attention to neither the medium not the brushwork, make this a nearly immaterial work, like the pure perception of the effect of light on a form.

A MON CHER PROFESSEVR ET AMI
Mᴿ SAGE

W BOVGVEREAV
1886

FÉLIX BRACQUEMOND

Paris 1833 – Sèvres (near Paris) 1914

BORN INTO A MODEST FAMILY with no artistic background, Bracquemond trained as a young man in the studio of Joseph Guichard (1806–1880), a painter who had reconciled the teaching of Ingres (1780–1867) and Eugène Delacroix (1798–1863). As a result of this training, he maintained an uncompromising independence and hatred of academic circles, which he often sharply attacked.

Although he drew and painted a number of portraits, such as that of Madame Calmas, his career as a painter, launched in the 1852 Salon, was not terribly successful. From 1852 on, however, he played a leading role in the revival of interest in etching. His *Upper Part of a Swinging Door (Haut d'un battant de porte;* 1852) was the first of a number of masterpieces to be found among the hundreds of prints he did from 1849 to 1910, including original compositions (*Portrait of Meryon,* 1853; *Portrait of Goncourt,* 1882; *The Old Rooster,* 1882), as well as reproductive prints (after works by Delacroix, Corot, Millet, Gustave Moreau, and others). No less considerable was his influence – particularly with regard to printmaking – on the careers of his friends Meryon, Corot, Millet, Manet, and at a later date, Gauguin, Pissarro, and Rodin.

Bracquemond had a wide range of interests. His many friends in important literary circles included Champfleury, Banville, Baudelaire, Goncourt, Dolent, and Geffroy. Moreover, he was among the founders of the most important groups and societies that animated France's artistic scene in the second half of the century: the Société des Aquafortistes (1862–1867); the Impressionists; the Société nationale des Beaux-Arts, founded in 1910; and the Société des Peintres-Graveurs, beginning 1889–1890. In addition to printmaking, he was interested in ceramics, and contributed to the development of both its form and decoration (Rousseau Service, 1866); from 1872 to 1881 he was director of a porcelain research studio in Auteuil, a suburb of Paris. His involvement with the decorative arts is shown by the works in silver, the furniture, and the tapestries he executed about 1900. A passionate theoretician and critic, he wrote many articles and brochures, and the important treatise, *Du dessin et de la couleur* (1885).

EXHIBITIONS
Exhibited regularly in the Paris Salons from 1852. Salon des Refusés, 1863. Impressionist exhibitions, 1874, 1879, 1880. Société nationale des Beaux-Arts from 1890. Société des Peintres-Graveurs from 1889.

AWARDS AND HONOURS
Medal, Salon of 1866 (painting). Medal, Salon of 1868. Second-Class Medal, Salon of 1872. First-Class Medal, Salon of 1881. Medal of Honour, Salon of 1884. Chevalier (1882) and Officer (1889) of the *Légion d'Honneur.* Grand prize, Paris Universal Exhibition, 1900.

BIBLIOGRAPHY
Henri Beraldi, *Les graveurs du XIX siècle: guide de l'amateur d'estampes modernes,* vol. III, *Bracquemond,* Paris: L. Conquest, 1855-1889. Jean-Paul Bouillon, "Une visite de Bracquemond à Gaston La Touche," *Gazette des Beaux-Arts,* March 1970, pp. 161–177; Bouillon, exhibition catalogue, *Félix et Marie Bracquemond,* Montagne, May 1972; Bouillon, "La correspondance de Félix Bracquemond," *Gazette des Beaux-Arts,* December 1975, pp. 351–386; Bouillon, "Bracquemond, Rops et Manet," *Nouvelles de l'Estampe,* March–April 1974, pp. 3–11, and January–February 1975, p. 26; Bouillon, exhibition catalogue, *Hommage à Félix Bracquemond,* Paris, 1974; Bouillon, exhibition catalogue, "Bracquemond impressioniste," *Céramique impressioniste,* Paris 1974; Bouillon, "Correspondance de Bracquemond et de Poulet-Malassis," *Bulletin du Bibliophile,* 1975, vol. 1–4, and 1976, vol. 4, pp. 371–404; Bouillon, "Manet vu par Bracquemond," *Revue de l'Art,* no. 27 (1974), pp. 37–45.

J.-P.B.

14

Portrait of Madame Calmas 1860–1863
Pastel on paper laid on canvas
46.8 x 35.2 cm

INSCRIPTION
Signed and dated u.1., *Bracquemond, 1863.*

PROVENANCE
Hector Brame, Paris; returned to the artist about 1909; Serge Michel, New York; Shepherd Gallery, New York. Acquired April 1975.

EXHIBITIONS
Salon of 1863(?). 14 May 1909, Paris, *Exposition rétrospective de portraits de femmes sous les trois Républiques organisée par la Société Nationale des Beaux-Arts dans le Palais de Bagatelle,* no. 22. 20 May–June 1927, Paris, Palais des Beaux-Arts, *Exposition rétrospective des oeuvres de Félix Bracquemond,* no. 4 (*Portrait of a Lady,* pastel [?]). May–June 1968, New York, Shepherd Gallery, *The Non-Dissenters,* vol. IV, Shepherd Gallery, no. 161, repr. pl. no. XXI, as *Portrait Bust of Madame Marie Bracquemond.* May–June 1975, New York, Shepherd Gallery, *Ingres and Delacroix Through Degas and Puvis de Chavannes: The Figure in French Art 1800–1870,* no. 131, pp. 309–310, repr. as *Portrait of Marie Quivoron.*

BIBLIOGRAPHY
E. Cantrel, "Salon de 1863," *L'Artiste,* 1 May 1863, p. 197(?).

SINCE BRACQUEMOND'S PASTEL is signed and dated, the only historical and iconographic problem it poses is the identification of the sitter. This, in itself, is a considerable problem which has been too quickly and too lightly dealt with by previous commentators.

Two recently discovered documents complicate the history of the painting but, at the same time, help solve the problem of identification. The first (fig. 1) is an old photograph of a portrait that seems very similar; the second, a photograph dating from 1909, shows the Tanenbaum picture in Bracquemond's studio at the end of his life. Both the photographs were in the artist's personal archives at the time of his death.

The portrait recorded in the old photograph differs from that under discussion in several respects: it is signed at the right, dated 1860, and varies in treatment considerably, particularly in the areas behind the model's neck and in the clothing on the right side. The portrait might therefore be an earlier version of the picture here, or it might have been subsequently reworked and used as the basis of the Tanenbaum portrait. The similarity of execution suggests the second hypothesis. Indeed, it is possible to detect the trace of the earlier signature and date, which were more carefully executed, with letters and figures resembling those found in Bracquemond's pastel portrait of Horace de Montègre, the artist's patron during his youth, also dating from 1860 (Musée du Louvre). The present state of the portrait would thus be the result of changes made in a work which was essentially finished in 1860. Since the period 1860–1863 witnessed the beginnings of Bracquemond's Japanism and his first contacts with Manet (1832–1883), this becomes an important factor in analyzing the portrait and explaining its stylistic characteristics. For the nature of the changes indicate that the reworking was done to improve the portrait: the disappearance of the flower in the arrangement of the woman's hair and the modifications in the clothing reinforce the simple contrasts that make this an effective work.

On at least one other occasion, Bracquemond is known to have similarly reworked a pastel portrait; the work in question was the *Portrait of My Grandmother* (Louvre) shown at the 1852 Salon. We do not know when Bracquemond modified the work, but clearly it was after 1852.

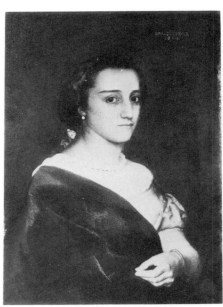

Fig. 1
Portrait of Madame Calmas,
before reworking

The reworking of this portrait could have been done with a view to exhibition in the famous Salon of 1863. While it does not appear in the catalogue or the records of the exhibition, a critic wrote before its opening that Bracquemond had, for this Salon, "attempted a portrait in pastel" (Cantrel, "Salon of 1863"). At present, we know of no work other than this portrait to which the critic could have been referring. The lack of admission records for the Salon for these years makes it impossible to settle the question; nor do we know why Bracquemond might have withdrawn this portrait which, had it been rejected by the Salon jury, would have been shown at the Salon des Refusés.

Another photograph of the portrait, discovered at the Archives photographique (Paris), documents only the name of the sitter: Madame Calmas. We know also that a pastel portrait of Madame Calmas by Bracquemond is recorded – but not reproduced – in an exhibition catalogue of 1909 (Le Palais de Bagatelle, Paris). At that time the portrait was recorded as being in the collection of the art dealer Hector Brame. Then, as the photograph of Bracquemond's studio attests, the portrait was in Bracquemond's possession shortly thereafter. As with the 1864 portrait of Manet, which was returned to Bracquemond in 1904, the artist may have temporarily or permanently taken back this portrait. But in view of the fact that he did not touch the Manet portrait, even though it was unfinished, it is most unlikely that he would have modified the *Madame Calmas* at that time.

The question of the identity of Madame Calmas remains to be solved. This name does not appear in the biographical dictionaries, and research has failed to unearth any information. There is, however, no reason to doubt the information in the 1909 catalogue, published during Bracquemond's lifetime. It is impossible to confuse the sitter with Nina de Callias, whom Manet knew and painted much later (1874); and the theory that she could be Bracquemond's wife Marie Quivoron (Shepherd Gallery catalogue, 1968, 1975) is untenable. The artist met his future wife at a later date and she bore no resemblance to the sitter in this portrait. Moreover, although the first version of the Calmas portrait was done at the same time as the portrait of Montègre, and the similar signatures are symetrically placed, the different dimensions of the works exclude for the moment the hypothesis that the works are pendants.

The date of 1860 better explains the overall conception of the Madame Calmas portrait. In his paintings and drawings (but not in his prints) of this period, Bracquemond was influenced by the Ingresque aesthetic which had been passed on to him by his first and only teacher, Guichard. In order to understand the overall composition, the pose, the expression, the position of the arm and hand, we must look first at the self-portrait of 1853 (Fogg Art Museum); then at Guichard's self-portrait (1829), copied by Bracquemond in 1851 (Private Collection); and finally, at the famous Ingres self-portrait, done before 1861 (Musée de Chantilly), which is closely related to the other works. The second major influence was Holbein (1497–1543), an artist much admired at that time and one whom Bracquemond had studied closely, following his 1858 commission to do an etching after the Louvre's *Portrait of Erasmus.* He worked on this print until 1863, when it was shown in the Salon des Refusés; a comparison of the Erasmus portrait and *Madame Calmas* sheds light on the importance given to the hand and the positioning of the fingers in Bracquemond's pastel.

In this portrait, Bracquemond is at the peak of what one could call his "Ingresque classicism": the stable composition is built on a triangle whose base is formed by the lower corners of the table. The diagonal made by the line of the jaw, cape, and arm balances the three-quarter pose with the turn of the head and particularly the position of the left forearm. The sobriety of the composition has been accented by the modifications, and emphasized by the simple contrast of the two areas of the clothing, black and pearly white against the acid blue of the background. This coldness is balanced by the orange-pink of the flesh tones. The subject's social class is indicated only by the highlighted pearl earring and gold bracelet, which creates an axis perpendicular to that of the two areas of the clothing.

The year after *Madame Calmas* was finished, this classicism was confronted with the methods and concerns of the new avant-garde: the portrait of Manet (1864), for instance, incorporates a similar pose, but the figure is positioned off centre, thereby reflecting the Japanist formal devices with which Bracquemond's friend Degas (1834–1917) was experimenting at the time.

The concentration on style, the search for perfection in the modelling (for which the artist used a stippled technique comparable to that found in engraved portraits), and the energy and frankness of the realism natural to Bracquemond, give this work its particular flavour. This portrait marks an important moment in the artist's early career, and reveals a personalized version of the Ingresque aesthetic of the early 1860s.

EUGÈNE CARRIÈRE

*Gournay, Seine-et-Marne 1849 –
Paris 1906*

CARRIÈRE, THE SON OF A POOR INSUR-
ANCE SALESMAN, was raised in Stras-
bourg and given training in art as a
background to his apprenticeship in
lithography. Though his paternal
grandfather and uncle were artists, he
encountered parental objections in 1868
when he announced his decision to
become an artist himself. Seeing the
paintings by Rubens (1577–1640) in the
Louvre had inspired this resolve.
Shortly before the outbreak of the
Franco-Prussian War he enrolled in the
courses of Alexandre Cabanel
(1823–1889) at the École des Beaux-
Arts where, after returning from mili-
tary service, he resumed his studies in
1871. To support himself during
1872–1873, Carrière worked in the
lithographic shop of his friend, Jules
Chéret (1836–1932), whom he had met
as a fellow apprentice in Strasbourg. In
1877, he terminated his studies under
Cabanel, and that same year he mar-
ried. But so far, success eluded him. He
was forced to find occasional employ-
ment, usually with printers, till as late
as 1889. In London, where he and his
bride spent six months in 1877, he
designed Christmas illustrations. Dur-
ing this period he became an admirer of
the paintings of Turner (1775–1851).
Between 1880 and 1885 his brother,
Ernest, a ceramist, arranged part-time
employment at Sèvres Porcelain, where
Carrière and Auguste Rodin
(1840–1917) met, thus beginning their
very close friendship.

At the Salon of 1884, where his *Child
with Dog (Enfant au Chien)* received an
honourable mention, Carrière gained
the support of the critic Roger Marx.
During the next half decade the artist
came to count among his friends
Edmond de Goncourt, Paul Gallimard,
and Georges Clémenceau. The Paris
Universal Exhibition of 1889 marked
the beginning of Carrière's continued
success (see Awards and Honours).
Amazingly, at this moment of triumph,
he broke with the Société des Artistes
Français to become a founding member
of the Société Nationale des Beaux-Arts.

Carrière expressed admiration for
many Old Masters, but he was
influenced mainly by his contemporary
Jean-Jacques Henner (cat. no. 40),
whose advice he sought in the early
1880s when the former's distinctive style
was developing. By the mid-1880s
Carrière's work was increasingly char-
acterized by a dense atmosphere, cre-
ated by monochromatic brown out of
which the images only partially emerge,
and a preference for themes of familial
bonds, especially motherhood. The inti-
macy and tone of quiet reverie, which
became important in the visual arts in
the 1890s, quickly led critics to observe
his influence and note the existence of
an École Carrière. The artist was wel-
comed at the Café Voltaire, and even
became involved in the Symbolist thea-
tre.

In August 1902 Carrière was among
several artists who established a new
salon, the Salon d'Automne, to which
he was named honorary president. His
position of esteem in the art world was
publicly acknowledged in December
1904 at a banquet in his honour
attended by five hundred guests. This
event, organized by the sculptor Émile
Bourdelle (1861–1929) and presided
over by Rodin, demonstrated the affec-
tion that society had for him.

After Carrière's death from cancer
of the throat, the Société Nationale des
Beaux-Arts and the Salon d'Automne
in 1906, followed by the École Natio-
nale des Beaux-Arts and the Libre
Esthétique in 1907, held major retro-
spectives of his work.

EXHIBITIONS
Salons of the Société des Artistes Français,
1876–1880; 1882–1889. Société Nationale
des Beaux-Arts, 1890–1902, 1904–1905.
Salon d'Automne, 1903–1905. Libre Esthéti-
que, 1894, 1896, and 1899. Société Interna-
tionale, 1898. Munich Secession, 1896, 1899,
1905, and 1906. Berlin Secession, 1904.

AWARDS AND HONOURS
Second-Class Medal, Salon of 1885; Medal,
Salon of 1887. First-Class Medal, Paris Uni-
versal Exhibition, 1889. Chevalier (1889) of
the *Légion d'Honneur.* Grand Prize for
Graphic Arts, Paris Universal Exhibition,
1900. Gold Medal, St Louis Universal Exhi-
bition, 1904.

BIBLIOGRAPHY
Robert James Bantens, *Eugène Carrière – His
Work and His Influence,* Ann Arbor: Univer-
sity Microfilms, 1976. Anne-Marie Berryer,
"Eugène Carrière: sa Vie, son Oeuvre, son
Art, sa Philosophie, son Enseignement,"
Ph.D. dissertation, University of Brussels,
1935. Eugène Carrière, *Écrits et lettres choisies,*
Paris: Société du Mercure de France, 1907.
Jean-René Carrière, *De la vie d'Eugène
Carrière,* Toulouse: Édouard Privat, 1966.
Loys Delteil, *Le Peintre-Graveur illustré,* vol. 8,
Eugène Carrière, Paris: Chez l'Auteur, 1913.
Jean-Paul Dubray, *Eugène Carrière: Essai
critique,* Paris: Éditions Marcel Seheur, 1931.
Élie Faure, *Eugène Carrière, Peintre et
Lithographe,* Paris: H. Floury, 1908. Gustave
Geffroy, *L'Œuvre de Eugène Carrière,* Paris: H.
Piazza, 1902. Charles Morice, *Le Christ de
Carrière,* Brussels: Éditions de la Libre
Esthétique, 1899; Morice, *Eugène Carrière –
l'Homme et sa Pensée; l'Artiste et son Œuvre, Essai
de Nomenclature des Œuvres principales,* Paris:
Société du Mercure de France, 1906.
Gabriel Séailles, *Eugène Carrière, l'Homme et
l'Artiste,* Paris: Édouard Pelletan, 1901;
Séailles, *Eugène Carrière: Essai de Biographie
psychologique,* Paris: Armand Colin, 1911.

R.J.B.

15

Mme Carrière c. 1895

Oil on canvas

55.5 x 46.8 cm

INSCRIPTION
Signed l.l., *Eugène Carrière*.

PROVENANCE
Collection of Max Robin, Paris, until *c.* 1967; Schweitzer Gallery, New York. Acquired July 1968.

EXHIBITIONS
Paris, 1920, Galerie Manzi, Joyant et Cie, cat. no. 85. 1968–1969, Allentown, Allentown Art Museum, *Eugène Carrière 1849–1906; Seer of the Real*, cat. no. 45, repr. 1969, Art Gallery of Ontario, *The Sacred and Profane in Symbolist Art*, p. XLI, cat. no. 169, pl. 151.

BIBLIOGRAPHY
Berryer, "*Eugène Carrière*," p. 97, cat. no. 360 (as *Femme pensive*).

MME CARRIÈRE POSED TIRELESSLY for her husband throughout his career. She appears in several hundreds of his works whose themes cover nudes, *maternités* or familial scenes, and pensive or melancholic figural studies. Though she was so frequently the focus of her husband's artistic vision, one is unable to form a clear mental picture of her personality. The tender and poetic moods found in these paintings more likely reflect the artist's feelings rather than those of his wife.

Carrière's letters and writings exhibit an ability for intelligent and poetic expression which made him at home in intellectual milieus. From the mid-1880s on, when Carrière's mature style and imagery were evolving, there was an increased tendency towards a Symbolist tone in the visual arts. While Gustave Moreau (1826–1898) was the creator of an imaginative world of fantasy, Odilon Redon (1840–1916) that of hallucination, and Puvis de Chavannes (1824–1898) that of an otherworld Arcadia, the dominant motivation was to find a poetic, dream-like reverie. The influence of poets and playwrights in the development of Symbolism in the visual arts has been accepted without question. Carrière's extensive social contacts with writers, poets, and critics, specifically those allied to this literary movement, were such that he, perhaps

more than other artists, was aware of Symbolist developments. The formulation of his personal style and its philosophic basis were derived from this movement.

The specific interest in the dream and the spiritualizing approach in Symbolist literature left its imprint on Carrière. This was almost immediately recognized by his contemporaries, who referred to his work as "reality having the magic of dream" (Jean Dolent, *Amoureux d'Art* [Paris: Lemerre, 1888], p. 240). By employing a monochromatic brown palette, softening the focus, and enveloping his figures in a thick, dark atmosphere, Carrière denies a sense of natural space, light, and colour. As a result, the daily reality of the artist's surroundings was transformed into mysterious, ethereal images that have the quality of a religious hush or a pervasive silence.

Verlaine's admonition, "no colour, nothing but nuances" *(Verlaine: Œuvres poétiques complètes*, eds. Y.G. Le Dantec and Jacques Borel [Paris: Gallimard, 1962], p. 327), describes Carrière's work in which subtlety and suggestion as well as a limited use of colour predominate. The artist's efforts seem to be the visual counterpart of Mallarmé's statement that to name an object is to suppress three quarters of the joy of the poem which comes from the pleasure of discovering its meaning, little by little ("Réponse à une Enquête," in Jules Huret's *Enquête sur l'Évolution littéraire* [Paris: Charpentier, 1891], p. 60). Had the poet been referring to Carrière's painting instead of poetry, he still would have been correct when he further commented that to suggest – there is the dream.

Though Carrière deeply loved his wife, it is probable that it was the spirit of all mankind, not specifically her image, that the artist was trying to capture when she posed for him. His strong faith in the brotherhood of man was such that he thought of his family as a microcosm of the macrocosm. As Carrière said in the preface to the catalogue of his exhibition at the Salon de l'Art Nouveau in 1896, "I see other men in me and I find myself in them; what impassions me is dear to them" *(Écrits*, p. 11). In conformity with this concern for universality, his figures were often unindividualized and presented in a vacuous environment. In effect, they are usually not to be perceived as specific individuals, but as archetypal inhabitants of a very poetic world whose guiding force is love, and in which the birth and development of life has an almost religious significance. Another of Mallarmé's comments seems appropriate in relation to this and other works:

"Everything that is sacred and wishes to remain sacred envelops itself in mystery" ("L'Art pour tous," reprinted in *La Doctrine Symboliste* [Paris: Nizet, 1947], p. 17). This is exactly what Carrière has done visually. He transformed the daily reality of his personal life into universal images, reminding one of Teodor de Wyzewa's statement that every image is the microcosm of nature in its entirety ("M. Mallarmé," *La Vogue*, vol. 1 [July 1886] p. 421).

The introspective quality of the sitter is in keeping with the artist's concentration on the inner or spiritual being as contrasted to the physical world. It is a portrayal of a mental state – not of external appearance. The abrupt transitions from light to dark sharply simplify the features of her face, which is free of distinguishing characteristics. It is her pose – the tilt of her head, the gesture of the hand – that conveys the figure's expression, not the indistinct mouth or eyes. Most elements are only vaguely defined; all save the face and the hand are largely obscured by the fusing of figure and ground. Only highlights and the ring on her finger are distinct. Increasingly, in his late paintings Carrière reintroduced colour. In this painting, a faintly perceptible red highlight was added to the hair, thus enriching the colour of that area. The smooth surface finish is enlivened by the impasto of the forehead or the scumbled passages to the left. By scratching the signature in wet paint and by lightly wiping off pigments beneath this, Carrière created yet another type of texture which contrasts with the smooth and impasto areas.

As a personality and as a physical being, Mme Carrière does not fully come into focus because both are merely suggested. The trance-like quiet, the awareness of the pictorial surface, and the lack of spatial depth, in addition to the monochromatic palette, underline this as an image distinct from normal perception. In a fully symbolist sense Carrière made a record of an inner or spiritual level of existence, another reality.

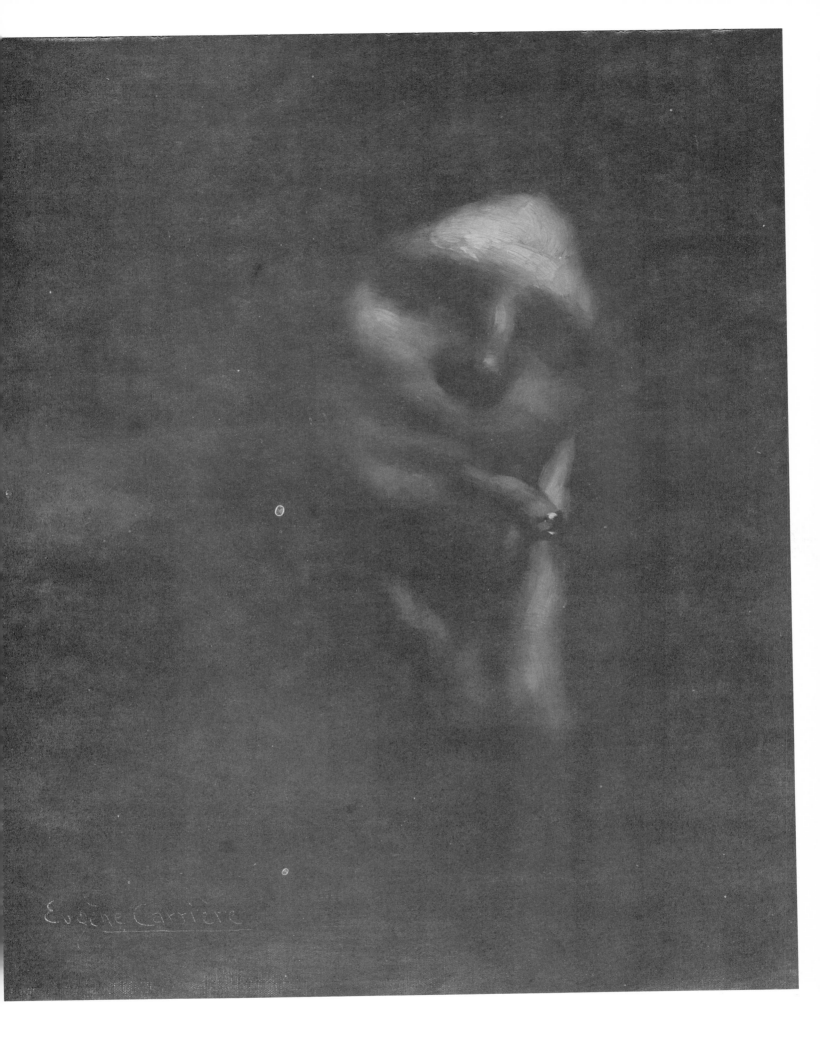

16

Painting *c.* 1899
(La Peinture)

Oil on canvas
1.30 x 1.37 m

INSCRIPTION
Signed l.l., *Eugène Carrière.*

PROVENANCE
Given by the artist to Henri Lerolle, Paris;
Maurice Denis, Paris; Dr J.B. Denis,
Rouen, 1943; Georges Martin du Nord,
Paris; Shepherd Gallery, New York.
Acquired February 1977.

EXHIBITIONS
1970, Paris, Musée de l'Orangerie, *Eugène
Carrière, 1849–1906*, cat. no. – D (as *Le Peintre
et son Modèle*).

RELATED WORKS
Version submitted to the 1899 Salon of the
Société Nationale des Beaux-Arts (cat. no.
304, as *l'Étude*), oil on canvas, 1.08 x 1.29 m.
(Berryer, cat. no. 591, Séailles, cat. no. 79).
Collections: Jean Dolent, acquired 1906 by
J. Rouché, Paris; A. Robert; Paris. A
smaller version, oil on canvas, 0.64 x 0.46 m,
repr., Geffroy, l'*Œuvre de Eugène Carrière*, pl.
33.

PAINTING is an unusual work for Carri-
ère in that it is a full-scale sketch done
in preparation for a finished version (see
Related Works). This sketch was pre-
ceded by another, whose basic composi-
tional lines have been transferred to this
canvas. In the lower right corner and
slightly to the left of this area is a series
of three equally spaced lines which
determine the vertical height of the base
of the palette within the picture plane.
The location of key elements of the
composition, such as the two arcs which
define the fold of the artist's sleeve, are
established in black lines beneath the
brown pigments. Carrière apparently
did not feel constricted by these trans-
ferred points of reference. For example,
within the face of the model is a large
oval, part of the preliminary drawing,
that can be seen through the paint,
revealing that he freely modified his
design. His technique was such that
drawing was visible through the oils.
However, most of Carrière's paintings
were done *alla prima*, without under-
painting or drawing, thus demonstrat-
ing the artist's confidence in his
technical mastery. In addition to this,
Carrière, quite amazingly, usually

worked without the benefit of studies or
sketches.

A letter of 21 January 1905 to Ugo
Bernasconi (1874–1960), one of his stu-
dents, is the most complete surviving
statement by Carrière on his technique
(*Écrits*, pp. 320–323). The acknowledge-
ment of his debt to the Old Masters is
significant, because the description of the
manner in which he worked was
quite similar to the traditional method
of laying-in the preliminary under-
painting. The choice of earth tones is in
keeping with the procedure of the Old
Masters, who created what Carrière
called a "general atmosphere" with
them. Carrière then modified this by
the addition of black or white, or even
by lighter or darker browns, to establish
the desired relative value relationships.
This involved only modulation of select
areas of the canvas, which in some cases
were extensively treated, and sometimes
involved the addition of other colours,
though not, of course, the customary
complete polychromatic overpainting.
Thus Carrière's revolutionary concept
was to work underpainting to varying
degrees, and to present the result of this
technique as a "finished" work of art.

To state what the artist did does not
explain why he arbitrarily limited his
palette, thereby emphasizing the con-
trast of relative values, and for what
reason he created images out of what
was considered painting's primal state
of execution. Surely his technique was
an integral part of his artistic expres-
sion. At the same time that he began to
be influenced by Symbolism, Carrière
seems to have perceived underpainting
as representing more than just the ini-
tial state of his art. He did not refer to
his palette as being brown, but rather as
earth tones. The predominance of this
colour, and the importance of light,
which selectively picks out images from
the surrounding earth-toned environ-
ment, are surely related in symbolic
function.

In 1886 Carrière stated that he must
continually remind himself that paint-
ing is the logical development of light
(Dolent, *Amoureaux d'Art*, p. 213). As the
first element of Biblical creation, as the
source of all energy and life, and as a
generative force, light penetrated the
primal flux bringing life. The artist
seems to have been thinking of this con-
cept of light when he evolved a dark-
brown palette and a technique wherein
forms coalesce out of their enveloping
atmosphere. The earth tones could sym-
bolize the conditions necessary for the
generation of life that is brought about
by miraculous activating powers.

The ideas of Jean-Baptiste Lamarck
seem to have influenced Carrière's evo-
lutionist philosophy which the artist

presented in his speech, "L'Homme
visionnaire de la Réalité," at the
Muséum d'Histoire naturelle in March
1901 (*Écrits*, pp. 27–39). Lamarck held
that gelatinous or mucilaginous matter
of solid or fluid elements was activated
by an "exciting cause," or vital princi-
ple, resulting in a living cell. From the
aboriginal cell all plant and animal life
was derived, as nature evolved from the
homogeneous to the heterogeneous. The
dark, vaporous paintings of Carrière
may reflect the hypothesis that life
came into being through the permea-
tion of formless matter by a non-mate-
rial vital force. The exciting cause,
which Lamarck thought was composed
of heat and electricity, seems to have
been interpreted by the artist as light
and its effect as an animating power.

In *Painting*, Élise, Carrière's eldest
child who was an artist in her own
right, is studying the features of her
younger sister, Marguerite. That he
chose to paint an artist and her model
who, in this instance are sisters, may
indicate that he intended a symbolic
significance. Comparing the two figures,
it is evident that it is the model who is
the more clearly articulated. To further
distinguish them, the artist has made
the figure of Élise lighter in value and
placed her against a lighter back-
ground. Within her outline, forms are
blurred and flow together. The artist
and her palette become one, in contrast
with the model, who is given much
greater definition.

Carrière stated that he had a vision-
ary concept of reality, and he seems to
have projected this into the relationship
of these two figures. Nature, represented
by the model, is undergoing the scrutiny
of the artist. It is the latter, of course,
who experiences the mystical meaning
of nature which is appropriately
implied by the softened focus represent-
ing this level of awareness. Since the
artist and her palette fuse, become one,
it may be that Carrière perceives the
artist's body and artistic implements as
instruments of the creative spirit that
searches for nature's secrets. In this
work we see not the birth of life but
light revealing the miracle of life to this
poet of the visual experience.

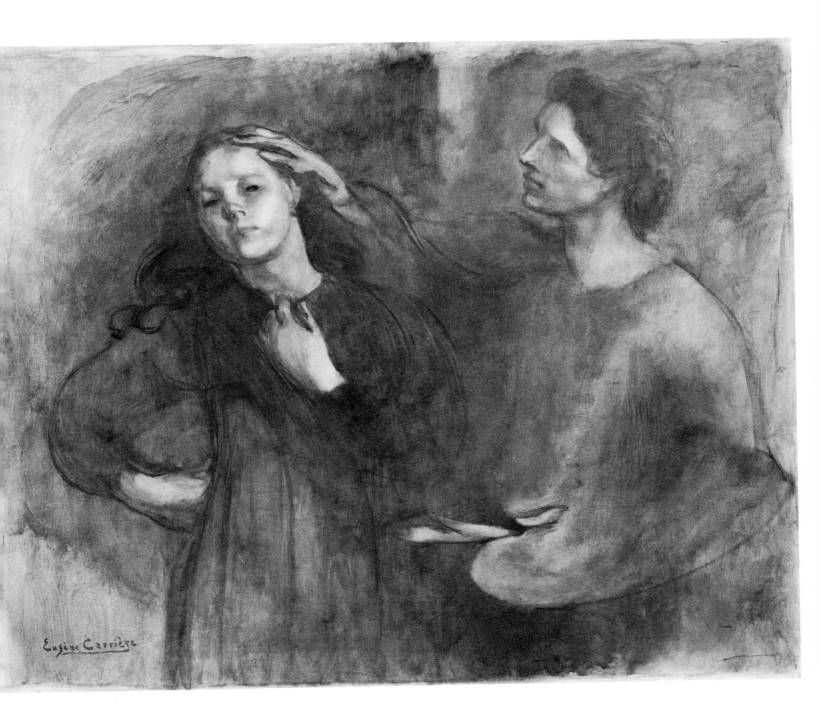

17

Landscape *c.* 1895
(Paysage)
Oil on canvas
29 x 37.2 cm

INSCRIPTION
Signed l.r., *Eugène Carrière*.

PROVENANCE
Sold or given to Louis Delaquerière by the
artist; Berry-Hill Galleries, New York.
Acquired July 1969.

EXHIBITIONS
1968–1969, Allentown, Allentown Art
Museum, *Eugène Carrière 1849–1906: Seer of the
Real*, cat. no. 49, repr. (as *Tempête*). 1969,
Art Gallery of Ontario, *The Sacred and
Profane in Symbolist Art*, p. XLI, cat. no. 169 (as
Tempête), not repr.

CARRIÈRE'S INTEREST in landscape
painting was not generally known dur-
ing his lifetime. The only occasion that
he showed works of this theme was in
1901 in an exhibition at the Galerie
Bernheim Jeune, which included
twenty-seven landscapes. Their chro-
nology has been difficult to establish,
since it has not been determined when
Carrière started to explore this theme;
in addition, few of these landscapes are
dated or are precisely datable.

If it was the artist's exposure to the
countryside which inspired him to paint
landscapes during the decade before the
Bernheim exhibition, he had many
opportunities for this interest to devel-
op. In 1889 the Carrière family began
to spend their summers at Parc Saint-
Maur. Then, travelling by himself, he
visited Brittany and Normandy in 1893.
In 1896, due to Mme Carrière's delicate
health, the artist and his family spent
the first of several winters at Pau in the
Pyrenees.

Sometime before his final departure
for the South Pacific in the spring of
1895, Paul Gauguin (1848–1903) com-
mented to Jean Dolent, a mutual
friend: "Nobody knows the landscapes
of Carrière, and already they are being
imitated" (Dolent, *Monstres* [Paris:
Alphonse Lemerre], 1896, p. 130). It is
thus likely that sometime between 1889
and 1895 the artist began painting
landscapes. Though they share many
stylistic and philosophic characteristics
with his work in general, Carrière seems
to have considered them to be of interest

only to himself, for it was not until 1901,
as mentioned above, that he exhibited
them.

Despite his concentration on figural
themes, it was less of a problem for Car-
rière to paint landscapes than one
might expect. He had emphasized the
inner, immaterial essence of his figures
and, fittingly, in his landscapes, he
extended his views to a broader, cosmic
scope. His faith in the continuity of
these forces appeared in some of his
paintings as forms indistinct from their
environment and yet, in other exam-
ples, as subtle rhythms that tie all ele-
ments together.

The artist recounted to Gabriel
Séailles (*Eugène Carrière*, 1911, pp.
162–163) a personal experience that
reveals his belief in the universal har-
mony of form. One day, while travelling
by train to Paris from Saint-Maur, Car-
rière was admiring the countryside –
the undulation of the hills and the cor-
responding movement of the greenery –
and then turned to see a beautiful
woman seated opposite him. The lines
of her face were the same as those that
he had just observed through the train
window. In accordance with his
humanistic outlook, he said that if a
woman is in a landscape, one sees only
her; but in her is perceivable the entire
environment because all forms are sym-
pathetic and have a familial relation.
He saw the lines of a landscape in the
human face and presumably was capa-
ble of the reverse. The artist's accept-
ance of this theory was further
demonstrated by a series of sketches of
fruits and flowers which he transformed
into images of women.

When working before nature in the
sunlight, Carrière did more than merely
soften the focus, as he customarily did in
his figural works. He abstracted his
vision into broad planes distinguished
from each other by value or texture. His
landscapes, whether pencil sketches or
oils, generally exhibit a high degree of
technical freedom and experimentation
and demonstrate his interest in purely
visual and esthetic concerns. In this
landscape, as in so many oils seemingly
intended solely for the artist's own
pleasure, the paint was applied very
thinly so that the texture of the canvas
was not obscured. The texture was
emphasized in some areas by brushing
on a lighter or darker colour, or even by
wiping off some of the pigments. Occa-
sionally, as at the right of the painting,
Carrière scratched into the painted sur-
face, thus creating patches distinct in
value and texture from their surround-
ings. The combination of additive and
subtractive processes was quite unortho-
dox and reflects his interest in technical
innovation. These effects are often simi-

lar to those that he attained in his dis-
tinctive work in lithography. However,
they evolved in his oils independently
and prior to 1890, when he turned his
attention to lithography as a medium of
artistic expression.

In this painting both the earth and
the sky are equally indistinct or
dematerialized and complement each
other in their opposing general values.
Carrière surely felt that the cosmic
unity of nature was established by the
"s-curve" that starts at the lower left,
moves up to the right, reverses its course
crossing the horizon to the left of the
steeple, and then curves up to the right.
Where a dark shape, the foliage of the
trees, fills the lower curve, a light cloud
above moves within the countercurve,
further establishing a balance between
the upper and lower halves of the
composition. Similarly, the steeple can
be perceived as being countered by the
downward break in the line of the hori-
zon to the right. He seems to have
viewed nature here as a harmonious
balance of light and dark, solid and
void, bound by a pervasive spiritual
force.

The monochromatic, vaporous,
swirling landscape reminds one that it is
drawn from the artist's private vision of
the world. Carrière's interest in techni-
que – the visual evidence of stroking,
wiping, and scratching the wet paint on
the canvas – is consistent with his lack
of concern for a convincing indication
of depth or location. In the process of
recording the three-dimensional reality
of nature on the two-dimensional sur-
face of the canvas, he has transformed
nature by viewing it in a mystical fash-
ion, underlined by the visually evident
technique. Carrière's work with land-
scape was not a radical departure from
his other efforts but a means to explore
thematically a broader application of
his Symbolist vision.

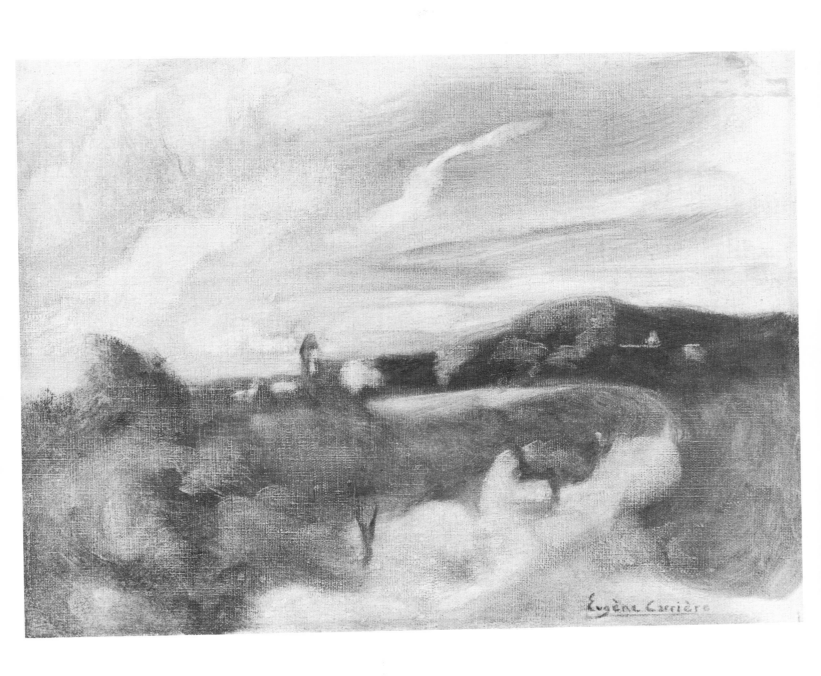

EUGÈNE CARRIÈRE

18

Grief c. 1903
(*La douleur*)

Oil on canvas

74.6 x 93.4 cm

INSCRIPTION
Signed l.l., *Eugène Carrière*.

PROVENANCE
Georges Bernheim, Paris (acquired 16 March 1911, Hôtel Drouot, Paris, as *Mater Dolorosa*); Antonio Santamarina, Buenos Aires; Hôtel Drouot, Paris, 2 February 1970, cat. no. 183 (sold to Mme Loudmer); Georges Martin du Nord, Paris. Acquired March 1973.

EXHIBITIONS
1936, Buenos Aires, Museo Nacional de Bellas Artes, cat. no. 13 (as *Mater Dolorosa*). 7 June–23 July 1972, London, Hayward Gallery, *French Symbolist Painters: Moreau, Puvis de Chavannes, Redon, and Their Followers*, cat. no. 25, repr. (as *Grief* or *Mater Dolorosa*).

RELATED WORKS
Pietà (*Étude*), oil on canvas, 46 x 37 cm, undated and unsigned, Berryer, cat. no. 626, collection of Mme Séailles, Barbizon.

THIS PAINTING has been variously designated by the titles *Grief* (or *La Douleur*), *Pietà*, and *Mater Dolorosa*. An apparent confusion exists as to its meaning. Obviously it deals with grief – the pain of emotional suffering caused by the death of a loved one. The pervasive quiet and the resigned mourning lend it a sacral quality suggesting the possibility that this is one of Carrière's few religious works, all of which were done late in his career. Given the lack of emphasis on the female, it is unlikely that this was intended to be a mater dolorosa. The religious tone, together with the equal visual importance of both figures, suggests that it is a Pietà, but an unorthodox one. There are no halos indicated and the dead man lacks the classic facial features of the traditional image of Christ. Geneviève Lacambre has noted recently that the dead man bears a general resemblance to Paul Gauguin (Hayward Gallery, *French Symbolist Painters*, p. 31, cat. no. 25). The figure has Gauguin's distinctive profile, a fact which supports the identification.

The death of Gauguin occurred during the period when this painting was executed. The two men had been friends since the fall of 1890 when they met, probably at the Café Voltaire, where poets, artists, and critics gathered every Monday evening. Soon after their meeting, Carrière started a portrait of his friend (Yale University Art Gallery) and in turn received a self-portrait (Collection of Mr and Mrs Paul Mellon) which Gauguin had dedicated to him. Carrière was among those present at Gauguin's farewell banquet in March 1891, shortly before his departure for Tahiti. After Gauguin returned to France in August 1893, the two artists resumed their friendship. In February 1895, with the assistance of Carrière, Gauguin travelled to the South Pacific under the pretext of being on an official mission. They did not see nor communicate with each other thereafter. When Gauguin died in the Marquesas Islands in 1903, Carrière wrote a short article for the *Mercure de France* in memory of his departed friend. He mourned the loss of such a great artist whose genius had been appreciated only by those who were close to him.

Thus Carrière would have had sufficient motivation to create a visual tribute to Gauguin. The artist who had earlier painted a portrait of his friend is the same artist who would most likely commemorate the passing of that friend. One could interpret his painting as a personification of the arts lamenting the passage of one of its great practitioners. This would undoubtedly be an appropriate testimonial to his artistic and personal regard for Gauguin. However, the observation by Maurice Denis and other writers that many of Carrière's works are secularized religious images raises the possibility that this is a secularized Pietà. If, as has been asserted, his *maternités* were perceived as representing the Madonna and Child in contemporary guise, a religious title for this painting is inappropriate. On the other hand, had Gauguin painted this, such a title surely would have been used since he had occasionally likened himself to Christ in works such as his *Christ in Gethsemane – Self-Portrait* (1889; Norton Gallery of Art, West Palm Beach.) He may have seen himself as an artistic messiah who suffered for his fellow man. Carrière was certainly aware of this and has fittingly commemorated his friend in the role that Gauguin had chosen for himself. Despite their separate artistic paths and the passage of eight years without communication, Carrière felt that his friend's death was a loss to the world.

The solemnity of *Grief* is created by the theme as well as by the composition and the technique. Centred within the painting is a smaller but similar rectangle bounded by the two forearms, the upper arm, and the line running from the shoulder to the forehead of the grieving woman. The remaining portions are indistinct, with the exception of the dead body, which functions visually as a compositional base. Carrière gave the work a smooth, enamel-like finish notable for the absence of surface movement. This and the compositional stability establish a sense of serene quiet. Furthermore, the softened focus of the figures is extended into a uniform, over-all vaporousness by scumbling a transparent film of reddish brown over the background, thereby giving it a slight translucency where it would otherwise have been dark and opaque.

Grief is an unusually large work for Carrière. The size and meticulous finish indicate that it was intended for Salon exhibition or else had been formally commissioned. Because there is no documentary evidence to suggest the latter, one must assume that Carrière planned to exhibit the painting. That it was never exhibited may be perhaps related to Carrière's struggle with cancer. *Grief* remains a touching tribute to Gauguin's genius and to Carrière's feelings for him.

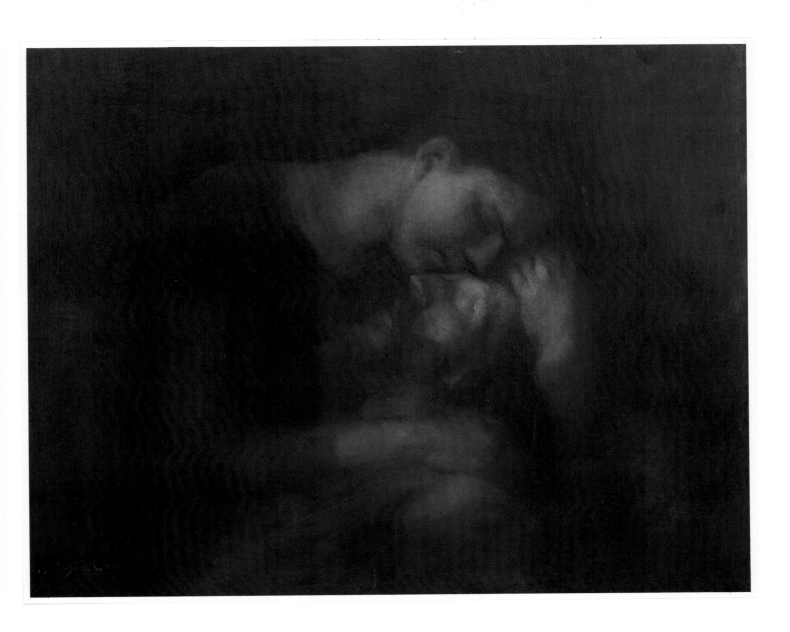

THÉODORE CHASSÉRIAU

Samaná (NE Dominican Republic)
1819 – Paris 1856

CHASSÉRIAU WAS ACCEPTED by Ingres (1780–1867) as a student, and entered his atelier in 1833.

When, in 1834, Ingres went to Rome, he asked Chassériau, by then his favourite student, to accompany him. Chassériau refused and remained in Paris preparing for his Salon debut (1836). In 1840, however, he did go to Italy and there met with Ingres. But, as he later confessed to his brother, he and his former master no longer shared the same ideas.

After his return to France in 1841, Chassériau received his first major decorative commission: the murals for the church of Saint-Merri in Paris. The same year these murals were completed (1843), the artist exhibited *The Two Sisters of the Artist (Les Deux Sœurs de l'Artiste)*, which received critical acclaim, but a poor response from the public.

In 1844 he received a second major mural commission for the decoration of the great staircase of the former Palais de la Cour des Comptes, quai d'Orsay (destroyed by fire by the supporters of the Commune in 1871). In the same year Chassériau published a series of fifteen etchings of scenes from Shakespeare's *Othello*. The critics accused Chassériau of being too strongly influenced by Eugène Delacroix (1798–1863) in this series, an accusation which was again levelled against his entry, *Defence of Gaul (La défense des Gaules)*, shown at the Salon of the Universal Exhibition, 1855.

When Ali ben Ahmed, Caliph of Constantine (Algeria), was in Paris, he befriended Chassériau. The artist then visited Constantine in the spring of 1846, where he became intrigued by the North African light, colour, and exoticism. As a result, many of his smaller pictures treated oriental themes. Chassériau's work received a cool reception in the Salon of 1852, but his *Tepidarium* won favourable reviews the following year.

Chassériau exhibited for the last time in 1855. In 1856 he fell seriously ill, but in September of that year, after a rest, he returned to Paris with the hope of continuing work. His hope went unfulfilled; the artist died on 8 October 1856.

EXHIBITIONS
Paris Salons of 1836 to 1855.

AWARDS AND HONOURS
Third-Class Medal, Salon of 1836; Second-Class Medal, Salon of 1844. Second-Class Medal, Paris Universal Exhibition of 1855. Chevalier of the *Légion d'Honneur*, 1849.

BIBLIOGRAPHY
Léonce Bénédite, *Théodore Chassériau: Sa vie et son œuvre* (ms., n.d. [1911] published by André Dezarrois), Paris: Les Éditions Braun [1932]. Valbert Chevillard, *Un peintre romantique: Théodore Chassériau*, Paris: A. Lemerre, 1893. Marc Sandoz, *Théodore Chassériau: Catalogue Raisonné des peintures et des estampes*, Paris: Arts et métiers graphiques, 1974.

19

Saint Philip Baptizing the Eunuch of the Queen of Ethiopia 1854

Charcoal with oil wash, heightened with gouache on paper laid on canvas

81.8 x 37.3 cm

INSCRIPTION
Signed and dated l.l., *Th^re Chassériau 1854.* (The sketch was dated later than the painting, which is dated 1853.)

PROVENANCE
Collection of Admiral Victor Duperré or the De Montigny collection (the two collections may be the same); Wildenstein and Co., New York. Acquired July 1977.

EXHIBITIONS
March 1968, Baltimore, The University of Maryland Art Gallery, *Hommage à Baudelaire*, p. 34, repr. p. 67 (as *Baptism of a Eunuch*).

BIBLIOGRAPHY
Chevillard, *Un peintre romantique*, nos 107, 108. Sandoz, *Théodore Chassériau*, p. 368, repr. pl. CXCIIa.

RELATED WORKS
There are numerous drawings and painted sketches for *Saint Philip Baptizing the Eunuch of the Queen of Ethiopia* (1853) in the baptismal chapel of Saint-Roch Church, Paris.

THIS SKETCH was mentioned by Valbert Chevillard, and has been exhibited only once before. It had been in the same private collection since 1854, until, in 1965, it came on the market.

Among the many sketches and drawings for this decorative work (see Sandoz, no. 227A, p. 368, and nos. 231–234), this one is of particular interest since of all the preparatory sketches still in existence, it is most closely related to the final painting. In fact, all the other sketches reveal a rather hesitant approach to composition and posture. While the compositional elements remain the same, the position and posture of the eunuch change in each of the sketches: in one (see Sandoz, no. 230) his arms are crossed on his chest in an attitude of submission; in two others (see Sandoz, nos 232, 234), his arms are raised in supplication and prayer. In this sketch, which is quite different, his arms are outstretched and his head inclines towards the water in a gesture of peace and serenity, a fundamental aspect of this baptism.

The depiction of the silent dialogue between Saint Philip and the angel also shows interesting variations in intention: in one sketch, the angel faces the saint and seems to speak to him directly (see Sandoz, nos 230–233). In this work, the angel is apparently perceived only by the viewer; thus, the mystery of the invisible is introduced into this "holy conversation." The angel appears behind Saint Philip; his upraised arm creates a barrier between the physical presence of the saint and his own ephemeral presence. Sandoz (p. 368) mentions numerous sources for this flying angel, including works by Raphael (1483–1520) and his followers as well as paintings by the great masters of the Bolognese school. It is also worth noting in the new composition adopted after the preliminary drawings (see Sandoz, p. 368) the figures in the chariot and the horses with their groom.

On the whole, this sketch is close enough to the final work for it to be classified as the last in chronological order, done immediately before the large painting. However, there are several noteworthy variations. In the painting, the eunuch's hands are more open and express a more definite gesture. Although the saint does not look at the angel, he turns his head slightly towards him and raises his eyes to heaven, providing a more effective link between the divine will heralded by the angel and the physical act of baptism. As well, the position of the saint's head avoids the medal-like profile used in the sketch.

The nuances of detail give us a valuable indication of Chassériau's working method. It involved a constant creative effort, since from the first rough sketch to the final version he accepted nothing as final; he constantly questioned his approach. He wanted every detail to be in perfect harmony with the whole of the work, and was always ready to revise and adapt to obtain this objective.

"Inventing, always inventing, building up enthusiasm . . . until the object springs forth and achieves the strong, gentle, sad or sombre quality which makes the figures stand out and brings them to life in the intimacy, light and fluidity of nature . . ." he wrote in one of his sketchbooks. This thoughtful approach explains the brilliance and obvious immediacy of Chassériau's figures, and his particular ability as a painter of religious decoration which

includes the chapel of Sainte-Marie-
l'Égyptienne in the church of Saint-
Merri, Paris (1843), the baptismal
chapel in the church of Saint-Roch
(1853), and the ceiling in the choir of
the church of Saint-Philippe de Roule
(1855). It also explains the unforgetta-
ble presence in his long and celebrated
series of female figures: *Marine Venus*
(1834), *Suzanne at the Bath* (1839),
Andromeda Bound to the Rock (1840), *Esther*
(1841), *Apollo and Daphne* (1844), *Sappho*
(1849), and *Bather Sleeping beside a Spring*
(1850).

M.S.

THOMAS COUTURE

Senlis 1815 – Villiers-le-Bel 1879

COUTURE'S BIRTHPLACE is an old Roman town, still with its ancient ruins, and the impact of this environment is felt in the conception of his most famous picture, *Romans of the Decadence* (*Les romains de la décadence*, 1847). His father, Jean Couture, descended from a long line of shoemakers, and while he hoped for a professional career for himself, he eventually succumbed to family pressures to remain in the family trade. Jean came to regret this decision, and compensated for his failure by encouraging his own children to become scholars and academicians. Thomas, however, proved to be a disappointment by his seeming lack of intellectual promise, and the father spent most of his spare time teaching an older son the classics. Thomas grew up with a basic insecurity about his education, and he consistently wavered between a desire to show up authority with his independence and a need to impress with his erudition.

About 1828 Couture matriculated in the École gratuite de dessin at the Conservatoire des arts et métiers on Rue Saint-Martin in Paris. Here he was inculcated with the ideal of combining art and technology, and later he executed designs for the applied arts and encouraged his students to follow his example. It would seem also that his suggestion to make the locomotive a fit subject for *grande peinture* stems from his early training at the Conservatoire. Couture studied under Antoine Gros (1771–1835) from 1830 to 1835, and following the master's suicide, switched to the atelier of Paul Delaroche (1797–1856). He was officially registered at the École des Beaux-Arts on 2 April 1831. Couture identified academic doctrine with his father's viewpoint: under Gros and Delaroche, he experienced a conflict between loyalty to their ideals and the need to maintain his individuality. In 1837 he placed second in the competition for the *Prix de Rome*, but after two more unsuccessful attempts to place first, he left the school and struck out on his own. Ultimately, his personal temperament meshed perfectly with the prevailing political and philosophical climate of the July Monarchy – an outlook designated by contemporaries as the "juste milieu." He employed assertive brushwork and a high-keyed palette for his proverbial themes, like the *Prodigal Son* (*Enfant prodigue*, 1841) and *Love of Gold* (*L'amour d'or*, 1844) which earned him a third-class medal at the Salon. His notorious masterpiece, *Romans of the Decadence*, climaxed his early series of works based on themes of moral depravity and enjoyed a resounding success at the Salon of 1847. It represented an ambitious attempt to outdo his rivals by embracing the motifs of several recognized old master paintings and incorporating stylistic features of the two main currents of the day, Romanticism and Classicism.

In his writing on technique, Couture designated the base (*ébauche*, or underpainting) as the primary consideration, and secondly the accord of the contraries or complementaries: red-green, orange-blue. He even prepared the *ébauche* in view of the superimposed complementaries; he provided a ruddy base for greenish tones, and a greenish base for amber or red tones. The underpainting in each case shone through and gave sparkle to the canvas. He referred back and forth to the underpainting in the course of his definitive execution, and the painted substructure either remained visible in the final stage or was covered in the same coarse fashion with the successive layers of pigment. Where the outlines disappeared, they were as a rule repainted by superimposing them on the toned surface. Sometimes the outlines reappeared in an irregular and interrupted form for an improvised look. From first to last, Couture struggled to retain the freshness and expressiveness of the initial lay-in.

Couture's reputation as both a solid draftsman and expressive colourist placed him in the forefront of French painting by the time of the Revolution of 1848; already in December of the previous year he had begun work on his ill-fated *Enlistment of the Volunteers of 1792* (*Enrôlement des volontaires de 1792*), influenced in large measure by the writings of Jules Michelet (whose portrait he had painted in 1843) and ultimately commissioned by the Second Republic. Depicting the call to arms in 1792, when France was declared to be in danger from its enemies, Couture's monumental canvas shows a united French society marching enthusiastically to the frontiers in defence of the homeland. As in his later large-scale attempts, Couture tried to combine allegory and reality, elevated theme and topical commentary, classic design and modern technique. The advent of the Second Empire, however, drained off the work's underlying conviction, and succumbing to the covert pressure and tantalizing offers of the new government, Couture abandoned the picture in favour of a new round of Imperial commissions. In 1856 he obtained the order to paint the *Baptism of the Prince Imperial* and a series of monumental decorations for the Pavillon Denon in the newly rehabilitated Louvre, glorifying the regime's military success in the Crimea and its suppression of anarchy on the domestic front.

Unfortunately for the painter's aspirations, his natural disinclination to deal with authority, his paranoia, and jealous intrigues on the part of his rivals led to a falling out with the court of Napoleon III. All commissions save the *Baptism* were cancelled, and in reaction he stopped showing at the Salons (until after the demise of the regime) and entered a kind of exile by withdrawing to the environs of his home town. He became increasingly bitter and cynical, often painting pictures for a wealthy American clientele whom he gleefully overcharged. He began a series of satirical canvases including several based on the characters of the Commedia dell'Arte, and looked to Honoré Daumier (1802–1879) and Molière for inspiration. His popular caricature of the Realist showed an unthinking novice sitting on a cast of the Olympian Jupiter, sketching the head of a pig. He also began painting his well-known genre scenes like *Soap Bubbles* (*Bulles de savon*), *The Lazy Schoolboy* (*L'écolier paresseux*), *Drummer Boy* (*Enfant au tambour*), and *The Bird-Catcher* (*L'oiseleur*).

Couture's most important contribution to the history of art was an an independent teacher, and his eclectic proclivities attracted an international student body. Among his immediate students were the French painters Manet, Puvis de Chavannes, Desboutin; the Germans Feuerbach, Henneberg, and Gentz; and the Americans Hunt, Johnson, Newman. Since many of his disciples became influential in their own right, we must consider his far-reaching impact on Impressionism, Post-Impressionism (Seurat and Cézanne admired him), and Symbolism; and through his influence on the teacher of Albert Pinkham Ryder (1847–1917) and on the ideas of the Ashcan School of the early twentieth century he entered directly into the mainstream of contemporary American art.

EXHIBITIONS
Paris Salons of 1838, 1840, 1841, 1843–1845, 1847, 1855, 1872.

AWARDS AND HONOURS
Third-Class Medal, Salon of 1844; First-Class Medal, Salon of 1847. Chevalier of the *Légion d'Honneur*, 1848. Gold Medal, Paris Universal Exhibition of 1855.

BIBLIOGRAPHY
Roger Ballu, *Catalogue des œuvres de Thomas Couture, Palais de l'Industrie, Paris, 1880.* Albert

Boime, "Thomas Couture and the Evolution of Painting in Nineteenth-Century France," *The Art Bulletin*, March 1969, pp. 48–56; Boime, *The Academy and French Painting in the Nineteenth Century*, London: Phaidon, 1971. G. Bertauts-Couture, *Thomas Couture, sa vie, son œuvre, son caractère, ses idées, sa méthode, par lui-même et par son petit-fils*, Paris: Le Garrec éditeur, 1932. Jane Van Nimmen, *Thomas Couture: Paintings and Drawings in American Collections*, Department of Art, University of Maryland, 1969–1970.

A.B.

20

Portrait of a Man 1856

Oil on canvas

56.5 x 40.9 cm

INSCRIPTION
Initialled and dated above shoulder r., *T.C./1856*.

PROVENANCE
H. Shickman Gallery, New York; David Daniels Collection, New York. Acquired May 1975.

EXHIBITION
October 1971, New York, H. Shickman Gallery, *The Neglected 19th Century: An Exhibition of French Paintings*, Part II (unpaginated), repr.

BIBLIOGRAPHY
Albert Boime, "Newman, Ryder, Couture, and Hero-Worship in Art History," *American Art Journals*, vol. 3 (1971), pp. 17, 20.

THE DOMINANT SUBJECT of Couture's repertoire is the portrait. Although orders for his portraits accelerated in the boom years following the success of the *Romans of the Decadence*, he worked in this genre throughout his career. Couture pioneered a certain type of portrait which affected such prominent contemporaries as Gustave Ricard, Gustave Courbet, and his students Uno Troili and William Morris Hunt: he showed only the head and shoulders against a shadowy or blank backdrop, and most sitters look out from the corners of their eyes at the spectator. The hallmarks of his style are a splash of scumbled light, which forms a kind of aura in the otherwise dark background, and a flash of white in the collar. Couture painted mainly distinguished sitters, aristocrats, and self-made men who came to power during the July Monarchy and Second Empire.

Couture's *Portrait of a Man* belongs to a series of frontally-posed sitters dating from the mid-1850s (*Portrait of a Man*, Petit Palais, Paris; *Auguste Mimerel of Roubaix*, Jacques Seligmann & Co., New York), when the painter enjoyed relatively high status at the court of Napoleon III. The majority of his sitters are shown from a three-quarter position and glance sidewise at the spectator; but during his mature period, he executed full-face portraits which are distinguished by the candour and directness of the gaze. The astonishing charcoal drawing, *Georges Sand* (Musée Carnavalet, Paris) is an exception, but while she glances to the right, her face remains open and almost ingenuous.

Portraits from the early 1850s especially are often shrouded in a brooding atmosphere, and the eyes of the sitters seem full of suspicion and mistrust. They point to Couture's negative state of mind during the political upheavals of the period 1848–1852. Eventually, as he put behind him the conflict (both inner and public) over the *Enlistment of the Volunteers of 1792* and established rapport with the Imperial family, he enjoyed a short-lived period of mental calm and security. Not surprisingly, after the final rupture with the Court, his portraits tended to become rehashes of his earlier ones.

Couture's frontal portraits of young men (including *Prince Alonso*, 1852; Musée des Beaux-Arts, Bordeaux) also suggest the relaxed exchange in student-teacher, patron-client relationships. He felt more comfortable with students and eccentric patrons, in whose company class distinctions were of little or no consideration. Despite their origins, the young sitters of this period seem less stratified socially than most of his other subjects, and project a relatively modest demeanor. These portraits are characterized by an unaffected charm, a quiet elegance, an almost provincial reticence based on the dignity of the sitters and the exceptional tact of the painter. Though somewhat wistful, their expressions mirror the artist's state of mind, communicating a sense of self-assurance absent in many works coming before and after. Here sitter and painter confront each other from a position of equality; they are confident and at ease.

While the subject of this portrait exemplifies this self-possession, a close inspection reveals the artist attuned to contradictions and ambivalence. The eyes of the man are out of focus, and this, together with the shadow on the left side of the face, seems to divide the head into halves. The bifurcation is reinforced by the more or less straight, uniform contour on the right side of the portrait and the irregular, angular movement on the left. The mass of hair on this side juts out abruptly and joins with the fuller beard and the sharp angle of the collar to pull the image to the left. Even the two sides of the moustache differ, echoing also the contrasting slopes of the shoulders. Yet the internal contradictions are so neatly absorbed in the over-all design that the result is blissful equilibrium, as if the sitter and the artist deliberately had set out to harmonize opposites.

21

Lawyer Pleading His Case c. 1875–1876
(*L'Avocat plaidant*)
(Study of the lawyer Bénazé for
The Lawyer Pleading His Case)

Oil on canvas

38.8 x 46.7 cm

INSCRIPTION
Initialled above shoulder l., *T.C.*

PROVENANCE
Bertauts-Couture (the artist's grandson),
Paris; H. Shickman Gallery, New York.
Acquired September 1975.

EXHIBITION
1880, Paris, Palais de l'Industrie, *Catalogue
des œuvres de Thomas Couture*, introduction by
Roger Ballu, cat. no. 199.

BIBLIOGRAPHY
*Catalogue de tableaux, aquarelles et dessins mod-
ernes composant la collection de M. Barbedienne*,
Paris, 1892, cat. no. 48. Bertauts-Couture,
Thomas Couture, p. 53.

RELATED WORKS
A more complete version (fig. 2), location
unknown; repr. in Bertauts-Couture, *Thomas
Couture*, opp. p. 113.

AN OIL STUDY for a more complete ver-
sion of the sitter pleading at the bar (fig.
2), Couture's energetic portrait of the
lawyer Bénazé evades the desultory
effigies of the later period because the
painter, rather than neutralizing his
subject by placing him in the privacy of
a studio or drawing room, identifies him
with his public function. The serious set
of the features revealing deep concen-
tration is somewhat enlivened by the
accumulation of tiny impastoed mod-
ules on the face (a mark of Couture's
late modelling) and by the painter's
basic colour scheme of underlying
greenish-greys and complementary pink
flesh tones. Couture's effective use of the
ébauche around the eyes, nose, mouth,
and other shadow areas and the incisive
brushwork for the cravat demonstrate
his masterful technique. The artist
ingeniously captures the character of his
sitter in the unusual tilt of the head, the
ill-fitting collar, and the loose strands of
hair and swooping spectacle cord which
seem to vibrate with his movement.

Couture's interest in the subject
must have also been sparked by the
opportunity to introduce ideas related
to his narrative paintings as well as by
familiarity with the sitter who was a
compatriot from Senlis. It is a measure
of his own character that, while he
relied in part for his living on painting
portraits of eminent physicians and law-
yers, he singled these groups out for
attack in his satirical genre pictures.
Indeed, Healy (see cat. no. 22) – who
owned the two hand studies for this pic-
ture – reported that Couture despised
these professions: "He had two pet
hatreds – lawyers and doctors. In M.
Barbedienne's gallery are some very
spirited drawings and sketches of law-
yers speaking before the court, or sleep-
ing during the discourse of their brother
lawyers. As to doctors, he never would
allow one in his house. He was so vio-
lent in his animosity that, when he fell
ill, he refused all medical aid."

Couture caricatured these profes-
sions in the manner of Molière and
Daumier; his *Returning from Trial (En
revenant du tribunal)* depicts a young law-
yer, striding through the streets of Senlis
with his heavy portfolios amidst a brood
of clucking hens and a strutting turkey.
It conjures up Daumier's parade of bar-
risters walking through their chambers,
raising their noses to vulnerable clients,
and sweeping grandly down the long
flight of stairs of the Palais de Justice.
Couture shared Daumier's fascination
with the picturesque silhouette of the
legal robes which, like an actor's mask,
provide a socially legitimate front for
self-aggrandizement.

Curiously, the large version of the
lawyer Bénazé assumes the identical
hand gesture of Harlequin defending
Pierrot in the *Judgement of Pierrot* (1863;
Private Collection, Cleveland). Harle-
quin, whose lozenged costume peeks out
beneath the lawyer's robe, plays the role
of the advocate and uses the hand ges-
ture to persuade the court to believe in
his disguise. He eloquently pleads
Pierrot's case with learned arguments,
and surrounds himself with heavy tomes
which he has consulted for precedents.
The painting is a parody of the legal
system, for it is obvious that Pierrot is
guilty of the pilfering he is being
accused of.

Although the study of the lawyer
Bénazé shows the subject in a far more
serious and sympathetic light, the fact
that he gesticulates with the right hand
– exactly as the Harlequin – suggests
that Couture associated certain stero-
typed poses with different professional
groups. He unconsciously attributed to
his fellow citizen some of the dislike and
scepticism he felt about the legal profes-
sion.

Couture's fascination with, and
ambivalence towards, doctors and law-
yers probably reflect a personal jealousy
relating to his own insecure professional
status. His sensitive sketches of the
courtrooms at Senlis and Beauvais in
preparation for his satires reveal a wish-
fantasy to participate in the give-and-
take of legal battles and to dispense jus-
tice from "on high." As he compromised
his principles in his late years and was
cut off from the centre of artistic activi-
ty, he may well have projected his anxi-
eties on to those enviable professions,
where, he believed, charlatanism often
abounds.

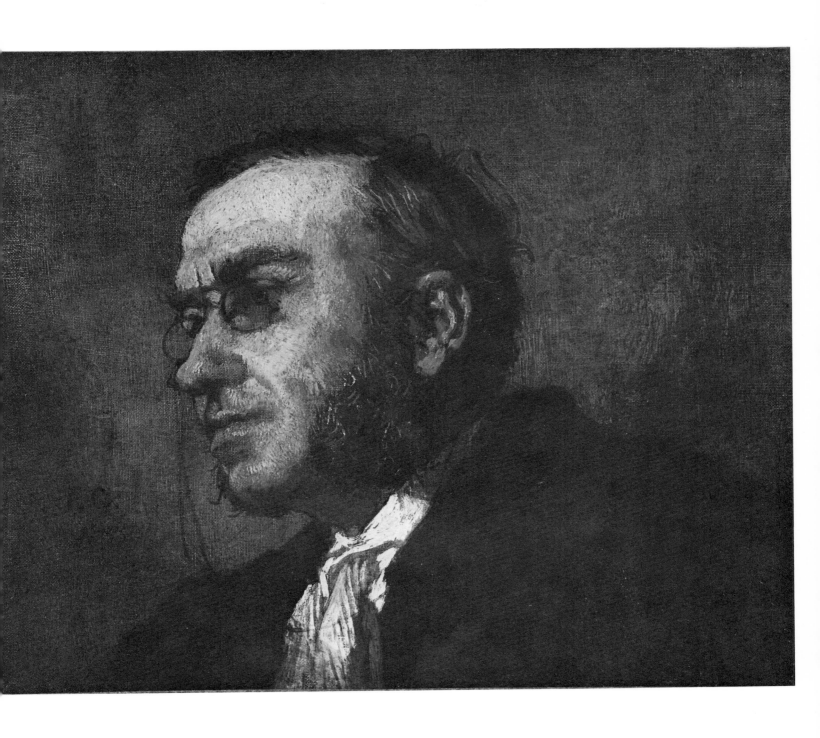

◁ **Fig. 2**
The Lawyer Pleading His Case (location unknown)

22

Hand Leafing Through Pages of a Book
c. 1875–1876
(Study for *The Lawyer Pleading His Case*)

Oil on canvas

33.8 x 42 cm

INSCRIPTION
Initialled l.l., *T.C.*

PROVENANCE
Collection of G.P.A. Healy, Paris; H. Shickman Gallery, New York. Acquired August 1971.

EXHIBITIONS
1880, Paris, Palais de l'Industrie, *Catalogue des Œuvres de Thomas Couture*, introduction by Roger Ballu, cat. no. 200. October 1971, New York, H. Shickman Gallery, *The Neglected 19th Century: An Exhibition of French Paintings*, Part II (unpaginated), repr.

COUTURE'S STUDY of the lawyer's hand dexterously leafing through a legal tome in search of precedent is a tour de force. Like the Renaissance masters, Couture was fascinated by the pictorial possibilities of the human hand, and he did many studies of hands and arms. During the same period of the execution of *The Lawyer Pleading*, he developed a major narrative painting, *Nobility*, for which he did several beautiful arm studies. None of these, however, compare in complexity with this example. George Healy (1808–1894), the American portraitist who was one of Couture's close friends, owned both this study and that of the lawyer's other hand – suggesting the esteem in which the two artists held these preparations. A comparison of the study with its projection in the large version reproduced in Bertauts-Couture (see cat. no. 21, fig. 2) reveals how carefully Couture planned his work. The book is segmented by the picture plane at the identical place in both works.

What makes this study so intriguing is its apparent autonomy despite its preparatory function. Its self-contained character is determined by the dramatic interaction of light and dark and by the series of laterally shifting diagonals highlighted by the angular shadow on the left side of the table, the foreshortened middle finger, and the gutter of the open book. That Couture carefully contrived the design is confirmed by the fact that his monogram follows the general direction of the composition.

The introspection of this study is almost Rembrandtesque and suits the intellectual activity. The hand which responds to the thought emerges out of darkness just as the thought itself illumines the dark recesses of the mind. The act of thumbing the pages throws light on injustice and clarifies the meaning of equity. Couture's passion here imparts to the detail a depth of feeling absent in the final picture. One is reminded of the *Praying Hands* of Dürer (1471–1528), another preliminary study whose self-sufficiency springs from the identification of the hands with a specific activity and professional duty.

The effect of both the Dürer and the Couture recalls the fascination of the primitive and the child with the tracing of their own hands and the magical hold of the design. Religious images of autonomous hands like the reliquary, the Hand of Benediction, and the Hand of God – particularly as we find it in the Pamplona Bibles in the context of Belshazzar's Feast – must be related to the primitive obsession with the outlined hand. Perhaps the modern equivalent of the apotropaic sign is the magistrate's gesticulating fingers which signify his authority in the temporal realm.

El Greco (1541–1614) is another artist who comes to mind when we look at Couture's study: so many of his holy figures are identified with a canonical text which they trace with the fingers or the whole hand – *Canonico Bosio, Saint Philip*, and especially *Saint Jerome as Cardinal*, who points to a biblical commentary in fulfillment of his divine calling, just as the lawyer looks for a precedent in fulfillment of his earthly occupation.

As in so many of his sketches, Couture here permits himself an unselfconscious plunge into the subject, a state of mind which always diminished as he approached the final stages. With these sketches, he betrays, in a sense, a genuine love for his métier which he seems loath to admit in the more premeditated attempts. He left us a complete record of his life and times in his detailed preparations, and it is regrettable that he could not have foreseen the day when they might be taken as the fullest expression of his creativity.

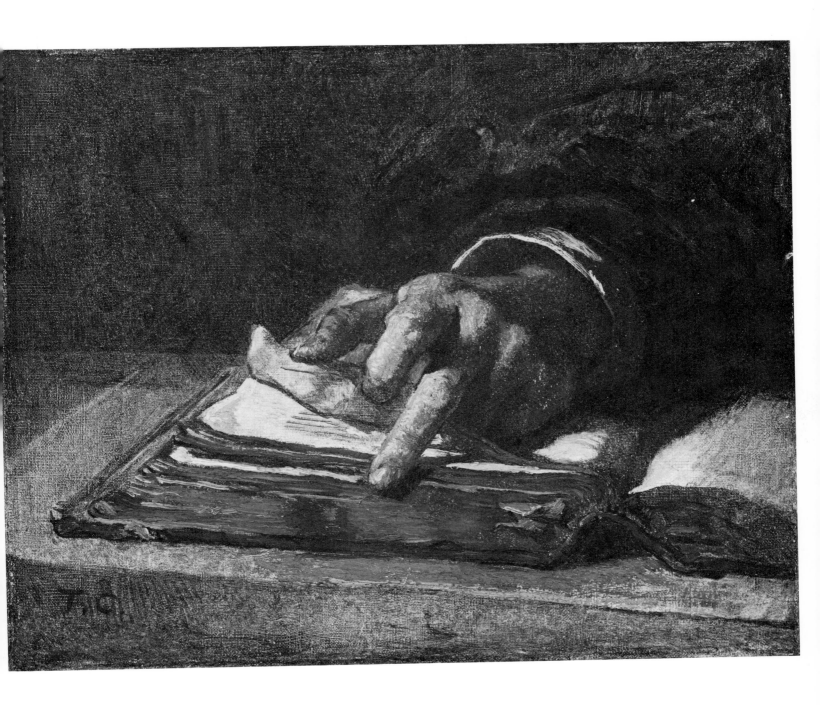

ALEXANDRE GABRIEL DECAMPS

Paris 1803 – Fontainebleau 1860

SOMETIME BEFORE 1816, Decamps and his brother, the future art critic and essayist, Maurice-Alexandre Decamps (1804–1852), at the insistence of their father, Pierre-Augustin, spent a few years in the small village of Arsy in Picardy in order to learn the hard life of the fields. Instead of finding this existance too rigorous, Decamps enjoyed the rustic demands. He also became inspired by chalk drawings made by local peasants. After approximately three years, he returned to Paris where he entered the atelier of Étienne Bouhot (1780–1862), without parental encouragement. Late in 1818, Decamps left Bouhot for the studio of Alexandre Denis Abel de Pujol (1785–1861). Neither master had a measurable influence on Decamps's style, nor could they make him understand the importance of academic training. He left Abel de Pujol's studio about 1819–1820 and embarked on a career as a professional artist. His memories of Arsy continued to serve as the point of departure for many of his works throughout his life, beginning with his earliest known signed and dated painting *Arabian House* (1823; Musée d'art et de l'industrie, Saint-Étienne).

After a period of fair economic success during the early 1820s, Decamps made his debut at the Salon of 1827–1828. He exhibited consistently at official exhibitions from that time until 1855, when he went into semiretirement.

Decamps received all of the major awards and recognitions that were bestowed on contemporary artists (see Awards and Honours). His most famous painting, *The Defeat of the Cimbrians (La Défaite des Cimbres*, 1833; Musée du Louvre) was exhibited at the Salon of 1834. In 1849 he was commissioned by the State to paint a subject of his choice for the Musée du Luxembourg (*Job and His Friends*, 1853; Minneapolis Institute of Arts). Perhaps the crowning point of the artist's career was the Paris Universal Exhibition of 1855, where he was given a retrospective with Ingres (1780–1867) and Delacroix (1798–1863); all three were awarded the Grand Medal of Honour.

Decamps, an uncontested leader of the so-called School of 1830, the first champions of the Romantic Movement in France, travelled extensively during his illustrious career. He went to Switzerland, like so many Romantic artists, in 1824. Then in 1828, he visited North Africa, Turkey, Albania, and Greece, becoming the first major nineteenth-century French painter to travel in the Balkans and the Middle East. In 1832, he was in the south of France, accompanied by his best friend, the painter, Louis-Godefroy Jadin (1805–1882). Decamps made the traditional pilgrimage to Italy in 1835, travelled throughout France the next year and again in 1839. By 1843, he was spending more and more time in the forests around Fontainebleau, well before many artists who would become associated with the Barbizon School. After another voyage in the south of France in 1852, Decamps moved permanently to the Fontainebleau region in 1853. That all of these trips had an influence on Decamps's art is indicated by the *Goatherder of the Abruzzi* (1845; Ottawa, The National Gallery of Canada), a painting in memory of the Italian sojourn.

In addition to the first-hand experiences provided by travel, Decamps admired and learned from the art of such diverse masters as Raphael, Titian, Giovanni da Bologna, Rembrandt, Poussin, Léopold Robert, and Théodore Géricault.

The esteem in which the artist was held is illustrated by the *Monument to Decamps*, a bust by A. Carrier-Belleuse (1824–1887), erected in 1862 at Place Decamps in Fontainebleau, which still stands today.

EXHIBITIONS
Salons of 1827–1848 and 1851. Paris Universal Exhibition, 1855, retrospective.

AWARDS AND HONOURS
Second-Class Medal, 1831 Salon; First-Class Medal, Salon of 1834; Grand Medal of Honour, Paris Universal Exhibition of 1855. Chevalier (1839) and Officer (1851) of the *Légion d'Honneur*.

BIBLIOGRAPHY
Charles Baudelaire, *Art in Paris 1845–1862, Salons and Other Exhibitions*, translated by J. Mayne, London: Phaidon Press, 1965. Ernest Chesneau, *Le Mouvement Moderne en Peinture: Decamps*, Paris: Typographic E. Ponckoucke, 1867. Charles Clément, *Les Artistes Célèbres: Decamps*, Paris: Librairie de l'Art, 1886. Pierre du Colombier, *Maîtres de l'Art Moderne: Decamps*, Paris: Les Éditions Rieder, 1928. Paul Mantz, "Decamps," *Gazette des Beaux-Arts*, vol. 12 (1862), pp. 98–128. Adolphe Moreau, *Decamps et son Œuvre*, Paris: Chez D. Jouaust, 1869. Dewey F. Mosby, *Alexandre-Gabriel Decamps: 1803–1860*, New York: Garland Publishing, 1977. Archives du Louvre, Paris, P–5 (1860, 9 October), letter from M. Marini to the Director of Fine Arts, written from Paris. Dr Véron, "Notice biographique de Decamps, écrite par lui-même," *Mémoires d'un Bourgeois de Paris*, Paris, 1854.

D.F.M.

23

Evening Landscape 1846
(*Paysage [Effet de Soir]*)
Oil on canvas
49 x 76.5 cm

INSCRIPTION
Initialled, signed, and dated, in red, b.r., *DC/46/Decamps*.

PROVENANCE
Amédée Susse, sale, 11 February 1847, Paris; Galerie Jacques Fisher-Chantal Kiener, Paris, 1976. Acquired February 1977.

BIBLIOGRAPHY
Moreau, *Decamps et son Œuvre*, p. 210.

DECAMPS WAS AN EXTREMELY PROLIFIC ARTIST, producing an estimated two thousand paintings, drawings, and prints. As a result, certain images or themes recurred over the whole of his career. We see, for example, the basic image of an equestrian figure or figures set in a landscape in a painting *View Taken in the Middle East* (c. 1831; location unknown; Mosby checklist no. 530); in the lithograph, *A Meeting* (1835; Moreau, p. 28, no. 15); and again in *Tow-Horse* (1842; Louvre). In each instance Decamps recorded images that he had seen.

In this painting, a man on a ploughhorse points out a fleeting rabbit to a boy mounted behind him. The evening effect tells us that they are returning home after a day's work in the fields. The supporting evidence of the shepherd with his flock on the left, the woman near the centre, who balances on her head bread or water for the evening meal, and the figure gathering the herd of cattle on the right – perennial Decamps motifs – all indicate the end of the work day. The scene is undoubtedly taken from the area of Fontainebleau where Decamps resided at the time.

Decamps did not intend any allusion to the plight of the worker or commentary on labour in his choice of subject. He was attracted to scenes like this one beginning with his childhood stay at Arsy. It ought to be mentioned, however, that during the late 1830s and the 1840s, he aspired to history painting. In fact, he received wide critical acclaim as a history painter at the Salon of 1845. But amidst the critics' praise was a longing for a little of the old Decamps, the chronicler of everyday life (*cf.* Charles Baudelaire, *Art in Paris*, 1965, p. 9). Decamps's paintings of 1846, such as this landscape, are characteristic of the earlier genre works with which he made his reputation, yet were actually produced as a direct response to the requests of the critics. Decamps

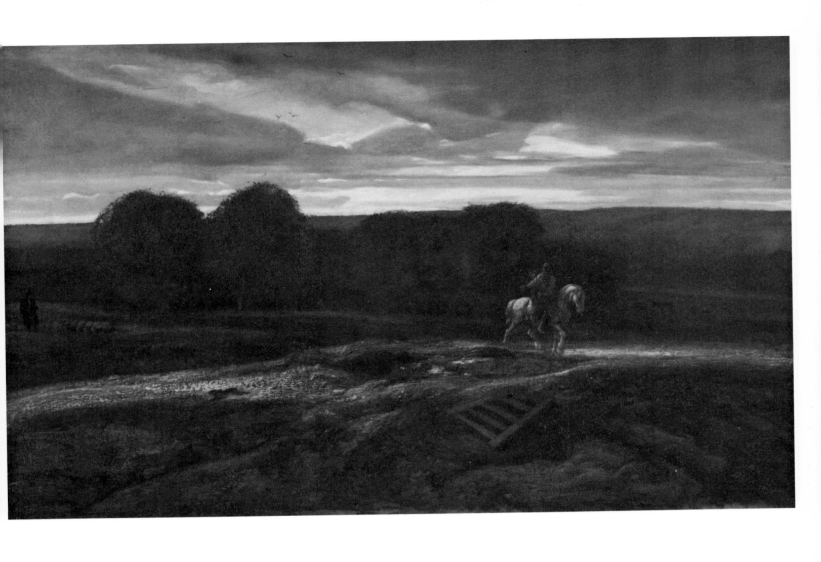

was always very sensitive to what they wrote.

Evening Landscape is typical of Decamps's working method for this genre at this date. The composition is conceived as a series of horizontal bands, beginning with the rugged terrain of the foreground, moving into the pasture and trees of the middleground, and ending with the mountains and sky in the background. The figures, animals, and trees serve as vertical accents. Decamps used the section of a cattle barrier in the right foregound and the various highlights to add diagonal movement to what would have been a very simple, if not rudimentary, arrangement. The composition is made even more complex through the contrasts of lights and darks. Moreover, the artist has contrasted the foreground terrain – an excellent example of his *cuisine* (or the inimitable, golden brittle textures for which he is well known) – with the soft, cool greens of the grazing land behind it. The sky, in addition to its own contrasts, works harmoniously against the trees and mountains, and sets the mood for the action which takes place under it. The fact that Decamps was a master of colour emerges clearly in such subtle touches as the gleaming red in the skirt of the woman in the middle distance and in the multitude of colours that make up each object and section of the painting. These complexities of composition are offset by a certain clarity which permits us to understand, for example, the actions of the miniscule figure with the cows in the right middleground. Decamps's approach to the painting, beyond his first-hand knowledge of similar scenes, owes a great deal to seventeenth-century Dutch art.

Because Decamps did not send this landscape to a Salon, there is no contemporary critical response to it. There are no known preparatory drawings or sketches for the composition, nor prints done after the painting was completed. However, we do know that Decamps considered the painting an important work. For instance, it was sold by Amédée Susse, one of the painter's major dealers and framers during the 1840s. Even more important is the fact that the painting is fully signed, initialled, and dated, because, as Marini wrote, "Monsieur Decamps . . . signed with his full name only those works that he particularly liked" (Paris, Archives du Louvre, P–5, 9 October 1860).

The mood and stylization of Decamps's paintings place him solidly in the Romantic school, but his choice of subjects, such as the modestly titled *Paysage (Effet de Soir)*, points to tendencies that would exist only after mid-century with such Realists as Gustave Courbet and Jules Breton.

GUSTAVE DORÉ

Strasbourg 1832 – Paris 1883

DORÉ WAS BORN in Strasbourg and spent his childhood in a house located a stone's throw from this city's famous cathedral. It was there, apparently, that he acquired and developed his taste for Gothic art, with its spires, gables, and finely sculptured tracery which occur in his work with obsessive frequency. Doré's talent was evident at a very young age, and as early as 1847 he went to Paris to collaborate on Philipon's famous *Journal pour rire*, on which Daumier (1808–1879) had also worked. He frequented the Louvre and the Bibliothèque Nationale, and collected prints which he studied in order to perfect his craft.

Virtually his entire career was devoted to the illustration of more than ninety books, the most famous of which were tomes by Rabelais, Balzac's *Contes drolatiques*, Cervantes' *Don Quixote*, Dante's *Inferno*, and the Bible. At the same time, because his main ambition was to be a painter, Doré exhibited his work regularly at the Salon. However, in paint he merely repeated the themes and motifs of his prints; thus his canvases – even the great religious productions of his last years – are perhaps the least important part of his œuvre.

As a painter Doré was not appreciated in France, and in 1868 he opened the Doré Gallery in London. Here he easily sold his canvases, for which there had been no market among his compatriots, to captivated English and American buyers.

EXHIBITIONS
Doré exhibited regularly at the annual Salons in Paris between 1848 and 1882. From 1868 to his death, he exhibited in the Doré Gallery, London.

AWARDS AND HONOURS
Chevalier (1861) and Officer (1879) of the *Légion d'Honneur*.

BIBLIOGRAPHY
René Delorme, *Gustave Doré, peintre, sculpteur, dessinateur et graveur*, Paris: Librairie d'art, Baschet, 1879. Louis Dézé and Jean Valmy-Baysse, *Gustave Doré: bibliographie et catalogue complet de l'œuvre*, Paris: M. Seheur, 1930. Doré Gallery, *Descriptive Catalogue of Pictures by Mr Gustav Doré, on exhibition at the Doré Gallery*, London, 1869–1891. Blanchard Jerrold, *Life of Gustave Doré*, London: W.H. Allen, 1891. Henri Leblanc, *Catalogue de l'œuvre complet de Gustave Doré*, Paris: C. Bosse, 1931. Pierre Mornand, *Gustave Doré*, Paris: Le Courrier graphique [1946]. Millicent Rose, *Gustave Doré*, London: Pleiades Books, 1946.

L. d'A.

24

Spanish Street Scene

Oil on canvas

1.32 x 1.93 m

INSCRIPTION
Signed in red 1.1., *G^{ve} Doré.*

PROVENANCE
H. Shickman Gallery, New York. Acquired
April 1970.

EXHIBITION
February 1970, New York, H. Shickman
Gallery, *The Neglected 19th Century: An Exhibition of French Paintings,* cat. no. 11, repr.

IN THE EARLY 1840s, when the decline
of the "grand style" of painting in
France first became evident, many artists began to seek new sources of inspiration. They turned their attention to far-off lands, thus beginning the reign of
what was known as "le pittoresque."
The Orient, Constantinople, Syria,
Egypt, and Morocco provided new settings for this attempted artistic renewal.
Spain also became a source of inspiration, as Italy had been earlier. Théophile Gautier and Prosper Mérimée,
who first visited Spain in 1840, are
prime examples of the influence this
country had on the intellectual milieu
in which these first-generation Romantics lived. Doré's interest in Spain was to
remain within the confines of an agreeably descriptive exoticism, rather than
becoming the passionate escapism
found in Mérimée and Gautier.

Doré first visited Spain in 1855,
accompanied by Gautier and Paul Dalloz, a critic with the *Moniteur Universel.*
This brief trip, however, does not
appear to have left any imprint on his
work. He made a second visit in the fall
of 1861, this time accompanied by
Baron Charles Davillier. In the course
of this trip he made a large number of
drawings which he would adapt later in
other drawings, prints, and paintings.

Between 1862 and 1869, 304 of
Doré's plates on Spanish subjects were
to appear in the *Tour du Monde.* (They
were later republished in reduced size
in Edmond de Amicis' *L'Espagne,* 1878.)
In 1874 Davillier's *Spain* was published,
illustrated with 306 wood engravings by
Doré, based on sketches done during his
1861–1862 trip to Spain.

Beginning in 1863 and until the

early 1870s, Doré exhibited at the Salon
canvases devoted to Spanish themes.
These paintings, many very large,
included *The Vito, A Gypsy Dance at
Granada (Le vito, Danse de Gitanos à
Granade;* 1863 Salon, no. 597), *A Spanish
Gypsy Woman (Une gitane espagnole;* 1865
Salon, no. 684); *An Evening in the Granada Countryside (Une soirée dans le campagne de Grenade;* 1866 Salon, no. 602);
*The Siesta, A Recollection of Spain (La siesta,
souvenir de l'Espagne;* 1868 Salon, no.
818), and *Alms (L'aumône;* 1870 Salon,
no. 868).

The scene takes place at the door of
a church, where two young society
women are being asked for alms by beggars and gypsies who are waiting outside. For this composition Doré used
ideas previously explored in his illustrations of Spain, such as *Beggars in the
Cloister of the Barcelona Cathedral* (Davillier, *Spain,* p. 7), *Sketch Made in Alicante* (p.
115), *Ladies of Granada Listening to Dwarf
Musicians* (p. 139), *Gate of the Sala de
Justicia* (p. 187), and especially
Fortune-telling at Sacro-Monte (p. 213).
Many of these wood engravings explore
the almost invariable motif of two elegant women, one viewed from the front
and the other from the side. They are
usually surrounded by beggars or gypsies in order to create a picturesque contrast between wealth and abject
poverty, with beauty and elegance set
against deformity and coarseness.
"Three elegant senoras passing by stopped for a moment, their marvellous
beauty and their finery creating a curious contrast with the ugliness and the
tattered clothing of the poor dwarfs,"
wrote Davillier (p. 141); this quotation
is indicative of the tone of his book, and
it was in the same spirit that Doré illustrated *Spain* and did the paintings
related to this project.

Spain did not, however, enjoy the
same success as *Don Quixote,* which was
also illustrated by Doré on his return
from Spain in 1863: "*Spain* created no
sensation, and is most inferior to *Don
Quixote,* lacking all its witty vivacity and
full instead of saccharine pictures of
blind beggars and bull-fighters" (Rose,
Gustave Doré, p. 64).

However, although its theme is both
clichéd and conventional, *Spanish Street
Scene* does contain some fine bits of
painting – such as the side view of the
seated gypsy in the left foreground and
the mother and child standing on the
right. Doré also demonstrates his innate
talent as a director: one would think
this was a tableau from a theatrical production. Here, Doré the illustrator is
perhaps more prominent than Doré the
painter.

Strangely enough, the Tanenbaum
picture does not appear to be recorded
in the complete catalogue of Doré's
work, compiled by Louis Dézé in 1930
from the descriptive catalogue of the
Doré Gallery (1869), from Georges
Duplessis's catalogue for the Gustave
Doré exhibition by the Cercle de la
Librairie (Paris, 1885), and from other
sources. Nor was it among the major
paintings of Spanish subjects displayed
at the Salon between 1863 and 1868. It,
therefore, may have been done after
1870, which would explain the stiffness
of the composition, a reworking of
images which were no longer as vivid in
the artist's memory as they once had
been.

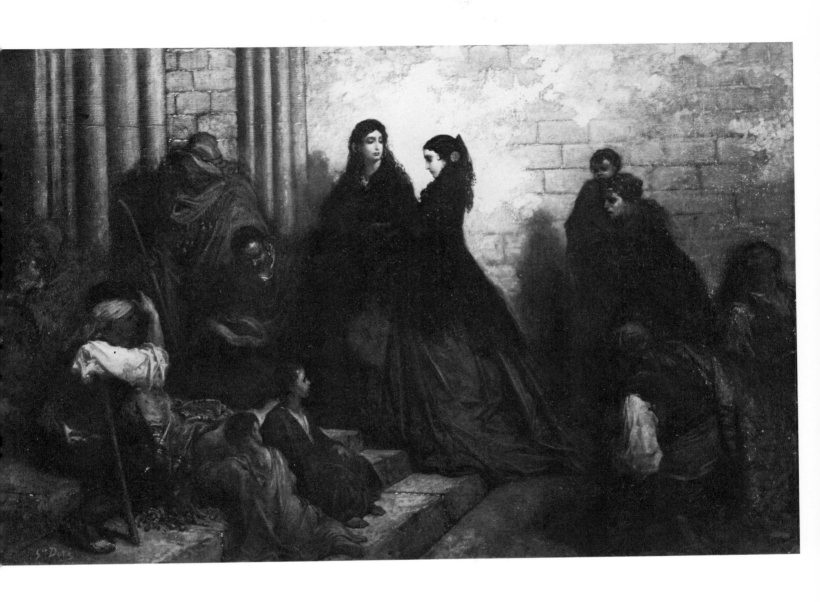

25

Scotch Landscape 1878

Oil on canvas

1.10 x 1.95 m

INSCRIPTION
Signed and dated, l.l., *G^ve Doré 1878*, in
black, over a previous signature in red, par-
tially covered but with *G^ve D* still visible;
identifying stamp, in red, of the Gustave
Doré studio, l.r.

PROVENANCE
Hôtel Drouot, Paris, sale from the studio of
Gustave Doré, 8–13 April 1855, no. 38 (as
Paysage d'Écosse, 1.10 x 1.92 m); Hôtel
Drouot, Paris, sale of 25 October 1971, no.
132 (as *Paysage vallonné*), repr.; Schweitzer
Gallery, New York. Acquired January 1972.

EXHIBITION
About 1882, London, Doré Gallery, Francis
Roubiliac Conder, *Descriptive Catalogue of Pic-
tures in the Doré Gallery*, cat. no. 16 (as *Scotch
Landscape*; 3'7" x 6'7").

BIBLIOGRAPHY
Jerrold, *Life of Gustave Doré*, p. 409 (men-
tioned as *Scotch Landscape*, 3'7" x 6'3"). Dézé
and Valmy-Baysse, *Gustave Doré*, p. 125.
Leblanc, *Catalogue de l'œuvre complet*, p. 536.
Blanche Roosevelt, *Life and Reminiscences of
Gustave Doré*, New York: Cassell, 1885.

RELATED WORKS
(?)Watercolour, 1878 Salon, no. 2809, *A Val-
ley near Braemar, Scotland* (*Un vallon aux environs
de Braemar, Écosse*).

JEAN VALMY-BAYSSE reports that Gus-
tave Doré "spent some time in Scotland
in 1873 and did numerous sketches
there" (p. 324). Blanche Roosevelt says,
in her *Life and Reminiscences*, that Doré's
visit took place in April, and that he
was accompanied by Colonel Teesdale.
Doré was apparently greatly impressed
by the magnificent wild country of Scot-
land, and he drew many scenes in the
open air, completing the sketches from
memory with watercolours when he
returned to his hotel in the evenings. He
even involved himself in such activities
as fishing for salmon and taking part in
traditional dances in Scottish dress.

The artist is thought to have paid a
second visit to Scotland sometime after
this (Roosevelt, *Life and Reminiscences*,
p. 382). There could be a connection
between the Tanenbaum painting and
a watercolour exhibited at the 1878
Salon (no. 2809) entitled *A Valley near
Braemar, Scotland* (location unknown).

The grandeur of the site, the size of
the painting, combined with the small
figure in traditional costume (who
seems to have been added to give some
idea of the awesome majesty of this
countryside), make this a heroic land-
scape, analogous in purpose to Isabey's
large seascapes (cf. cat. no. 41).

There is another Scottish landscape,
dated 1875, and approximately the
same size as this one, in the Toledo
Museum of Art.

Placing Doré's art in the context of
his period, one cannot imagine any-
thing further removed from the princi-
ples of the new Impressionist aesthetics
than this painting, which is descriptive,
objective, solid, and eternal, "like the
art found in museums."

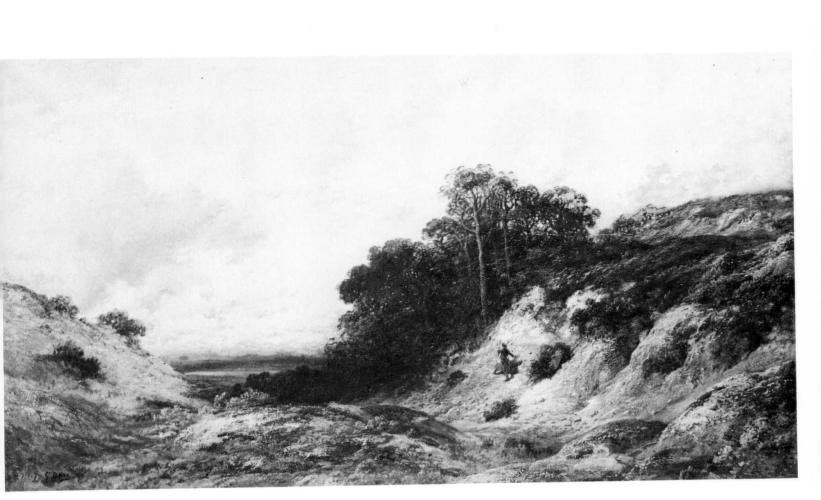

IGNACE HENRI JEAN THÉODORE FANTIN-LATOUR

Grenoble 1836 – Buré (Orne) 1904

SON OF A PORTRAIT PAINTER AND
PASTELIST, Fantin studied first with his
father and then, beginning in 1850,
with Horace Lecoq de Boisbaudran
(1802–1897), who was affiliated with
the École de Dessin and held classes at
his own atelier. Fantin remained with
Lecoq for approximately six years, dur-
ing which time he was briefly – and
unsuccessfully – a student at the École
des Beaux-Arts. Formal studies were
supplemented by executing copies after
old master paintings in the Louvre, a
practice begun in 1853 and continued
for the next twenty years.

Fantin first submitted works to the
Salon in 1859. These were refused, but
two of the three were subsequently
shown at the studio of François Bonvin
(cat. nos 8–10), along with works by
Théodule Ribot (cat. nos 52–60),
Antoine Vollon (cat. nos 70, 71), and
James McNeil Whistler (1834–1903).
On Whistler's invitation, Fantin visited
England in 1859. This and subsequent
visits (1861, 1864, and 1881) were of
great consequence to his career.
Through connections made there – par-
ticularly his association with his friends
and sponsors Edwin and Ruth Edwards
– Fantin gained access to the English
market from which, for the better part
of his life, he would earn his living sell-
ing still lifes. While Fantin was most fre-
quently represented by portraiture at
the Salon, another major interest was
what he called his "projets
d'imagination" (imaginative projects),
the most important of which were
inspired by the music of Brahms, Schu-
mann, Berlioz, and Wagner.

The most successful vehicle for these
imaginative compositions proved to be
lithography, to which the artist first
turned in the early 1860s. The litho-
graphs were regularly exhibited at the
Salon from 1877 onwards, and by the
end of the century the artist had gained
the reputation as the greatest contem-
porary master of the lithographic
medium in France.

Fantin's youthful enthusiasm for the
work of Jean-Baptiste Corot, Jean-
François Millet, and Eugène Delacroix
never waned; his interest in the work of
his immediate contemporaries, on the
other hand, did. Fantin met Gustave
Courbet (1819–1877) in 1859 and
attended the classes he gave in 1861.
But admiration for this controversial

figure was short-lived, and by 1865 Fan-
tin had repudiated Courbet's talent and
importance. Similarly, by the end of the
1860s, Fantin had reached a parting of
the ways – both artistically and person-
ally – with his friends Alphonse Legros
and Whistler. While his high regard for
Manet continued into the seventies,
Fantin became increasingly distressed
with this artist's involvement with the
Impressionists, whose work he abhorred.

Disenchanted with the world
around him, Fantin slowly withdrew
from the society of his contemporaries.
Still greater isolation followed upon his
marriage in 1876. While he continued
to produce works of high quality for the
remainder of his life, he ceased to evolve
as an artist.

EXHIBITIONS
Paris Salons of 1861, 1863–1867, 1869–1870,
1872–1899. Salon des Refusés, 1863. Paris
Universal Exhibition of 1889. Centennial
Exhibition of 1899, 1900. London, Royal
Academy, 1876, 1878–1884, 1886–1900.
Brussels, 1875, 1878, 1883, Brussels, 1875,
1878, 1883–1884, 1886–1887, 1890, 1893,
1897, 1900. Antwerp, 1879, 1882,
1884–1885, 1888. Munich, 1879, 1883,
1888–1889. Manchester, 1880. Vienna and
Amsterdam, 1882. Brussels, *Les XX*, 1885,
1889. Copenhagen, 1888. Ghent, 1889,
1895. Berlin, 1896-1897. Stuttgart, 1896.
Retrospective exhibition, Paris, École des
Beaux-Arts, 1906.

AWARDS AND HONOURS
Third-Class Medal, 1870 Salon; Second-
Class Medal, 1875 Salon; honourable men-
tion for lithography, 1881 Salon. Chevalier
(1879) and Officer (1900) of the *Légion
d'Honneur*. Gold Medal, Antwerp, 1879. Gold
Medal, Manchester, 1880. Member of the
Royal Institute, London, 1883. Knight of
the Order of Leopold, Belgium, 1894.

BIBLIOGRAPHY
Léonce Bénédite, "Histoire d'un tableau; le
'Toast' par Fantin-Latour," *Revue de l'art
ancien et moderne*, vol. XVII (1905), pp. 21–31,
121–136. Larry Curry, "Henri Fantin-
Latour's *Tannhauser on Venusberg*," *Los Angeles
County Museum of Art Bulletin*, vol. XVI (1964),
pp. 3–19. Mme Henri Fantin-Latour,
Catalogue de l'œuvre complet de Fantin-Latour,
Paris: Floury, 1911. Frank Gibson, *The Art of
Henri Fantin-Latour: His Life and Work*, Lon-
don: Drane's, 1924. Germain Hédiard, "Les
dessins de M. Fantin-Latour," *Gazette des
beaux-arts*, vol. XXVI (December 1901), pp.
459–467; Hédiard, *Fantin-Latour: Catalogue de
l'œuvre lithographique du maître*, Paris: Librairie
de l'art ancien et moderne, 1906. Adolphe
Jullien, *Fantin-Latour: Sa vie et ses amitiés*, Par-
is: Lucien Laveur, 1909. Gustave Kahn,
Fantin-Latour, Paris: F. Rieder, 1926. Charles
Morice, "Fantin-Latour," *Mercure de France*,
vol. LII (October 1904), pp. 63–78. Pierre
Schneider, "Henri Fantin-Latour," *Art News
Annual*, vol. XXIV (1955), pp. 54–78.

D.D.

Portrait of Alphonse Legros 1858

Oil on canvas

52.2 x 45.3 cm

INSCRIPTION
Signed and dated u.l., *Fantin/1858*.

PROVENANCE
Otto Scholderer, Frankfurt, 1858 to 1902;
Gustave Tempelaere, Paris (acquired by
1903 from Scholderer estate); Madame Paul
Paix, Douai, by 1906; H. Shickman Gallery,
New York, by 1970. Acquired June 1971.

EXHIBITIONS
May–June 1906, Paris, Palais de l'École
Nationale des Beaux-Arts, *Exposition de
l'œuvre de Fantin-Latour*, cat. no. 16. February
1970, New York, H. Shickman Gallery, *The
Neglected 19th Century: An Exhibition of French
Painting*, cat. no. 13 (as *Portrait of Delacroix*),
repr.

BIBLIOGRAPHY
Léonce Bénédite, "À propos des 'Peintres-
Lithographes': Deux nouvelles œuvres de
Fantin-Latour," *La revue de l'art ancien et
moderne*, vol. XIV (1903), p. 380; Bénédite,
"Fantin-Latour," *Art et Décoration*, vol. XIX
(May 1906), p. 156; Bénédite, "Fantin-
Latour," introduction to the catalogue
*Exposition de l'œuvre de Fantin-Latour au palais de
l'École Nationale des Beaux-Arts*, Paris, 1906, p.
20; Jullien, *Fantin-Latour*, pp. 18, 84-85, repr.
opp. p. 8. Mme Fantin-Latour, *Catalogue de
l'œuvre complet*, cat. no. 96. Gibson, *The Art of
Fantin-Latour*, p. 35.

RELATED WORKS
Fantin painted Legros' portrait on two other
occasions – a small sketch (1856; Mme Fan-
tin, cat. no. 64/65; location unknown), and
Legros as one of the ten sitters for *Hommage à
Eugène Delacroix* (1864; Mme Fantin, cat. no.
227; Musée du Jeu de Paume, Paris).

THE *PORTRAIT OF ALPHONSE LEGROS* was
one of four pictures which Fantin sent
to his friend Otto Scholderer
(1834–1902) in Frankfurt in the late
summer or fall of 1858. The other works
included two self-portraits (Mme Fan-
tin, cat. no. 94; Nationalgalerie, East
Berlin; Mme Fantin, cat. no. 95; Musée
Royal des Beaux-Arts, Antwerp) and
The Two Sisters (*Les deux soeurs*; Mme
Fantin, cat. no. 97, formerly collection
J. Tempelaere, Paris).

Fantin had met Scholderer in 1857,
shortly after the latter's arrival in Paris
to study art. Scholderer's interest in
contemporary French painting, his
knowledge of music, and his love of dis-
cussing both, made him attractive to the
circle of friends Fantin had formed
while studying with Lecoq de Boisbau-
dran – including Guillaume Régamey
(1837–1875), Marc Solon (1835–1913),
Léon Ottin (active 1855–1882), the
painter Louis Sinet, the journalist Fer-
let, and particularly Alphonse Legros

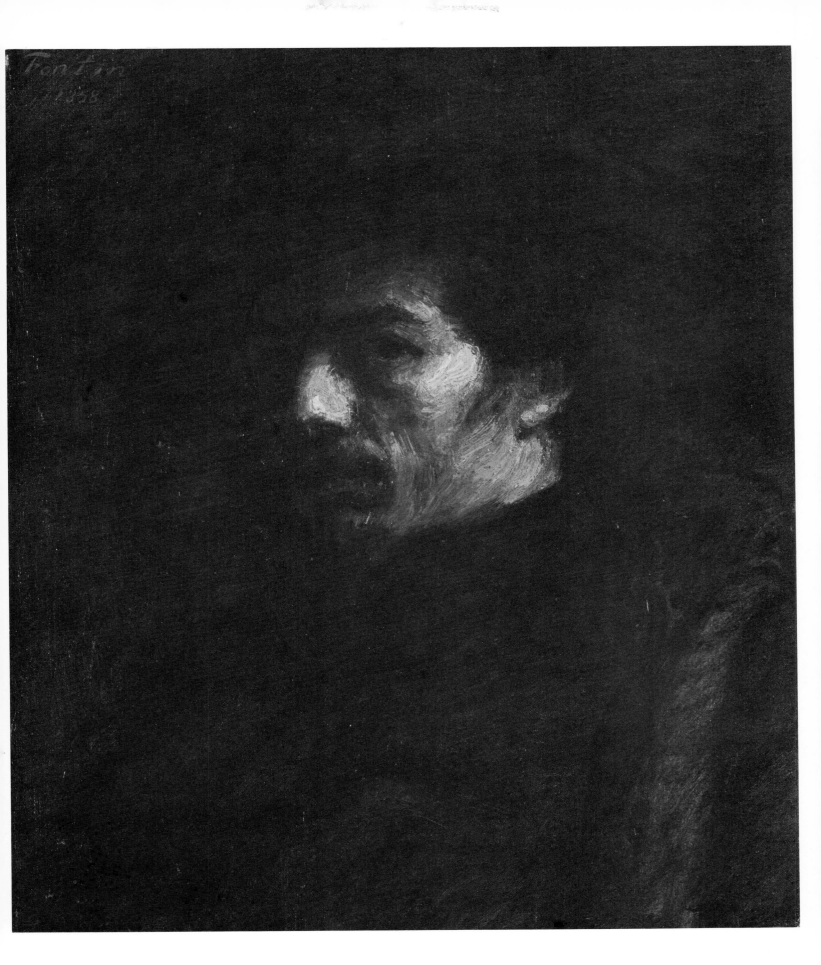

IGNACE HENRI JEAN THÉODORE FANTIN-LATOUR

(1837–1911). Fantin found in his German friend a kindred spirit, an artist who shared his ideas and aspirations; and while he was to drift away from the companions of his youth, he and Scholderer remained close friends until the latter's death in 1902.

After Scholderer left Paris in the spring of 1858 to return to Frankfurt, the two friends corresponded frequently. Bénédite (1903, p. 380; 1906, p. 156 and p. 20) and Jullien (pp. 18, 84–35) tell the story – undoubtedly related by Fantin – that Scholderer wished to have a number of French frames sent to Frankfurt, but realizing that empty frames were taxed more heavily than framed works of art, he asked Fantin to fill each one with an old picture or "any canvas at all covered with daubing" (Bénédite, 1903, p. 380). The four portraits which Fantin sent are said to reflect his compliance with this request.

While there is undoubtedly some truth in this story, it certainly is misleading to claim that the portraits "were brushed in with playful abandon by Fantin simply to fill up some frames" (Jullien, *Fantin-Latour*, p. 85). In both scale and intention, the paintings represented Fantin's most ambitious original works to date. They are benchmarks in Fantin's development as an artist and reflect a confidence and sense of purpose which the twenty-two-year-old artist had only recently developed. On every level they embodied the artist's current thinking and interests. Important to their understanding in this regard is a full appreciation of the portrait of Alphonse Legros.

By 1858 the feeling of shared purpose which had characterized the group studying with Lecoq was beginning to disintegrate. With the arrival of Scholderer, new alliances had been formed, based on ideas regarding the nature and direction of painting. Writing to Fantin from Bèze, near Dijon, in February 1858 (before Scholderer's departure), Legros noted confidently: "I am more and more convinced that we are *right*" (Bibliothèque d'Art et d'Archéologie, Paris, MS.). The "we" whom Legros designated as sharing "true ideas" included Scholderer, Fantin, Legros, and – conditionally – Guillaume Régamey. Of this group, which distinguished itself from "all the nonsensical things said by the *others*," Legros felt closest to Fantin, whom he

regarded as his artistic alter ego. In the same letter he wrote: "I have nothing but the echo of the truth which tells me 'yes,' and I would like this echo to come from your lips. In spite of everything, I believe that it is you who answer 'Yes. That's it! You're right!' "

By the fall of 1858, about the time Fantin was painting the portrait of Legros, the disdain of the two friends for the "brutes" who did not share their ideas had brought dissension to those who had formerly worked so closely together. Indeed, Ferlet wrote to Legros's uncle, Ludovic Barrie, that "there have been a few clouds over our relationship this autumn." He went on to explain, somewhat ironically:

> The proverb, "All are not saints who go to church" applies to painters as well. It seems that a great many people had believed themselves entitled to the name of painter because they stuck some colour on canvases, but it was the right of Messers Sinet, Fantin, and Alphonse Legros alone to demonstrate what had to be done to merit this glorious title. In their enthusiasm, in their love of art, they had founded and inaugurated the *painting of the future*. They had set themselves apart, erected a scaffolding built of artistic theories while demolishing everything around them. They had even established – for their exclusive use – the *Société des vrais bons* (Society of the Truly Worthy). No sooner had these gentlemen set out on their explorations than they believed they had arrived: they imagined they had captured success; they paraded their future glories and from on high on the pedestal which they erected over the ruins of modern art, they watched the poor devils like ourselves, who had not had our share of their sunshine, floundering below. The only acceptable action from then on has been to prostrate oneself in silence before their superiority, and those who made the slightest objection have been crushed, annihilated under the weight of a *corrosive* and, I could even say, *objectionable* banter (Bibliotèque d'Art et d'Archéologie, Paris, 6 January 1859, MS.).

That within this society of three, the strongest bond was between Legros and Fantin is clear from subsequent events. Shortly after Fantin and Legros made the acquaintance of Whistler in October 1858 the *Société des vrais bons* was forgotten. Whistler proved more interesting than Sinet, and Fantin and Legros joined with the American artist

to form the *Société des trois*, a concrete manifestation of their feelings of artistic superiority and a pledge to one another of admiration and support.

Fantin's involvement in the *Société des trois* did not weaken his ties with Scholderer. Indeed, the four paintings which he sent to Frankfurt must be seen as both a pledge of friendship and a logical extension of their exchange of ideas in letters. In addition to the two self-portraits which depict the artist confidently at work with easel in hand, the *Portrait of Alphonse Legros* is a statement of artistic purpose and an expression of Fantin's convictions. For, believing that his portraits conferred a sort of immortality on his sitters (letter from Fantin to Edwards, November 1864, Private Collection), Fantin restricted himself, when doing noncommissioned portraits of fellow artists, to depicting those whom he felt shared his views on the "true" direction of contemporary art. Even with Legros and Whistler, friendship was predicated on artistic merit. Writing to both friends at the time of the Salon des Refusés, he stated: "I am happy to be a part of the *Société des trois*, but for me it is only a natural thing. You create better than anyone: I will not abandon you so long as you do things which please me" (University of Glasgow; Bernie Philip Bequest, BP II, L/42).

Thus the *Portrait of Alphonse Legros* is the first in the series of portraits of fellow artists which constituted Fantin's artistic manifesto over the following decade. These include the *Portrait of the English Painter Ridley* (1861; Mme Fantin, cat. no. 168; formerly collection Twiss, Rotterdam); *Homage to Eugène Delacroix* (1864; Mme Fantin, cat. no. 227; Musée du Jeu de Paume, Paris); *The Toast: Homage to Truth* (1865; destroyed); *Portrait of Manet* (1867; Mme Fantin, cat. no. 296; Art Institute of Chicago); and *Atelier de Batignolles* (1870; Mme Fantin, cat. no. 409; Musée du Jeu de Paume, Paris).

If the subject matter of the Legros portrait is significant, so is the manner in which the sitter is depicted. While Legros had been in Bèze, Fantin had written to him of his admiration for Rembrandt and had discussed the expressiveness of the Dutch master's portraits (see letter from Legros to Fantin, Bèze, 12 March 1858, Bibliothèque d'Art et d'Archéologie, Paris, MS.). The dramatic chiaroscuro of the Legros portrait reveals the influence of Rembrandt and may be specifically related to the so-called *Portrait of a Young Man* in a large-brimmed hat (Paris, Louvre. Bredius,* cat. no. 292); it is this portrait

*A. Bredius, *Rembrandt: The Complete Edition of Paintings*, rev. by H. Gersen, 3rd ed. (New York: Phaidon, 1969).

which is also said to have greatly attracted Whistler and inspired his *Self Portrait (Whistler in the Big Hat)* (Freer Gallery of Art, Washington), done at approximately the same time as the Legros portrait (E.R. and J. Pennell, *The Life of James McNeill Whistler*, London, 1911, p. 52).

In handling too, the Legros portrait reflected Fantin's most recent concerns. Isolated in Frankfurt, Scholderer was discouraged by the problems which he was experiencing with his commissioned portraits. In particular, he was finding it difficult to work quickly and to achieve the effects of colour and luminosity which he sought. In the letters (now lost) of encouragement which Fantin wrote to Scholderer, he discussed his own ideas on colour and luminosity and stressed the necessity for working quickly. (These issues are touched on in letters from Scholderer to Fantin, Frankfurt, fall 1858, and 6 January, 1859, Private Collection.) The portraits sent to Frankfurt seem to have been created in accordance with these theories, which are undoubtedly those to which Ferlet had alluded.

Intrigued by Fantin's description of the portraits, Scholderer had awaited their arrival with impatience (letter to Fantin, Frankfurt, fall 1858, Private Collection). He was not disappointed. Yet, while he praised the drawing, colour, and luminosity of the self-portraits and *The Two Sisters*, it was, he wrote, the portrait of Legros which pleased him most: "there is a magnificent dark colouring. The flesh tones are very good. . . . The portrait bears a great resemblence as well and I do not understand how you could have done this in two hours" (Scholderer to Fantin, fall, 1858, Private Collection).

For Scholderer, the portraits were both object lesson and inspiration. In his first letter written after receiving them, he noted gratefully that they had arrived "just in time." Indeed, they remained a source of courage, for in his next letter to Fantin, he wrote: "your pictures remind me of you constantly: they . . . are very precious to me and help me not to lose my way and to stay on the right path" (fall, 1858).

Scholderer's high regard for Fantin's portraits was undoubtedly enhanced by the approval given them by the painter Scholderer most admired: Courbet. While in Paris the German artist had failed to meet the influential Realist, but in the letter acknowledging receipt of the paintings, Scholderer told Fantin that, ironically, he now had finally met and befriended Courbet who, having recently arrived in Frankfurt, occupied the studio directly above him. Scholderer enthusiastically told Fantin of

Courbet's reaction to the portraits: "He found them to be very beautiful and looked at them closely; he said that this was not painting for the bourgeois; he thought they were very luminous . . . the portrait of Alphonse pleased him particularly" (fall, 1858).

Courbet did, however, voice one reservation: on both this first viewing and on a subsequent visit when he again praised the works for their colour and luminosity, he expressed the wish to see something by Fantin that was "more finished." The reason for this request is found in Scholderer's own observations regarding the portrait of a woman (probably that of Mme Erlanger) which Courbet had just completed. Scholderer described it to his friend: "it is done with extraordinary delicacy, no brush marks can be seen; it consists of nothing but colour, and how well it is modelled and drawn" (fall, 1858). By contrast, the brushwork in the portrait of Legros reflects the rapidity and spontaneity of Fantin's working method. The dark areas are thinly laid in and subsequently articulated by drawing with a brush and a more concentrated black; contours are blurred so that figure and ground merge. On top of still-damp colours, Fantin deftly applied the lighter values in the face with a more heavily loaded brush, creating the modelling with strokes of rather abrupt value contrasts. In short, the work has the characteristics of an *ébauche*; that is, the spontaneously executed underpainting on a full-sized canvas which is conceived of as the basis for a more "finished" work to be developed in succeeding layers of paint. As such, Courbet could not judge it as a finished work of art.

It is true that the *Portrait of Alphonse Legros* and the other works sent to Scholderer were not executed with a view to exhibition or sale. Yet, for Fantin they were complete statements which point the way to the artist's subsequent development. While more "finished" than the portrait of Legros, the works Fantin did on commission, for sales in England, or for submission to the Salon during the following years, still stressed the qualities of immediacy and direct expression characteristic of the *ébauche*. For this reason, he sometimes lost commissions and received adverse criticism. Yet even when a sale depended on bringing a work to a more conventionally acceptable degree of finish, Fantin laboured "to finish it without losing the zest and charm of my *ébauche*" (letter to his parents, London, 28 July 1864, Private Collection). It was only about 1865 that the artist felt the need to make his portraits and still lifes more finished. In so doing, he relin-

quished something of the "mystery of the indefinite" (letter from Edwards to Fantin, Sunbury, 2 January 1865, Private Collection) which had characterized his earlier works, such as the *Portrait of Alphonse Legros*.

IGNACE HENRI JEAN THÉODORE
FANTIN-LATOUR

27

Portrait of Fantin 1861

Oil on canvas

37.8 x 33.6 cm

INSCRIPTION
Signed l.r., *Fantin.*

PROVENANCE
F. and J. Tempelaere, Paris, by 1906; Gal-
erie Heinemann, Munich; Georges Bern-
heim, Paris; San Marino Collection;
Sotheby's, London, 2 April 1974, cat. no. 5,
repr.; Eugene Thaw, New York. Acquired
August 1977.

EXHIBITION
May–June 1906, Paris, Palais de l'École
Nationale des Beaux-Arts, *Exposition de
l'œuvre de Fantin-Latour,* cat. no. 4.

BIBLIOGRAPHY
Mme Fantin-Latour, *Catalogue de l'œuvre
complet,* cat. no. 171.

LIKE THE *PORTRAIT OF ALPHONSE LEGROS*
(cat. no. 26), the *Portrait of Fantin* is a key
work in the understanding of Fantin's
development as an artist. If we compare
the two, it is evident that Fantin had
made significant progress in a relatively
short period of time. The luminosity,
subtle colour sense, fluid brushwork,
and sensitivity to consistency of paint
surface in the self-portrait demonstrate
a mastery of means not to be found in
the portrait of Alphonse Legros. There
is a difference in conception as well.
Portrait of Fantin belongs to the group of
self-portraits the artist produced from
1856 to 1862, when he was interested in
recording dramatic light effects in both
paintings and drawings. Yet the con-
temporary portraits of friends and
members of his family lack the mystery
and brooding intensity of these self-por-
traits which, by virtue of their psycho-
logical force, are unique within the
artist's portraiture.

By contrast, the later portraits,
although marvellously adept, are
drained of vitality; the sitters seem to
lack an inner life. This and the fact that
the artist quite suddenly stopped doing
self-portraits in 1862, the year of his first
important *projet d'imagination,* the
Tannhauser lithograph (Hédiard, 1906,
cat. no. 1), are intimately related. A
comprehension of the peculiar status of
the early self-portraits is therefore an
important factor in understanding

Fantin's seemingly contradictory artis-
tic nature, in explaining why, through-
out his life, Fantin alternated between
subjects based on reality, such as *Woman
Reading* (*La Lecture,* 1863; Mme Fantin,
cat. no. 215; Musée des Beaux-Arts de
Tournai, Belgium; 1863 Salon) and
imaginative subjects, such as *The Display
of Enchantment* (*La féerie,* 1863; Mme
Fantin, cat. no. 214; Montreal Museum
of Fine Arts; 1863 Salon des Refusées).

In 1855 Fantin had stated his artis-
tic credo in a diary kept by the group of
friends studying with Lecoq: "In . . .
modern art . . . nature around us is the
only subject matter for the Artist. . . .
One's era, the beautiful things in it, the
varied characters, the passions, the
beauty of nature, the countryside
around us . . . are of great interest. Both
the man of genius and the less-talented
artist can find something of interest in
the wide and varied range of nature's
wealth. We are . . . in a great age; we
are following the true way: nature"
(Album Cuisin, Louvre, Cabinet des
Dessins, Paris, p. 18. Entry dated 15
November 1855).

Despite the expansiveness of
Fantin's credo and its seeming echo of
Courbet's "Realist Manifesto" of the
same year, the artist's personal view of
nature and its role in his art was very
restricted. Unlike Courbet and his sup-
porters, Fantin felt that art should have
nothing to do with politics (letter to
Edwards, Paris, 24 October 1864, Pri-
vate Collection). Moreover, the idea
shared by Baudelaire and others that
the contemporary artist should provide
an interpretation of his own epoch,
should record *la vie moderne,* was equally
abhorrent to Fantin. He felt – and con-
sistently repeated in his correspondence
of the sixties – that art and contempo-
rary life were, and had to be, separate.
In the same year in which this self-por-
trait was painted, Fantin was writing to
his friend Edwards that, "as time passes
my conception of Art removes me from
the things of this life" (Paris, October
1861, Private Collection).

Fantin could not find a suitable
escape from *la vie moderne* in painting
landscape because, as he admitted to
Edwards, he had a "horror of
movement" (letter, Paris, 26 June 1865,
Private Collection). Rather for Fantin
working after nature meant doing still
lifes and portraits. In restricting himself
to these subjects, he could follow the
advice he gave to Whistler: "painting
after nature must be done at home"
(letter from Whistler to Fantin,
September–October 1862, Library of
Congress, Washington). Only in the
studio could he work with that
"inflexibility" and "sincerity" which he
felt that studies after nature demanded

(letter to Whistler, 7 February 1863,
University of Glasgow, Bernie Philip
Bequest, B.P. II, 1/30).

The early self-portraits, of which
this particular work is an excellent
example, may have been inspired by
the Rembrandt self-portraits with
which Fantin was familiar. Yet there is
a great reserve, a watchful guardedness
in Fantin's images of himself which is
not to be found in the Rembrandt por-
traits. In this particular portrait, as in
others of the period, the fixed stare with
which the artist looks at himself in his
mirror, is disquieting; the viewer detects
a feeling of unrest and uncertainty.
Existing documents substantiate this
interpretation and make clear the
degree to which Fantin's self-portraits of
the late fifties and early sixties are rec-
ords of the artist's state of mind as well
as of his appearance. During the second
half of the fifties and throughout the six-
ties, Fantin was, for the most part,
unhappy with his personal life and
uncertain about his capabilities and his
future. A positive outlook was often
exaggerated and always brief. Thus,
after his rejection at the Salon of 1859,
the agressive self-confidence of the pre-
vious months (see cat. no. 26) yielded to
the basic insecurity which is revealed in
numerous letters. Fantin withdrew into
himself. A letter to Whistler reveals his
insularity and the meaning self-portrai-
ture had for him: "it has reached such a
point that I am cured of all banter, of
criticism. . . . I remain alone, I work for
myself . . . aloof from the world . . . Oh
nature, what a beautiful thing! I come
back from the Louvre, I eat and from 5
to 8 in the evening I sit before my mir-
ror and, face to face with nature, we tell
each other things worth a thousand
times more than anything the most
charming of women could say" (Fantin
to Whistler, Paris, June 1859, Univer-
sity of Glasgow, Bernie Philip Bequest,
BP, II, L/25).

Because of his egocentric nature,
Fantin was unable to have this same
intimate communion with others. Only
in certain portraits of his sisters – such
as *The Two Sisters* (1859; Mme Fantin,
cat. no. 114; City Art Museum, St
Louis) – is there a comparable tension
between the appearance of the sitter
and the intimation of an inner turbu-
lent life beneath the surface calm.
Afraid of the unknown, Fantin prefer-
red not to get too close to others; his sal-
vation was isolation and the familiar.
Late in life, Fantin justified his
approach to portraiture in a conversa-
tion with Camille Mauclair, who
quoted him as saying: "One paints peo-
ple as one does flowers in a vase, and
the artist is happy enough if he can
draw the outside as it is – but what

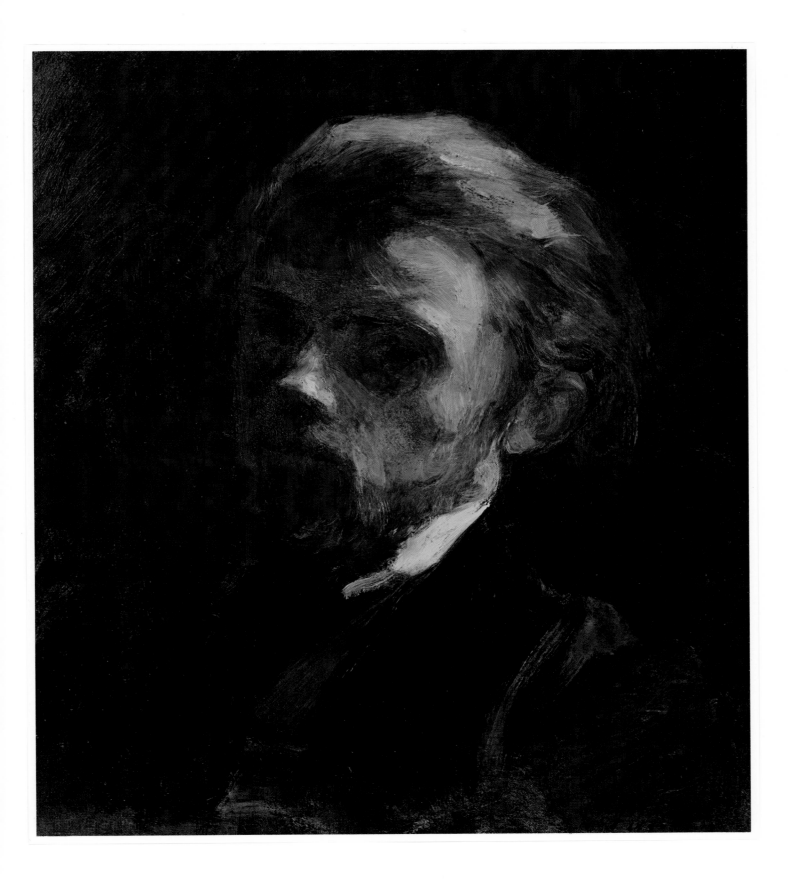

about the inside? . . . The soul is like music playing behind the veil of the flesh; it cannot be painted, but you can make it heard . . . at least try, show that it has been thought about" (*Servitude et Grandeur Littéraires*, 2nd ed. [Paris: Ollendorf, 1922], p. 158).

Combined with this feeling of the virtual impossibility of penetrating the sitter's façade was Fantin's belief that the true artist who works after nature loves "the exterior, the form, the colour, Art for Art's sake" (letter to Edwards, Paris, 27 November 1864, Private Collection). As a result of his concentration on what he believed to be the essentials of art, Fantin tended to place little importance on subject matter when working after nature. Criticized for not varying his still-life compositions, he replied: "I confess, I pay so little attention to what I am painting, in terms of the objects, that it is true; I always do very nearly the same thing" (letter to Edwards, 2 January 1867, Private Collection). That he approached portraiture in the same way is underlined in the correspondence surrounding his proposed idea of 1865 to do a large painting depicting a picnic on the lawn of Edward's house at Sunbury. Initial enthusiasm gave way to fear of the difficulties of *plein air* painting. When he finally abandoned the idea, Fantin explained to Edwards: "Think of the sun, the clouds, the changing weather; all this is too short-lived; it does not permit me to copy – which is more my style" (letter to Edwards, Paris, 23 July 1865, Private Collection).

That Fantin was content to "copy" his sitters and did not seek to lift "le rideau de chair" is very much in keeping with his personality. The outside world failed to move this basically self-centred man. Yet he was capable of intense emotions and these needed an outlet. It was in art, and specifically music, that Fantin glimpsed the inner life which eluded him in nature. As he told Mauclair: "As for me, it is in music that we may recognize ourselves" (*ibid.*, p. 157). The *Tannhauser* lithograph of 1862 represents the artist's first serious attempt to incorporate musical subject matter into his art. Henceforth he was able to make the neat separation between appearances and feelings, the outer and inner life, making now one his muse, now the other. It is not sur-

prising that at precisely this time, his interest in self-portraiture disappeared.

The portraits shown at the Salon from the mid-seventies onwards were most often described as sad, muted, mournful, sober, and Jansenist. Yet the mood reflected in the works was not that of the sitter's but rather Fantin's view of the world. Some of the more perceptive critics were aware that the artist was holding back. Thus Chesneau stated that Fantin's approach to the portraits revealed "the most extraordinary dominance of will over instinct," which he designated as the sensibility displayed in the *projets d'imagination* (E. Chesneau, "Le Salon de 1875," *Paris Journal*, 1875). But Fantin never changed. It is only in the early self-portraits that he consistently displayed himself as a sensitive portraitist in addition to being a sensitive painter. It is for this reason that the best of them rank among the finest of his works.

JEAN-LOUIS FORAIN

Reims 1852 -- Paris 1931

AS A YOUNG BOY, Forain decided to
become an artist. His uncle, a restorer
of sculpture at the Reims cathedral, was
his first teacher; then Jacquesson de la
Chevreuse (1839–1903), Jean-Baptiste
Carpeaux (cat. nos 74–77), and André
Gill (1840–1885) gave him instruction
in Paris. He studied briefly at the École
des Beaux-Arts with Gérôme (cat. nos
30–38, 83), but left there to work inde-
pendently at the Louvre and
Bibliothèque Nationale where he cop-
ied the Old Masters. Carpeaux advised
him to search the city streets for models.
Forain followed this counsel, and for the
rest of his life he was to find there sub-
jects for his sharp wit in his political and
social cartoons, etchings, and paintings.
He was friendly with numerous Impres-
sionist artists and painted in the styles of
Édouard Manet (1832–1883) and
Edgar Degas (1834–1917). Degas per-
suaded him to enter paintings in four
Impressionist shows. J.K. Huysmans
saw the 1879 exhibition, praised
Forain's work, and became his devoted
friend.

In 1882, Forain went to Italy to
study the Renaissance masters. In 1884
and 1885, he was accepted at the Salon.
His first one-man show was held at the
Galerie Boussod-Valadon in 1890, pre-
sided over by Théo Van Gogh.
Forain had taken up etching in 1873,
and began a career as an illustrator. He
gained recognition as an artist by draw-
ing satirical cartoons for numerous
Paris newspapers, among them *Le
Figaro*. When he asked, "Where is your
exhibition to be held?" Forain replied,
"In the kiosks!" He edited two of his
own journals: *Le Fifre*, a social comment
on Parisian bourgeoisie, and *Psst!*, an
antisemitic publication prompted by
the Dreyfus affair.

When war was declared in 1914,
Forain enlisted in the camouflage divi-
sion. *De la Marne au Rhin* was a de luxe
edition of some of his war cartoons that
appeared in the newspaper *L'Opinion*.

In 1924 he did twenty-four drawings
for *Le Figaro*. This same year marked
Forain's retirement as an illustrator for
the Parisian press. But, although his
drawings were the most publicized of
his works, Forain produced paintings
and etchings throughout his career, and
in the 1890s he made numerous litho-
graphs. His most repeated themes dealt
with the pastimes of the bourgeoisie (the
racetrack, dancers backstage, and
receptions). He was also fond of portrai-
ture, and of depicting court scenes remi-
niscent of those of Daumier, biblical
subjects, and artists at work in their ate-
liers.

EXHIBITIONS
Paris Impressionist Exhibitions of
1879–1881, 1886; Paris Salons of 1884,
1885.

AWARDS AND HONOURS
Chevalier of the *Légion d'Honneur*, 1893;
member, Académie Française, 1923; Presi-
dent of the Société Nationale des Beaux-
Arts, 1925–1931.

BIBLIOGRAPHY
Adolphe Brisson, *Nos Humoristes*, Paris:
Société d'Éditions artistiques, 1901. Camp-
bell Dodgson, *Forain: Draughtsman, Lithogra-
pher, Etcher*, N.Y.: M. Knoedler and Co.,
1936. Gustave Geffroy, *Forain*, in L'Art et
Les Artistes Series no. 21, Paris, 1921. Louis
Gillet, "Forain," *La Revue de Deux Mondes*,
Series no. 8, vol. 4 (1931), pp. 676–689.
Marcel Guérin, *J.L. Forain, Catalogue raisonné
de l'œuvre lithographique de l'artiste*, Paris: H.
Floury, 1910; Guérin, *J.L. Forain aquafortiste.
Catalogue raisonné de l'œuvre gravé de l'artiste*,
Paris: H. Floury, 1912. Arthur W. Heintzel-
man, *Jean-Louis Forain-Painter*, Springfield,
Mass.: Museum of Fine Arts, 1956. J.K.
Huysmans, *Certains*, Paris: Tresse and Stock,
1889. Charles Kunstler, *Forain*, Paris: Ried-
er, 1931. Jean LeFranc, "Forain, Serviteur
de Dieu," *Le Temps*, 13 January 1913, p. 3.
Jacqueline Magne, "Forain Témoin de son
Temps," *Gazette des Beaux-Arts*, vol. 81
(1973), pp. 241–251. Pol Neveux, "Jean-
Louis Forain," *La Revue de Paris*, vol. 4
(1931), pp. 773–796. Jean Puget, *La Vie
Extraordinaire de Forain*, Paris: Éditions
Émile-Paul, 1937. John C. Sloane Jr.,
"Religious Influences on the Art of Jean-
Louis Forain," *The Art Bulletin*, vol. 23 (Sep-
tember 1941), pp. 199–207. Léandre Vaillat,
En Ecoutant Forain, Paris: Flammarion, 1931.
Ch.-M. Widor, *Notice sur la Vie et les Travaux
de M. Jean-Louis Forain*, Paris: Firmin-Didot,
1931.

28

The Adulteress before 1908
(*La Femme adultère*)

Oil on canvas

60.3 x 73.1 cm

INSCRIPTION
Signed lower right, *forain.*

PROVENANCE
Collection Dr Funck-Brentano; H. Shickman Gallery, New York. Acquired November 1970.

EXHIBITIONS
February 1970, New York, H. Shickman Gallery, *The Neglected 19th Century*, repr. pl. 15.

RELATED WORKS
The Adulteress (La Femme adultère, 1910), drypoint (Guérin, 1912, cat. no. 122). *The Adulteress (La Femme adultère*, 1910), etching (Guérin, 1912, cat. no. 121).

BIBLIOGRAPHY
Kunstler, *Forain*, pl. 46.

THE ADULTERESS is an important example of Forain's religious work. It came as a surprise to many people that Forain, who hitherto had been considered a painter and illustrator of contemporary Parisian life, should change his subject matter so drastically in both his paintings and his prints. Many explanations have been offered for this appearance of new subject matter in the artist's work.

Interest in religion had always been part of Forain's life. He grew up in the shadow of Reims cathedral and loved its beauty. His first teacher, Jacquesson de la Chevreuse, was a devout Catholic, and took his young pupil to mass before breakfast in different churches in Paris every day of the week.

Although Forain had been a practising Catholic, he renewed his religious ties on Christmas Eve of 1900 when he came to Ligugé (near Poitiers) to take midnight communion with his old friend Huysmans. Huysmans advised Forain to place his art in the service of God and encouraged him along this path until his own death in 1907. In his essay "Religious Influences on the Art of Jean-Louis Forain" in the *Art Bulletin*, John C. Sloane suggests that Forain may have become committed to religious subject matter as a memorial to his friend Huysmans.

Another reason given by several authorities for Forain's turning to religious themes was his interest in the paintings and prints of Rembrandt (1606–1669). In emulating the technique of the master, he was also drawn to Rembrandt's biblical subjects.

It may be that Forain felt that his art could develop only so far in a naturalist vein. In exposing the seamy side of life, naturalist writers like Huysmans as well as painters like Forain felt that they had penetrated the depths of human experience as far as possible, and that another direction for expression had to be found. In 1884 Barbey d'Aurevilly applied the same comment to Huysmans' *A Rebours* as he had done to Baudelaire's *Fleurs de Mal*: "After such a book, it only remains for the author to choose between the mouth of a pistol and the foot of the Cross."

Finally, Forain's use of religious subject matter has been seen as a reaction to the social unrest of the Roman Catholic Church in France at that time. Because certain religious orders had defied the government in the Dreyfus Affair, they were penalized. Prime Minister Combes refused all authorization to religious orders in 1903. Many were exiled and church property confiscated. Relations with Rome were discontinued, and in 1905 Church and State were officially separated in France. Forain was always a champion of the persecuted, and, as Louis Gillet has suggested, it may be that the artist saw his mission as a defence of the oppressed, even if the oppressed was "le bon Dieu."

One very important feature of Forain's representation of biblical events is his frequent use of modern settings and contemporary clothing. In *The Adulteress* a contemporary mode is stressed by the bowler hat on the man on the right who is dragging his victim. This detail also appears in the second of Forain's two prints of the same subject, a drypoint (Guérin, 1912, cat. no. 122) done September 1910. Both this and the etching (Guérin, 1912, cat. no. 121), done in the same month, show the woman being dragged to the left in a reverse image of the painting *The Adulteress*. In all of these representations the feeling of a contemporary event is very strong and leads one to believe that Forain intended his message to be immediate and not a pious image of an event that took place two thousand years ago. He had seen the self-righteousness, greed, and vindictiveness of contemporary men and their miserable victims, and he used contemporary dress to emphasize the continuing moral problems.

Forain's originality in presenting the scene is not limited to its contemporary setting. Unlike other depictions of woman taken in adultery, his do not portray the confrontation of the woman with Christ or with her accusers but rather the prelude to the event. He shows the human pathos of the victim and the victimizers, who are themselves as guilty as she.

Forain's painting of *The Adulteress* is executed in browns, blacks, and whites used to create a dramatic chiaroscuro. The light concentrated on the woman in the foreground is echoed in the figure of Christ in the background. Both this and the directional emphasis created by the right arm of the adulteress serve to link spatially and psychologically the two major protagonists of this drama.

The Adulteress, like Forain's other religious work, relies on New Testament subject matter. His two main religious themes were events from the life of Christ and the series on Lourdes. Forain was not interested in Old Testament scenes or illustrations of the Bible: he concentrated mainly on the impact of the life of Christ on his followers, as in his many representations of the *Supper at Emmaus, Calvary, Pietà, Christ Carrying His Cross*, and the *Prodigal Son's Return*. In almost all of these representations, the contemporary setting or dress of the people underline the modern relevance of Forain's New Testament works.

A.C.F.

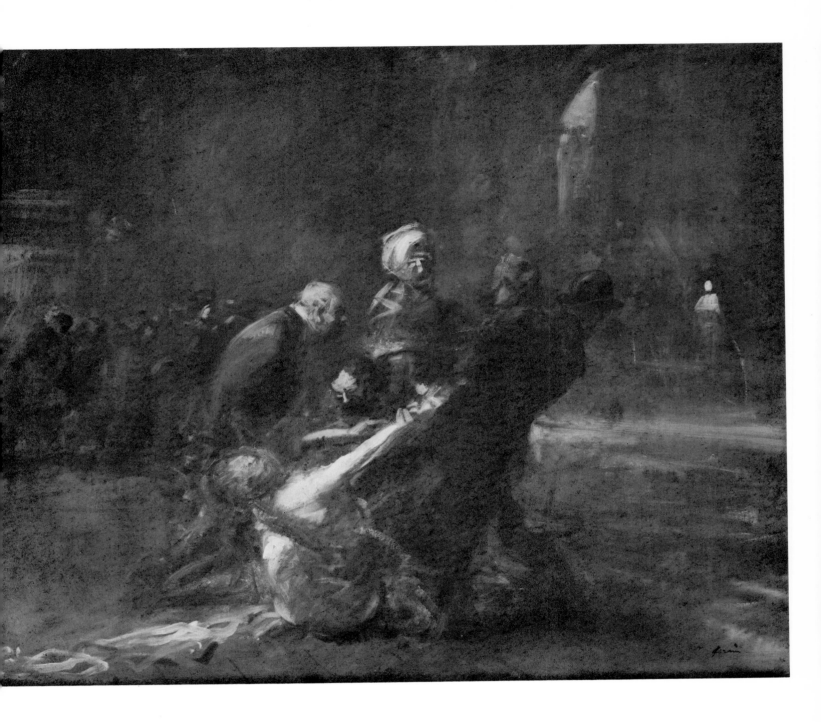

29

The Agitator c. 1897
(Scène de grève)

Oil on canvas

54.8 x 65.8 cm

PROVENANCE
David Hughes, England. Acquired September 1969.

BIBLIOGRAPHY
Guérin, *Forain lithographe* (1910), pp. 57–59.

RELATED WORKS
Three lithographs, each bearing the title *Scène de grève* (*c.* 1897) (Guérin, 1910, cat. nos 57, 58, 59).

THE AGITATOR reveals Forain's social consciousness and concern with the economic upheavals of his time. As an illustrator for papers like the *Courier Français*, *l'Écho de Paris*, the *Revue Illustrée*, and *Le Figaro*, he delineated the political events of his time, such as the Panama Canal scandal and the Dreyfus case in the 1890s.

Unlike many artists of his day, Forain did not turn away from contemporary political events or social agitation. From his own bohemian existence in his youth, he knew poverty first hand and sympathized with the victims of society: the industrial proletariat and the urban poor. At the same time he could not find any utopian solutions to these social problems and disavowed anarchist or socialist political goals.

Forain treated the theme of a man addressing a crowd in a factory setting in three lithographs; the second of these (Guérin, *Catalogue raisonné* [1910], cat. no. 58) was published in *The Studio* (vol. 11, 1897, opp. p. 199) under the title of *The Agitator*. The image presented in these lithographs is a mirror image of the painting, with the speaker on the mound appearing on the right-hand side of the composition. All three lithographs (Guérin, *Catalogue raisonné*, cat. nos 57–59) have the title of *Scène de Grève*, or scene of a strike, and Guérin mentioned that there was a painting on the same subject in *grisaille* (Collection of M.E. Lamberjack), which may refer to the Tanenbaum picture.

In this painting Forain divides our attention between the man addressing the crowd and the people in the crowd itself. These are not anonymous work-ers; Forain has taken care that the faces of those closest to the picture plane are clearly defined. The factory smokestacks in the background inform us that this is an industrial scene, with workers listening to an orator. This might almost be a scene from Émile Zola's *Germinal* (which deals in part with a miners' strike), since Forain gives as stark a picture of the industrial proletariat as do such naturalist writers as Huysmans, the brothers Goncourt, and Zola.

There is a contrast, both in the painting and the prints, between the poor workers and the bourgeois figure of the speaker on the raised mound, who is separated from the crowd both spatially and spiritually. He may be speaking about the workers' cause, but he is not really of it.

The colour scheme is muted, an almost unrelieved monochrome. The muddy brown tonalities appear to be an expressive device to underline the feeling of the painting. The factory workers live a colourless life in a grey town and are represented in earth colours, outlined in black and relieved only in a few places by white accents.

The Agitator relates to Forain's general œuvre in its concern for the victims of society. He treated the same theme in a different setting in his Law Courts series where the poor and uneducated are the prey of avaricious lawyers and unscrupulous judges.

Forain may well have been an eyewitness to a scene such as the one represented in *The Agitator*, since the last decades of the nineteenth century and first decades of the twentieth century saw strikes and unionization in the recently industrialized areas of France. Although the eight-hour day had already been won in America, workers in France were still campaigning for it in 1906, when a twelve-hour day was not unusual. The unrest culminated in the general strike of 1 May 1906 and in the great railroad strike of 1910.

A.C.F.

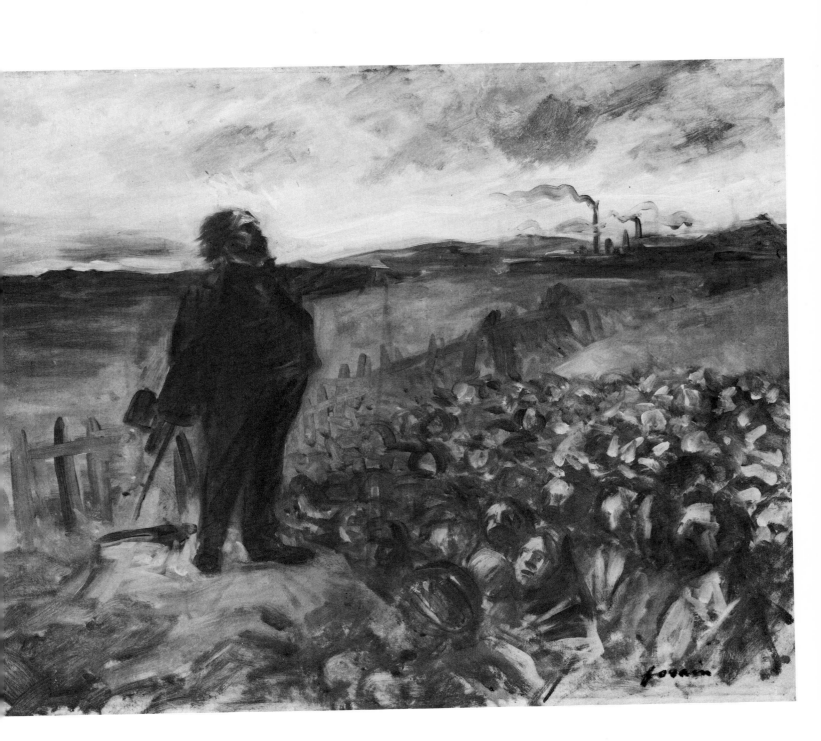

JEAN-LÉON GÉRÔME

Versoul (Haute-Saône) 1824 – Paris 1905

GÉRÔME WAS THE SON of a prosperous silversmith who sent him to Paris in 1839 to study painting in the studio of Paul Delaroche (1797–1856) with an allowance of one hundred francs a month. He quickly became a favourite of his master and travelled with him to Rome in 1843, after Delaroche had turned his studio over to the Swiss painter Charles Gleyre (1808–1874). After a year in Rome, Gérôme returned to Paris and to Gleyre's atelier to qualify for the *Prix de Rome*; however, although he entered the contest, he did not win it. The next year *The Cock Fight* (*Jeune grecs faisant battre des coqs*, 1847; Paris, Louvre) was hung in the 1847 Salon. It was mentioned with great enthusiasm by Théophile Gautier in a review of the Salon in *La Presse*, and overnight, at the age of twenty-three, Gérôme became famous.

About the same time he discovered his love for travel and visited Turkey and Egypt repeatedly, often on safari. Realistic ethnographic subjects by him appeared in the Salons alongside works in the frivolous Neo-Grec style in which he was preeminent. His subject matter dealing with the past gradually became more serious and realistic in concept. By 1865 his reputation was made (see Awards and Honours); he no longer needed state commissions (in any case his prices were too high for the State). He was appointed professor at the École des Beaux-Arts and conscientiously fulfilled his duties until he died. In over forty years of teaching, he had some two thousand students in his classes. By the seventies he would be included in anyone's list of the greatest painters of the day (along with Bouguereau [cat. nos 11–13] and Meissonier [cat. no. 49]). His reputation began to fade as Realism went out of fashion and almost vanished when the champions of the Impressionists made him a *bête noire* and presented him as the prototype of the academic painter.

In his sixties he started to exhibit sculpture at the Salon (see Sculpture, cat. no. 83). He outlived his style and was, as a Realist, somewhat of a reactionary in his old age, for which, until recently, few would forgive him. He continued to be active in artistic circles and politics, healthy and vigorous, until he died in his sleep at eighty in 1904.

EXHIBITIONS

Salons of 1847–1903, with the exception of those between 1870–1874. From 1878, exhibited sculpture in Salons, in addition to paintings. London, Royal Academy, 1870, 1871, and 1873.

AWARDS AND HONOURS

Third-Class Medal, Salon of 1847; Second-Class Medal, Salon of 1848; Second-Class Medal, Paris Universal Exhibition, 1855; Medal of Honour, Paris Universal Exhibitions, 1867, 1878, Medal of Honour, Salon of 1874. *Hors de concours*, Paris Universal Exhibition, 1889. Member of the Institut de France, 1865. Chevalier (1855), Officer (1867), Commander (1878), Grand Officer (1900) of the *Légion d'Honneur*. (For other Awards and Honours, see cat. no. 83, sculpture.)

BIBLIOGRAPHY

The Dayton Art Institute, Minneapolis Institute of Arts, The Walters Art Gallery, *Jean-Léon Gérôme (1824–1904)*, 1972–1973. Organized by Bruce H. Evans, introduction and commentaries by Gerald M. Ackerman, essay by Richard Ettinghausen. Jean-Léon Gérôme, *Œuvres*, 25 vols of mounted studio photographs, Cabinet des Estampes, Bibliothèque Nationale, Paris; Gérôme, "Catalogue of Paintings and Drawings Prior to 1883," MSS notebook, Cabinet des Estampes, Bibliothèque Nationale, Paris. Fanny Field Hering, *Gérôme: His Life and Works*, New York: Cassel, 1892. Paul Lenoir, *Le Fayoum, le Sinaï et Petra*, Paris, 1872. W.H. Low, "Gérôme," in John C. Van Dyke, *Modern French Masters*, New York, 1896. Frédéric Masson, "J.L. Gérôme. Notes et Fragments des Souvenirs du Maître," *Les Arts* (1904), pp. 17–32. Charles Moreau-Vauthier, *Gérôme, peintre et sculpteur, l'homme et l'artiste, d'après sa correspondance, ses notes, les souvenirs de ses élèves et de ses amis*, Paris: Hachette, 1906. Edward Strahan (pseud. Evert Shinn), *Gérôme: A Collection of One Hundred Photogravures*, New York: Goupil, 1881–1883, ten folios. C.H. Stranahan, *A History of French Painting*, New York: Scribners, 1897, pp. 308–319, 329 ff. Charles Timbal, "Gérôme, Étude biographique," *Gazette des Beaux-Arts*, vol. 14, 1876, pp. 218 ff and 334 ff.

G.M.A.

30

Portrait of a Lady 1853

Oil on canvas

127.4 x 87.3 cm

INSCRIPTION

Signed and dated middle l., *J.L. Gérôme/1853*.

PROVENANCE

Boussod-Valadon Gallery, Paris; J.N. Streep; Hammer Gallery, New York; Shickman Gallery, New York, by 1970. Acquired May 1972.

EXHIBITIONS

February 1970, New York, Shickman Gallery, *The Neglected 19th Century: An Exhibition of French Paintings*, cat. no. 21, repr. (as *Portrait of Mlle Duvergier*). 1972–1973, Dayton Art Institute, Ohio, *Gérôme*, cat. no. 3, pp. 32–33, repr. (as *Portrait of Mlle Duvergier*. (The identification of the lady as Mlle Duvergier does not seem to have any support.)

BIBLIOGRAPHY

Burlington Magazine, vol. 112 (1970), p. 645. Jerrold Lanes, "New York," *Art Forum* (April 1970), p. 79, repr.

BECAUSE OF THE DEMANDS of holding a pose, the young lady standing so primly is frozen into immobility, an immobility which the accurate and unwaveringly honest eye of Gérôme refuses to animate with any transitory expression or hint of movement. She looks, as if in shyness, away from us to one side. Her hands are clasped, relaxed, yet revealing impatience. Her skin is fair, her dress black, the background a somnolent dark green. The severity of the picture is enlivened only by the brightness of her yellow shawl and the pink roses in her hair.

Before he painted this portrait, Gérôme had been looking at the work of Ingres (1780–1867) who, as Gérôme's friend Charles Timbal (1821–1880) wrote, must have found it hard, when it came to portraiture, to convince himself that Gérôme was not one of his pupils. Those who know the beautiful portrait by Ingres, *Madame Moitessier* (1851; National Gallery, Washington, D.C.), will recognize at once the source of the lady's pose and Gérôme's inspiration. Several other of Gérôme's early portraits of women are also "after Ingres." One wonders if this is because he admired Ingres and consciously emulated him or if it was because his sitters demanded that they be painted in the fashionable manner of the more famous painter. Although Ingres was the master of the elegant portrait, he did not invent it; it came via Van Dyck (1599–1640) from Bronzino (1503–1572) and was used for portraiture by most young

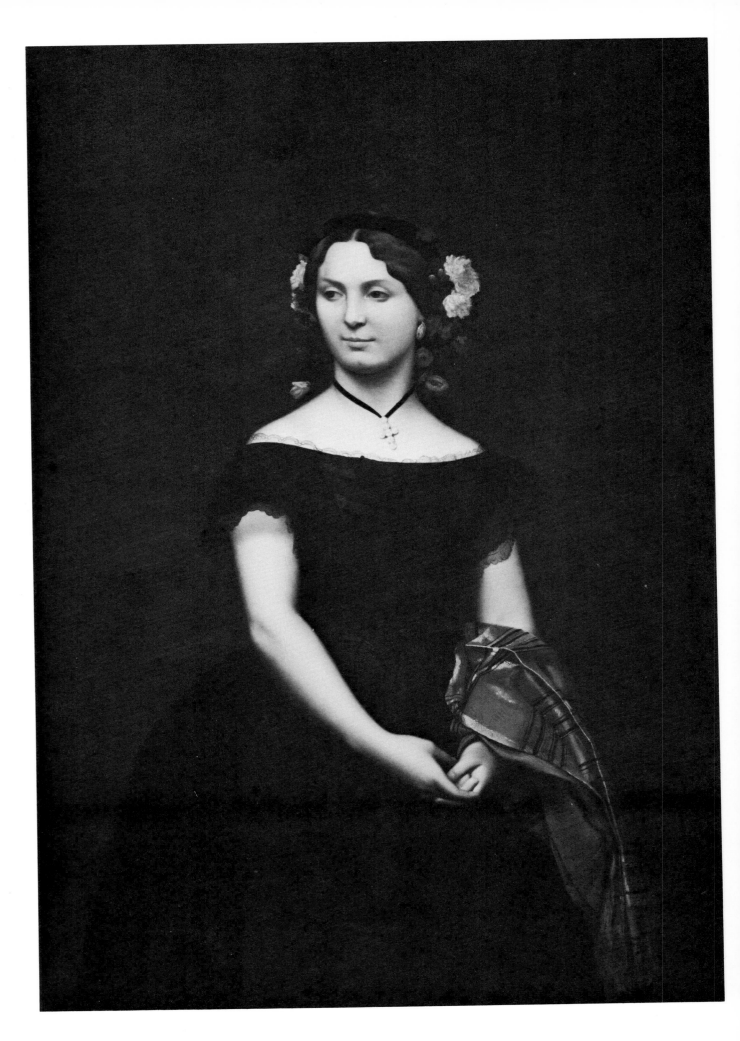

painters working in France in the 1840s and 1850s. In his later life Gérôme maintained a silence about these early portraits. He did not include photographs of them in his studio files; he did not have them listed by the author of the manuscript in the Bibliothèque Nationale; nor did he mention them to later biographers. They have simply turned up by themselves here and there in recent years. Perhaps he was embarrassed by their dependence upon Ingres, or perhaps he simply thought them unsuccessful. His friend Charles Moreau-Vauthier wrote of him:

> This genre which requires a complete submission [to the subject] was repugnant to [Gérôme's] natural vivacity. Gérôme knew how to be exact and observe closely, but he had to do so in complete liberty, so to speak, without the burden of feeling he was being dominated. And also keeping a person perfectly still for long hours – someone who was not a trained model, supple and obedient – reduced the sitter to a mannequin. These reasons are the explanation of why he did so few portraits, as well as his own opinion that he was not a portrait painter (*Gérôme*, pp. 154–155).

But if his other portraits were like this one or the equally beautiful young lady in the museum at Montauban, he need not have been ashamed. His inspiration may have come from Ingres, but he shows his independence by his intelligent criticism of Ingres' mannerisms.

Whereas Ingres has simplified all features in terms of geometry and roundness, Gérôme has worked towards structure and angular planes. Whereas Ingres is sensuous, provocative, Gérôme has stilled the fire and made the woman secretive; he has even moved her further back into the illusory "space" of the canvas. And whereas Ingres has ignored or mocked anatomy, Gérôme's arms and shoulders are marvels of correctness. All in all he has replaced the hot voluptuousness of Ingres with cool modesty.

Gauthier's enthusiastic review of *The Cock Fight*, exhibited in the 1847 Salon, gained for Gérôme many official and private commissions. The latter were probably mostly for portraits. For the next ten years or so, after the success of *The Cock Fight*, he painted occasional portraits for private individuals. Although only three have been found, about ten are known by title before 1865, and the known titles may represent only a part of his portrait production. Even so, Gérôme did not like painting portraits. Throughout his long, active life, he painted only about twenty-five that we know of. Those portraits of fashionable women seem all to date from his early years. The others, mostly of male friends, are sprinkled throughout his career, as if he had been moved by friendship rather than commissions to paint them.

A portrait of another unknown lady recently acquired by the National Gallery of Canada presents the sitter in a restrained pose, and the position of her hands and the expression on her face reveal the psychological complexity of her nature. The underlying tension, surprising in the work of Gérôme, reminds one more of the portraiture of Henri Lehmann (1814–1882), a student of Ingres.

31

Egyptian Recruits Crossing the Desert 1857
(*Recrues égyptiennes traversant le désert*)

Oil over graphite on panel

37.5 x 61.5 cm

INSCRIPTION
Signed l.l., *J.L. Gérôme.*

PROVENANCE
H. Early, Philadelphia, *c.* 1860–1862; Schweitzer Gallery, New York, by 1972. Acquired January 1973.

EXHIBITIONS
Salon of 1857. 1860, 1861, 1862, Pennsylvania Academy of Fine Art. 1972–1973, Dayton Art Institute, Ohio, *Gérôme*, cat. no. 6, repr. p. 38.

BIBLIOGRAPHY
Théophile Gautier, "Salon de 1857," *L'Artiste*, vol. I, 5 July 1857, p. 248. Strahan, photogravure reproduction. *Hering*, Gérôme p. 65. Gerald Ackerman, "Thomas Eakins and his Parisian Masters, Gérôme and Bonnat," *Gazette des Beaux-Arts*, vol. 72, 1969, repr. p. 234.

RELATED WORKS
Arnaut Officer (*Officier arnaute*, see cat. no. 32). *The Egyptian Recruiter*, location unknown but known from a photo in Gérôme, *Œuvres*, vol. VII, p. 3. The recruiter is seated on a donkey, and seen from profile, leads the recruits across the desert.

UNDER A STIPPLED SKY, throbbing with heat and thick with dust, a group of "recruits," young men conscripted from Egyptian villages trudge forward across the desert. They are handcuffed in pairs and march under the leadership and guard of several Arnauts, Albanian or Greek officers in the Turkish Army identifiable by their white, pleated skirts. The recruits may be conscripts into the army of the Khedive Said or a convoy of forced labour gathered to work on the Suez Canal. Marching groups of handcuffed conscripts had been a common sight in Egypt since the first Khedive, Mohammed-Ali, had begun to build up the Egyptian army in the 1820s. Gérôme must have seen such a group on his trip to Egypt in 1857; he was so impressed by this sight that he painted it twice. The other version, *The Egyptian Recruiter*, has not been found.

In his youth, Gérôme liked to paint in a bravura miniature technique, but here he simplified his manner to depict the atmosphere thick with heat and filled with the sand which the troup kicks up. Many of the soldiers or workers are lost in the glare to the left, and we feel that many others have already passed by; the sand before the men is well trampled.

The soldier to the left is painted in a

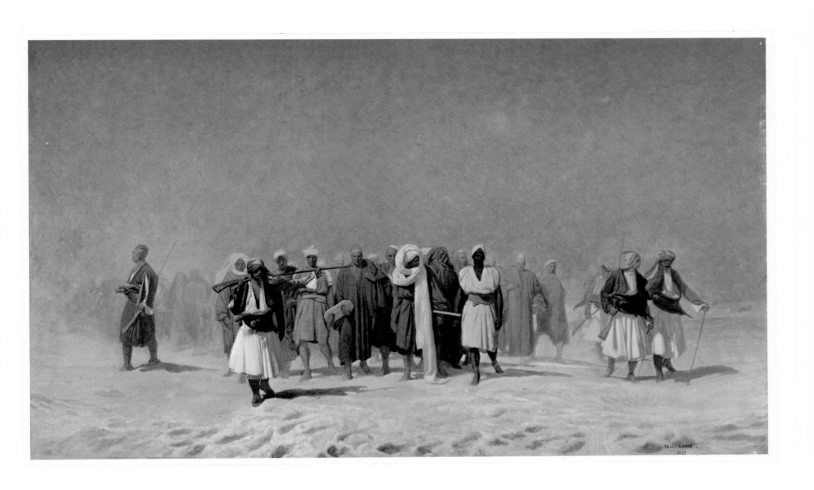

limited range of red-blue. Looking carefully, we can discern the blue outline of the basic drawing; it adds a glow to the profile. Throughout the picture the outlines of the underlying graphite drawing are visible – in the rocks of the foreground, around the shadows at the prisoners' feet, around their legs, and in detail after detail of their bodies and their clothing. A thin, steady, bold rather than sensitive line, it is perhaps a tracing. Because of the thinness of the paint, we can see how the painting surface was built up: first, Gérôme covered the panel with a light ground; then the sketches of the figures and their shadows were transferred or traced onto the ground. Next he carefully built up each figure – within the outlines – with just enough paint to make each body emerge from the glare. He used continuously softer touches from the high relief of the foremost Arnaut guard to faint touches on the figures in the background. Then, he gradually added the sand and the sky, working first with a large brush and then with a medium brush. Once the painting was dry, a final coat of thick paint was added to various areas of the sand and rock to enliven their surfaces and to deepen their shadows.

The work is a vision, an apparition, a nightmare of enslavement by fate. In his review of the Salon of 1859, Gautier remarked that Gérôme had denied himself the easy task of choosing emotional or dramatic scenes connected with the conscription; for instance, the invasion of the village, the separation of the men from their families, or their exhaustion. Instead, he chose a more complex moment, the acceptance by the men of their fate.

The Arnaut guards wear their traditional pleated skirts. Gérôme was fascinated by the pleated skirts; he liked their patterns of sharp lines and dark shadows, the graceful way they conformed to the movement of the body, and their manner of reflecting and absorbing light. Here the skirt is portrayed in vivid sunlight that blots out the creases of the pleats in the highlights and deepens the shadows of the folds.

Gérôme first went to Egypt in the winter of 1857–1858. He saw the exotic but hard life of the Egyptians with the objective eye of a realist and thus helped end the romantic interpretation of the Orient. Even Gautier did not

mind. In discussing this picture in *L'Artiste* he noted: "We are not of those who desire that art should have a purpose outside of itself; but, without being the least bit utilitarian, we think that painting is useful when – respecting the requirements of beauty – it acquaints us with the types, customs, aspects and usages of distant countries" (p. 247).

Ironically, Gérôme had made the trip with the money earned by painting a large allegory for the government (*The Age of Augustus, the Birth of Christ* [*Siècle d'Auguste: naissance de N.-S. Jésus-Christ*], Musée de Picardie, Amiens). He went with five companions, among them the playwright Émile Augier and the sculptor F.A. Bartholdi (1834–1904). They rented a boat and spent several months on the Nile, and at various stops they took excursions inland to look at antiquities and to hunt. Gérôme sketched and painted throughout the trip, and Bartholdi took photographs. Gérôme was more taken by the seemingly heroic life of the desert dwellers than by the archaeological sites. Thus he started the immense collection of sketches and photographs – to which he would add on several other trips to Egypt. They were his artistic capital, the source of the innumerable scenes of Egyptian life that he would paint for the next fifty years. Gérôme went one step further. He bought the costumes of the Egyptians he sketched, for instance, the outfit of the Arnaut. It remained in his studio and reappeared in work after work until the end of his life.

32

Arnaut Officer 1857
(*Officier arnaute*)
(Study for *Egyptian Recruits Crossing the Desert*, cat. no. 31)

Oil over graphite on panel

33 x 26.8 cm

INSCRIPTION
Inscribed on back by Félix Boutreux, *Donné par J.L. Gérôme/5 novembre 1894/ avec son buste par Carpeaux*; signed F. Boutreux.

PROVENANCE
In September 1894 Gérôme was arranging to have a bronze cast made of his portrait bust by Jean-Baptiste Carpeaux (cat. nos 74–77) for the Gallery of Professors at the École des Beaux-Arts (Paris, Archives Nationales, AJ52–451). Boutreux was an architect who was probably associated with the École des Beaux-Arts. His son Félix was a student and friend of Gérôme. From the Boutreux heirs the painting passed directly to the Galerie André Watteau, Paris; Galerie Tanagra, Paris; H. Shickman Gallery, New York. Acquired May 1974.

EXHIBITION
1974, Paris, Galerie Tanagra, *Gérôme*, cat. no. 33 (as *Guerrier Arabe*), repr.

RELATED WORKS
See cat. no. 31.

THE SMALL PAINTING, *Arnaut Officer*, is obviously a section from an earlier conception of *The Egyptian Recruits Crossing the Desert*. The figures on either side are the same as those in the larger work, and the Arnaut is the same, albiet larger. The similarity of the two figures shows how clearly Gérôme had his picture in mind before he started to paint. Once he knew what a figure in a composition would look like, he could paint it twice without variations, down to the smallest shadows. After finishing all the underpainting of the chief Arnaut, Gérôme decided to revise the composition, for he saw that it would be more effective if the officer were shown to look more as if he were sharing the fate of the captives, rather than being separated from them. Gérôme stopped work on this panel and started to work on the new version. The old, unfinished panel stayed in his studio until late in his life. It looks as if he cut away the unfinished figures to either side to focus attention on the central figure.

The sketch is interesting because of the boldness of the drawing, both in the Arnaut and in the subsidiary figures, and for the marvellous way in which the rather bold outlines are brought to life by the application of colour. Some of the shadows are underpaint, ready to add dark sustenance to an intended glaze above them. The sketch shows

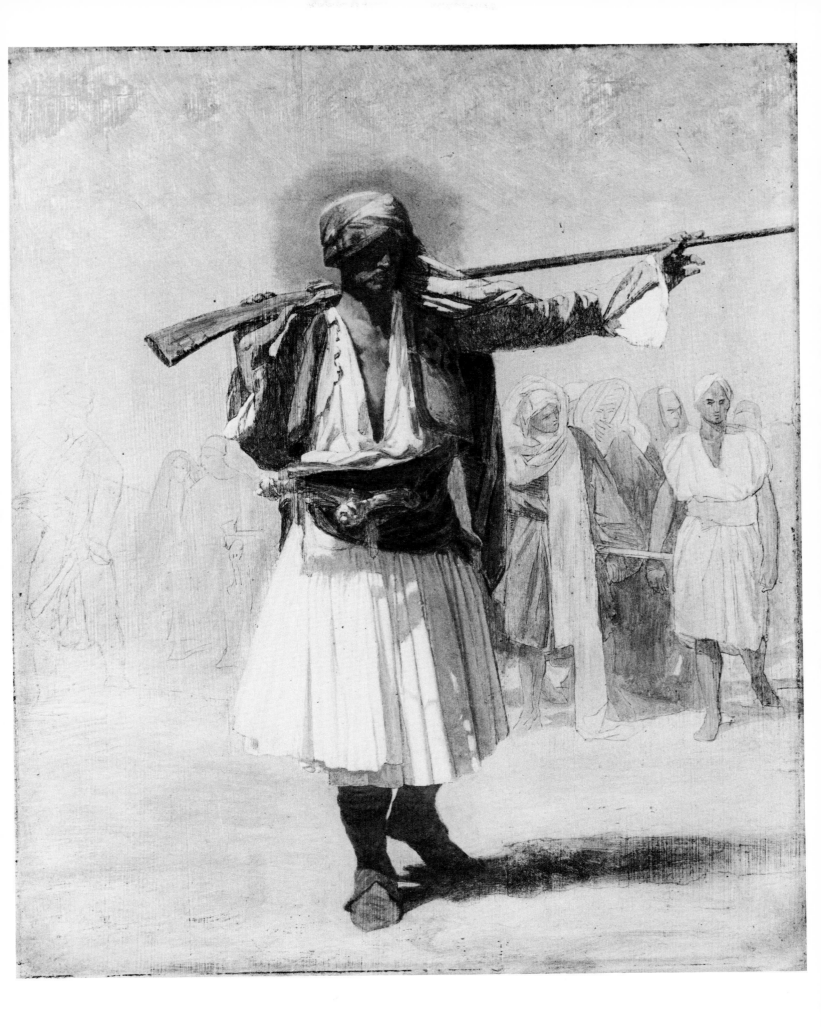

that although Academicians are expected to be good draughtsmen – and Gérôme was one of the strongest of his time – this Academician was an even stronger painter.

33

Portrait of Pho Xai 1861

Oil on canvas

27.5 x 22.5 cm

INSCRIPTION
Signed l.l., *J.L. Gérôme/1861*; and inscribed u.r., *Pho xai fils du 2eme ambassadeur. Siamois.*

PROVENANCE
Edwin D. Hewitt, Japan (on loan from Hewitt family and heirs, San Francisco, Palace of the Legion of Honor, 1864–1977); Sotheby Parke-Bernet, New York, 28 April 1977, no. 206 (as *A Siamese Prince*), repr. Acquired April 1977.

EXHIBITION
1972–1973, Dayton Art Institute, Ohio, *Gérôme*, p. 55, fig. 15–1.

BIBLIOGRAPHY
(Works cited hereafter refer to the 1865 Salon piece. See Related Works). Théophile Gautier, *Moniteur Universel*, 13 June 1865. Hering, *Gérôme: His Life and Works*, pp. 111–112 (her text includes a translation of Gautier's description). Moreau-Vauthier, *Gérôme, peintre et sculpteur*, p. 211. Prosper Mérimée, *Correspondance générale*, 2nd series, Paris: Le Divan, 1941–1965, vol. 4, pp. 311–313.

RELATED WORKS
Reception of the Siamese Ambassadors at Fontainebleu (*Réception des Ambassadeurs siamois à Fontainebleau*), Salon of 1865, Musée de Versailles. Portrait studies of other Siamese, both in pencil and oil, are known: 1977, Paris, Galerie de Bayser, *Jean-Léon Gérôme, exposition vente*, cat. nos 41–43. Two oil sketches are in the collection of Madame Georges Masson, Paris.

THIS SMALL BUT CHARMING SKETCH was done in preparation for a larger painting that includes over eighty portraits: *The Reception of the Siamese Ambassadors at Fontainebleau*. Perhaps with the aid of photographs, certainly with the aid of sketches from life, and probably with both, supplemented by a sitting with the young man himself, Gérôme has depicted the son of the Second Ambassador of Siam to France. His name is Pho Xai, and Gérôme has inscribed his name both in Latin letters and in a Thai script. When he was travelling in Egypt, he also inscribed the portraits he made of his Arab and Egyptian guides bilingually. Even in an unassuming work like this portrait, he seems to be working as an ethnographer looking for the salient features of another race. He was proud of the picture, for he signed it in block letters along with the date. Normally, he inscribed sketches in longhand.

The work is astounding for its combination of two major traits usually considered contradictory – freshness and austerity. Gérôme has painted the head and especially the garments deftly, thinly, and quickly. At the same time, almost from the viewpoint of an anthropologist, he has reduced the features of the young boy to what he hoped would represent a racially pure type. (It was probably his reputation as an accurate painter of exotic types that got him the commission.) The skull has been hardened and simplified to its most salient planes, and the counterpoint of soft flesh attached to the skull has been depicted with accuracy, the round cheeks and chin especially. Overall is the taut, impeccable skin. Gérôme observes and paints with chilling accuracy.

In the 1860s King Mongkut (the hero of *The King and I*) opened up Siam to trade with eager Western countries. In 1856 he concluded a treaty with France which called for the exchange of ambassadors. They arrived in France in the summer of 1861. A great reception had been planned at Fontainebleau, and Gérôme was commissioned to be the painter recording the event. He bargained for 20,000 francs, a high sum but one which he had recently received for a history picture, the *Phryné* in the Hamburg Kunsthalle, with admittedly, fewer figures. The high prices Gérôme was demanding were too expensive for official commissions, and this was his last. When he accepted it, he probably thought it was a good opportunity to get work hung in the Imperial collection and perhaps, too, he hoped that the commission would provide an *entrée* to the Court. He started the setting with great energy and joy. The room is a

marvel of observation, of architectural details, and of light effects on interior walls. As models he probably had in mind the cold and wonderful depictions of the Sistine Chapel which Ingres had painted in Rome at the beginning of the century and the great *Crowning of the Empress Josephine by Napoleon* (*Le Couronnement de l'Empereur et de l'Impératrice*) of Jacques-Louis David (1748–1825), now in the Louvre. This was the only painting by David which Gérôme had ever been heard to admire. But painting the eighty odd portraits for the new commission soon depleted his enthusiasm. The work dragged on and was not finished until 1865. By that time Gérôme was famous, rich, married, and a professor at the École des Beaux-Arts; he no longer needed official commissions.

The *Portrait of Pho Xai* is the best of the several known portrait sketches made for *The Reception of the Siamese Ambassadors*; some are oil, others are pencil sketches. Gérôme used the study rather literally for the head of Pho Xai in the finished work. (He is the fourth crouching figure from the left, not far from Gérôme's own self-portrait, the last person on the left in civilian clothes. Near Gérôme stands the short, stout Ernest Meisonnier, with just the beginning of what was later to become a wonderous beard.)

Prosper Mérimée, who was present at the ceremony, described it as colourful but dull and proper. He says that the only enlivening incident took place when the Empress picked up the young Pho Xai and hugged him.

ผไปไฝปไ

Pho xai fils du 1er
ambassadeur Siamois

J.L. GERÔME.
1861

JEAN-LÉON GÉRÔME

34

Turkish Butcher in Jerusalem 1863
(Boucher turc à Jérusalem)

Oil on panel

33 x 27.4 cm

INSCRIPTION
Signed u.r., *J.L. Gérôme.*

PROVENANCE
John Hoey, Jr, New York, *c.* 1867; William
B. Dinsmore sale, New York, 14–15 April
1892, no. 113 (as *The Butcher Boy*); H.
O'Neill, Sale J.F. French Collection and
Others, New York, 20 January 1921, no. 61
(as *The Butcher Boy*); Mrs. C.F. Darlington,
New York; Shepherd Gallery, New York.
Acquired March 1974.

EXHIBITIONS
Salon of 1863. 1865, New York, Goupil's.
Paris Universal Exhibition of 1867. Spring
1975, New York, Shepherd Gallery, *Ingres &
Delacroix through Degas and Puvis de Chavannes:
The Figure in French Art 1800–1870*, cat. no.
106, p. 255, repr. p. 256 (as *Turkish Butcher
Boy in Jerusalem*).

BIBLIOGRAPHY
Gérôme, *Œuvres reproduites en photographie*,
1860–1863, no. 14; Gérôme, *Œuvres*, vol. 19,
p. 8. *Magasin Pittoresque*, 1863, p. 305, repro-
duced in a wood engraving.

RELATED WORKS
Another butcher is pictured in the Gérôme
Œuvres, vol. 14, p. 4. This second version
depicts the butcher seated on the ground by
a tripod supporting a tray of calves' heads.
Several dogs stand attentively nearby. The
manuscript catalogue of Gérôme's works
prior to 1883 contains listings of at least four
similar titles. The first, *Egyptian Butcher*
(*Boucher égyptien*) is listed under 1858 and as
being at the Demidoff sale, Paris, May 1864.
A Turkish Butcher (*Boucher turc*) is listed for
1860 and 1861. The picture presented here
is clearly identified as *Boucher turc à Jérusalem*
and as having been exhibited at the Salon of
1863 and the Universal Exhibition of 1867;
it was given the dimensions 22 x 26 cm. I
assume that the author meant to write 32 x
26 cm. Several crossings-out in the manu-
script show that the author of the catalogue,
too, was confused by so many similar titles.
However, the provenance of this picture is
fairly certain, since it was so often described
or illustrated, and the dimensions in the var-
ious listings are approximate. Even when
repainting the same scene, Gérôme began
his compositions afresh, and he seldom
painted replicas.

IT IS LATE EVENING and a young boy,
presumably Turkish, stands in a narrow
street in Jerusalem selling the less entic-
ing parts of goats, calves, and sheep.
Heads of animals are scattered on the
ground before him and two are propped
up against the buttress of the wall –
which also supports him in his hashish-
induced trance. Entrails – lungs, proba-
bly – hang from two pegs in the wall
beside him.

The butcher himself is a marvellous
figure. He is firmly, delicately painted
but with a lightness withall. His pose is
relaxed. The arm held akimbo is an
accurate record of lean but strong mus-
culature. His expression – staring eyes,
mouth hanging open – makes one won-
der how he could conduct and conclude
a sale.

The picture is meticulous in detail,
but does not have the high finish it
would require were it a scene in bright
daylight, for it is late evening and the
sun has just set. The last reflection of
light, a faint flush of rose, diffuse and
gentle, comes from above and slightly
alters the surface of the upper part of
the wall. Thomas Eakins (1849–1916),
Gérôme's most famous American stu-
dent, quoted Gérôme as saying that, "in
a good picture you see what o'clock it is,
afternoon or morning, if it's hot or cold,
winter or summer" (Ackerman,
"Thomas Eakins and His Parisian
Masters," GBA, vol. 72, 1969). And even
a small picture of such modest dimen-
sions with a single figure had to be a
"good picture" when Gérôme painted
it, especially when it was a Salon pic-
ture.

Small paintings of single figures usu-
ally in ethnographic settings and
costumes, sometimes with or without
attributes, are the most numerous genre
in Gérôme's output. He painted them
constantly throughout his life. They evi-
dently sold well, and they were easy to
do in his studio. A good model, pictur-
esque costumes from his own collection,
and a background copied from a photo
or invented from memory, and the work
was set up. Yet the paintings entailed
carefully thought-out poses and compo-
sitions, as in this picture, where the
figure and the background are united in
light effects and colour. This work and
Arnaut Smoking (cat. no. 35) demonstrate
that paintings of single figures are
among Gérôme's best and most careful
works.

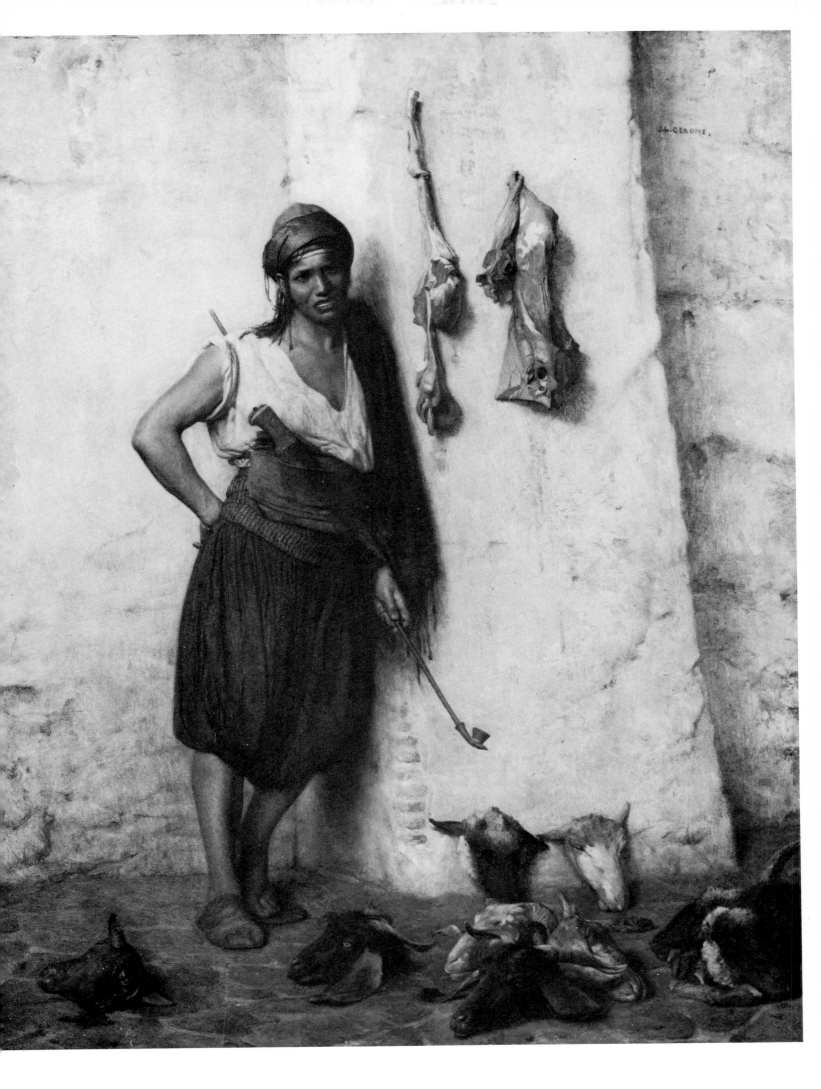

JEAN-LÉON GÉRÔME

35

Arnaut Smoking 1865
(*Arnaute fumant*)

Oil on panel

35.3 x 25.2 cm

INSCRIPTION
Signed on wall u.l., *J.L. Gérôme*.

PROVENANCE
Christie's, London, 19 January 1968, cat.
no. 85 (as *A Turk by a Window Smoking a
Hookah*); Charles Jerdein, London; James
Coats, New York. Acquired July 1968.

BIBLIOGRAPHY
Strahan, *Gérôme: A Collection of One Hundred
Photogravures*.

RELATED WORKS
The date of this work is given by Strahan.
The manuscript catalogue of Gérôme's
works prior to 1883 notes that there are two
versions: the title of the other is given as
Arnaut Smoking Hashish on a Divan (*Arnaute
fumant le kief sur un divan*, also referred to as
Smoking Arnaut (*Arnaute fumant*). Other
smokers are listed for 1881 and 1882. *An Ara-
bian Warrior Resting* (*Guerrier arabe se reposant*,
1877) has a hookah by his side. There are
many variations of this theme in the œuvre
of Gérôme.

FROM A DISTANCE this modestly-sized
picture seems like a darkened Terborch,
a master Gérôme was probably imitat-
ing. We see into a dimly lit room pro-
tected from the brightness of the North
African daylight by a complicated
wooden screen which covers three sides
of a balcony or dormer. A handsome,
large-boned Arnaut sits in the corner of
the window-seat and pauses during a
relaxing smoke. His legs are crossed
under him; one arm rests on a cush-
ioned ledge and the other on a knee.
The mood is contemplative, quiet, and
restful.

The indirect light coming into the
room is controlled in a manner only the
Dutch artists of the seventeenth century
and Gérôme could handle. The blind-
ing light from the sky and street outside
is shaded and filtered by the carving of
the wooden screen. The contrast
between the bright light of the outdoors
and the subdued light of the interior is
completely believable. The screen itself
is a marvel of calculation and patience.
The light that filters in falls blandly, as
reflected light does, over the body and
costume of the Arnaut, leaving not
highlights but areas of dull glare, pick-
ing out few details and letting the shad-
ows spread. The light from the screen is
strongest on the left arm – convincingly
firm and strong through its sleeve – and
on the skirt. In painting the skirt, Gé-
rôme does not literally transcribe every
pleat from waist to hem – he knows the
folds and creases are there, but he
represses his knowledge for the naïve
observation of the effects of the indirect
natural light. The filtered light glows
softly and gently across the surface of
the skirt. Highlights flatten out and
obscure the pleats beneath them, and
the shadows, too, glow in reflected tones.

In this picture Gérôme was setting
the style for his later rival in single-
figure paintings, Charles Bargue (cat.
nos 4, 5). Gérôme's work is cooler, less
obviously spectacular in details, and
more attentive to the light of the setting
than is Bargue's, whose figures seem
always to be painted in a pure atelier
light. Both excelled in understanding
the structure of their models.

The theme of smoking as recreation,
as rest from work and the troubles of the
world, seems to have been started ear-
lier in the century by Honoré Daumier
(1810–1879), who more or less secular-
ized what had once been a moral
theme: earlier, smoking had repre-
sented one of the five senses, usually
taste or smell, and it was a wordly dis-
traction from attention to spiritual
needs. Gérôme has completely reversed
the admonitary tone; he is full of admi-
ration for the Arnaut and for his way of
life.

JEAN-LÉON GÉRÔME

36

A Street Scene in Cairo 1870–1871
(*Une rue au Caire*)

Oil on canvas

59.7 x 93.8 cm

INSCRIPTION
Signed on lowest step, right, *J.L. Gérôme.*

PROVENANCE
Paul Horowitz, Great Neck, Long Island,
1945–1976; H. Shickman Gallery, New
York. Acquired October 1976.

EXHIBITIONS
London, Royal Academy, 1872. Paris,
Exposition des Merlitons, 1873.

BIBLIOGRAPHY
Strahan, *Gérôme: A Collection of One Hundred
Photogravures.* Gérôme, *Œuvres,* vol. 14, p. 2.
London Athenaeum, 1872, p. 437. Hering,
Gérôme: His Life and Works, p. 212.

RELATED WORKS
Several of the figure motifs in this picture
are treated separately in other pictures:
chess players, merchants and shoppers, don-
key boys with their beasts, etc. On the other
hand, Gérôme painted several other street
scenes without incidents and very few
figures. Another picture with the same title,
Une rue au Caire, n.d., is illustrated in *Le
Figaro Illustré,* for July 1901. It bears no
resemblance to this work.

THIS LIVELY SCENE depicts the inde-
pendent activities of some twenty-five
people and incorporates much of
Gérôme's repertoire of types from sin-
gle-figure paintings: donkey boys and
their beasts of burden, standing
Arnauts, beggars, and merchants. Gé-
rôme spreads out his treasures on the
street as a street peddler spreads his
wares out on a carpet. These are mostly
studio studies painted in the general
light of an atelier. To accommodate the
effect, Gérôme places them all in the
noncommital light of late day – a
diffuse, glowing light which falls with-
out shadows and does not penetrate into
the recesses of the open-front shops.

The wall of the buildings that line
the street are infinitely varied. Stone
and wood carvings show their age, and
it is evident that Gérôme has taken
delight in every detail.

The favourite Arnaut costume
appears again. In the *Egyptian Recruits*
the details of the skirt are blurred by the
brightness of the sun; in the *Arnaut
Smoking* the pleats were softened by a
weak, diffused light. Here, they are seen
simply without optical complications,
painted deftly and precisely. Gérôme
seems to have first painted the grey
shadows on a light ground and then
added the highlights between the shad-
ows in a light impasto. And he repeats
the skirt twice again – in the darkened
portico of a shop front where an Arnaut
plays checkers and in the shadow of a
partition against which a handsome
Arnaut leans. But the most striking skirt
is the one on the mounted soldier. The
comparison of Gérôme's various treat-
ments of the pleated skirt reveals the
attention he gave to what could have
become an automatic production. Yet
he refused to let himself lapse into prac-
tice or *maniera*; he insisted on looking at
the object again, and by looking at it in
a fresh, naïve manner, he continued to
observe and to record new effects.

This picture was probably painted
in London in 1870 or 1871 while Gér-
ôme waited for the end of the Franco-
Prussian War. When the invasion of
France had started, Gérôme moved his
family out of Paris to Bougival where he
had a summer home. He had left his
house and studio on the Boulevard de
Clichy in the care of his new young
friend, the Spanish painter Mariano
Fortuny y Garbo (1838–1874), whose
meteor-like career had just begun. Per-
haps he thought that the nationality of
Fortuny would protect him from both
the invaders and the local government.
Then, according to Hering, he took his
family to London, settled them, and
returned to France to aid in the defence
of Paris. It was too late; the city was
surrounded, and the seige was on. He

returned to London. He later wrote:
"When I arrived in London the year of
the war, with my wife and children, I
had neither brush, canvas, paint, nor
custumes. I soon made the necessary
acquisitions, and as I found some Ital-
ians near by, I hastened to profit by this
in employing them as models."

He was probably without any assets
other than his talent, so it was necessary
to start to work at once. He began to
exhibit on Pall Mall in a French gallery
run by a Mr Wallis, who had works of
many famous expatriate French paint-
ers to choose from. Gérôme produced
compositions which he could easily
improvise from models, properties, and
memories, without lengthy study. *A
Street Scene in Cairo* must have been one
of these works, more ambitious than the
many single figures he did in London.

JEAN-LÉON GÉRÔME

37

Thirst 1888
(*La soif*)

Oil on canvas

49.9 x 82.2 cm

INSCRIPTION
Signed l.r. corner, *J.L. Gérôme*.

PROVENANCE
Alexander III, Tsar of Russia; Arthur W.
Moritz, Chappaqua, New York; Sotheby
Parke-Bernet, New York, 16 January 1975,
cat. no. 142, repr; H. Shickman Gallery,
New York. Acquired May 1975.

EXHIBITIONS
Salon of 1888.

BIBLIOGRAPHY
Gérôme, *Œuvres*, vol. 5, p. 6. Hering, *Gérôme:
His Life and Works*, p. 264.

RELATED WORKS
Thirst: A Tigress and Her Young (*La soif: tigresse
et ses petits*, location unknown) depicts a
tigress standing on guard as her two cubs
drink from a stream in an oasis at the foot of
high cliffs. *The Lion in a Desert* (*Lion dans un
Désert*, Albright-Knox Gallery, Buffalo, New
York) depicts the animal drinking from a
stream. Neither work is as dramatic as this
piece.

THIRST is a composition of startling
drama. In a wide, dried-out river bed
under a blue sky that seems to quiver in
the oppressive heat, a lion crouches by a
shallow puddle and laps the water in
what Hering describes as "an ecstasy of
thirst." The king of the beasts is desper-
ate; he stoops to drink from a muddy
pool, but the concentration he gives to
his task preserves his dignity. Softly,
gently painted, remarkable in its
colouristic restraint, this is one of the
best of Gérôme's lion pictures.

Gérôme had been fascinated by ani-
mals from the beginning of his career.
His first success, *The Cock Fight*, had fea-
tured two gloriously painted fighting
cocks. He came back from his first trip
to North Africa with his portfolio filled
with drawings of camels and exotic
birds. He loved horses, and kept various
animals in his studio – at different times
he had a monkey, cats, dogs, parrots,
and even an old, tame, and toothless
lion. His primary love seems to have
been for lions. Gérôme's first name was
Léon, or Léo, and his last name was
almost the same as that of the early
Christian Saint Jérôme who is always
represented with a lion. Gérôme
painted this saint, sleeping in his cell
with his head propped up against the
belly of the pet beast who acted as a pil-
low. And for the high school that had
been named the Lycée Gérôme in his
home town, Vesoul, Gérôme painted a
picture of a large, recumbant lion, with
a device in one corner; the shield
showed a rampant lion with a palette in
one hand and above the device was the
motto, *Nominor Leo*. The picture still
hangs in a classroom of the Lycée.
Albert Boime has suggested that
Gérôme's affinity for the lion lies even
deeper, that it was a personal, totemistic
identification (Boime, *Art Quarterly*,
1971).

Boime points out as well that the
lions in Gérôme's pictures are almost
always alone – hunting, stalking, sun-
ning themselves. Gérôme must have
identified strongly with their independ-
ence.

Most of Gérôme's cat pictures were
painted in the 1880s and 1890s, proba-
bly for the same public that bought the
small bronzes of the *animaliers*. They evi-
dently sold well. Gérôme needed money
for the many expensive sculptural pro-
jects he had underway at the time.
Their compositions are usually carefully
thought out. This one, for instance, has
all the requirements for the accuracy
demanded by Gérôme's type of realism;
environment, a character, and a crisis
that causes interaction between the
environment and the character. With a
few exceptions, the cat pictures were
small in dimensions, meant for domestic

settings. However, *Thirst* turned out so
well that Gérôme sent it to the Salon.
He knew himself that it was one of his
most remarkable pictures.

38

*Prayer in the Mosque
of Quat Bey, Cairo* *c.* 1895
(La prière dans la mosquée de Caïd-Bey, Caire)

Oil on canvas

77.4 x 101.5 cm

INSCRIPTION
Signed l.l. on wall, *J.L. Gérôme.*

PROVENANCE
Nathan Mitchell, London; Pickhaver Gallery, London; Schweitzer Gallery, New York, July 1964; Associated Galleries, New York; Frederick Thom Gallery, Toronto. Acquired November 1968.

BIBLIOGRAPHY
Richard Ettinghaussen, "Jean-Léon Gérôme as a Painter of Near Eastern Life," in *Jean-Léon Gérôme*, p. 23, fig. 13.

RELATED WORKS
La prière dans la mosquée de Caïd-Bey, Caire shown at the Salon of 1895 is the same size and has the same background. However, it includes two figures, a father and a son in the area to the right. This version was sold at New York, Parke-Bernet sale, 28 January 1953, cat. no. 60, repr. There are countless other scenes of Muslims at prayer in various mosques in Egypt and Turkey in Gérôme's work, but these two are the most alike.

THIS SCENE in the Mosque of Quat Bey was painted by Gérôme in his early seventies. Although he was still in good health and an intrepid traveller, he had not visited Egypt or Cairo for some twenty years. On his last trip to North Africa in 1883, he caught dysentery which was to trouble him for a year afterwards. After that he limited his trips to European cities. Still he remembered and loved the East, and using his great stock of drawings, photographs, and memories, he continued to paint ethnographic scenes with a remarkably sharp memory of the qualities of North African light. *Thirst* (cat. no. 37) demonstrates his exact recollection of the combination of heat and sunlight on the desert, and *The Prayer in the Mosque of Quat Bey, Cairo* demonstrates his remembrance of the difficulty of seeing into the corners of large interiors when blinded by the direct sunlight.

The room may have been worked up from photographs. The mosque was built by the famous Sultan Quat Bey about 1470. The sanctuary depicted here is considered a masterpiece of arabesque ornament. The figures in the room are all in stock poses from Gérôme's notebooks. Although loosely painted, they are admirably placed, and Gérôme indicates their total absorption in prayer. But the triumph of the picture is the sunlight. It penetrates the room through several high windows, streaks across an upper wall, and leaves burning patches of light on the floor mats. The patch of light on the wall illumines the dust in the room, blinding us to the walls behind it, obscuring them with an optical blur. The effect is astounding: intuitively, we are aware of the far corners of the room just as we are aware of the walls of a dark barn when we step in out of the sunlight. The architecture and the figures could have been worked up by a studio assistant, but only Gérôme, with his years of observation and practice, could so accurately paint the sunlight bouncing off the wall and setting up reflections throughout the room.

The variations of grey within each of the foreshortened circles of the marble floor also show Gérôme's deftness in the handling of colour. They change from a grey relieved by much white lead at the left through a combination of tones in the middle to an unrelieved, textureless grey on the last circle to the right. The mixture of colours on the floor, like the mixtures of ochres and brown on the floor mats of the prayer area, is the result of consummate skill.

The version shown at the Salon of 1895 (see Related Works) was also noted as a virtuoso performance. The critic "Torpèdo" wrote in *Le Pays* (18 February 1895), "The painting of the mosque is a miracle! . . . The sun which passes through a window, irreverently brightens up this strange austerity like a burst of laughter." Even more astounding, this magical effect is an invention. Gérôme could not have seen such lighting in the Mosque of Quat Bey or even in a photograph of the interior, for its clerestory windows are covered with pierced plaster screens set with small pieces of coloured glass.

The looser handling of the picture is typical of Gérôme's painting in the 1890s. Possibly the ideas of Impressionism or the fact that he was growing older were beginning to change his style of painting.

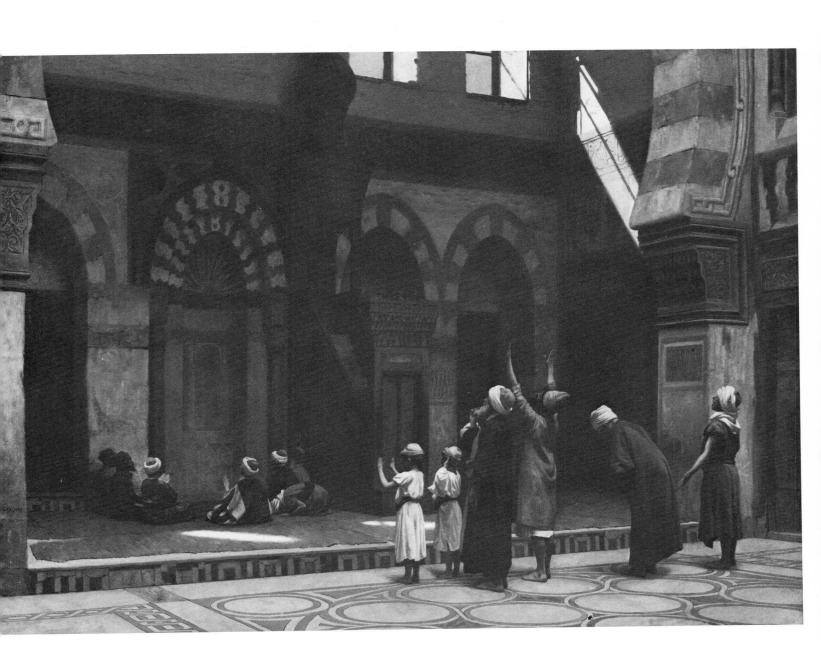

EDWARD JOHN GREGORY

Southampton 1850 – Marlow 1909

BOTH GREGORY'S FATHER and grandfather worked as engineers for the Peninsular and Oriental Company. As a matter of course, Gregory started as a draughtsman in the drawing office of the company at the age of fifteen. He also attended evening classes at the Southampton School of Art. In 1868, together with his old friend, Hubert von Herkomer (1849–1914), he attended a life class. The following year, Gregory left Southampton to enroll in the South Kensington School of Art; however, the endless copying from casts, and the tedious stippling technique which the students were required to use, must have frustrated him, because he remained there only six months. Apart from these two experiences and an equally short sojourn at the Royal Academy schools, Gregory was entirely self-taught. Nevertheless, he was often referred to as one of the best-read artists in London.

After leaving the art school he was able to get a job painting murals in the ceramic gallery of the South Kensington Museum (now the Victoria & Albert), and a year later, in 1871, he was employed as an illustrator on *The Graphic.* He contributed to this newspaper until 1875, and quickly established a reputation as a brilliant illustrator. One of his first assignments was to transcribe the sketches of the Franco-Prussian war which Sydney Hall (1842–1922) had sent back to London. He, himself, was also sent to Paris, and this was to be one of the many trips to the Continent which he made during his lifetime. Vincent Van Gogh (1853–1890) greatly admired Gregory's work for *The Graphic.* His letters to Anthon Van Rappard (1858–1892) contain several references to it, and particularly to *Paris, under the Red Flag,* in *The Graphic,* 22 April 1871, which is mentioned twice (see *Complete Letters of Vincent Van Gogh,* New York Graphic Society, 1958, vol. 3, R 15, R 20, R 23, R 24, and R 28). Gregory later specialized in shipboard scenes for *The Graphic,* and these are often novel and startling.

During these years he also became known as a fine watercolour artist. He was asked to become an associate of the Painters in Watercolour in 1871, and in 1898 he became president. He showed great aptitude for the duties of a president, and upheld the tradition of watercolour painting in England. Some of his best watercolours, which showed "dainty control over pure and lovely hues," were made on a protracted visit to Venice in 1882. The trip itself may have been inspired by Whistler's (1834–1903) Venetian work, which was shown at the Fine Art Society, London, in 1880 and 1881.

In 1875 Gregory sent his first work, a portrait, to the Royal Academy. All of his early exhibits at the Royal Academy were portraits, and it was a likeness of Miss Galloway (the daughter of his most important collector, Charles Galloway) that established his name at the Grosvenor Gallery in 1878. During the eighties he expanded the range of his subject painting with such works as *Piccadilly, Intruders,* and *Marooning* (Tate Gallery Collection). In later years, his most popular painting was *Boulter's Lock: Sunday Afternoon* (Lady Lever Art Gallery, Port Sunlight, Cheshire) which secured his election to the Royal Academy in 1898. It stands with the best of the colossal subject pictures as a document of the manners and customs of Victorian life.

Gregory was not a prolific artist. At the Galloway sale (Christie's, 24 June 1905), the 103 of his works which were sold were said to represent one third of his total output. Upon his election to the Royal Academy, he was chided for "a chaste tendency to idleness," but this lack of production seems to have been more the result of "his studious methods . . . through all stages of his picture-making" than of laziness.

Gregory was admired and liked by his fellow artists, including John Singer Sargent (1826–1925) and Paul Helleu (1859–1927). In a letter to Gregory, Sargent wrote: "Many thanks for *Boulter's Lock* which I am very glad to have. You send me two proofs [of reproductions] so I will give one to my friend Helleu who collects whatsoever he can of yours" (15 November 1898, Maas Gallery, London).

EXHIBITIONS
London, Royal Academy, from 1875 to 1909. London, Royal Institute of Painters in Watercolour, from 1871 to 1909.

AWARDS AND HONOURS
First- and Second-Class Medals, Paris Universal Exhibition, 1889. First-Class Medal, Munich Jahresausstellung, 1891. First-Class Medal, Brussels Universal Exhibition, 1897. President of the Royal Institute, London, 1898. First-Class Medal, Paris Universal Exhibition, 1900.

BIBLIOGRAPHY
A. Lys Baldry, "The Art of Edward John Gregory, R.A.," *The Studio,* vol. XLVII (November 1909), pp. 87–97. Edmond Duranty, "Les Écoles Étrangères de Peinture," *Gazette des Beaux-Arts,* vol. 18, 1878, p. 314. *Theme and Variations: "Boulter's Lock," by Edward Gregory,* London: J.S. Maas, 1970. Frederick Wedmore, "E.J. Gregory, A.R.A.," *Magazine of Art,* vol. 8 (1884), pp. 353–359.

A.G.

39

Dawn c. 1872–1876
Oil on canvas
122.5 x 101.5 cm

PROVENANCE
Purchased from the artist's studio sale by W.W. Sampson, Christie's, London, 31 January 1910; Julius H. Weitzner Gallery, London. Schweitzer Gallery, New York, 1969. Acquired April 1971.

BIBLIOGRAPHY
Gleeson White, *The Master Painters of Britain,* Edinburgh: T.C. and E.C. Jack, 1896, p. 12.

RELATED WORKS
A finished version, oil on canvas, 146 x 113 cm, Paris Universal Exhibition, 1878, purchased from J.S. Sargent's studio sale by W.W. Sampson, Christie's, London, 27 July 1925. Smaller version, oil on canvas, 27 x 23 cm, Royal Academy, London, 1910, formerly collection of Harold Hartley.

THIS IS AN UNFINISHED VERSION of the *Dawn* (fig. 3) which was in Sargent's collection. It may have been painted a few years earlier than the Sargent *Dawn,* which was painted in 1876. If this is so, then it is typical of the way in which Gregory worked. He was a fastidious but able technician, and often spent years making studies for one picture. An examination of the radiograph of the Tanenbaum picture revealed that several major changes had been made around the figures. (Dr Aileen Ribera has pointed out to me that the style of the woman's dress in the Tanenbaum picture appears to be one of the early seventies, whilst the style of the dress in the Sargent picture is definitely mid-seventies.)

The male figure in *Dawn* bears a close resemblance to contemporary photographs of Gregory. He was heavy set and appeared much older than he actually was. The female figure in the finished version may be the woman whom he married in 1876. The position of the figures in the two paintings has been reversed, which is typical of Gregory's working method. He was fascinated by the variety of positions that the human model could take up, and his working drawings often show the same figure sketched in many different poses.

When the Sargent *Dawn* was exhibited at the Paris Universal Exhibition, in 1878, Edmond Duranty wrote in *Gazette des Beaux-Arts:* "I find many old

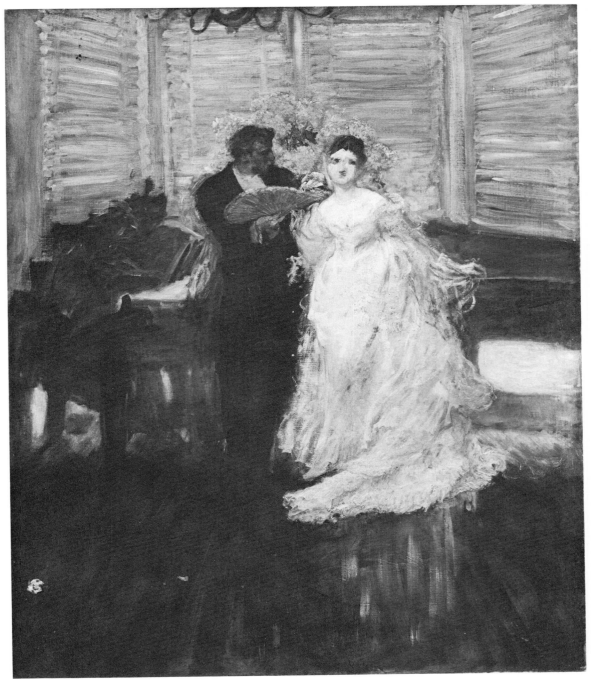

Fig. 3
Dawn
(formerly in the collection
of John Singer Sargent,
present location unknown)

attempts of Mr Whistler in the *Dawn* of Mr Gregory." Distinct Whistlerian influences can be seen in the white dress of the female figure, in the Japanese devices of the fan, and in the arrangement of the hydrangeas on the piano. The simplified composition and the diffuse grey light of dawn which Duranty thought revealed "a sense of light completely new and daring, with a subtlety of transitions and impressions" also point to Whistler. Gregory definitely would have seen Whistler's *The White Girl Symphony in White, No. 1* and *La Princesse du Pays de la Porcelaine* at the International Exhibition held at the South Kensington Museum in 1872.

The ambiguous intensity of the psychological relationship of the two figures in *Dawn* is endemic to English subject painting of the period. Millais's enigmatic *Autumn Leaves* and *The Vale of Rest* instigated these trends which were adopted by Whistler in the sixties, and can still be seen in the society portraits of William Orchardson (1832–1910) of the late seventies and the eighties.

A connection can be made between the society-concert picture *Too Early* by Tissot (cat. nos 65–69), which was shown at the Royal Academy in 1873, and Gregory's ball-concert, *Dawn.* Gregory almost certainly knew Tissot personally after 1876, when he moved to 6 Abercorn Place which was a few minutes away from Tissot's Grove End Road residence in St John's Wood, and he would have been familiar with Tissot's work at the Royal Academy. But Gregory was not necessarily influenced by Tissot's paintings of musical soirées. Soirées were often illustrated in *The Graphic* (see, for example, *High Life, Belgravia,* 26 October 1872). It is possible that the highly detailed black-and-white illustrations of the fashionable women who attended these functions influenced Tissot's style of the seventies.

Also, in comparison to the work of Tissot, *Dawn* had slightly more bohemian connotations. As Wedmore commented in the *Magazine of Art:*

> *Dawn* catches the flirtation of a night at its last and most critical moment. The scene, very likely, is some big villa in the Regent's Park; the immediate place is a large bow-windowed drawing room, in which through the drawn blinds the first light of the pale cold morning enters to struggle with the glare of the chandeliers. Tawdry curtains drape the recess. At the keyboard of a grand piano, the paid musician, detained too long from the humble bed that awaits him in his lodgings in Soho or Camden Town, half dozes as he plays, and it seems that nobody dances, for there are but two other figures, and these, standing by the curve of the piano, are now in their flirtations' most violent phase.

After *Dawn* was exhibited in 1878, Gregory's reputation as one of the most promising young artists in England was established, and the renown which it brought to him caused George Moore to remark that it is "the most fairly famous picture of our time" (*Modern Painting,* London: Walter Scott, 1893, p. 184).

JEAN-JACQUES HENNER

Bernwiller 1829 – Paris 1905

HENNER EXHIBITS IN HIS WORK an admixture of mystery and reality common to a number of painters from Alsace, including Brion, Doré (cat. nos 24, 25), Bastien-Lepage, Bartholdi, and expecially Carrière (cat. nos 15–18), who was very much affected by Henner's example. Their eccentric stylistic features, often difficult to pin-point, are no doubt related to the identity confusion stemming from this frontier region which had changed hands several times between France and Germany. Henner was torn over the ceding of Alsace-Lorraine to the German Empire after the Franco-Prussian war, and in response to his torment, he executed an allegorical personification of Alsace as an exiled woman in mourning with the French tricolour on her black robes. He signed it *Un alsacian de Bernwiller* and presented it to Léon Gambetta, who had been Minister of the Interior in the government of La Défense nationale, established after Napoleon III's surrender at Sedan in September 1870.

Henner was the sixth and last child of a family of farmers whose ancestors included a line of surgeons. At twelve, he attended the college of Altkirch, where he met Charles Goutzwiller (1810–1900), a drawing instructor who was to become Henner's closest friend. Goutzwiller recognized the youth's talent and made him practice with the drawing-instruction books of Bernard Julien (1802–1871); later, the older artist became attached to the Mayor of Colmar where he continued to use his influence on Henner's behalf.

In 1844 Henner went to Strasbourg to study with Gabriel Guérin (1790–1846), a former student of Jean-Baptiste Regnault (1754–1829) who ran the École gratuite de dessin. Guérin's admiration for Pierre-Paul Prud'hon (1758–1823) and Antonio Correggio (c. 1489–1534) stimulated Henner to follow in their direction. Guérin died in 1846, and the next year Henner went to Paris to enroll in the studio of an Alsatian compatriot, Martin Drölling (1786–1851). Drölling encouraged the young artist, and managed to get him a grant from the home-town region just before his death. Henner then went to the atelier of Picot (1786–1868), and in 1858 he won the *Prix de Rome* for his depiction of *Adam and Eve Finding the Body of Abel,* an entry that many critics

felt was one of the most original in the history of the competition.

Henner's trip to Italy proved eventful. There he discovered the vitalizing sources of Prud'hon, Leonardo, and Correggio, and study of these masters influenced him to paint in a *sfumato* technique. Throughout his career he, like them, was preoccupied with penumbral effects. At the height of his development, Henner used layers and layers of glazes to soften the effect of his nudes, and he ingeniously blended their bodily contours with the surrounding space by whisking over them with short brush strokes of a lighter tone than used in the main form.

Henner wanted to be both traditional and modern, and he looked upon Corot (1796–1875) as the contemporary equivalent of his favourite old masters. As he told a friend, "Corot is one of the greatest landscapists who ever lived. He dealt only with volumes, with values; he painted silhouettes; everything he did is ideal and has the touch of the masters; it is pure Virgil." It is no wonder that one of Henner's contemporaries called him "the Corot of the human figure." Unlike Corot, however, who almost always sought his effects at dawn, Henner painted his landscapes at dusk when the silhouetted tree masses take on a sombre, threatening aspect – a mood entirely opposed to the Barbizon master.

Henner's national confusion coincides with his aesthetic confusion; his work occupies a position between the academic and avant-garde movements of his day. He was on intimate terms with Gérôme (cat. nos 30-38, 83) and Moreau, Manet, and Degas, and while the Academy accorded him membership in 1889, his audacious brushwork and vivid colorations seem closer in spirit to the more advanced painting of his contemporaries. Yet, as one critic observed, "Certainly, the hour of Henner was not the hour of the Impressionists." Henner's nudes have a distinct quality due to the twilight effect, occasionally reminiscent of Giorgione (1475–1510), but their rendition was pervaded by a wholly modern psychology. Another critic noted that his painting possessed "a melancholy completely modern, a feeling particular to our time, which Giorgione does not possess." It is, finally, this plaintive character that allies him with people like Fantin (cat. nos 26, 27) and Carrière, who borrowed pointers from their older contemporary. Henner also shared with them a debt to Thomas Couture (cat. nos 20-22), from whose writings and visual example he extracted the use of the ruddy *ébauche,* the modelling in broad planes, and the

interest in twilight effects which Couture discusses in his *Méthode et entretiens d'atelier.* Thus Henner's eclecticism incarnated the "juste milieu" ideal of the Third Republic.

The artist remained a bachelor who professed puritannical ideals, but the female nudes of his crepuscular landscapes exhibit a smoldering eroticism. While he tried to emulate Prud'hon's unique combination of voluptuousness and chastity, his figures are far more self-conscious and uncomfortable in their Arcadian worlds. His portraits often depict pubescent girls with precocious eyes or older women with Mona Lisa smiles who would not seem out of place in an exhibition of *femmes fatales* by *fin-de-siècle* Symbolist painters.

Early in his life Henner claimed "bread above all," and he did not make a secret of his wish to make money with his art. His brilliant synthesis appealed to an international clientele, and once he established himself he more or less repeated his successful formula. His greatest popular triumph was *Fabiola,* exhibited at the Salon of 1885; the adolescent head veiled in a red cowl (resembling the *Mater Dolorosa* of Carlo Dolci [1616–1686]) was reproduced in the millions and endeared itself to persons of all classes. Ultimately, his formula became easy prey for the forger, and with the possible exception of Corot, he was more copied, imitated, and faked than any other nineteenth-century painter. It was claimed that the woods were "full of red-haired libels" – a comment on Henner's taste for auburn- and russet-coloured hair. He won almost every award available to artists in his day, climaxed by that of the Grand Officer of the *Légion d'Honneur* in 1903.

EXHIBITIONS
Salons of 1863, 1865, 1866, 1889, 1895, 1898. Paris Universal Exhibitions of 1878, 1900.

AWARDS AND HONOURS
Third-Class Medal, Salon of 1863. First-Class Medal, Paris Universal Exhibition, 1878. Member of the Institut de France, 1889. Medal of Honour, Salon of 1898. Chevalier (1873); Officer (1878); Commander (1898); Grand Officer (1903) of the *Légion d'Honneur.*

BIBLIOGRAPHY
Jules Clarétie, *Peintres et sculpteurs contemporains,* Paris: Librairie des bibliophiles, 1882–1884, second series, pp. 81–104. Louis Loviot, *J.J. Henner et son œuvre,* Paris: R. Engelman, 1912. Pierre Alexis Muenier, *La vie et l'art de Jean-Jacques Henner,* Paris: Librairie Ernest Flammarion, 1927.

A.B.

40

The Levite of Ephraim and His Dead Wife

c. 1898

(Le Lévite d'Ephraim et sa femme morte)

Oil on canvas

91 x 167.5 cm

INSCRIPTION
Signed l.l., *J.J. Henner.*

PROVENANCE
Charles Jerdein, London. Acquired March 1968.

BIBLIOGRAPHY
G. Haller, *Nos grands peintres,* Paris, 1899, pp. 205–208. P.-A. Meunier, *Jean-Jacques Henner,* p. 39, repr. p. 102.

RELATED WORKS
The Wife of the Levite of Ephraim, Salon of 1895. In the catalogue *Musée J.-J. Henner* (Paris) are mentioned: study for the *Levite of Ephraim,* 1896, cat. no. 338; two sketches for the same subject, 1896, 1897, cat. nos 339, 340; sketch for *The Levite of Ephraim and His Dead Wife,* cat. no. 341; and a prepatory sketch for the same subject, cat. no. 116.

THIS PAINTING which earned Henner a Medal of Honour at the Salon of 1898 is his masterpiece. Many of his other works are important, but none is so complex and spellbinding as this image of sexual violence and brooding revenge. A subject that preoccupied him off and on during the 1890s, *The Levite of Ephraim* is based on the tragic Old Testament narrative of rape, mutilation, and internecine warfare (see *Judges,* 19–21). A Levite from Mount Ephraim is deeply attached to his concubine from Bethlehem, who, however, is unfaithful to him. She flees to the house of her father, but is followed by the Levite in his attempt to persuade her to return. The father-in-law at length surrenders his daughter who sets out with the Levite and his servant for Mount Ephraim.

When night falls, they lodge at Gibeah, a town belonging to the tribe of Benjamin. Eventually, a kinsman from Mount Ephraim takes them in, but their sojourn is interrupted by a band of rowdy youths on a drunken spree. They demand to see the stranger, but the host, fearful for his kinsman, presents the concubine to them to appease their violent disposition. They rape her repeatedly in the night and release her just at dawn. She dies at the threshold

of the host's house where her husband finds her later that morning. In his subsequent rage, he dismembers her body into twelve parts and distributes each to one of the tribes of Israel. The tribes avenge their brother by rising against the Benjamites, but in the ensuing blood bath both sides pay dearly.

The biblical drama was popularized in France by Jean-Jacques Rousseau's prose poem, *Le Lévite d'Ephraim,* written in 1762 when Rousseau was forced into exile following the publication of *Émile.* He was passionately moved by a reading of the episode during a period of profound bitterness and despair, and wanted to recast it "à la manière de Gessner" – in the bucolic style of the *Idylles.* He translated his melancholy state into an evocative interpretation which makes the landscape an expressive complement of the human events. Rousseau noted in Book XI of his *Confessions* that the work had profound significance for him: "If the Levite of Ephraim is not the best of my works, it will always be the most cherished." The fame of Rousseau's work was extended into the nineteenth century by the painter Auguste Couder (1790–1873), whose *Levite of Ephraim* enjoyed a resounding success at the Salon of 1817.

There are a number of elements relating to both the original story and Rousseau's version that would have made the subject especially appealing to Henner. The lugubrious mood of the episode, so much of which takes place during the transitional moments between night and day, seems eminently appropriate to Henner's natural predilection for crepuscular effects and doleful themes. At the same time, the metaphorical allusions to national disunity and political dismemberment, as well as the savage and rapine character of the story, would have had great impact on an Alsatian who suffered deeply from the cleavage of France after the Franco-Prussian War. As he wrote in a letter to Goutzwiller in 1872: "When I think that, when I return to my country I love so much, that I must return as a stranger – it is horrible!" Here again, he would have identified with his namesake Jean-Jacques Rousseau, a Swiss who adopted Paris as his cultural base and spent a good portion of his life in exile. We may recall that Henner's allegory of *Alsace* depicted an exiled woman in grief, and somewhat akin to the Levite of Ephraim, he presented his image of dismemberment in outrage to Gambetta, who formed the new French government following the defeat of the French army at Sedan (2 September 1870). Ironically, the legend accompanying the allegory read, "She

waits": still hopeful immediately after 1870, Henner became increasingly bitter and pessimistic in the closing years of the century. This mental state must have been especially acute during the late 1890s, when the Dreyfus Affair threatened French society with the spectre of civil war. It was in January 1898, just a few months before the exhibition of the *Levite,* that Zola published his famous *J'accuse* and indicted the War Office of a judicial crime. The line between *Dreyfusards* and *anti-Dreyfusards* did not coincide with the basic political divisions in French society and tore apart old affiliations. For Henner, this Affair would have had the most painful implications: Dreyfus was an Alsatian Jew accused of spying for the Germans by the anti-Semitic head of the counterespionage unit who was also from Alsace. While there is no evidence that Henner shared the prevailing Alsatian anti-Semitism, it is certain that the Affair in the context of Alsace-Lorraine would have taxed his loyalties and greatly intensified his resentment.

Above all, Henner was obsessed with the motif of the supine nude corpse, both male and female, sometimes alone but often accompanied by a member of the opposite sex. This seems at first to be merely a formal extension of his interest in the nude female body recumbent in an idyllic twilight landscape. But even in these works the mood of reverie is set in a crepuscular atmosphere which often gives a menacing note to an otherwise serene backdrop. The bodies in these landscapes are enveloped in a voluptuous haze of warm lights, yet the marmoreal or ivory-look of the flesh, stark light and dark contrasts, and the solemn mass of the trees undermine what pretends to be an "arcadian" scene. Only occasionally does he openly expose his anxieties and sense of threat in the context of the live human, as in the astonishing *Andromeda* of 1883 where the terrors of the night are imminent. His very first success, *Adam and Eve Finding Abel's Body,* anticipates his late works by extending Abel's body the length of the horizontal plane. Even the grief-stricken Eve and the bearded Adam, who clutches his head in horror, have an affinity to the Levite of Ephraim in their compositional and thematic role. Not surprisingly, Henner was overjoyed at the prospect of doing the École project and wrote to Goutzwiller: "I could not have chosen a subject which suits me more. . . . My Abel lies in the foreground; Eve, on her knees, rushes towards him; Adam, on the contrary, seems rather to draw back. . . ."

Henner's fascination for the pictorial motif is seen also in the three old

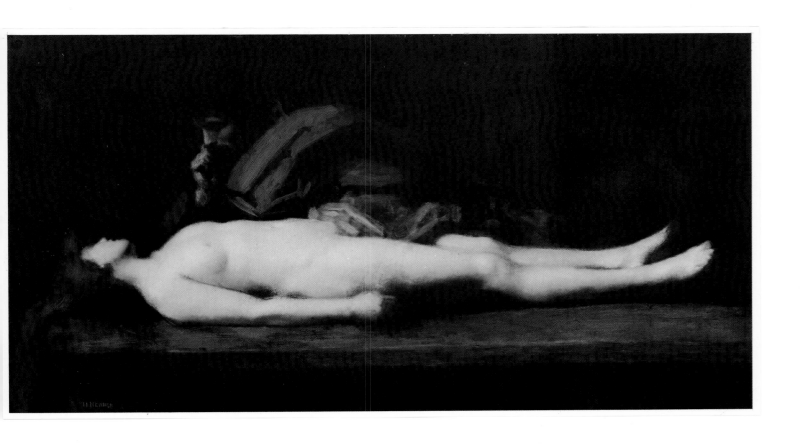

master works that had haunted him from childhood: Mathias Grünewald's (*c.* 1445–*c.* 1528) *Crucifixion* from the *Isenheim Altarpiece* which he saw regularly on his visits to the Musée Unterlinden at Colmar; Hans Holbein's (1497–1543) *Christ in the Tomb* in Basel (Öffentliche Kunstsammlung, a work related to the predella of the *Isenheim Altarpiece*) which Henner studied religiously; and Prud'hon's *Christ on the Cross* (a copy of which hung in the Metz Cathedral). From the Grünewald he gleaned the brilliantly lit body silhouetted against a ghostly landscape, from Prud'hon the pearly flesh and suffused contours, and from Holbein (1497–1543) the narrow, horizontal format. While the extended corpse of Christ has a long tradition and enters nineteenth-century French painting through Flandrin's (1809–1864) bizarre *Pieta* (Musée des Beaux-Arts, Lyons), it is especially Holbein's version that affected Henner's funereal series. This is demonstrated in Henner's life-size study, *Christ with the Shroud (Musée J.-J. Henner,* cat. no. 211), where the tortured head is almost identical to that of the Holbein.

Starting from the 1870s, Henner's series of dead heroes gradually displaces the pastoral nudes in importance and attest his growing moroseness in the aftermath of the Franco-Prussian War. What is only hinted at in the earlier period or is clad in sanctified academic trappings now assumes front rank. His *Dead Christ,* exhibited at the Salon of 1876, is virtually repeated in 1878, 1879, 1884, and 1896. In addition, he launched a series of related motifs in the dead drummer boy *Bara* (1882), *The Martyr* (1889), and *The Wife of the Levite of Ephraim* (1895), showing only the dead wife and which ultimately sparked the Tanenbaum version. Significantly, his last project was the *Death of Atala,* which remained unfinished at the time of his death in 1905.

No doubt his obsession with this image has to do in part with his having been exposed to the trauma of death at an early age: two of his five siblings died young, and one of his most memorable early works depicts his sister Madeleine on her deathbed, thus anticipating his later imagery. His fears may be expressed by the fact that his Christs bear a remarkable resemblance to himself, and one of his most eccentric paintings, the *Christ with Donors (Christ aux donateurs)* of 1903, shows the Christ on a winding sheet surrounded by members of Henner's own family.

In the end, Henner's involvement with the nude corpse borders on morbidity and suggests a kind of necrophiliac fascination. He was obsessed with painting flesh, and once in a discussion of his rivals' nudes, he remarked: "They don't know how to paint flesh! Look at Velasquez! Look at Titian! Each one paints differently, but both paint flesh! Velasquez's *Christ* is admirable – that's flesh! One would like to kiss his stomach!" Henner's female nudes and dead corpses attest to his love of the objectified flesh, chilled, marmoreal, and embalmed. In this, he relates to others of his generation including Moreau, Puvis de Chavannes, and Lefebvre, whose erotic sensibility was expressed through highly stylized bodies floating through the wastelands of an Arcadia *manqué.*

This painting gains its power from the fact that its theme and form blend with the artist's psychological sensibility and political pessimism. The Levite, sunk in bitter grief and torment like the Ugolino-like figure of Géricault's (1791–1824) *Raft of the Medusa,* yields an indelible image of those whom death leaves behind.

LOUIS GABRIEL EUGÈNE ISABEY

Paris 1803 – Montévrain (near Lagny, Seine-et-Marne) 1886

EUGÈNE ISABEY began his career as a painter at the urging of his father Jean-Baptiste Isabey (1767–1855). He learned the rudiments of his art from his father and his career was launched largely through Jean-Baptiste's influence as well as his own merit. Indeed, Jean-Baptiste was in a powerful position to help his son, for besides being a famous miniaturist, he was the portraitist for all the courts from the First Empire to the July Monarchy.

Eugène, however, soon struck out on his own, moving away from his father's influence and closer to Delacroix (1798–1863) and the Romantics.

At the age of eighteen Isabey accompanied the writer Charles Nodier (1780–1844) on his travels, and executed the unpretentious illustrations for Nodier's *Promenade de Dieppe aux Montagnes d'Écosse* (1821). His search for "the picturesque" took him on many trips through France, England, and Holland.

Isabey's easy-going personality, his great technical ability, and his eclectic tastes are evident in the fashionable subjects he painted. His work was a meeting-ground for the different tendencies in painting in the first half of the nineteenth century. In his prolific production there are traces of orientalism (showing the influence of an expedition to Algeria in 1830), a decided taste for landscape, imaginary scenes from history, and seascapes.

Faced with such variety, one may wonder about the true nature of this artist and whether, in his case, brio did not take the place of genius. However, despite his obvious craftsmanship, his best canvases express a very personal vision. One is tempted to describe him as a painter who makes the familiar seem fantastic.

EXHIBITIONS
Salons of 1824, 1827, 1831, 1833–1834, 1836, 1839, 1840, 1842–1845, 1847, 1850, 1859, 1865, 1867, 1869, 1878. Paris Universal Exhibitions, 1855, 1867, 1887. Paris, Galerie Georges Petit, 1887.

AWARDS AND HONOURS
First-Class Medal, Salons of 1824 and 1827. Chevalier (1832) and Officer (1852) of the *Légion d'Honneur*. First-Class Medal, Paris Universal Exhibition, 1855.

BIBLIOGRAPHY
Catalogue des tableaux, études, esquisses, aquarelles, et dessins par E. Isabey, Paris: Georges Petit, 1887. Fogg Art Museum, *Eugène Isabey: Painting, Watercolours, Drawings, Lithographs*, Cambridge, Mass., 1967. Louis de Fourchaud, "Eugène Isabey," *Society of French Water-Colourists*, vol. 2, Paris: Goupil, 1883, pp. 305–320. National Graphic Arts Salon, on the occasion of the centenary of the painter's birth, Paris, 1904. Le Pavillon des Arts and Musée de Dieppe, *Eugène Isabey, 1803–1886*, Paris and Dieppe, 1966.

P.B.

41

The Shipwreck 1856
(*Le Naufrage*)

Oil on canvas

94.5 x 142.5 cm

INSCRIPTION
Signed and dated l.l., *E. Isabey/1856.*

PROVENANCE
H. Shickman Gallery, New York. Acquired
May 1972.

EXHIBITIONS
October 1971, New York, H. Shickman Gallery, *The Neglected 19th Century: An Exhibition of French Paintings,* Part II, repr. (as *The Storm*).

THE SHIPWRECK belongs in the category of Isabey's "tragic" works. It is similar in technique and pictorial treatment of water and sky to *The Effect of Waves* (*L'Effet de vagues,* Louvre) and even more to *Low Tide* (*Marée basse,* 1861; State Archives, Musée du Havre). There is also a certain similarity of subject in these two paintings, but *The Shipwreck* is more dramatic. The composition derives its movement from the strong oblique lines of the masses of cloud, the ships' masts, the waves, and the distant hills.

In the foreground two groups introduce the action. Women and children, standing on a dike which is being lashed by the waves, are trying to rescue the shipwrecked fishermen from the sea. The despairing women beckon and call to those who are still clinging to the pieces of wreckage.

The raging elements, storms, and shipwrecks are all part of the panoply of Romanticism, and the commotion and confusion might be likened to a scene from Victor Hugo. Isabey was inspired to depict man's struggle against the sea in many of his compositions, some of which are considered among his best. These include *Town and Port of Dieppe* (*Ville et port de Dieppe*) with its brooding storm clouds (1842; Musée des Beaux-Arts, Nancy) and *Fire on the Steamer "Austria"* (*L'Incendie du Steamer "L'Austria"*), which creates an impression bordering on delirium (Musée des Beaux-Arts, Bordeaux).

Isabey had wanted to be a sailor and had become a painter only to please his father. His penchant for stormy seascapes was not exclusively a nineteenth-century phenomenon. While it is difficult to establish an exact line of descent of marine painters who were skillful at depicting storms, one cannot avoid referring to the Dutch landscapists of the seventeenth century, particularly Jacob Ruisdael (1625–1682). In France in the eighteenth century Joseph Vernet (1714–1789) appeared as an heir to both the Dutch as well as the Italian tradition in which Salvator Rosa (1615–1673) was preeminent. The Italian influence was felt primarily in the decorative elements of Isabey's work. At the end of the eighteenth century, Philippe J. de Loutherbourg (1740–1812), a follower of Vernet, introduced to England a taste for sublime subjects in landscape painting through the success of his *eidophusikon* or "spectacle of nature." It appears that it was in England with Turner (1775–1851), after having made various trips in the company of Delacroix (1798–1863) and Bonington (1801–1828), that Isabey came upon this source of inspiration. But once again one must be careful to avoid over-

simplification in determining the interplay of certain influences. Isabey's trips to Holland must have sparked compositions other than *Ladies and Gentlemen on the Shore at Scheveningen* (*Seigneurs sur la plage de Scheveningen,* Louvre). Moreover one cannot mention Bonington without recalling that his subjects have a curious similarity in their variety to those which Isabey painted time and again during his long career.

Théophile Gauthier, who unfailingly recognized the most original talents of his time, gave this appreciation of Isabey in his report on the Salon of 1857. "His depiction of nature is never flat; he heightens it with fantasy, caprice, and gusto. His way of applying colour is breathtakingly high-spirited, infectiously enthusiastic, and pungently bizarre: he scorches the canvas."

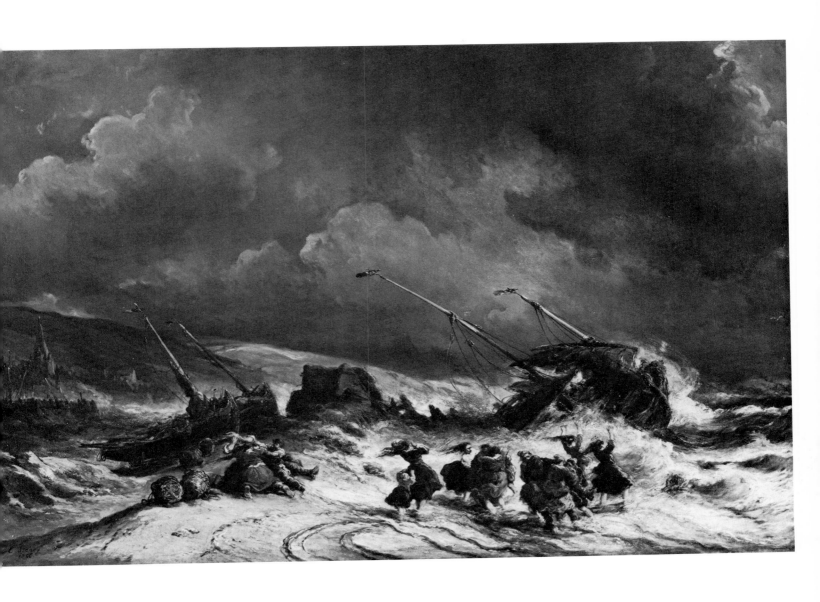

JOHAN BARTHOLD JONGKIND

*Latrop (The Netherlands) 1819 –
Grenoble 1891*

THE EIGHTH CHILD of a modestly-placed tax-inspector, Jongkind was eighteen when he entered the studio of Andreas Schelfhout (1787–1870) at the Hague School of Art. Eight years later, in 1845, his work there came to the attention of Eugène Isabey (cat. no. 41), the leading French landscape painter of the day. Isabey persuaded him that he should continue his studies in France, and he joined Isabey in Paris in 1846. His fellow students were, among others, Thomas Couture (cat. nos 20–22), Théodore Rousseau (1812–1867), and Adolphe Bouguereau (cat. nos 11–13). He continued to be interested exclusively in landscape painting, and in 1847 he travelled to Normandy and Britanny, a journey he repeated in 1850 and 1851 in Isabey's company.

In 1848, Jongkind exhibited for the first time at the Salon, but his work received no recognition. It was not until 1852, when he exhibited for the third time, that he finally obtained a third-class medal. In 1851 and 1853 two of his paintings were purchased by the State from the Salons of those years, but this was to be the last mark of official favour he received. By 1855, disappointed by the lack of further recognition, and already showing signs of mental instability, Jongkind returned to The Netherlands. He was to remain there for five years, during which time he continued to send paintings regularly to Paris, where they sold reasonably well.

Jongkind returned to Paris in 1860, where he met the young Claude Monet (1840–1926). Together, they travelled and painted, accompanied by Eugène Boudin (1824–1898). In 1863 Jongkind's work was turned down by the jury of the Salon, and as a result he decided to exhibit with Manet (1832–1883), Whistler (1834–1903), and others, at the notorious Salon des Refusés. From that date onward he continued to travel every year until 1869, when he settled permanently in France, dividing his time between Paris and the Dauphiné province.

Despite the absence of official recognition, Jongkind had a growing number of admirers. Collectors were buying his work, particularly his Dutch landscapes and, by 1878, there were even forgeries of his paintings in circulation. His landscapes were much admired by such fellow-painters as Monet, who was to write many years later, "He was my real master; it was to him that I owe the final education of my eye." Many critics also had a great regard for him. Émile Zola thought him a supreme master, and Jules de Goncourt wrote, after having visited the Salon of 1882, "One thing strikes me at this Salon: It is Jongkind's influence. All landscape painting of any value at this moment derives from him."

Jongkind retired after 1881 to Côte Saint-André, near Grenoble, but his health began to decline rapidly. For a time, he was still clear-minded enough to paint well – his style had scarcely changed in thirty years – and to enjoy the news of his success in Paris. By 1891, however, he had become hopelessly ill, and was removed to an asylum for the insane where he died within the same year.

Jongkind's position in the history of art is not easy to determine. A hard-working man, he rarely, if ever, voiced an aesthetic opinion. Among landscape painters he idolized Corot, but his painting clearly owes something to his Dutch origins. Although Jongkind never thought of himself as an innovator, his work remains inextricably linked to the emergence of Impressionism. As early as 1863, well before the birth of the movement, the critic, Jules-Antoine Castagnary, singled out the painter's effects of light, and wrote, "With him, everything lies in *impression*." Yet, despite their profound originality, Jongkind's landscapes evade the Impressionist cast. They were all painted in the studio, from sketches, and some of his landscapes were completely imaginary compositions.

EXHIBITIONS
Paris Salons of 1848, 1850–1853, 1859, 1864–1870, 1872. Paris Universal Exhibition, 1855. Salon des Refusés, 1863.

AWARDS AND HONOURS
Third-Class Medal, Salon of 1852; Silver Medal, Lyons, 1858.

BIBLIOGRAPHY
Exhibition catalogues: *Jongkind en Dauphiné*, Musée de peinture et de sculpture, Grenoble, 1955; *Johan Barthold Jongkind*, E.J. van Wisselingh, Amsterdam, 1960; *Jongkind, 1819–1891*, Galerie Schmit, Paris, 1960; *Jongkind and the Pre-Impressionists: Painters of the École Saint-Siméon*, Sterling and Francine Clark Art Institute, Williamstown, 1976. Victorine Hefting, *Jongkind d'après sa correspondance*, Utrecht: Haentjens Dekker & Gumbert, 1969; Hefting, *Jongkind – sa vie, son œuvre, son époque*, Paris: Arts et métiers graphiques, 1975. Étienne Moreau-Nélaton, *Jongkind raconté par lui-même*, Paris: Grès, 1918. Paul Signac, *Jongkind*, Paris: Grès, 1927.

M.P.

42

Moonlight Scene 1866
Oil on canvas
33.1 x 47 cm

INSCRIPTION
Signed and dated l.r., *Jongkind 1866*.

PROVENANCE
H. Shickman Gallery, New York. Acquired August 1971.

EXHIBITIONS
February 1970, New York, H. Shickman Gallery, *The Neglected 19th Century: An Exhibition of French Paintings*, cat. no. 28, repr. (as *Moonlight Scene*).

JONGKIND'S FAME was established through paintings in which landscape was represented in a variety of subtle atmospheric conditions, and, above all, by the pictures the artist called "clairs de lune," those moody renditions of light effects by night. The first of these moonlight scenes appears to have been painted towards the end of 1852. Jongkind sent it to the dealer Peyralongue, who sold it very shortly afterwards. The success of this first effort encouraged the artist to continue, and several views of Paris, dated 1853, as well as a particularly dramatic example (Musée des Beaux-Arts at Reims), dated 1854, survive.

In his correspondence between 1856 and 1860 the artist makes frequent reference to moonlit landscapes (they represent canals at Rotterdam or the Meuse at, or near, Dordrecht), which were requested by his Parisian dealers Adolphe Beugniet and Pierre Firmin Martin. Jongkind was the first nineteenth-century painter to make use of the imaginative possibilities offered by nocturnal light effects, an idea undoubtedly inspired by the example of earlier, seventeenth-century Dutch painting, as practised by Aert van der Neer (1603–1677). By 1857, the moonlight pictures had attained considerable success, and critics were specifically associating Jongkind's name with this genre; thus we find Jean Rousseau deploring the artist's absence from the Salon of 1857 with the words, "There is no equal to Monsieur Jongkind's rendering of the views of Paris and moonlight effects." Even though, by this time, the artist was complaining to his dealer that he wished he did not have to continue with the theme, he nevertheless did so, in order both to please his public, and to court favourable reviews.

Jongkind's views are usually horizontal – only a few vertical examples are known. They are based on simple combinations of motifs: water, trees,

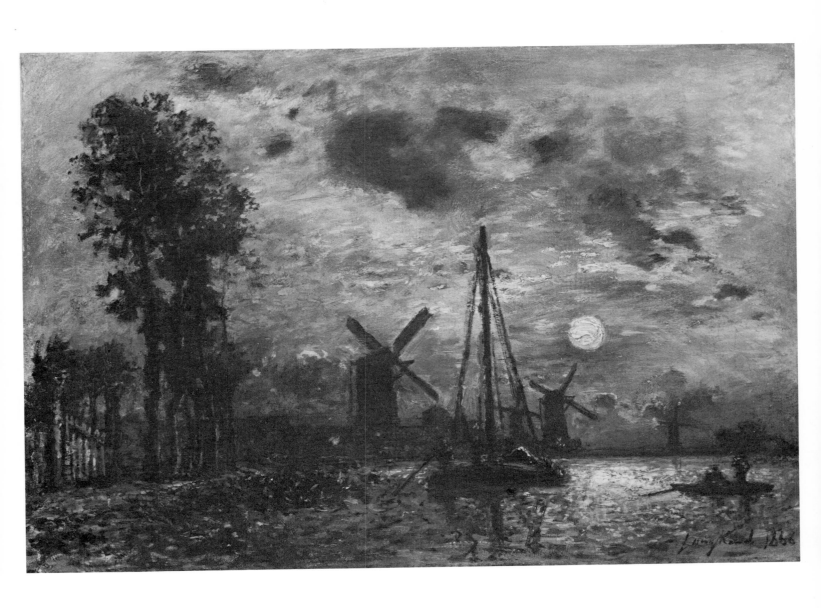

windmills and boats, re-assembled in a composition, either conceived symmetrically, or based on a strong diagonal. Some of these works were painted as companion pieces, such as those executed for Théophile Bascle, Jongkind's patron, who owned no less than eight *clairs de lune* among his fifty-three Jongkinds.

In 1866 the artist was particularly active. He exhibited at the Salon, then toured the Low Countries, where he produced an unusually large number of sketches and watercolours. Several moonlight scenes with Dutch subjects, dating from 1866, are ascribed to the latter part of this year. Four pictures are almost identical in size: one, recorded by Mrs Hefting in a private collection (Hefting, *Jongkind*, 1975, no. 369), and another, on the art market some years ago (Sotheby's, 29 June 1972, lot 100), have a relatively elaborate *mise-en-scene.* Two others, the Tanenbaum Jongkind and *Mill in Holland,* sold in 1969 (Parke-Bernet, 12 March 1969, lot 143), are more austere and intense in concept. Were it not for the existence of similar landscapes, signed and dated 1867, one would be tempted to associate either of these two groups with the two "Dutch landscapes with windmills and moonlight effects" which Jongkind was ready to deliver, on 5 June 1867, to Beugniet.

JEAN-PAUL LAURENS

*Fourquevaux (Haute-Garonne) 1838 –
Paris 1921*

THE SON OF A FAMILY of very modest
means, Laurens began his studies at the
École des Beaux-Arts in Toulouse in
1854 as a protégé of Professor Villem-
sens (1806–1859), who assumed respon-
sibility for his education and instilled in
him a taste for history. He continued his
training at the École des Beaux-Arts in
Paris from 1860 to 1864. In 1872, Lau-
rens won public favour with *The Death of
the Duc d'Enghien* (Musée de Peintures,
Alençon) and *Pope Formosus and Stephen
VII* (Musée des Beaux-Arts, Nantes)
which earned him a first-class medal at
the Salon.

Thereafter his success was ensured.
He visited Italy, then returned to
France where he devoted himself to his-
tory painting, of which he was the last
outstanding representative. Laurens
was a tireless worker. In addition to
painting numerous easel pictures (many
of which are now in museums), he exe-
cuted grand, decorative projects for
buildings in Paris (the Panthéon, Sor-
bonne, Odéon, the Hôtel de Ville, and
the Palais de la Légion d'Honneur); in
the provinces (City Hall of Tours, the
Capitole in Toulouse, the theatre in
Castre); and abroad (City Hall, Balti-
more). Moreover, he produced illustra-
tions for several books, including
Augustin Thierry's *Les temps mérovingiens,*
Goethe's *Faust,* Alfred de Vigny's
L'Imitation de Jésus-Christ, and *La Bible
internationale.* He prepared cartoons for
monumental tapestries woven at the
Manufacture des Gobelins (*Glorification
of Colbert, The Tournament,* a series
devoted to the life of Joan of Arc).
Besides all this Laurens held many
administrative positions: professor at
the École des Beaux-Arts in Paris and
the Académie Julian; director of the
École des Beaux-Arts in Toulouse;
member of the Institut de France; and
president of the Société des Artistes
Français.

At the end of the nineteenth century
Laurens was an internationally cele-
brated artist. After World War I, how-
ever, his work fell into almost complete
oblivion from which it is now just begin-
ning to emerge.

EXHIBITIONS
Salon des Refusés, 1863. Salons of
1864–1914. Paris Universal Exhibitions,
1889, 1900. Numerous international exhibi-
tions. 1923, Paris, Retrospective Exhibition,
Salon des Artistes Français.

AWARDS AND HONOURS
First prize (drawing), École des Beaux-Arts,
Toulouse, 1857. Grand prize (painting),
École des Beaux-Arts, Toulouse, 1860. Hon-
ourable mention, Salon des Refusés, 1863.
Medal, Salon of 1869. First-Class Medal,
Salon of 1872. Grand Medal of Honour,
Salon of 1877. Member of the Institut de
France, 1891. Chevalier (1874); Officer
(1878); Commander (1900); and Grand
Officer (1919) of the *Légion d'Honneur.*

BIBLIOGRAPHY
Art Méridional, no. 32 (April 1938), issue
devoted to Laurens. Jules Clarétie, *Peintres et
sculpteurs contemporains,* Paris: Librairie des
bibliophiles, 1882–1884; second series, pp.
273–296. Jérôme Doucet, *Jean-Paul Laurens,*
series *Les peintres français,* Paris: Juven, 1906.
Ferdinand Fabre, *Le roman d'un peintre,* Paris:
Charpentier, 1878; Fabre, *Jean-Paul Laurens,*
series *Grands peintres français et étrangers,* Paris:
Launette et Goupil, 1895. Edmond Montro-
sier, "Jean-Paul Laurens," *Gazette des
Beaux-Arts,* vol. 2 (1898), pp. 441–451 and
vol. 1 (1899), pp. 145–157. Félix Thiollier,
L'œuvre de J-P. Laurens, Saint-Étienne, 1906.
Jean Valmy-Baysse, *Jean-Paul Laurens, sa vie,
son œuvre,* series *Peintres d'aujourd'hui,* Paris:
Félix Juven, 1910.

A.K.

43

After the Interrogation 1882–1883
(*Après la question*)

Oil on canvas

83 x 123 cm

INSCRIPTION
Signed l.r., *J-Paul LAURENS.*

PROVENANCE
Noah L. Butkin, Cleveland, Ohio; Shepherd
Gallery, New York, 1977 (as *Presentation of the
Body of Saint Francis to the Abbess Saint Claire*).
Acquired February 1977.

BIBLIOGRAPHY
Emmanuel Fougerat, *Jean-Paul Laurens*,
Album d'art rétrospectif, no. 8, series *Drogues
et Peintures:* Paris, Laboratoire Changereau,
1937, repr. pl. VII, p. 13 (as *Après la question*).

LAURENS WAS A LEARNED MAN who took
pleasure in digging up little-known his-
torical facts which he illustrated with
great attention to detail. Particularly
attracted to tragic events of the Middle
Ages, he undertook a subject only after
immersing himself in specialized texts.
The source for the subject of this paint-
ing was Jean Barthélémy Hauréau's
*Bernard Délicieux et l'Inquisition albigeoise
(1300–1320)* (Paris: Hachette, 1877).

Hauréau, like Laurens, was vio-
lently anticlerical, and Laurens had
drawn inspiration from this particular
work twice before. This painting was
the third in a series devoted to the life of
the Franciscan Délicieux, who had
denounced the cruelty of the repression
(ordered by the Inquisition and carried
out by the Dominicans) which had been
forced upon the south of France at the
end of the twelfth century after the
Catharist schism was crushed.

*The Release of the Prisoners of Carcas-
sonne (La délivrance des emmurés de
Carcassonne*, Musée des Beaux-Arts, Car-
cassonne), exhibited in the 1879 Salon,
illustrates the glorious and triumphant
beginning of the story. The Salon hand-
book cited the following passage from
Hauréau: "In the month of August
1303, the people of Carcassonne and
Albi came to remove the many prison-
ers who were locked in the dungeons of
the Inquisition. Bernard Délicieux, a
Franciscan, tried to calm the crowd that
he had stirred up with his words. The
reformer from Languedoc, Jean de Pic-
quigny [a Dominican], accompanied by

several consuls of Carcassonne, watched
the invasion of the dungeons but could
not prevent it."

But this emancipation was soon fol-
lowed by further repression; the Fran-
ciscan was arrested, accused of heresy,
and tortured. This is the subject of *The
Interrogation before the Court of the Inquisition
(L'interrogatoire devant le tribunal de
l'Inquisition)* exhibited in the Salon of
1881 (Hermitage Museum, Leningrad).
Despite the tortures of the rack, Déli-
cieux refused to admit to any of the
charges laid against him; with bloodied
hands and feet, his flesh made raw by
the rubbing of ropes and irons, he was
returned to his cell. It is this episode
which is depicted here.

In this picture, as in all of Laurens's
work, every detail has been researched
with great care. The historical recon-
struction of the architecture (see J.L.
Gilet, "L'architecture dans l'œuvre de
Jean-Paul Laurens," *Art Méridional*, no.
32, pp. 10, 11), of the clothing, of the
stretcher-bearers and of the stretcher
itself, is remarkable. Just as remarkable
is the analysis of expressions and poses.
Laurens wanted the torturers to remain
in the shadows, their faces hidden by
their hoods, but at the same time he was
careful to make them recognizable. The
mixture of resentment, arrogance, and
haughty impatience in the Dominican
Jean de Picquigny, whose left hand
clutches angrily at the black cloak of his
habit, contrasts strongly with the uneasy
conscience of the monk who, bending
over, prepares to open the cell, and the
tranquil and simple indifference of the
torturers who will never be troubled
with moral anxiety. Only Délicieux, the
victim, a pale form against a dark back-
ground, arrests the onlookers' attention.
His eyes speak of suffering; they reveal
a pathetic, quiet resignation to the
hopelessness of the situation.

This work has sometimes been mis-
taken for an illustration of the life of
Saint Francis of Assisi, since Délicieux
wears the Franciscan habit and has on
his hands and feet wounds which could
be confused with the stigmata. Laurens
once again looked to Hauréau's book
for *The Agitator of Languedoc* (exhibited in
the Salon of 1887, location unknown) in
which the Franciscan rails at his accu-
sers, who are also his judges. The history
of the French and Spanish Inquisition
was certainly the artist's favourite
source of inspiration during the 1880s
and many of his works reflect this. Lat-
er, his themes changed; that of inquisi-
torial torture did not reappear until
1910.

Discussing Laurens, the critic Saint-
Juirs wrote: "Art is divided between two
eternal forces: love and death. Apart
from them, all is useless and petty.

Death is the subject to which the new
professor at the École des Beaux-Arts
has devoted his talent. He is the only
one celebrating it today. We live, after
all, in a Latin country, and our origins
have endowed us with a superstitious
terror of the macabre. In the work of
Jean-Paul Laurens, the Latin influence
manifests itself only in the clarity of his
thought and the simplicity of his
composition" ("Le nouveau professeur
de l'École des Beaux-Arts," *Le XIXᵉ siècle*,
6 November 1885). This passage per-
fectly summarizes the painter's art.
Laurens was the antithesis of his con-
temporary Renoir as this picture, typi-
cal of the artist's style, excellently
demonstrates.

After the Interrogation exhibits the
same simple lines of force as do two
works of 1875 – *The Convict* (Musée du
Havre) and *The Excommunication of Robert
the Pious* (Louvre) – and later canvases
such as *Men of the Holy Office* (1889;
Musée départemental et municipal de
Moulins), and *The Hostages* 1896; Musée
de Lyon). There is nothing but the
ochre of the walls, the blue of the sky,
and the chalk-white ground; no obsta-
cle distracts the eye. The simplicity of
the composition gives it grandeur.
There is but one stage on which the
drama of suffering and death is played
out. Laurens's painting impresses one
before it captivates. The viewer may not
immediately be struck by the colours
and their rich tones and values; he may
at first not notice the painter's skill and
the relief given to objects and bodies;
but he cannot escape the authority and
anguish which emanate from this unfor-
gettable work.

Laurens has been reproached for the
austerity of his subjects. The artist did
take pleasure in scenes of murder, and
the morbidity of theme is undeniable.
To be fair, however, we must qualify
this judgement. As a convinced atheist
and humanist, Laurens was revolted by
the crimes committed throughout his-
tory in the name of the "true God" and
on behalf of what is "right." Very often,
his pictures are implacable indictments
of intolerance, an affirmation of his
despair in the face of the injustice of
death. This affirmation is all the more
powerful because of its silence – in con-
trast, for example, to the theatricality of
the fashionable painter Georges-An-
toine Rochegrosse (1859–1938). If Jean-
Paul Laurens had been born half a cen-
tury later, he would have been one of
the great film directors of our time; not
an Abel Gance, despite his passion for
history, but a Carl Dreyer.

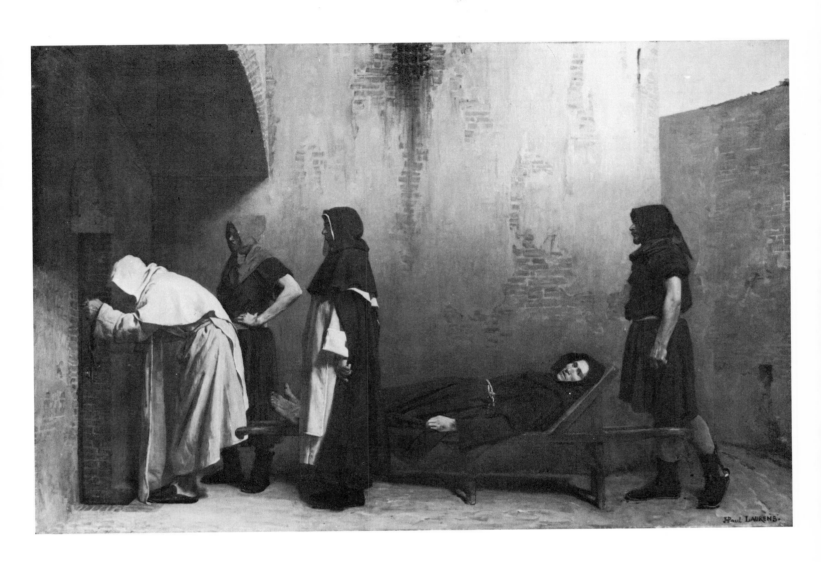

FREDERIC LORD LEIGHTON

Scarborough 1830 – London 1896

LEIGHTON STUDIED at the Städelsches Institute in Frankfurt (1846), and subsequently in Rome (1852) and Paris. His first exhibited work, *Cimabue's Celebrated Madonna Is Carried through the Streets of Florence* (cat. no. 44) created a sensation at the Royal Academy of 1855, and was purchased by Queen Victoria. His polished, continental style was, however, resented by the artistic establishment, and he was not elected an associate of the Royal Academy until 1864 (he became a full Academician in 1868). Thereafter his success was assured, and he became one of the leading champions of academic art in England. He gradually abandoned his interest in mediaeval history, and in the mid–1860s he embarked on the classical works for which he is famous. Academic by training, he was also influenced by the poetic and aesthetic tendencies of the time, and his best work is marked by suggestive form and sensuous colour. Elected president of the Royal Academy in 1878, he carried the institution through troubled times with brilliant success. His cosmopolitan background, allied to a commanding personality and courtly manners, made him a natural spokesman on all issues affecting the arts. He was the first artist for nearly two centuries to be created a baronet (1886), and the only British artist ever to have been raised to the peerage (1896).

EXHIBITIONS
London, Royal Academy, 1855–1856, 1858–1896. Paris Universal Exhibitions, 1855, 1878, 1889. 1874, London, Dudley Gallery. 1877–1882, 1885, London, Grosvenor Gallery. Retrospective exhibition, Royal Academy, 1897.

AWARDS AND HONOURS
Second-Class Medal, Paris Salon of 1859. President of the Royal Academy, 1878. Honourable Member of the Royal Scottish Academy and the Royal Hiberian Academy, 1878. Associate of the Institut de France, 1878. Honourary Member of most academies in Europe. Chevalier of the Order of Coburg; Prussian order *pour le mérite*. Officer (1878), Commander (1889) of the *Légion d'Honneur*. Commander of the Order of Leopold, 1889. Knighted, 1878; created baronet, 1886; created Baron Leighton of Stretton, 1896.

BIBLIOGRAPHY
Mrs Russell Barrington, *The Life, Letters and Work of Frederic Leighton*, 2 vols, London: G. Allen, 1906. Alice Corkran, *Frederic Leighton*, London: Methuen, 1904. Leonée Ormond and Richard Ormond, *Lord Leighton*, London: Yale University Press, 1975. Ernest Rhys, *Sir Frederic Leighton*, preface by F.G. Stephens, London: George Bell and Sons, 1895; Rhys, *Frederic Lord Leighton*, London: George Bell and Sons, 1898. Edgcumbe Staley, *Lord Leighton of Stretton*, London: Walter Scott Publishing, 1906.

R.O./L.O

44

Colour sketch for
Cimabue's Celebrated Madonna Is Carried Through the Streets of Florence 1854
Oil on canvas
30.8 x 66.2 cm

PROVENANCE
B.G. Windus; Christie's, London, G.P. Wall sale, 16 March 1912 (lot 26), (sold to Cross & Phillips); Viscount Leverhulme, with his collection to the Lady Lever Art Gallery, Port Sunlight, Cheshire; sold by Sotheby's, London, 6 June 1958 (lot 135); John Bryson, sold by his executors by Christie's, London, 13 May 1977 (lot 171); sold to Charles Jerdein, London. Acquired June 1977.

EXHIBITIONS
London, Royal Academy Winter Exhibition, 1960, cat. no. 244.

BIBLIOGRAPHY
Barrington, *The Life, Letters and Work of Frederic Leighton*, vol. 1, p. 151; Ormond, *Lord Leighton*, pp. 30, 150 (24), repr. pl. 1 (col.).

THIS IS THE COLOUR SKETCH for Leighton's early masterpiece, now in the Royal Collection. As mentioned above, it was enthusiastically received by the Royal Academy of 1855, and immediately established the painter's reputation. Its success was sealed when Queen Victoria decided to purchase it on the advice of Prince Albert.

Scenes from the lives of the old masters had been popular with European painters since the early nineteenth century. In Frankfurt Leighton had painted several works inspired by Vasari (1511–1574), including *Cimabue Finding Giotto in the Fields of Florence* (c. 1848; Baroda Museum, India), and *The Death of Brunelleschi* (1852; Leighton House, England). In Rome he spent more than two years painting *Cimabue's Madonna*, a subject previously treated by his friend, Peter Cornelius (1783–1867) in the old Pinakotek building in Munich, and by a number of Salon painters in France. Once again Leighton's text was inspired by Vasari, who describes how the picture of the Madonna and Child by Cimabue (1240?–c. 1302) was carried from the artist's studio to the Rucellai Chapel in Santa Maria Novella. The Rucellai Madonna is now in the Uffizi, but it is attributed to Duccio (c. 1255–c. 1319) – not to Cimabue. In the centre of Leighton's picture, Cimabue and Giotto (his artistic heir apparent) walk hand in hand. In front of them are a band of musicians and a bishop with attendants. Behind is a trestle with the Madonna carried by Cimabue's fellow artists, then a group of townspeople, and on the right the equestrian figure of Charles of Anjou who happened to be in Florence at the time. Dante, with his back turned, gazes at the procession as a spectator. Behind the figures is a polychrome marble wall, and in the distance a view of Porta San Niccolo and San Miniato. The picture is intended as a tribute to early Renaissance culture. All ranks of society accord devotion to art and beauty; genius is accorded universal recognition; harmony and joyfulness reign.

Leighton's picture was inspired by early Italian processional pictures. He was a keen and knowledgeable student of Renaissance painting, of which he made copies. One of his major sources for figures and accessories were the frescoes of Andrea da Firenze (active 1343–1377) in the Spanish chapel in Santa Maria Novella. The motif of the house and wall came from Massaccio (1401–1428), and other elements can be traced to the cycle of frescoes in the Campo Santo in Pisa, and to the processional pictures of the great Venetians like Carpaccio (c. 1460–1525/1526). Leighton's picture was worked out with a Renaissance sense of geometry and harmony. The work is roughly two times as long as it is high. The wall is two thirds the height of the picture, and the adult figures are two thirds the height of the wall. The hands of Cimabue and Giotto fall exactly in the centre of the design, and the groups on either side of them, twenty-two on the left, twenty-one on the right, balance each other.

Leighton's vision of the Middle Ages was dreamy and imaginative, like that of the contemporary Pre-Raphaelites, whom he knew well. The *Athenaeum* called the picture "a sheer abstraction," and it is conditioned to a much greater extent by the aesthetic conventions of mid-nineteenth-century art than by the example of Renaissance painting. Leighton's debt to artists in Frankfurt, like Rethel, Schwind, and Steinle, is very clear, not only in the architectonic conception of the design, but also in the fanciful treatment of the theme and in the wealth of detail. Its quaint Gothic subject and ambitious decorative idea appealed to critics and public alike. Queen Victoria called it "a beautiful

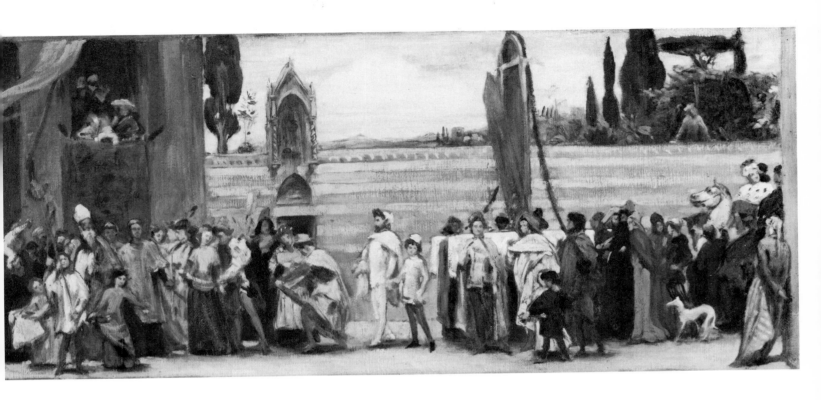

painting quite reminding one of a Paul Veronese, so bright and full of lights."

Leighton started work on *Cimabue's Madonna* in 1853, and finished the big picture in the spring of 1855. The existence of more than thirty surviving drawings demonstrates his painstaking methods of composition. The colour sketch was finished by the end of May 1854, when Leighton had already defined the finished composition in preliminary cartoons. The function of the sketch was simply to provide the artist with a guide to the colour scheme when he was at work on the canvas. Writing to his old master Edward Steinle (1810–1886) in Frankfurt on 24 May 1854, he described his activities: "I have now under-painted 'Romeo and Juliet' in grey (*grau untermalt*), made both the colour sketches, and have now fairly got into the over-painting, or rather second under-painting of 'Cimabue.'" The colour sketch has the vividness of touch sadly missing from the big picture, which suffers from an over-elaborate finish. It is not without significance that the sketch should have appealed to B.G. Windus, one of the major patrons of Turner (1775–1851) and one of the first admirers of Pre-Raphaelite art. John Bryson, who owned the sketch after Windus, was no less discerning, and the sketch hung among a choice collection of Pre-Raphaelite works.

45

Hercules Wrestling with Death for the Body of Alcestis c. 1869–1871

Oil on canvas

1.53 x 2.69 m

PROVENANCE
Purchased from the Liverpool exhibition by Sir Bernhard Samuelson; Francis Samuelson; Dr Arnold Renishaw; Mrs Alice Duckett; sold at Knight, Frank & Rutley, London, 1968, bought by Charles Jerdein and Jeremy Maas, London. Acquired May 1970.

EXHIBITIONS
London, Royal Academy, 1871, cat. no. 215. 1871, Liverpool, Autumn Exhibition, cat. no. 193; according to Barrington (see below), exhibited by Samuelson all over the world. London, Royal Academy, 1897, *Leighton Memorial Exhibition,* cat. no. 7. London, Royal Academy, 1968, Bicentenary Exhibition, cat. no. 344. 1969. Toronto, Art Gallery of Ontario, *The Sacred and Profane in Symbolist Art,* cat. no. 128.

BIBLIOGRAPHY
Athenaeum: "Fine Art Gossip," no. 2205 (29 January 1870), p. 166; "Mr. Leighton's New Picture," no. 2206 (5 February 1870), p. 203; "Fine Art Gossip," no. 2210 (5 March 1870), p. 332; "Fine Art Gossip," no. 2257 (28 January 1871), p. 119; "The Royal Academy," no. 2270 (29 April 1871), p. 532. "The Royal Academy: The One Hundred and Third Exhibition," *Art Journal* (1871), p. 153. "The Royal Academy," *Graphic,* vol. III (20 May 1871), p. 466. "Exhibition of the Royal Academy," *Illustrated London News,* vol. LVIII (1871), p. 447. "The Royal Academy," *Saturday Review,* vol. XXXI (6 May 1871), pp. 567-568. "The President of the Royal Academy," *Review of Reviews,* vol. VII (1893), pp. 494–495. Rhys, *Sir Frederic Leighton* (1895), pp. 18, 68, repr. facing p. 18; Rhys, *Frederic Lord Leighton* (1898), pp. 23–24, 86, repr. facing p. 24. Corkran, *Frederic Leighton,* pp. 87, 183, 186, 195. Barrington, *The Life, Letters and Work,* vol. II, pp. 189–191, 370, 385, repr. facing p. 190. Staley, *Lord Leighton,* pp. 84–86, 237. Jeremy Maas, *Victorian Painters,* London: Barrie and Rockliff, Cresset Press, 1969, pp. 180–181, repr. facing p. 180. Ormond, *Lord Leighton,* pp. 64, 78, 89–90, 93, 130, 160 (no. 193), repr. 119.

RELATED WORKS
Black and white chalk drawing depicting the illness of Mrs Sartoris (12.1 x 24.1 cm), sold Christie's, 23 July 1974, lot 16. In the centre is a prone female figure on a bier. To the left two angels, representing life and death, wrestle, while behind a pair of pillars on the right, the husband kneels, head down, his arms around two children (presumably May and Algernon Sartoris), with two more figures behind. Although no colour sketch for the *Alcestis* is extant, there is an elaborate chalk drawing for the composition formerly in the collection of the Earl of Carlisle (repr. in *Review of Reviews,* 1893, see Bibliography); a sketch of this, squared for transfer, is at Leighton House, London (no. 511), together with detailed studies for the figures and accessories: the legs and torso of Hercules (nos 512–513); nude and draped studies of Alcestis (nos 514–515); a thumbnail sketch of the composition (no. 516); the wings of Death (no. 517); a nude study of the two girls in the foreground (no. 789); a sheet of sketches is at the Victoria & Albert Museum for the heads of Hercules and Death, and the legs and torso of Death (no. 732 – 1896).

THE SUBJECT IS TAKEN FROM THE PLAY by Euripides. Alcestis sacrifices her life for that of her husband, Admetus, and is in turn rescued from death by Hercules, who restores her to Admetus. In the play, the wrestling scene does not occur on stage, and Leighton's inclusion of it in his painting indicates his concern with the central drama of the story at the expense of the text of the play.

The violent action and tense atmosphere of the work make it almost unique in Leighton's œuvre. His earlier classical paintings include *Orpheus and Eurydice* (1864), *Electra at the Tomb of Agamemnon* and *Daedalus and Icarus* (both 1869), but the only picture of comparable size and importance, *The Syracusan Bride* (1865), is decorative and processional in character. In comparison, the design of *Alcestis* is elaborate and complex. The action of the wrestlers, thrusting diagonally out of the picture space, and of the mourners straining in the opposite direction, are held in balance by the rigidly prone figure of Alcestis. The two girls in the foreground, the man on the extreme left, the figures behind the bier (the old man variously identified in reviews as Admetus or his father Pheres, the latter probably correct), and the outstretched wing and drapery of Death, form part of an enclosing design, a dynamic circle of movement around a still centre. In the immediate foreground is a newly prepared grave, with a spade on the left, and beside the two girls are funerary vases and garlands of roses. The figure of Alcestis, severe and effigy-like, recalls that of Juliet in Leighton's picture *Count Paris* (1858), who is, like Alcestis, dressed in white to denote purity.

The labours of Hercules include several wrestling scenes, but in depicting the unusual subject of Hercules wrestling with Death, Leighton turned to Christian iconography, basing his image on traditional representations of Jacob wrestling with the Angel. The figure of Hercules, perhaps inspired by the classical statue of the *Borghese Warrior,* is one of Leighton's earliest representations of the male nude in motion. The influence of Michelangelo is unmistakable in the anatomical detail and powerful muscular force. In the figure of Death, the artist created a macabre creature of the underworld which recalls the work of Henri Fuseli (1741–1825). The greenish-grey flesh stands out against the healthy bronze colour of Hercules, just as his robe contrasts with the hero's lion skin.

By contrast the cringing mourners are painted with the utmost delicacy, in a range of soft reds, oranges, pinks, purples, and greens. The transparent effects of flesh seen through drapery, most noticeable in the young girls in the foreground, are evidence of the painterly subtlety and skill of Leighton's mature style. Most remarkable of all is the visionary seascape, glimpsed between the brooding and monumental cypress trees which divide the background like a tryptych – deep blue water flecked with white, a line of distant orange on the horizon, and cumuli clouds above. Distant views, framed in this way, are often a symbol of infinity in Leighton's

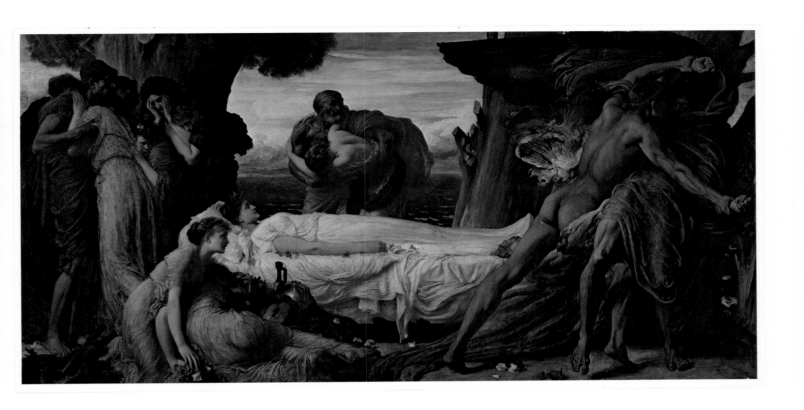

work, and in this painting he is perhaps suggesting the release of the soul to eternity as a counterpoint to the crowded action in the foreground.

The story of Alcestis had long been a popular theme in western art and literature. The death of Alcestis is often depicted on the sides of Roman sarcophagi, and there are many later precedents in sculpture. William Morris had included a lengthy version of the Alcestis story in his long poem, *The Earthly Paradise* (1868), and it inspired an opera by Gluck, *Alceste*. Both Leighton and Robert Browning attended a performance of *Alceste* in London in the spring of 1871, and shortly afterwards Browning began work on his own version of the myth, *Balaustion's Adventure*, published that same autumn. Included in the poem is a remarkable account of Leighton's picture, which Browning very much admired:

There lies Alkestis dead, beneath the
 sun,
She longed to look her last upon, beside
The sea, which somehow tempts the life
 in us
To come trip over its white waste of
 waves. . .
There strains
The might o' the hero 'gainst his more
 than match,
– Death, dreadful not in thew and bone,
 but like
The envenomed substance that exudes
 some dew
Whereby the merely honest flesh and
 blood
Will fester up and run to ruin straight,
Ere they can close with, clasp and
 overcome
The poisonous impalpability
That simulates a form beneath the flow
Of those grey garments. . .

According to Mrs Barrington, the subject of Alcestis had a particular significance for Leighton himself. In 1864, Mrs Sartoris, to whom Leighton was deeply attached, underwent an operation from which she was not expected to recover (in fact she did so) – but for some days Leighton remained in a state of acute anxiety. A drawing done at the time or soon afterwards appears to record the crisis of her illness, and it anticipates the design of *Alcestis* very closely (see Related Works).

It is not known exactly when Leigh-

ton began work on *Alcestis,* but certainly by the later part of 1869. It is described in the *Athenaeum* in January and February 1870 as already then being in an advanced stage. The *Athenaeum* articles mention a canopy above the bier, now gone, and what appears to be a different arrangement of the mourning figures. Leighton had intended to exhibit the picture at the Academy in 1870, but it was not until a year later, after a severe illness, that he was able to do so.

The known studies for this painting (see Related Works) represent probably only a handful of those actually carried out. They demonstrate the enormous care with which Leighton worked out every part of a picture.

The painting was well received at the Royal Academy of 1871. The *Times* called it one of the two highest achievements in the highest range of art by English Academicians (the other was Millais's *Moses*). The *Art Journal* praised the colour, remarking that Leighton had exchanged "German opacity for Venetian lustre and transparency, gained after the Venetian manner by glazing warm tones over white surfaces." Leighton's close friend, F.G. Stephens, writing in the *Athenaeum,* was less complimentary then usual, feeling that the artist's genius was not adapted to scenes of "tremendous action or tragic expression," but he praised the "graceful figures of the mourners," the "lovely dead Alcestis," with her "subtly harmonized white robes."

46

Nausicaa *c.* 1878
Oil on canvas
148.1 x 66.8 cm

PROVENANCE
A.G. Kurtz; Alderman Horatio Davies, his sale, Christie's, London, 27 June 1903 (lot 8), bought by Tooth Gallery, London; John Avery; Jeremy Mass, London (by 1973); Sebastian de Ferranti; Charles Jerdein, London. Acquired May 1976.

EXHIBITIONS
London, Royal Academy, 1878, cat. no. 145. 1878, Liverpool, Autumn Exhibition, cat. no. 183. 1886, Liverpool, Loan Exhibition, cat. no. 1217. 1895, London, Guildhall, Loan Exhibition, cat. no. 85. London, Royal Academy, 1897, *Leighton Memorial Exhibition,* cat. no. 143.

BIBLIOGRAPHY
Athenaeum: "Fine Art Gossip," no. 2629 (16 March 1878), p. 357; "The Royal Academy," no. 2636 (4 May 1878), p. 576. "Royal Academy Exhibition," *Art Journal* (1878), p. 147. "Royal Academy Exhibition," *Illustrated London News,* vol. LXXI (4 May 1878), p. 410. "The Royal

Academy," *Saturday Review*, vol. XLV (11 May 1878), p. 592. "Exhibition of the Royal Academy," *The Times* (4 May 1878). Rhys, *Sir Frederic Leighton* (1895), p. 69; Rhys, *Frederic Lord Leighton* (1898), pp. 29, 87, repr. facing p. 30. Corkran, *Frederic Leighton,* pp. 94, 203. Barrington, *Life, Letters and Work,* vol. II, pp. 200-201, 387, repr. facing p. 201. Staley, *Lord Leighton,* pp. 113, 240. Ormond, *Lord Leighton,* pp. 129, 164 (no. 248), repr. colour pl. V.

RELATED WORKS
In the same year as *Nausicaa*, Leighton exhibited *Winding the Skein* (Art Gallery of New South Wales, Sydney), a classical scene in a domestic vein, showing two figures winding wool on a terrace in Rhodes. The older girl, dressed in a classical robe and turban similar to Nausicaa's, is clearly the same model Leighton used for *Nausicaa*, as yet unidentified (she appears again in *Amarilla,* 1879). The little girl to the right of the older girl is Connie Gilchrist. F.G. Stephens records seeing *Nausicaa* and *Winding the Skein* side by side on the easel in Leighton's studio, and it is clear that they were painted in tandem. Chalk studies for both appear on the same sheet at Leighton House (no. 582), those of *Nausicaa* being preliminary thumbnail sketches. Also at Leighton House is a sheet of three studies for the figure of Nausicaa, including a nude study (no. 581), and another study is on a sheet otherwise devoted to the picture of *Elijah* (no. 589).

THE SUBJECT OF THE PICTURE comes from the eighth book of Homer's *Odyssey.* Nausicaa, the daughter of King Alcinous, finds the shipwrecked Odysseus on the beach and invites him back to her father's palace. Leighton's picture recalls Nausicaa's reaction to Odysseus's victory in the games with the Phaeicians: "Now Nausicaa, in all her heaven-sent beauty, was standing by one of the pillars that supported the massive roof. Filled with admiration as her eyes fell on Odysseus, she greeted him warmly" (Rieu translation).

The scene in which Nausicaa with her maidens first discovers the naked Odysseus had long been popular with painters. There are a number of seventeenth-century examples, notably by Gerard Hoet (Kunstmuseum Basel), Peter Lastman (Herzog Anton Ulrich Museum Brunswick and Alte Pinakothek, Munich), Guido Reni (Museo di Capodimonte, Naples), and Peter Paul Rubens (Pitti Palace, Florence). Among Leighton's contemporaries George Dunlop Leslie (1835–1921) had painted a picture of Nausicaa and her maidens (exhibited at the Royal Academy, 1871), and Edward Poynter (1836–1919) contributed a similar subject to the Academy in 1879 (collection of Lord Wharncliffe). Unlike these artists, Leighton was less concerned with telling a story than with evoking an atmosphere appropriate to a study of a

beautiful model. He does not show Nausicaa at the dramatic moment of her first encounter with Odysseus, nor even in the presence of the hero, but gazing out of the picture, presumably towards him, in a tender and reflective mood. Implicit in her wistful attitude is the knowledge that she will soon lose him; the idea of parting and loss is a persistent theme in Leighton's work, emerging again strongly in his later picture of *Captive Andromache* (cat. no. 47).

It is easy to exaggerate the importance of the text in relation to the picture. One feels that it would have lost little of its meaning if the model had been called by some other classical name. It is the decorative idea which is preeminent, the grace and beauty of the model, the exquisite rendering of flesh and drapery, the subtle harmony of colour. The later 1870s witnessed a resurgence of Leighton's aesthetic instincts, and one should view the picture within this context. His enormous processional picture of the *Daphnephoria* (c. 1876) embodies the Greek ideal of harmony, wholeness, and human beauty, with little ostensible subject. Similarly *The Arts of Industry as Applied to War,* one of two vast frescoes in the Victoria & Albert Museum (begun in 1878), is primarily a tribute to Leighton's powers as a decorative designer. Closer in feeling to *Nausicaa* are a number of studies of models, *Teresina* (1876), *Study; at a Reading Desk,* and *Music Lesson* (both 1877).

Unlike the figures in *Winding the Skein* (see Related Works), Nausicaa is shown in the simplest of settings. The rich furnishings of her father's palace as described by Homer are ignored in favour of a spare architectural framework of pavement and pilaster. Nothing distracts from the figure, supporting herself against the wall with one arm, and yet perfectly balanced. The features are idealized and somewhat vacant. The attitude of the arm supporting the head is almost like a Leighton signature. One can imagine his pleasure in solving the problem of how to paint the difficult, foreshortened forearm, the outward turning wrist, and the delicately clenched fingers. The result is studied and superbly elegant. The same sureness of touch and observation can be traced in the high arching instep of Nausicaa's left foot, a telling and sensual detail for which there are many precedents in his work. The folds of the drapery have a vitality of their own, as they echo the form and rhythm of the body, veiling but not disguising the warm flesh beneath. Above all the colour, a symphony of greys and greens and whites, gives the picture a mysterious and compelling presence.

Colour sketch for
Captive Andromache c. 1888

Oil on canvas

19.9 x 40.5 cm

PROVENANCE
Stewart Hodgson; by descent in the Hodgson family until 1976; Charles Jerdein, London. Acquired March 1976.

EXHIBITIONS
London, Royal Academy, 1897, *Leighton Memorial Exhibition,* cat. no. 115.

BIBLIOGRAPHY
Barrington, *Life, Letters, and Work,*, vol. 1, repr. col. facing p. 213. Ormond, *Lord Leighton,* p. 169 (no. 335), repr. col. pl. II.

RELATED WORKS
Large oil (1.95 x 4.06 m), City Art Gallery, Manchester, exhibited Royal Academy, 1888 (see Ormond, no. 334).

47

THIS IS ONE of the most beautiful of all Leighton's colour sketches. Though admired now for their immediacy of touch and brilliance of colour, the sketches played an important role in the production of his finished works. Describing his method of working in a letter of 1889 to M.H. Spielmann (quoted in *Magazine of Art,* 1898, p. 1), Leighton wrote: "At this moment [following the compositional drawing] the design being absolutely established, the *coloured* sketch is made. It is deferred till now because the exact *placing* of the colour is, of course, of as much importance as the harmony." In the same letter he wrote that he always treated colour in his painting "more or less ideally."

The large painting of *Captive Andromache* is one of Leighton's grandest and most memorable works. The subject comes from Homer's *Iliad.* Andromache, wife of Hector, appeals to her husband not to return to the fighting, fearing he will die. Hector refuses, although anticipating the worst, and he prophesizes his wife's exile: "I see you there in Argos, toiling for some other woman at the loom, and carrying water from an alien well, a helpless drudge, with no will of your own" (Rieu translation). After the fall of Troy, Andromache fell to the share of Pyrrhus, son of Achilles, who took her to Epirus in Thessaly.

The parting of Hector and Andromache was a common subject in western art, especially popular during the Neo-classic period. (There are, for example, paintings by Charles de la Fosse, Francesco Ferdinandi *dit* Imperiali, Angelica Kauffman, George Romney, and Benjamin West, and drawings by Jacques-Louis David and François Fabre.)

However, Leighton's depiction of the captivity of Andromache appears to be almost unique, and illustrates that tendency in his work away from traditional narrative towards more suggestive themes which left him greater freedom. *Captive Andromache* is conceived in magnificently decorative terms. The setting is perhaps intended to represent Pyrrhus's farm in Thessaly, with a distant landscape of mountains and a storm-laden sky. Groups of beautiful women are shown at, or on their way to, a well, posed in statuesque attitudes. Their costumes, ranging from intense blue on the left to vivid oranges, reds, and purples on the right, create a strong pattern of colour, from which the black-shrouded figure of Andromache stands out.

It is this tragic spectre who transforms the image of a golden age into something more memorable and profound. An object of curiosity to various onlookers in the foreground, she gazes at a happy family group on the right, remembering her own lost husband and son. The feeling of loss and despair which the picture communicates so strongly may reflect Leighton's own sense of what he had sacrificed in devoting himself so single-mindedly to his art.

The model for Andromache was the actress Dorothy Dene, who appears in so many of his late paintings, and to whom he was deeply attached. The main outlines of the painting had been laid in by July 1887, and the underpainting and probably this colour sketch were complete by the end of August. In spite of a further six months' work, the picture made slow progress. On 12 March 1888, Leighton wrote to Browning: "I am in an agony lest I should not get my blessed picture done, it is so backward or rather there is still much to do to it." Leighton's worries proved to be unjustified. The picture duly appeared at the Royal Academy in the spring of 1888, and it received an enthusiastic press.

Even before the picture was finished, Leighton was concerned about its final destination. He wanted it to go to a public collection, believing that it would "hold a prominent place among my works." Through Charles Deschamps he was in touch with the newly founded art gallery in Birmingham and

with Henry Tate, the future donor of
the Tate Gallery in London. Tate, how-
ever, turned it down on the grounds of
size. Alexander Henderson (later the
first Lord Faringdon), actually gave
Leighton a cheque for the picture, but
after protracted negotiations it went
finally to the City Art Gallery, Man-
chester, at a special price of six thou-
sand pounds. Leighton had to wait
while the Art Gallery committee raised
the necessary funds from local sources.
The oil sketch was purchased by
Leighton's old friend, Stewart Hodgson,
a stockbroker and collector, who owned
many of his paintings and sketches,
including the enormous *Daphnephoria.*

JOHN MARTIN

*Haydon Bridge (Northumberland) 1789 –
Isle of Man 1854*

JOHN MARTIN CAME from a lowly and
obscure family though, remarkably, two
of his brothers achieved notoriety: Jona-
than was the most successful arsonist of
his generation (he burnt down half
York Minster in 1829 for doctrinal rea-
sons), and William was an equally
impassioned pamphleteer who dubbed
himself "The Philosophical Conqueror
of All Nations." John Martin's eccen-
tricities were designed to overawe a
public accustomed to panoramic specta-
cles.

Martin had little formal training.
He started as an apprentice coach
painter in Newcastle-upon-Tyne; then
for a time he studied with a drawing
master, Boniface Musso. In 1805, he
moved to London where he found work
decorating china and turning out topo-
graphic views for Rudolph Ackermann,
the printseller and inventor. In 1813
Martin exhibited *Sadak in Search of the
Waters of Oblivion* at the Royal Academy.
This image of the archetypal romantic
hero, stranded on the lip of a waterfall
in an appalling volcanic wilderness, set
the style and prevailing mood of
Martin's subsequent set pieces. Most of
them were based on apocalyptic Old
Testament incidents and *Paradise Lost,*
each inferno partnered by some lush,
quasi-Claudian Eden. With *Joshua Com-
manding the Sun to Stand Still* (1816), *The
Fall of Babylon* (1819), *The Fall of Nineveh*
(1828), and other urban crises, he won a
popular following and lost any chance
of being accepted as a serious artist by
the Royal Academy. Though he exhib-
ited regularly at both the Royal Acad-
emy and the British Institution (where
he won premiums for *Joshua* in 1817 and
Belshazzar's Feast in 1821), he never
gained official recognition of his epic
skills in Britain. He was, however, made
a Knight of the Order of Leopold in
1833.

Martin produced mezzotint versions
of all his major works and two sets of
illustrations to *Paradise Lost.* These
brought him considerable financial
reward, much popularity, encouraged
imitators, and helped spread his reputa-
tion abroad. Victor Hugo was one of his
admirers. In the 1830s his vasty histori-
cal-reconstruction manner went out of
fashion and he devoted much of his
time to urban planning. He proposed
new systems of mine ventilation,
Thames embankments, and a sewage
and water-supply scheme for London.
These failed to win the support they
deserved and brought Martin to the
verge of bankruptcy. So he spent his
later years endeavouring to regain his
former security by returning to his first
subjects, doing mezzotint "Illustrations
of the Bible" and, finally, tackling the
Apocalypse proper. Three huge paint-
ings, *The Great Day of His Wrath, The Last
Judgement,* and *The Plains of Heaven* were
completed shortly before his death,
toured Britain and North America for
many years, fell into disrepute and dis-
repair, and only recently, in 1974, were
reunited in the Tate Gallery Collection.

Martin's art depended on literary
sources and a literary reading of the
painting. Constable once described
Martin's paintings as "pantomimes"
and, though doubtless intended
disparagingly, the description is apt.
The spectacle, the split-second transfor-
mations, the sweep and ostentation and
reliance on multitudes, ringmaster-
prophet figures, the non-stop frenzy and
sudden idylls, belong to a theatrical
rather than a Neo-classical tradition.

EXHIBITIONS
London, Royal Academy, 1811–1814,
1816–1817, 1820–1821, 1823–1824,
1837–1852. British Institution, 1813–1821,
1823–1824, 1826, 1828, 1833, 1840,
1842–1845, 1851. Society of British Artists,
1824–1826, 1835. Royal Scottish Academy,
1828–1829. Brussels Salon of 1833. Paris
Salon of 1835.

AWARDS AND HONOURS
British Institution: Second Prize (1817);
First Prize (1821). Gold Medal, Brussels
Salon of 1833. Knight of the Order of Leo-
pold, 1833. First-Class Medal, Paris Salon of
1835.

BIBLIOGRAPHY
Thomas Balston, *John Martin, 1789–1854, His
Life and Works,* London: G. Duckworth,
1947. William Feaver, *The Art of John Martin,*
Oxford: Clarendon Press, 1975. Christopher
Johnstone, *John Martin, Master of the Mezzotint
1789–1854,* London: Alexander Postan Fine
Art, 1974. Mary Lucy Pendred, *John Martin,
Painter. His Life and Times,* London: Hurst &
Blackett, 1923.

W.F.

48

Belshazzar's Feast 1820

Oil on canvas

1.62 x 2.53 m

INSCRIPTION
Signed and dated l.l., top of pedestal, *J. Martin 1820.*

PROVENANCE
William Collins; Thomas Wilson, until 1848; John Naylor, until 1889; John M. Naylor, his sale at Leighton Hall, Welshpool, 23 January 1923; H. Drake, his sale, Baltic Exchange, London, 1928; Percy S. Martin; Mrs Ruth F. Wright; Christie's, London, 18 March 1977, cat. no. 115, repr. Acquired March 1977.

EXHIBITIONS
1821, British Institution, cat. no. 72. 1854, Liverpool, cat. no. 30. 1862 (?), London. 1975, London: Hazlitt, Gooden and Fox, *John Martin 1789–1854,* cat. no. 15, repr.

BIBLIOGRAPHY
C.F. Waagen, *Treasures of Art in Great Britain,* London, 1854, vol. 3, p. 242. Pendred, *John Martin,* pp. 102–110, pl. facing p. 102. Ruthven Todd, *Tracks in the Snow,* London: Grey Walls Press, 1946, pp. 108–110. Balston, *John Martin,* pp. 41–48, 56–67, 202, 260–265 (reprint of "A Description of the Picture *Belshazzar's Feast* painted by Mr Martin," 1821), p. 276. Jean Seznec, *John Martin en France,* London: Faber & Faber, 1964, pp. 18, 42. Johnstone, *John Martin,* pp. 14–16, 37, and pl. 36 (col.). Feaver, *The Art of John Martin,* pp. 49–57, 68, 87, 157, 205, 206, 211, 215, 220, 221, 237, and pl. III (col.).

RELATED WORKS
A smaller version (95.2 x 121 cm, 1820; Mellon Collection) and another version, unsigned (153.7 x 177.8 cm, Laing Art Gallery, Newcastle) exist. A version on glass, possibly by Martin himself (47 x 72.4 cm) is in Syon House of the Duke of Northumberland. Martin did two engravings of the subject (1826, 1832), and slight variations on the subject appear in his *Illustrations of the Bible* (1831–1835) and in Westall and Martin's *Illustrations of the Bible* (wood engraving, 1835). The painting was engraved for other publications, among them *The Imperial Family Bible* (Glasgow: Blackie and Son, 1844, p. 927).

"THE PICTURE SHALL MAKE MORE NOISE than any picture ever did before," John Martin predicted. "His picture is a phenomenon," the painter Wilkie (1785–1841) wrote. "All that he has been attempting in his former pictures is here brought to its maturity." *Belshazzar's Feast* was the great success of the 1821 British Institution exhibition. It had to be railed off to stop the crowds dashing themselves against its headlong perspectives. In it Martin blundered past the history painting regulations and, instead of painting the noble-minded, bas-relief characters of Neo-classical convention (as Benjamin West [1738–1820], his mentor, had done in 1776), he kept faith with the spirit and letter of his Old Testament text: Daniel Chapter Five. His fleeting figures, King Belshazzar, princes, courtiers, assorted astrologers and concubines, react like the tuppence-coloured cut-outs from a toy theatre, as the prophet Daniel deciphers the flaming writing on the wall, pronounces judgement and doom, and lightning strikes at the Tower of Babel in the background.

"My picture of Belshazzar's Feast originated in an argument with [Washington] Allson," Martin wrote. "He was himself going to paint the subject and was explaining his ideas, which appeared to me altogether wrong, and I gave him my conception. He told me there was a prize poem at Cambridge, written by Mr T.S. Hughes, which exactly tallied with my notions, and advised me to read it. I did so, and determined on painting the picture" (autobiographical note, in The *Athenaeum,* 14 June 1834, p. 459).

The novelty in Martin's conception was the sheer effrontery of the perspective: rigid foreshortening, a vanishing point at the end of a Babylonic railway cutting. Martin took great trouble to produce "a perspective of light, and (if the expression may be allowed) a perspective of feeling," as he put it, in the (anonymous) explanatory catalogue published, complete with a key diagram, when the painting was re-exhibited at No. 343 Strand, London, soon after the British Exhibition triumph. He also attempted to reconstitute Babylon as it was on the night of its fall (the subject of his 1819 success) when the Feast took place, the heavens raged, and divine handwriting announced doom. Charles Lamb conceded that "its architectural effect is stupendous," but went on to compare the whole "huddle of vulgar consternation" to the reputed goings-on in Brighton where the Prince Regent (soon to be king and give a Coronation banquet that observers likened to Martin's *Belshazzar's Feast*) had, as his pleasure dome, the Royal Pavilion.

The painting was intended to be hung low and read from corner to corner, like a pictorial tract, the eye taken first by the sizzling words, then attracted by "the brazen serpent which seems to writhe in the portentuous glare," to pass over Daniel, who stands "with that sullen appearance which never leaves entirely the countenance of an exile," and over to the "interesting but supercilious features" of the king.

Though damaged and superseded in epic special effects by Cecil B. de Mille cinematics, *Belshazzar's Feast* remains a breakthrough in terms of re-animated myth or, as Martin preferred to see it, as authentic historical reconstruction. A masterpiece of sorts.

JEAN-LOUIS ERNEST MEISSONIER

Lyons 1815 – Paris 1891

REJECTING THE COMMERCIAL CAREER which his father, a dye merchant, had chosen for him, Meissonier made himself one of the most successful artists of the nineteenth century. His family moved to Paris when he was three, and it was there that he lived and worked most of his life, although he also acquired property in suburban Poissy about the years 1846–1847 and made occasional trips to Grenoble, Antibes and, after 1859, Italy. He spent only four or five months in the studio of Léon Cogniet (1794–1880) in Paris and felt he had learned little there. Far more influential was his independent study of works by seventeenth–century Dutch and Flemish genre painters, such as Gabriel Metsu (1629–1667) and Gerard Terborch (1617–1681), and by eighteenth-century French masters like Jean-Baptiste Greuze (1725–1805) and Jean-Baptiste Chardin (1699–1779). Most significant of all was his experience designing wood-engraved book illustrations for editors such as Léon Curmer and Jules Hetzel in the 1830s and 1840s. Meissonier first gained artistic recognition for the marginal vignettes he created for editions such as the 1838 *Paul et Virginie* and *La Chaumière Indienne,* by Bernardin de Saint-Pierre (Curmer). Here, too, he developed his characteristic aesthetic, which focuses on diminutive, but painstakingly perfected details.

The first paintings for which Meissonier became popular were very small, meticulously executed genre scenes. Frequent subjects, which are well represented in the Louvre and the Wallace Collection in London, were sixteenth- and seventeenth-century cavaliers and eighteenth-century smokers, readers, chess players, and artists with connoisseurs. In 1848 the experience of revolution in the streets of Paris led him to paint his *In Remembrance of the Civil War* (Louvre). About 1860 he inaugurated a second popular specialization in Napoleonic military subjects, dealing with both anonymous, single figures, such as sentries, and major episodes, for example *1814, The Campaign of France* (1864, Louvre) and *1807, Friedland* (1875, Metropolitan Museum of Art, New York).

Throughout the nineteenth century Meissonier was a distinctive figure in French art. From the 1840s until the end of his life the paintings he exhibited inspired extensive, delighted commen-

taries by critics like Théophile Gautier. Economic prosperity accompanied critical acclaim as members of the wealthy élite of the July Monarchy and the Second Empire vied with each other to acquire his works. A major retrospective exhibition at the Galerie Georges Petit in 1884 celebrated the fiftieth anniversary of his first Salon. As well as through his much-imitated example in choice of subject and style, Meissonier exercised his influence through his participation in numerous official organizations. By appointment and by election by fellow artists, he served on the juries for many Salons and Paris Universal Exhibitions; and in 1872 he played a leading role in preventing Gustave Courbet (1819–1877) from exhibiting the paintings he had executed while in prison for his activities during the Commune. Elected to the Institut de France in 1861, Meissonier twice served as its president. In 1889 he helped found the Société Nationale des Beaux-Arts, in concert with Puvis de Chavannes (1824–1898), who succeeded him as president on his death in 1891. The paintings of Meissonier fell quickly into disfavour after the artist's death and the posthumous sale of his studio in 1893. Valery Gréard, collaborating with the artist's widow, and Léonce Bénédite devoted the last serious attention to his work (see Bibliography), until recently, when his art has begun to be restored to its position of historical importance.

EXHIBITIONS
Paris Salons of 1834, 1836, 1838–1843, 1845, 1848–1857, 1861, 1864, 1865, 1877. Salons of the Société Nationale des Beaux-Arts, 1890–1891. Universal Exhibitions of Paris, 1855, 1867, 1878, 1889; of London, 1862; of Vienna, 1873; of Antwerp, 1885.

AWARDS AND HONOURS
Third-Class Medal, Salon of 1840; Second-Class Medal, Salon of 1841; First-Class Medal, Salons of 1843, 1848; *hors concours,* Salon of 1877. *Grand Médaille d'Honneur,* Paris Universal Exhibitions, 1855, 1867; *Rappel de Médaille d'Honneur,* Universal Exhibition of Vienna, 1873; of Paris, 1878, 1889; of Antwerp, 1885. Chevalier (1846); Officer (1855); Commander (1867); Grand Officer (1880); Grand Cross (1889) of the *Légion d'Honneur* (first artist to receive this honour). Member of the Institut de France, 1861. Grand Officer of the Order of Leopold (Belgium); Order of Franz Joseph (Austria); Commander of the Royal Order of the Northern Star (Sweden), 1886.

BIBLIOGRAPHY
Léonce Bénédite, *Meissonier,* Paris: Renouard, 1910. Valery C.O. Gréard, *Meissonier, Ses Souvenirs, Ses Entretiens,* Paris: Hachette, 1897, translated as *Meissonier, His Life and His Art,* New York: A.C. Armstrong and Son, 1897. Constance Cain Hungerford, "The Art of Jean-Louis-Ernest Meissonier: A Study of the Critical Years 1834–1855,"

Ph.D. dissertation, University of California, Berkeley, 1977.

C.C.H.

49

The Philosopher *c.* 1878–1880
Oil on canvas
33.4 x 42.5 cm

INSCRIPTION
Signed and dated l.l., *E. Meissonier 1880.*

PROVENANCE
Meissonier studio sale, Paris, Hôtel Drouot, 12–20 May 1893, *Catalogue des tableaux, études peintes, aquarelles et dessins composant l'atelier Meissonier,* cat. no. 156, repr.; F.O. Mathiessen sale, New York, 1–2 April 1902, cat. no. 100; John A. Hoagland sale, New York, 22 January 1903; Sotheby Parke-Bernet, New York, 4 June 1975, cat. no. 199. H. Shickman Gallery, New York. Acquired October 1976.

EXHIBITIONS
March 1893, Paris, Galerie Georges Petit, *Exposition Meissonier,* cat. no. 156.

AS MEISSONIER BECAME A FIGURE whose preeminence was manifested by his wealth, official honours, and activities, he came to feel some personal affinity with the revered masters of the Italian tradition, although they had been of little formative influence. He had travelled briefly to Italy in 1859 and 1860, but two of the most important events for him occurred when he represented France at a commemorative ceremony for Michelangelo's death in 1875 in Florence, and when he visited Venice in the 1880s. While he continued to produce the works which were already so sought after, he also explored more courtly and aristocratic "Italianate" subjects, sometimes on a larger scale, with freer brushwork and richer colour (*On The Staircase,* 1878; *The Song,* 1882). Occasionally he even identified subjects as being "Venetian."

Depicting a well-established scholar in a Renaissance interior, *The Philosopher* is a work in this later spirit. Another version appeared at the Paris Universal Exhibition of 1878. This particular work is not a self-portrait, but it corresponds closely to Meissonier's own image of himself at this time, as reflected in such self-portraits as the 1882 watercolour in Valenciennes. Here, the white-bearded artist is similarly clad in a long, velvet robe, surrounded by finely bound books, and seated in an identical chair. The more brilliant colour indicates Meissonier's later style, but his personal hallmarks remain, demonstrated especially in the

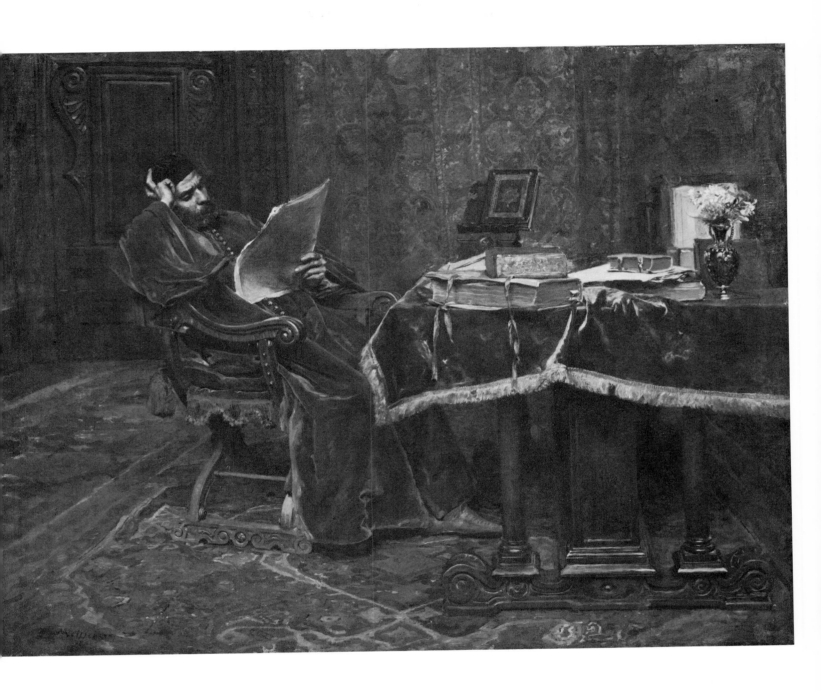

close attention paid to such details as buttons and chair studs, the carving of the furniture, the varied arrangement of precious books, and the vase with flowers, which adds a note of bright, local colour.

The greater sketchiness of the carpet and background tapestry suggests that the painting was never completely finished by the artist, in whose studio it remained until his death. The signature and date (1880), which do not appear in the illustration in the catalogue of the 1893 Meissonier studio sale, may have been added posthumously. The date at the time of the sale was given as 1878.

GEORGES MICHEL

Paris 1763 – Paris 1843

MICHEL WAS BORN IN PARIS, where his father worked at Les Halles. In 1775, at the age of twelve, he began taking his first painting lessons, but he soon showed a preference for drawing from nature. In 1789, after several visits to Normandy, Germany, and Switzerland, the young painter made what was to be a permanent move to Paris. About 1790 he became friends with the painter Lazare Bruandet (1755–1804), and the two artists made drawing excursions around the outskirts of Paris. Belleville, the Bois de Romainville, the Plaine Saint-Denis, the Pré Saint-Gervais, the Buttes-Chaumont, Vincennes, and especially the Butte Montmartre were their favourite sites. "Anybody who cannot find a lifetime of painting material within walking distance of home is a duffer who is looking for the mandrake but who will find nothing more than emptiness . . ." said Michel (Larguier, *Georges Michel*, p. 52). He was the first of his generation to scorn the traditional voyage to Italy, prefering the Île-de-France as a source of visual sensation to feed his imagination. Michel, known as "the French Ruisdael," left an indelible mark on the art of the painters of the Barbizon school, who began to produce their first significant works ten years or so before the artist's death in 1843.

EXHIBITIONS
Paris Salons of 1791 to 1814.

BIBLIOGRAPHY
Raymond Bouyer, "Petits maîtres oubliés. Georges Michel," *Gazette des Beaux-Arts*, vol. 2 (1897), pp. 304–313; Bouyer, "Un précurseur du paysage moderne. Georges Michel," *Revue de l'art*, vol. 51 (1927), pp. 237–248. J.G. Goulinat, "Le paysagiste Georges Michel," *L'Art et les artistes*, no. 73 (January 1927), pp. 109–115. Leo Larguier, *Georges Michel 1763–1843*, Paris: Delpeuch, 1927. Alfred Sensier, *Étude sur Georges Michel*, Paris: A. Lemerre, 1873.

L. d'A.

50

The Village

Oil on paper laid down on canvas

49.2 x 64.2 cm

PROVENANCE
Ernest May Collection, Paris; Jacques May
Collection, Paris (in 1927);(?) Henri Rivière
Collection, Paris; Marché aux Puces (Paul
Bert), Paris; Georges Martin du Nord, Par-
is; Galerie André Watteau, Paris; H. Shick-
man Gallery, New York. Acquired April
1973.

EXHIBITIONS
March–April 1927, Paris, Hôtel Jean
Charpentier, *Rétrospective Georges Michel*, cat.
no. 71 (as *Le village*, Jacques May Collec-
tion). October 1970, New York, H. Schick-
man Gallery, *The Neglected 19th Century: An
Exhibition of French Paintings*, Part II, n.p.,
repr. (as *Flat Landscape with Storm Clouds*).

THIS LANDSCAPE is characteristic of the
final stage in Michel's stylistic develop-
ment.

Until 1810 or thereabouts, his work
was divided between small, almost aca-
demic landscapes, perhaps marked by
the influence of Demarne (1744–1829)
with whom he collaborated, and
"romantic" scenes with gothic ruins,
winding roads, capricious bridges, fanci-
ful encampments and menacing wind-
mills looming up against brooding skies.
These canvases bear witness to Michel's
diligent craftsmanship and attention to
detail. He applied colour in small, jux-
taposed strokes and covered the surface
of the canvas uniformly; then he added
the highlights in impasto.

After 1810, Michel began to take an
interest in the effects created by meteo-
rological phenomena: storms seen in the
distance, trees bent by the wind, light
filtering through the clouds and
descending to earth in perpendicular
rays – just at the time when the similar
concerns of the English landscape
painters were being discovered in
France.

The canvas exhibited here is proba-
bly a product of a still later period in
Michel's career. The broad, fluid brush-
work, the rapid execution, and the
dark, warm tones are characteristic of
his production after 1830. The composi-
tion still shows the powerful influence of
Ruisdael (1600–1670) in the large diag-
onal which separates the houses on the
right from a wooded zone on the left, in
the contrast between the solidity of the
foreground and the haziness of the
background, and in the alternation of
light through a heavy, dark cloud. It
was Michel's custom to explore the out-
skirts of Paris in order to make small
studies; he then developed these into
more finished compositions in his stu-
dio. But, as this painting attests, the
freshness of vision and the spontaneity
of gesture were not lost in the process.

The Ernest May Collection (see
Provenance) included three other can-
vases by Michel, each with the same
dimensions as this one. The four paint-
ings, which were included in the Geor-
ges Michel exhibition held in 1927 at
the Hôtel Jean Charpentier in Paris,
were *The Cottage* (*La Chaumière;* cat. no.
65), *Sunshine and Storm* (*Soleil d' orage;* cat.
no. 66), this painting (cat. no. 71), and
Swamp (*Marais;* cat. no. 72, also in the
Tanenbaum collection). These four
may well have constituted a series of
paintings ordered by a collector, repre-
senting variations on a theme.

ALBERT JOSEPH MOORE

York 1841 – London 1893

ALBERT MOORE BEGAN his career as a precocious child-artist. First taught by his father and four older brothers, artists of some note, he began formal study at the York School of Design where, at age eleven, he was awarded a medal for one of his drawings. Following his father's death, in 1855 Moore moved with his mother and family to London. There he exhibited two watercolour drawings at the Royal Academy when he was only fifteen. In 1858 he entered the Royal Academy schools and formed a sketching society with his fellow students Henry Holiday, William Blake Richmond, Marcus Stone, and Frederick Walker.

Moore's early works had serious Biblical subjects and were executed with the sombre colours and minute realism of the Pre-Raphaelites. His most important early work, painted during a sojourn in Rome in 1862–1863, was *Elijah's Sacrifice* (Bury Art Gallery and Museum, Lancashire). Following a series of decorative commissions and experiments with fresco, about 1865 Moore began to break away from his early narrative and realistic style and to establish a new direction in his art. His Royal Academy entries from 1864 to 1866 reveal the emergence of a lighter palette and a new interest in rendering static classical figures and complex drapery patterns. During this period there is a close relationship between the work of Moore and James McNeill Whistler (1834–1903).

As a mature artist Moore lived and worked in London. He was not at all sociable and rarely left his studio where he worked in isolation. Although he exhibited regularly at the Royal Academy and was admired by other artists and critics, particularly Whistler, Leighton (cat. nos 44–47), and Swinburne, Moore received little official recognition.

The final years of Moore's life were clouded by a serious illness that was to end his life in 1893 at the age of fifty-two. In his last major painting, *The Loves of the Winds and the Seasons* (1890–1893; Blackburn Corporation Art Galleries), Moore included distinct emotional and symbolic content that had been conspicuously absent from his paintings for some twenty years. This new direction was cut short, however, for the artist died only a few days after the painting was finished. At his death

Whistler lauded Albert Moore as "the greatest artist that, in the century, England might have cared for and called her own . . ." (Baldry, *Albert Moore*, p. 25).

BIBLIOGRAPHY
Alfred Lys Baldry, *Albert Moore: His Life and Works*, London: G. Bell & Sons, 1894. Richard Green, *Albert Moore and His Contemporaries*, exhibition catalogue, Newcastle-upon-Tyne: Laing Art Gallery, 1972. W. Graham Robertson, *Life Was Worth Living*, New York and London: Harper and Brothers, 1931, pp. 57–62. John Sandberg, "Whistler Studies," *Art Bulletin*, vol. 1 (March 1968), pp. 59–64. Allen Staley, "The Condition of Music," *Art News Annual*, *The Academy*, vol. 33 (1967), pp. 80–87. Allen Staley et al., *The Victorian High Renaissance: Watts, Leighton, Moore and Gilbert*, exhibition catalogue, Manchester City Art Galleries, Minneapolis Institute of Arts, Brooklyn Museum (forthcoming, 1978).

G.H.

51

The End of the Story 1877

Oil on canvas

78.5 x 32.7 cm

INSCRIPTION
Signed with Greek anthemion, l.r.

PROVENANCE
William Kenrick Collection in 1894; Durlacher Brothers, New York, by 1964; James Coats, New York. Acquired July 1968.

EXHIBITIONS
1877, London, Grosvenor Gallery, cat. no. 52. 1964, New York, Durlacher Brothers, *Painters of the Beautiful*, cat. no. 11. 1969, Toronto, Art Gallery of Ontario, *The Sacred and Profane in Symbolist Art*, p. XLVIII, and cat. no. 38, repr. pl. 36. 1972, Newcastle-upon-Tyne, Laing Art Gallery, *Albert Moore and His Contemporaries*, cat. no. 55, repr. pl. 21.

BIBLIOGRAPHY
Baldry, *Albert Moore*, pp. X, 47, 103, repr. opp. p. 46; Baldry, "Albert Moore," *The Studio*, vol. 3 (1894), p. 12, repr. Staley, "The Condition of Music," p. 85, repr. p. 83. Green, *Albert Moore and His Contemporaries*, pp. 7, 10, 24, no. 55, repr. pl. 21.

RELATED WORKS
Moore executed another version of this painting, also entitled *The End of the Story* (fig. 4) that is very similar to the Tanenbaum painting in style, size, and subject. The colour schemes of the two paintings are different, however, as are such details as the number of strands of pearls, the pattern of the rug, and the size and placement of the book. The other version was recently auctioned in New York (Parke-Bernet, 4 June 1975, no. 267, oil on canvas mounted on masonite, 86 x 30.5 cm). Two other paintings by Moore, both entitled *A Reader*, are related to the two versions of *The End of the Story* in theme, style, and size. One was exhibited in 1877 at the Royal Academy

(no. 469) and is now in the Manchester City Art Gallery (no. 1934.413, oil on canvas, 87.2 x 32 cm). The other was auctioned in New York (Parke-Bernet, 4 June 1975, no. 266, oil on canvas mounted on masonite, 86 x 30.5 cm). It forms a pair with *The End of the Story* that was auctioned at the same sale. Both works are identical in size and were formerly in the collection of Dr Rudolf Knickenburg, Ottawa.

THE END OF THE STORY is a classic image dating from the artist's mature period. The painting depicts a female figure with golden yellow hair who is dressed in a green toga with white diaphanous drapery. Three strands of pearls are her only adornments. She has a casual contrapposto pose and is placed in a shallow space before a cloth curtain of floral design and behind a green-and-white patterned rug on the wooden floor. The relatively simple subject matter of this painting contrasts with the subtle colour harmonies and carefully worked out two-dimensional balance of the composition. The yellow of the woman's hair and the green of the toga are picked up and quietly echoed in the flowers and leaves of the curtain and in the pattern of the rug. The off-centred position of the rug and flower balances the figure's weighty right arm that holds a book.

Moore's first depiction of a single Grecian woman standing was *Azaleas*, a painting exhibited at the Royal Academy of 1868 and now in Dublin. Later he repeated the same basic composition in works cryptically entitled *Battledore*, *Shuttlecock*, *Sapphires*, *Birds*, *A Reader*, and *Blossoms*. With this group of paintings, Moore was repetitive in his subject matter, but as in the work of Josef Albers (1888–1976) or Mark Rothko (1903–1970), the variety of the works lies in the different colour combinations and subtle compositional changes. Moore considered the subject of a painting, such as *The End of the Story*, to be merely a vehicle for more important aesthetic concerns. The clearest illustrations of Moore's "art for art's sake" credo are his three paintings of 1875, *Apples*, *A Sofa*, and *Beads*. The size and composition of the three works are virtually identical; however, in each case, the colouring is completely different.

The End of the Story reflects the then current fascination on the part of many British artists with the ancient civilizations of Greece and Rome. The hair style and dress of the figure are clearly Antique, while the head has the sculptural qualities of a Greek marble and the rhythm of the drapery folds is in part inspired by the Parthenon sculpture then on view in the British Museum. Moore's interest in the Antique,

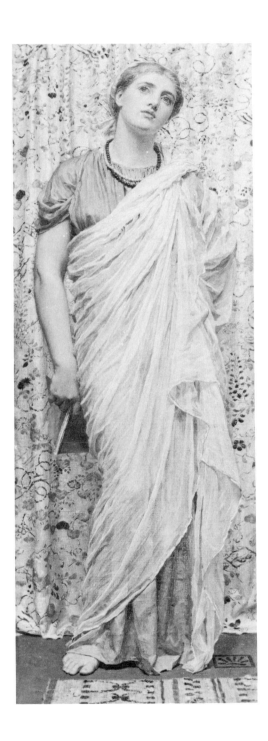

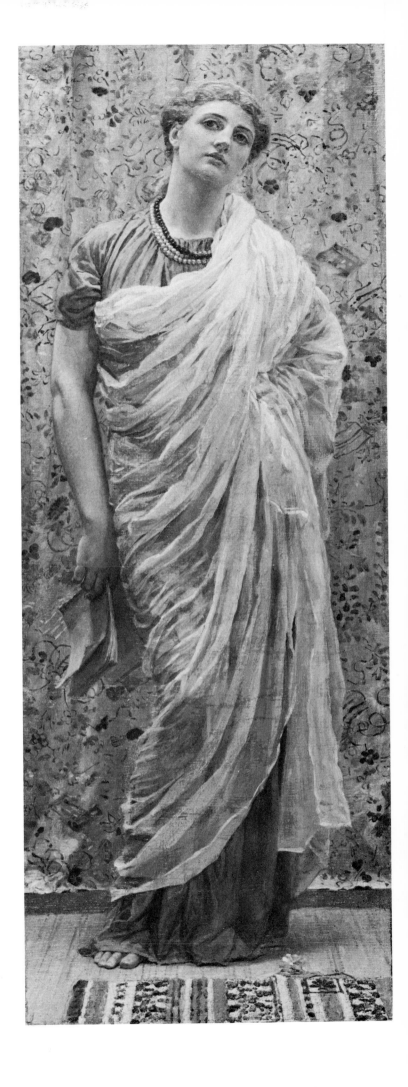

Fig. 4
Another version of *The End of the Story*
(Private Collection, Europe)

however, was fundamentally different from that of his very successful contemporary Alma-Tadema (cat. nos 1, 2). Moore was an aesthete who tried to recreate the generalized beauty and mood of the ancient world, whereas Alma-Tadema set out to make every detail of his Greek and Roman genre scenes as precise and archaeologically correct as possible.

Once the aesthetic qualities of *The End of the Story* are absorbed and appreciated, the view returns again to this static figure who stares out at us with an undaunted casualness that is somewhat disturbing. Although Moore's Grecian woman is generalized and timeless, one senses she is Hellenistic. She has an air of supreme confidence about her that suggests she was part of the later generations of Greeks who, like their Victorian counterparts more than two thousand years later, were born into a highly evolved civilization and world position forged by their ancestors. The sublime self-assurance of Britain in the 1870s is here expressed with a Hellenistic echo.

THÉODULE AUGUSTIN RIBOT
*Saint-Nicolas-d'Attez (Eure) 1823 –
Colombes 1891*

INCREASING INTEREST in the French Realist-Naturalist movement is leading to the reappraisal of Théodule Ribot. Long regarded as a late-comer to the Realist scene, which affected French painting following the 1848 Revolution, Ribot became immersed in several mid-century movements: the revival of still-life painting; the etching renaissance of the 1860s; and the way in which painters examined themes drawn from their environment and personal experience.

Despite a difficult life burdened by many family hardships, Ribot managed to train himself as an artist. After his father died in 1840, he found a low-paying job as a bookkeeper for a textile firm in Elbeuf (near Rouen) in order to support his mother and sisters. In 1845, after his marriage and because he wanted a better job, Ribot went to Paris. At first, he worked for a mirror manufacturer, decorating gilded frames. He still, however, maintained the serious interest in art that had begun when he was a young boy, and somehow he managed to work in the atelier of Auguste-Barthélémy Glaize (1807–1893), his only recorded master. Here he studied the nude and assisted his teacher by perfecting architectural backgrounds in Glaize's paintings.

The exact chronology of Ribot's activities during the late 1840s cannot be determined because this period was interrupted by a three-year stay in Algeria where Ribot worked as a foreman. Both before and after his return to Paris (1851), Ribot struggled to make ends meet. He coloured lithographs, decorated window shades and curtains, painted trade signs, and copied the work of Jean-Antoine Watteau (1684–1721) for American export. These commercial projects provided him with enough money to live on, but did not permit him to express his own talents.

The canvases Ribot completed in the late 1850s were painted by lamplight in the evenings at his home and were drawn from his own environment. These works emphasize dark and light tonalities – aspects of his style imposed by inadequate lighting conditions – but a style which he continued to perfect throughout his career. Although his work was rejected at the Salons during the late 1850s, Ribot found a supporter in François Bonvin (cat. nos 8–10) who exhibited his canvases, along with those of Antoine Vollon (cat. nos 70, 71), Henri Fantin-Latour (cat. nos 26, 27), and James McNeill Whistler (1834–1903), in his atelier in 1859.

In 1861 Ribot was finally accepted at the Salon. Several of his canvases of cooks were shown, a theme also used by Bonvin which was then attracting Parisian collectors. Public awareness of his work increased as he exhibited at the annual Paris Salons; at the international exhibitions (see Exhibitions); and provincial shows (Bordeaux, Lille, Rouen, Grenoble, Lyons, and Le Havre). During that period, some artists and collectors recognized his still lifes, genre scenes, and portraits as furthering the tradition of realism. Ribot was also accepted by the official art establishment with two Salon medals he received in 1864 and 1865. The purchase of his *Saint Sebastian* by the Second Empire for 6,000 francs in 1865 demonstrated that peasant types could be used in a religious scene if the work suggested those of the masters of the seventeenth century – and especially the Spanish painter José de Ribera (1591–1652).

During this same period, Ribot also exhibited paintings in Parisian galleries, such as the gallery of Louis Martinet, a sympathizer with the independent naturalist artists, and at the shop of Alfred Cadart, a patron of etching during the 1860s. In both locations, Ribot's works were hung with those by Bonvin and Édouard Manet (1832–1883).

Besides selecting themes from everyday life and popular literature, Ribot helped establish tonal painting. By using modulated tones of tan, grey, white, and black, Ribot created canvases of nuance reminiscent of the works of Frans Hals (1581/5–1666), in whom interest was then being revived. In modulating his dark and light scheme, Ribot worked within a limited colour range that also suggests another source – the Spanish painters of the seventeenth century.

During the Franco-Prussian War (1870), Ribot had a studio in the Parisian suburb of Argenteuil. When the Prussians invaded this village and found his atelier, they destroyed many of his works. This may account for the difficulty of locating a wide range of Ribot's early canvases. Also, in the late 1870s, after he had moved to Colombes, Ribot suffered a severe illness which prevented him from painting. Later, supported by a friend who solved some of his financial problems, Ribot continued to paint genre scenes and numerous portraits of family and close friends in a style suggestive of Rembrandt.

In 1878, Ribot was inducted into the *Légion d'Honneur*. At a special dinner held in 1884, a group of friends recognized his artistic contribution and presented him with a medal of honour inscribed: *A Théodule Ribot, le peintre indépendant*. That this award was presented by such well-known figures as Fantin-Latour, Bastien-Lepage, Jean-Charles Cazin, Alfred Stevens, J.F. Raffaelli, Joseph de Nittis, and Claude Monet documents Ribot's link with younger naturalist painters.

Several important exhibitions of his work took place during his lifetime: the first, in the gallery belonging to the periodical *L'Art* (1880), and two others at the gallery of Bernheim-Jeune (1887, 1890). He was honoured again in 1887 when he was made Officer of the *Légion d'Honneur*.

Ribot died in 1891 in the small village of Colombes. A year later, the large retrospective exhibition held at the École des Beaux-Arts continued to support Ribot's contribution at a time when many younger painters were repudiating artists of the Realist tradition because they had worked in dark tones.

Little of Ribot's personal life is known. There are no descendants, and letters and other documentary material are sparse. This makes reconstruction of his career difficult, especially since he seldom dated his paintings. Thus, most of the information on Ribot's life and work has been provided only by standard sources. In addition, the archives of André Watteau (Paris) are invaluable in establishing a visual chronology for Ribot's œuvre.

EXHIBITIONS
Paris Salons of 1861–1890. International exhibitions: 1865, Amsterdam; 1869, Munich; 1870–1871, London; 1873, Vienna. 1892, Paris, École des Beaux-Arts, retrospective exhibition.

AWARDS AND HONOURS
Medal (genre) 1864 and medal (genre) 1865 Salons. Third-Class Medal, 1878, Paris Universal Exhibition. Chevalier (1878) and Officer (1887) of the *Légion d'Honneur*.

BIBLIOGRAPHY
Louis de Fourcaud, *Théodule Ribot, sa vie et ses œuvres*, Paris, 1885. Eugène Véron, "Th. Ribot Exposition générale de ses œuvres dans les galeries de l'Art," *L'Art*, vol. XXI (1880), pp. 127–131, 155–161. Gabriel P. Weisberg, "Théodule Ribot: Popular Imagery and *The Little Milkmaid*," *The Bulletin of the Cleveland Museum of Art*, vol. LXIII (October 1976), pp. 253–263.

G.P.W.

THÉODULE AUGUSTIN RIBOT

52

The Tambourine Player *c.* 1860

Oil on canvas

47 x 39 cm

INSCRIPTION
Signed l.l., *t. Ribot.*

PROVENANCE
Hôtel Drouot, Paris, 8 November 1974; H. Schickman Gallery, New York. Acquired September 1975.

BIBLIOGRAPHY
Weisberg, "Théodule Ribot," fig. 6.

THE THEME OF A YOUNG STREET PERFORMER counting his earnings or playing an instrument was developed by the Realist painters. François Bonvin (cat. nos 8–10) also completed a canvas of a performer counting change (*The Little Chimney Sweep,* 1845; Museum of Boulogne-sur-mer) in an environment suggestive of the Spanish master Esteban Murillo (1618–1682). Ribot did canvases of single performers in a cabaret, but this is his only known work of a solitary performer counting his centimes.

Early in his career, Ribot was attracted to those themes linked to his friends, family, and children. Indeed, Ribot and Bonvin were considered among the staunchest advocates of painting observed reality. Ribot's sympathy for children is expressed in numerous studies of his young daughters during the 1860s; he often placed them in scenes drawn from popular literature and folklore. While *The Tambourine Player* may ultimately have come from a popular source, it was developed from Ribot's use of his own children (or studio models) whom he posed with the props and costume of a performer. The illumination, which accentuates the child's head and descends towards the small still life at the left, shows a theatrical use of lighting for dramatic effect.

The painting can be dated from the mid-1860s, a period when Ribot's numerous small canvases of young cooks and children proved popular. These studies were often in tones of grey, white, and black – demonstrating Ribot's dependence upon Spanish seventeenth-century painting, especially the compositions he studied by Diego Velasquez (1599–1660), and helped to create a tradition of tonal painting practised by Whistler and Vollon (cat. nos 70, 71).

The quality of intimacy, advocated by Realist critics such as Champfleury, is evident in this painting. This is an unusual theme in Ribot's work, but there is a companion – at least in terms of examining a young child's reactions – in his *Little Milkmaid* (The Cleveland Museum of Art), which was also completed in the mid-1860s.

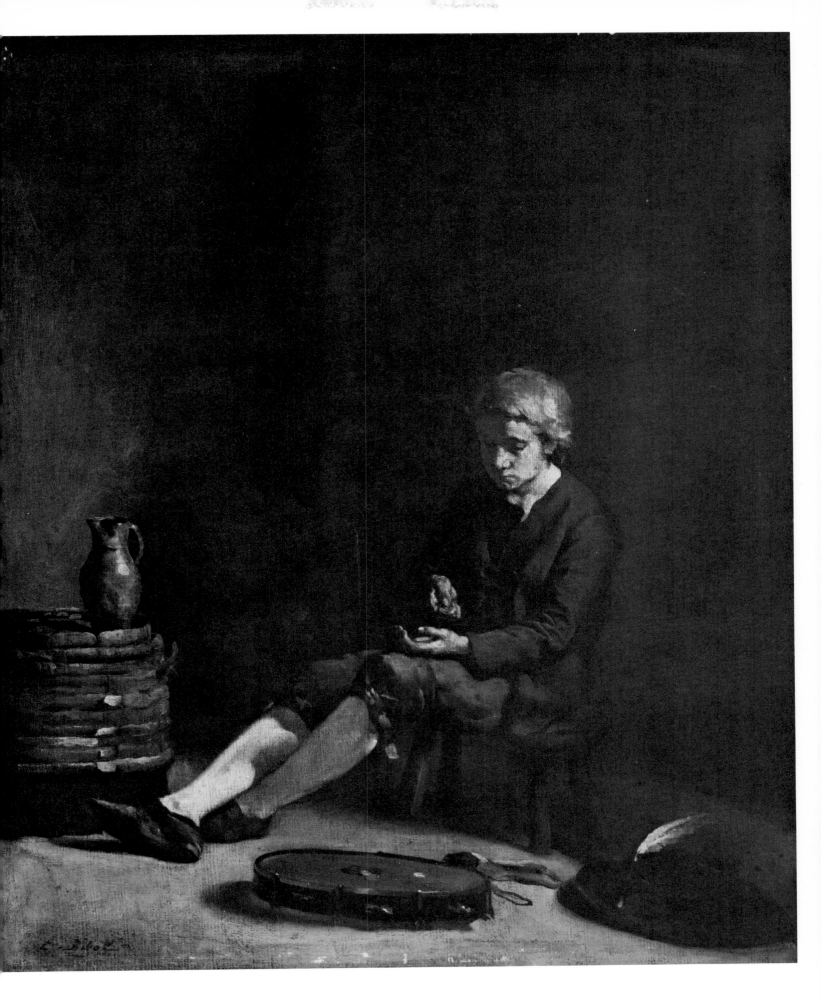

53

The Mandolin Player 1862

Oil on canvas

73 x 60 cm

INSCRIPTION
Signed and dated l.r., *t. Ribot, 1862.*

PROVENANCE
Collection of R. Gérard; collection of
Éduardo Mollard; public sale, Palais Galli-
éra, Paris, 1972; Galerie André Watteau,
Paris, 1975. Acquired June 1976.

EXHIBITIONS
December 1972–January 1973, Paris, Gal-
erie André Watteau, *Les Peintres-Graveurs du
XIXe siècle,* cat. no. 87.

BIBLIOGRAPHY
Burlington Magazine, December 1973, pl.
LXLV. Georges Pillement, *Les
Pré-Impressionnistes,* Zoug (Switzerland): Les
clefs du Temps SA, 1973, p. 249, cat. no.
268, repr. col.

RELATED WORKS
A painting with the same title is dated 1862
(Burrell Collection, Glasgow Art Gallery
and Museum). Ribot also painted women
playing instruments, as in the sketch *Woman
with Mandolin* (Private Collection, Paris) and
Young Girl with Guitar (Musée de Troyes).

THE RESURGENT INTEREST in folk melo-
dies instigated by balladeers inspired
Ribot to complete *The Mandolin Player.*
In 1853, Pierre Dupont published
Chants et Chansons, a collection of popu-
lar songs that examined themes used in
the visual arts. They were often sung by
balladeers to café audiences, and they
evoked the intimate character of the life
of the peasant and extolled the toil and
day-to-day activities of this class. A sim-
ilar interest is found in the work of
Ribot's friend Bonvin, although the
latter's depictions of music performers
suggest the influence of seventeenth-
century Dutch paintings, in which the
performers are relaxed and seem to be
playing for their own pleasure.

Ribot presents his balladeer in the
dress of the common people. The young
boy's cape is pulled back so that he can
strum the mandolin, and his greyed,
rough trousers, short rumpled vest, and
oversized plumed hat record a type of
singer who was to become popular in
the Montmartre cafés of the late 1880s
and 1890s (for example, Aristide Bruant
as depicted by Toulouse-Lautrec).

The boy's pose, with leg forward,
hand strumming the instrument, and
open mouth, conveys the immediacy of
the stage. Ribot has captured a scene
similar to Édouard Manet's image of
the Spanish guitarist, *The Spanish Singer,*
(*Le Guitarrero,* 1861; Metropolitan
Museum of Art, New York). Instead of
being seated on the bench, as in
Manet's composition, Ribot's musician
stands, looking towards an unseen audi-
ence. Ribot has created an impression
of theatrical activity with the use of
minimal stage props: the burning ciga-
rette (repeated from Manet's canvas),
and the sheet music cast on the floor are
the only reminders of the café. To recre-
ate the café environment, Ribot had
simply placed a model in his studio,
arranged the lighting, and thereby fol-
lowed a traditional artistic method.

Light from an outside source gently
illuminates the performer; only his face
and hands add bright colour. The
remainder of the canvas was completed
in tones of grey, white, and black. The
boy's white blouse contrasts with the
rich black of the cape, creating a har-
monious tonal balance used earlier by
seventeenth-century Spanish painters.
The effect of black (similar to that cre-
ated by Goya and Velasquez) also
enriches the tones of the greyed trousers.
At a time when Whistler and Vollon
were perfecting fully integrated colour
harmonies and when Manet was begin-
ning to use black, Ribot achieved a col-
our balance within a limited tonal
range.

The Mandolin Player raises questions
as to Ribot's relationship with Manet.
At the time when this work was com-
pleted, Manet had become an impor-
tant figure for younger artists. His two
paintings exhibited at the 1861 Salon,
Portrait of M et Mme Auguste Manet (Pri-
vate Collection, France) and *The Spanish
Singer* had ignited a controversy that
linked him with the Realist camp.
While contacts between Manet and
Ribot have not been fully documented,
it is known that both exhibited their
work as early as 1861 at the Société
Nationale des Beaux-Arts, established
by Louis Martinet in his gallery on the
Boulevard des Italiens. Ribot exhibited
still lifes at Martinet's, and a work such
as *The Mandolin Player* was available for
exhibition – raising the possibility that
Manet may have seen it. The Salon of
1861 also marked another significant
development for Ribot, for this was the
year he was admitted to the Salon for
the first time, exhibiting five canvases.
With both Manet and Ribot exhibiting
in the same locations, the probability
that they knew each other's canvases is
strong and suggests a reciprocal rela-
tionship.

By the mid-1860s (after the comple-
tion of *The Mandolin Player*), Manet and
Ribot were also exhibiting their can-
vases in another gallery: Cadart and
Luquet, on Rue de Richelieu. Cadart,
in 1862–1863, had become an energetic
patron of etching by forming the Société
des Aquafortistes, a casual group of
painter-etchers which included both
Manet and Ribot in their ranks.
Cadart's shop, aside from selling etch-
ings by members of the Société, also
exhibited paintings. It was here, in
1864, that Manet showed his
"Kearsarge" and the "Alabama"; similarly,
Ribot's painting, *The Singers* (Mr and
Mrs Noah L. Butkin Collection, Cleve-
land), was sold through Cadart's dealer-
ship.

Thus, the ties between Manet and
Ribot are documented not only through
their Salon participation, but through
the galleries they frequented and the
dealers who helped sell their canvases.
Within this context, it is essential to
place Manet's *Fifer* (1866; Louvre), in
which all accessory detail has been
eliminated to permit clear focus on a
young boy dressed in military garb.
This popular image is similar to themes
painted by Ribot during the 1860s and
epitomized by *The Mandolin Player.*
While Ribot's paintings were known
during the 1860s, his relationship with
Manet and his circle awaits further
clarification.

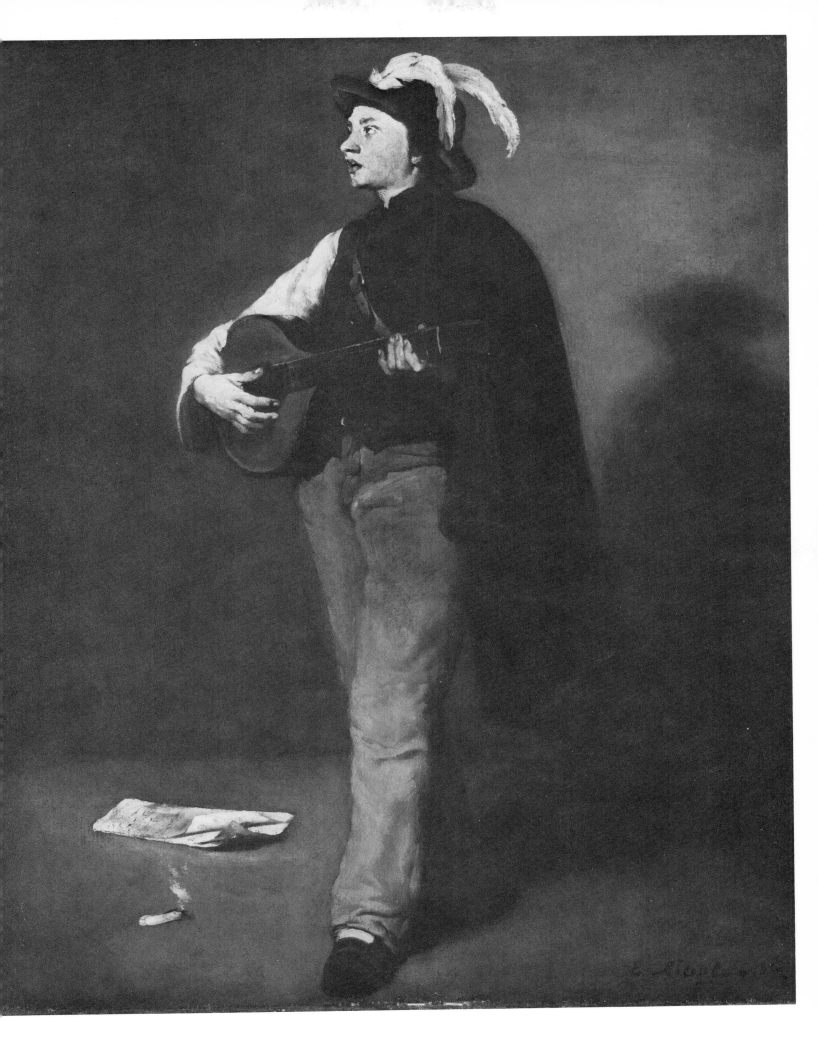

54

Kitchen Scene *c.* 1865–1870

Oil on canvas

43 x 50.7 cm

PROVENANCE
Galerie André Watteau, Paris; H. Shickman Gallery, New York, 1970. Acquired June 1971.

EXHIBITIONS
February 1970, New York, H. Shickman Gallery, *The Neglected 19th Century: An Exhibition of French Paintings*, cat. no. 38, repr.

RELATED WORKS
There are innumerable interiors with male cooks in Ribot's work, including *Cook's Boy with a Blue Apron* (The Hague) and *The Young Cook* (Private Collection, Cleveland, Ohio). *The Two Soubrettes* (1872; Private Collection, Paris) has two figures in an interior, an arrangement which resembles the right section of this painting.

AS A STUDY in the way in which Ribot developed images – spending considerable effort on faces, hands, and still life – this work is important. The faces and hands reveal the touch of a master interested in expressing character and capable of revealing qualities through a study of gesture. These areas are carefully painted with several layers of pigment, whereas most of the remaining areas have been lightly sketched in to give a loose, blocky appearance to the bodies of the three genre figures.

The composition is unusual. Ribot rarely created off-centre scenes (his early *Art Dealer*, 1862, now lost, has a similar spatial arrangement). An X-ray examination revealed a wooden table at the left, with a circular object on top of it (possibly a kitchen utensil). The table provided a place where the maid (centre) could put her shallow container of milk. Exactly why the table was removed is not known; the result created the unusual spatial scene.

Kitchen Scene includes two distinct vignettes: two figures, one a young servant paying for a pail of milk; and another in which the kitchen maid moves away with a bowl of milk. The darkened interior provides no clues to the environment in which the figures have been placed. By using two episodes, however, there is a heightened sense of figures frozen in time, an interest Ribot was pursuing in the 1860s.

In the right foreground is a still life with a wicker basket, a type of detail found in Spanish seventeenth-century *bodegones* (kitchen still lifes). In these earlier Spanish works, some inconsistencies in spatial organization also occur, for instance in Diego Velasquez's (1599–1660) *Old Woman Cooking Eggs* (National Gallery of Scotland, Edinburgh). *Kitchen Scene*, therefore, suggests an alternative way of confirming a relationship between Ribot and the Spanish masters, other than by solely examining the origins of his tonal style.

There is one other point that should be mentioned. Théodule Germain, who exhibited at the Salons of the 1860s, studied under Ribot. While most of his works are lost, we know of one painting, *The Milkmaid's Payment* (*Le compte de la laitière*), which was exhibited at the 1866 Salon. *The Kitchen Scene* corresponds thematically to Théodule Germain's composition, suggesting that Ribot's influence over his pupil might account for this type of imagery. Germain may also have assisted Ribot in the completion of the figures in *Kitchen Scene*, since it was not uncommon for a student to submit a work influenced by his teacher's training to a Salon. This might have been the case with *The Milkmaid's Payment*. Until more is known about Germain's work, however, this possibility remains conjectural.

55

The Musicians

Oil on canvas

133 x 99.4 cm

INSCRIPTION
Signed l.r., *t. Ribot.*

PROVENANCE
Munkaczy sale, Paris, 1898; Christie's, London, 23 April 1971, cat. no. 144, repr.; Galerie André Watteau, Paris; H. Shickman Gallery, New York. Acquired May 1973.

EXHIBITION
October 1971, New York, H. Shickman Gallery, *The Neglected 19th Century: An Exhibition of French Paintings*, Part II, n.p., repr.

RELATED WORKS
A composition of singing street performers, *The Singers* (Mr and Mrs Noah L. Butkin Collection, Cleveland, Ohio). *Strolling Musicians* (Private Collection, England) presents street performers collecting money. There is no known painting with a similar composition.

THE MUSICIANS, one of Ribot's largest figural compositions, depicts street performers of varied ages playing instruments, with one figure who is singing. It is painted with a brighter tonal range than most of his early works, and captures the street performer as an important segment of popular Parisian culture. As in *The Singers* (see Related Works), one musician is in the background, holding a sheaf of notes to guide the instrumentalists.

The type of musical grouping is derived from Dutch cabaret scenes of the seventeenth century. Ribot, in his choice of theme, may have been inspired by the itinerant musicians that strolled in the city streets during the 1850s and 1860s. This group may also be related to the travelling circus performers in the works of Honoré Daumier (1810–1879).

The viewer's attention focuses on all the performers: the two young girls, a mandolin player, and an oboist. The aspect of sound is emphasized by the cymbals and drum played by the two girls. Dressed in street clothes, the musicians create an atmosphere of informality. As in Ribot's *Mandolin Player* (cat. no. 53), the casual grouping and the placement of other instruments at the base of the composition (along with the singing musician's shoes) suggest a studio arrangement. Once again, Ribot has posed models (possibly his two young daughters as musicians) to recreate the atmosphere of an actual performance.

The monkey, beneath the wooden bench, adds an important detail. While this animal often accompanied street musicians, its presence in the works of this period implies that it was popular for other reasons. As a standard symbol of vanity in the seventeenth century, the monkey was widely used in the early 1800s and in the 1860s. Ribot would have been familiar with Decamps's satirical images of painting connoisseurs depicted as monkeys and with Vollon's still lifes which often showed monkeys in activities similar to those in Ribot's *Musicians*. Whether Ribot also wanted to create a genre scene as a celebration of sound, using the monkey as a symbolic reference to man's pursuit of the senses, remains to be documented. It is certain that, within the realist circle, both Bonvin (cat. nos 8–10) and Vollon (who exhibited with Ribot in Bonvin's studio in 1859) completed still lifes conveying a deeper significance; they celebrated all the senses in their work. When this became a standard practice in the 1860s as part of the revival of interest in the still lifes of Chardin (1699–1779), Ribot enlarged the scope of his themes by expressing the themes in the guise of a genre scene.

Further examination of the varied symbolic levels of meaning within realist imagery will clarify the full significance of *The Musicians* which, in its size and rough application of the paint (especially on the singer at the right), suggests a naturalism derived from Gustave Courbet (1819–1877).

THÉODULE AUGUSTIN RIBOT

56

Boy Singing

Oil on canvas

46.8 x 38.7 cm

INSCRIPTION
Signed l.r., *t. Ribot.*

PROVENANCE
Anonymous sale, 26 June 1942; H. Schickman Gallery, New York. Acquired September 1971.

RELATED WORKS
Ribot seldom painted a singer as an individual study. One other single singer exists (panel; location unknown) in a photograph in the archives André Watteau. Also, his paintings of singers without musical instruments are rare, but there is one in *The Singers* (Mr and Mrs Noah L. Butkin Collection, Cleveland, Ohio).

THIS UNFINISHED STUDY comes close to being a *tête d'expression*. As such, Ribot has posed a model, with a garment draped over one shoulder, to capture the momentary expression of a youth singing. Other Realist painters, notably Alexandre Antigna (1817–1878), often used studio models to record unusual reactions and to provide a broad range of facial expressions.

If this painting can be placed early in Ribot's development, when he was influenced by studies from the nude completed in Glaize's studio, then the smooth surface of the paint can be more easily explained. More often, in his later canvases, Ribot built up the paint surface to give a strong textural quality.

Boy Singing can also be seen as an exercise enabling Ribot to grasp spontaneous human expression as part of the lingering Baroque tradition. He may have studied Dutch and Italian painters of the Caravaggesque tradition; the youth's fleeting expression recalls certain paintings by Caravaggio (1573–1610), thereby suggesting that Ribot was familiar with the Italian seventeenth-century naturalist tradition.

This canvas could be one of the few preliminary oil studies that Ribot did for a larger, more involved work – perhaps, in this case, as a study for a larger version of *The Singers* (see Related Works). Ribot's method of working directly on canvas, without detailed preliminary drawings or oil sketches, resembles that of Manet and Vollon, who wanted to capture their own reactions to observed reality without carefully working out their compositions before they began painting.

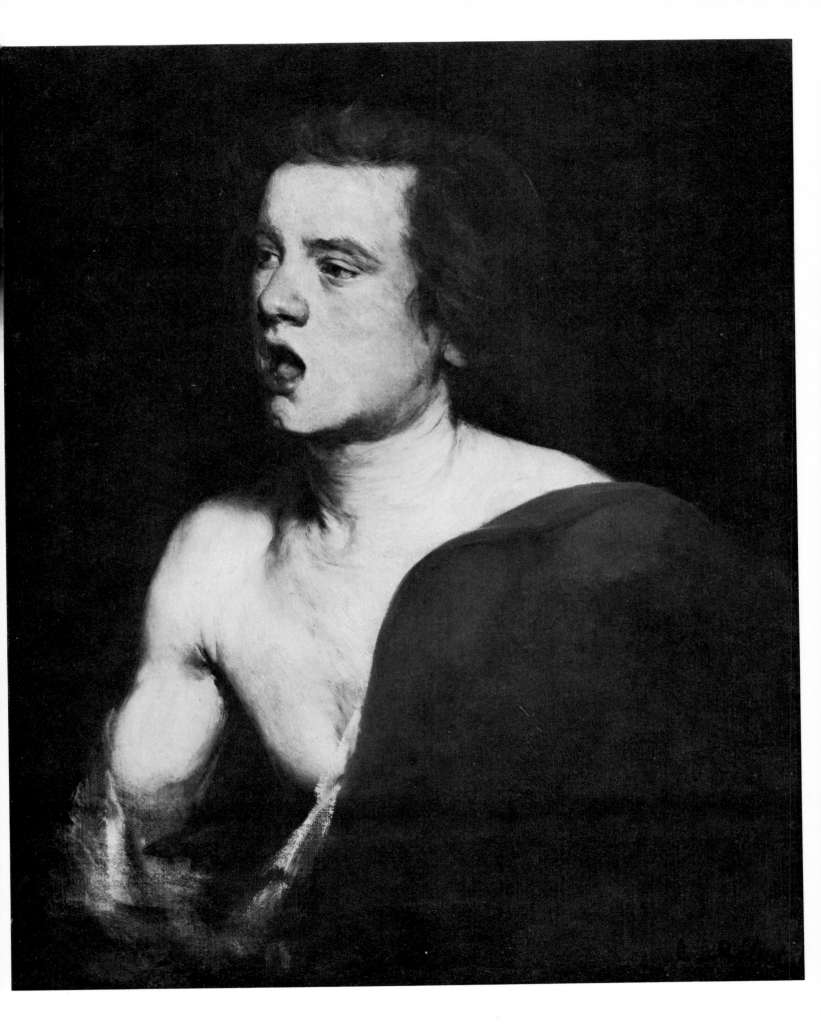

THÉODULE AUGUSTIN RIBOT

57

Still Life with Ceramic Jug, Eggs, and Knife

Oil on canvas

39.3 x 46.4 cm

INSCRIPTION
Signed l.l., *t. Ribot.*

PROVENANCE
Kaplan Gallery, London; Arcade Gallery, London; H. Shickman Gallery, New York. Acquired November 1972.

RELATED WORKS
A similar ceramic jug is found in *Still Life with Eggs on a Dish* (Musée du Haubergier, Senlis). Another is in a still life, *Carboy* (Johannesburg Art Gallery). A large, horizontal still life, with a different type of ceramic jug, is in the colletion of Dr and Mrs Sherman E. Lee, Cleveland, Ohio.

THE SOMBRE TONES of Ribot's still lifes convey a rugged realism, a quality made more emphatic by the coarseness of paint application. In this painting, Ribot has not built up the surface of the canvas with pigment; nevertheless, the grainy texture, noticeable in the ubiquitous ceramic jug, records how he conveyed the tactile quality of earthenware.

Exactly when Ribot began to paint still lifes is not known, although one work is listed as being exhibited in Rouen in 1862. Ceramic objects were often included in his genre compositions, demonstrating that from the outset of his career, Ribot devoted considerable attention to two aspects of realist art: the still life and genre themes. He produced fewer still lifes than did his friends François Bonvin and Antoine Vollon, both of whom were recognized as painters who made their living from doing still lifes. Ribot's are usually arrangements of a few common objects on a ledge or table; and he often suggests the important peasant meal by painting eggs, or a water container, and other details.

His canvases created a Spanish atmosphere, partially by using earthenware jugs (as in this painting) which suggest the foreground objects in the *Water Carrier of Seville* by Diego Velasquez. We do not know if Ribot actually went to Spain, but his interest in an earthy, still-life setting, using simple objects, and in a direct, raking light, suggests the Spanish influence and removes any hint of the fashionable aspects of still lifes, such as those by Philippe Rousseau (1816–1887), another contemporary Realist painter.

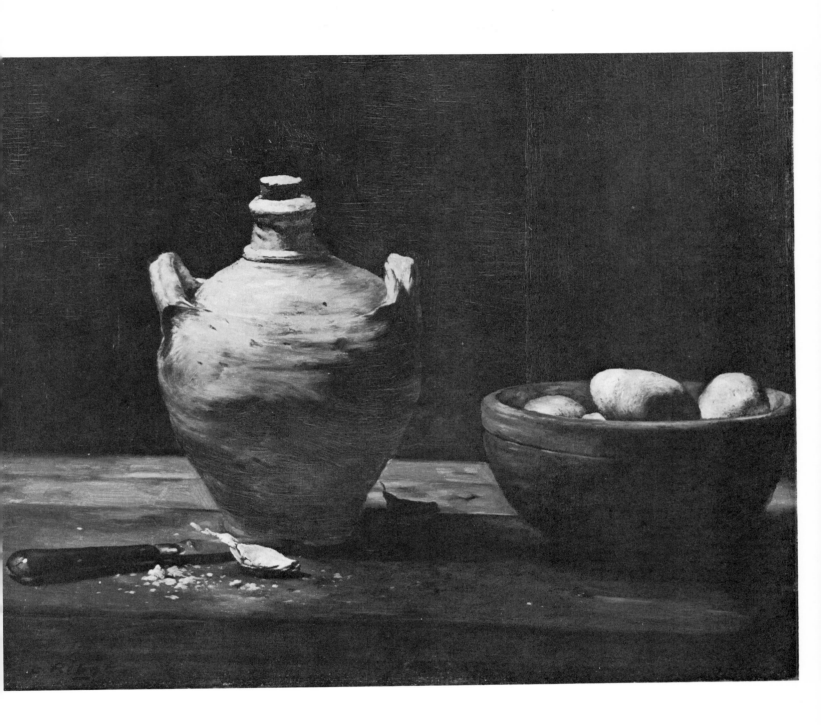

THÉODULE AUGUSTIN RIBOT

58

Still Life

Oil on canvas

92 x 73 cm

INSCRIPTION
Signed l.l., *T. Ribot.*

PROVENANCE
H. Shickman Gallery, New York. Acquired
November 1974.

EXHIBITION
October 1971, New York, H. Shickman Gal-
lery, *The Neglected 19th Century: An Exhibition of
French Paintings*, Part II. n.p., repr.

RELATED WORKS
In the archives of André Watteau, Paris,
there are no other paintings with exactly
this grouping of objects.

ANOTHER EXAMPLE of Ribot's love of
still-life painting, this work reveals the
artist's preoccupation with texture and
transparency. Like his pupil, Antoine
Vollon, Ribot keenly observed the
effects of light on the stationary objects
he studied in his atelier. In this work,
the rustic simplicity of his still lifes has
been modified by a dignified selection of
objects and by an exacting light that
falls on the shapes in the centre of the
composition. The environment is unim-
portant; Ribot focuses on the solidity of
the green pears and eggs in the ceramic
platter.

Ribot's use of simple objects that
often suggest a peasant meal was
repeated by his children, Germain and
Louise, who also became able still-life
painters. Germain (1845–1893) had
been a student of his father and Vollon,
and first exhibited at the 1875 Salon.
He exhibited continuously at the Salons
throughout the 1870s. Louise
(1857–1916) exhibited at the Salons in
the late 1870s and one of her still lifes
(Salon, 1884) was bought by the French
government for exhibition in the
museum of Douai. Both children
undoubtedly contributed to the interest
in still life throughout the century.

It was only Théodule, however, who
seems to have painted on a large scale,
paying full attention to the textural
qualities of the objects he selected. His
still lifes document how he was able to
capture the tangible aspects of the
objects, giving them permanence and
individuality. In this, he was never
equalled by the more limited range of
his son or daughter. His painting style is
similar to Cézanne's (1839–1906), but
Cézanne examined the intrinsic struc-
tural qualities of still-life objects even
more stringently than did Ribot.

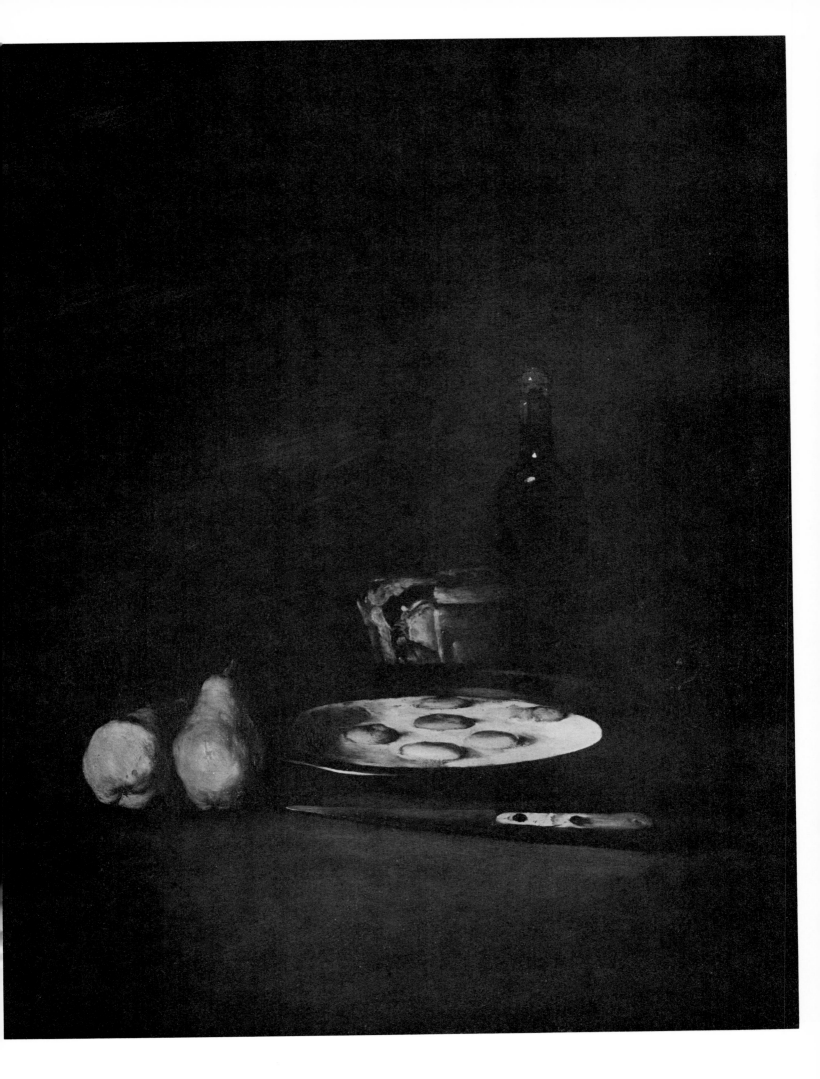

THÉODULE AUGUSTIN RIBOT

59

Portrait of a Young Woman *c.* 1880
Oil on canvas
93.5 x 65.5

INSCRIPTION
Signed l.r., *t. Ribot.*

PROVENANCE
October 1971, New York, H. Shickman Gallery, *The Neglected 19th Century: An Exhibition of French Painting*, Part II, n.p., repr.

RELATED WORKS
There are two drawings of this model. In one (1878; Private Collection, Paris) the model appears to be younger than in this painting. The second is undated and known only through a photograph in the archives of André Watteau. Another painting of two girls – one looking at the spectator and the other reading – was owned by the H. Shickman Gallery, New York (present location unknown). The girl looking at the viewer is the model in this painting.

DURING THE LATE 1870s and early 1880s, Ribot concentrated on studies of Breton peasants and large portraits of studio models, friends, and family. The same sombre palette that had predominated in Ribot's genre scenes and studies of children during the 1860s was modified in later portraits by the addition of a more dramatic light effect on the sitter's face.

As Ribot became more interested in psychological portraiture, his canvases emphasized qualities that reveal a careful study of Rembrandt's work. The same dramatic lighting of the face and the same intense Rembrandtian treatment of a sitter's personality create a distinct impression of a model's temperament. Similarly, by building up the surface – especially in the facial area – with several layers of paint, Ribot increases the tactile quality. In *Portrait of a Young Woman*, the background remains dark and the girl's hair is loosely brushed in. The viewer concentrates on the face. The young model returns this emphasis by looking in the viewer's direction – a standard device in Ribot's later portraits.

Ribot completed several paintings with the same model (possibly his daughter Louise), and maintained an accurate chronicle of his relatives and family through his work. This portrait tradition had been well established by earlier Realists – especially Alexandre Antigna – whose canvases of their families often revealed a penchant for intense observation and psychological examination.

The late Ribot portraits, in which faces seem to emerge out of darkness, were of importance to Eugène Carrière (cat. nos 15–18), an artist who is best known as a Symbolist and whose Realist origins are found in studies of his family done in tones reminiscent of Ribot.

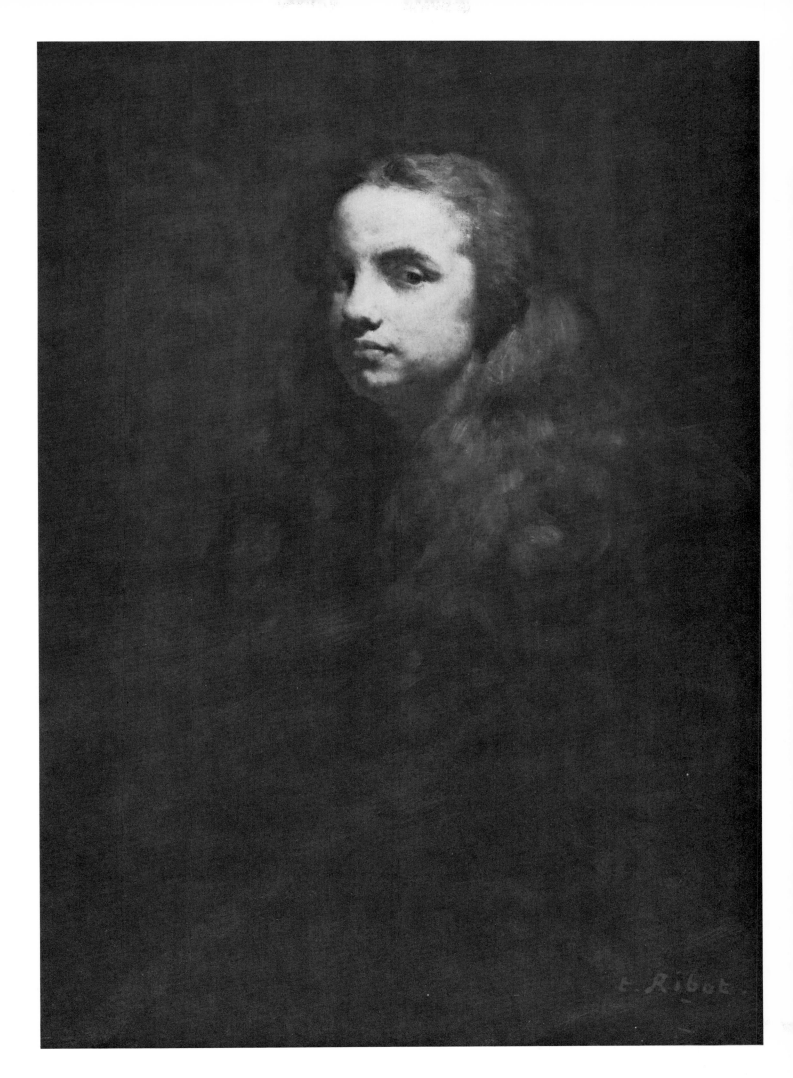

THÉODULE AUGUSTIN RIBOT

60

Old Man Reading

Oil on canvas

121 x 85 cm

INSCRIPTION
Signed l.r., *t. Ribot*

PROVENANCE
Galerie André Watteau, Paris; H. Shickman Gallery, New York. Acquired November 1973.

EVEN THOUGH RIBOT SUFFERED from ill health in his later years, he continued to paint portraits, especially of older figures, both men and women. He observed them with compassion, and his portraits went beyond recording surface detail to suggest their humanity and wisdom. In *Old Man Reading*, he evokes sympathy for this solitary figure (reminiscent of Rembrandt's aged philosopher as well as Manet's *Old Man Reading*, 1861), who adds a brilliance to his later portraits.

In this work, Ribot continued to focus on face and hands, examined in intense light as in earlier examples (see cat. no. 54), except that he showed the skin of the old man, ravaged by time. The ruddy complexion, depicted by the building up of a thick paint impasto, conveys a weathered face, appropriate to the man's age. Age is also conveyed by the man's beaklike nose and pitted skin. The tightly drawn lips, almost completely hidden beneath a white beard, indicate the man's intense concentration on a book he holds tenderly in gnarled hands. Ribot's varied painting manner is indicated by his handling of the white beard, in which the roughly applied paint suggests the texture of hair.

The later works are a fitting climax to a career dedicated, at least partly, to capturing the inner character of his sitters. His last portraits transcend realism and psychological naturalism to become moving statements about humanity, and establish a mature style for a painter who, sadly, has been overshadowed by his contemporaries.

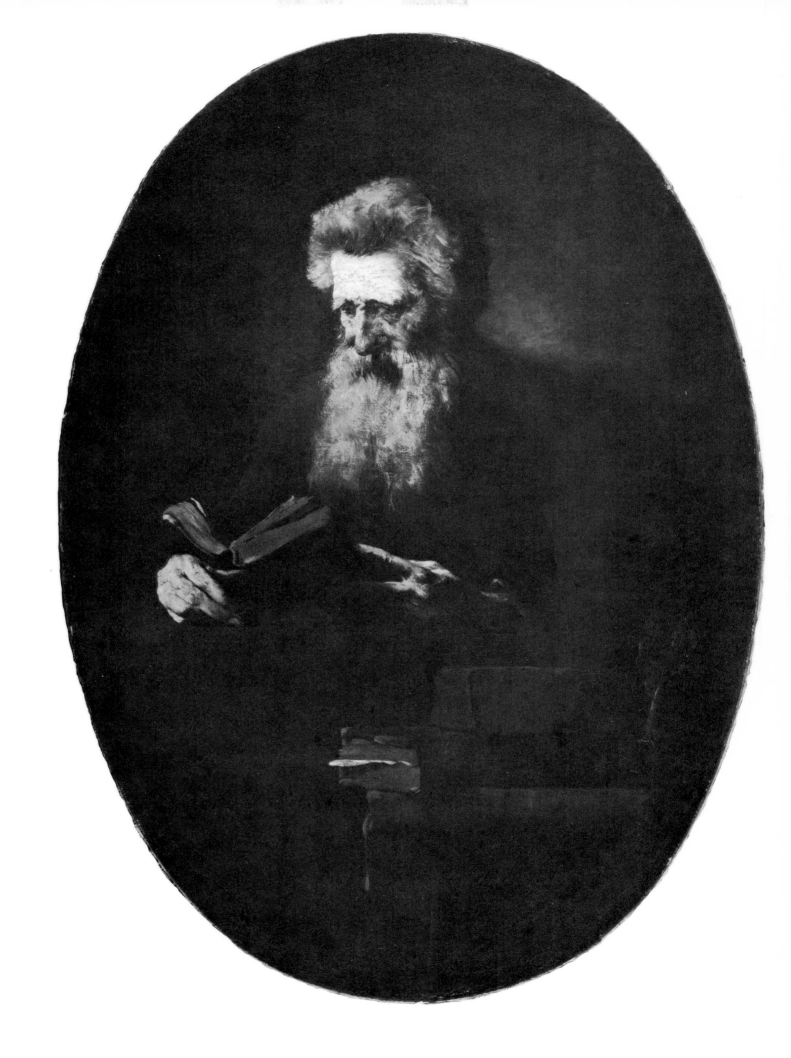

FERDINAND ROYBET

Uzès (Gard) 1840 – Paris 1920

ROYBET STUDIED ENGRAVING under Victor Vibert (1799–1860) at the École des Beaux-Arts in Lyons from 1857 to 1858 and then taught himself to paint from the example of works in the Musée des Beaux-Arts, Lyons. He was most strongly influenced by Dutch and Flemish paintings by Rembrandt, Hals, Jordaens, and Rubens, whom he studied further during a trip to the Lowlands in 1871. He also travelled to Algeria at this time. Seventeenth-century Spanish painting was another important source, so much so that Roybet's works were occasionally attributed to artists such as Velasquez (1599–1660).

In 1864 Roybet moved to Paris, where he went first to a fellow Lyonnais painter, Antoine Vollon (cat. nos 70, 71). Vollon introduced the newcomer to his own master Théodule Ribot (cat. nos 52–60), who reportedly paid twenty francs for Roybet's first painting, a scene of a maid in an interior. In 1865 the artist's first Salon submissions included two etchings done for the Société des Aquafortistes, as well as two paintings. Thereafter he devoted himself to painting. He obtained material success almost immediately, but its consequences were less happy and he became a widely discussed example of an artist very nearly ruined by his relationships with dealers. His reputation was established when he sold *A Court Jester of Henry III* (1866; Grenoble) to Princess Mathilde, cousin of Napoleon III. In 1868, he contracted to a Paris dealer, who guaranteed an annual income of 25,000 francs in return for the delivery of three paintings a month. By 1872 Roybet's arrangements were both more rewarding and more demanding. He ceased to exhibit at the Salon and worked principally for his dealers, including Hector Brame, and for patrons such as Alfred Chauchard and William Vanderbilt, producing scenes of flirtation, gambling, and conviviality, usually set in inns of the sixteenth and seventeenth centuries. He so exceeded his comfortable income by his casual expenditures that in 1884 creditors seized even his home and studio in Paris.

After reassessing his career and financial habits, Roybet made a much-heralded return to the Salon in 1892, painting fashionable portraits, in which the sitters often appear in period costumes; and less raucous genre scenes (*The Philosopher, The Astronomer, The Geographer*) for which such fellow artists as Albert Waltner, Antoine Guillemet, J.P. Laurens, and Jules Lefebvre posed. He also attempted a major history painting, *Charles the Bold at Nesles* (1890), which was the central work in a retrospective exhibition held at the Galerie Georges Petit in 1890. Roybet remained an active contributor to the Salons until the outbreak of World War I forced their suspension. His death in Paris was little noted and marked the beginning of a period of almost total neglect from which the artist is now emerging. The Musée Roybet-Fould in Courbevoie (suburb of Paris) exhibits many of his later works.

EXHIBITIONS
Paris Salons of 1865–1868 and 1892–1903, 1906, 1909, 1911, 1913, and 1914. Universal Exhibitions: Vienna, 1873; Paris, 1900; San Francisco, 1915.

AWARDS AND HONOURS
Medal, Salon of 1866; Medal of Honour, Salon of 1893; Chevalier (1892) and Officer (1900) of the *Légion d'Honneur*.

BIBLIOGRAPHY
Anon., "Au jour le Jour – Les Médailles d'Honneur d'Hier," *Le Temps*, 27 May 1893. J.P. Burgan, "F. Roybet," *L'Œuvre d'Art*, vol. 11 (February 1903).

C.C.H.

61

A Standard Bearer *c.* 1870–1880
(*Le Porte-étendard*)

Oil on panel

81.3 x 65.5 cm

INSCRIPTION
Signed l.l., *F. Roybet*.

PROVENANCE
Schweitzer Gallery, New York; Frederick Thom Gallery, Toronto. Acquired December 1968.

EXHIBITIONS
October – December 1974, Hempstead, N.Y., Emily Lowe Gallery, Hofstra University, *Art Pompier, Anti-Impressionism 19th-Century French Salon Painting*, cat. no. 77 (repr.).

A STANDARD-BEARER is typical of the many works painted by Roybet during the 1870s and 1880s. It capitalizes on the vogue which artists like Meissonier had created for cavaliers in picturesque sixteenth- and seventeenth-century costumes. Behind it, too, lie images drawn from the romantic theatre and the novels of authors like Alexandre Dumas *père*. Roybet distinguishes himself by painting on a larger scale and then presenting more complicated poses and passages of drapery, as well as more elaborate settings. Whereas the graceful figures in Meissonier's panels are carefully delineated and each detail is exactly finished (see cat. no. 49), Roybet, reflecting his study of Dutch and Flemish painters such as Franz Hals (1581/5–1666), outlines forms more roughly and suggests textures and details with looser slashes of the brush, giving his sturdy subject greater vigour. He employs a variety of eye-catching colours in the costume and banner, especially red and yellow-gold, but unifies even local colours through the addition of greys, thereby increasing tonal harmony.

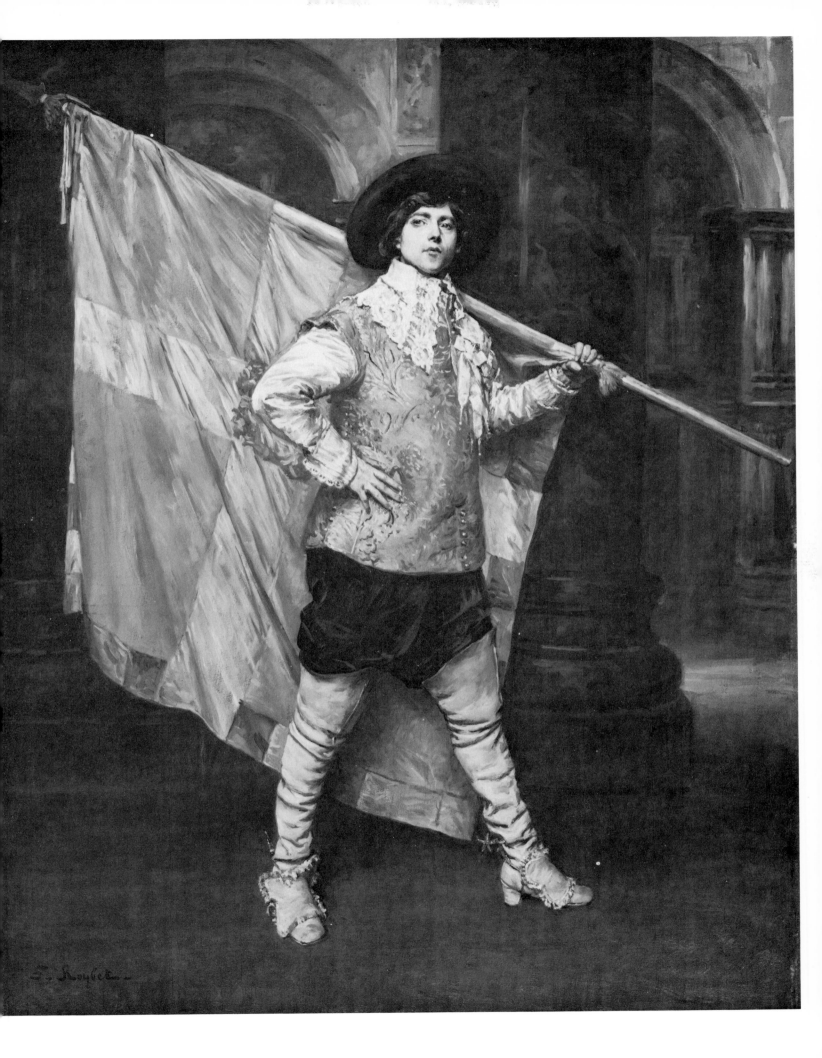

62

A Poet *c.* 1901
Oil on panel
82 x 65 cm

INSCRIPTION
Signed l.r., *F. Roybet.*

PROVENANCE
H. Shickman Gallery, New York. Acquired
September 1971.

EXHIBITIONS
October 1971, New York, H. Shickman Gal-
lery, *The Neglected 19th Century: An Exhibition of
French Paintings,* Part II, n.p., repr.

THE WORKS WHICH ROYBET exhibited at
later Salons, after a twenty-four-year
absence from the public view, included
portraits, often of friends, and such psy-
chological studies of introspective or
scholarly gentlemen as this *Poet.* The
greater element of aristocratic dignity
parallels Meissonier's evolution in later
works such as *A Philosopher* (cat. no. 49).
Roybet relies less on intriguing accesso-
ries and costumes and instead focuses on
the inwardly searching expression of his
subject. The simple, muted colour con-
trasts of the black hair of the poet, the
fur trim, the brown robe, and the deep
emerald green background enhance the
seriousness of the sitter's reflections,
while the quick, spontaneous strokes
which suggest the pattern of the table
cloth and the lace at the man's throat,
together with the heavier touches of
paint which sculpt the flesh, give the
figure a vivid physical presence. The
unidentified model for this work
appears in several other paintings, nota-
bly the *Duc d'Orbieno* (Amiens) and *The
Scholars* (1901).

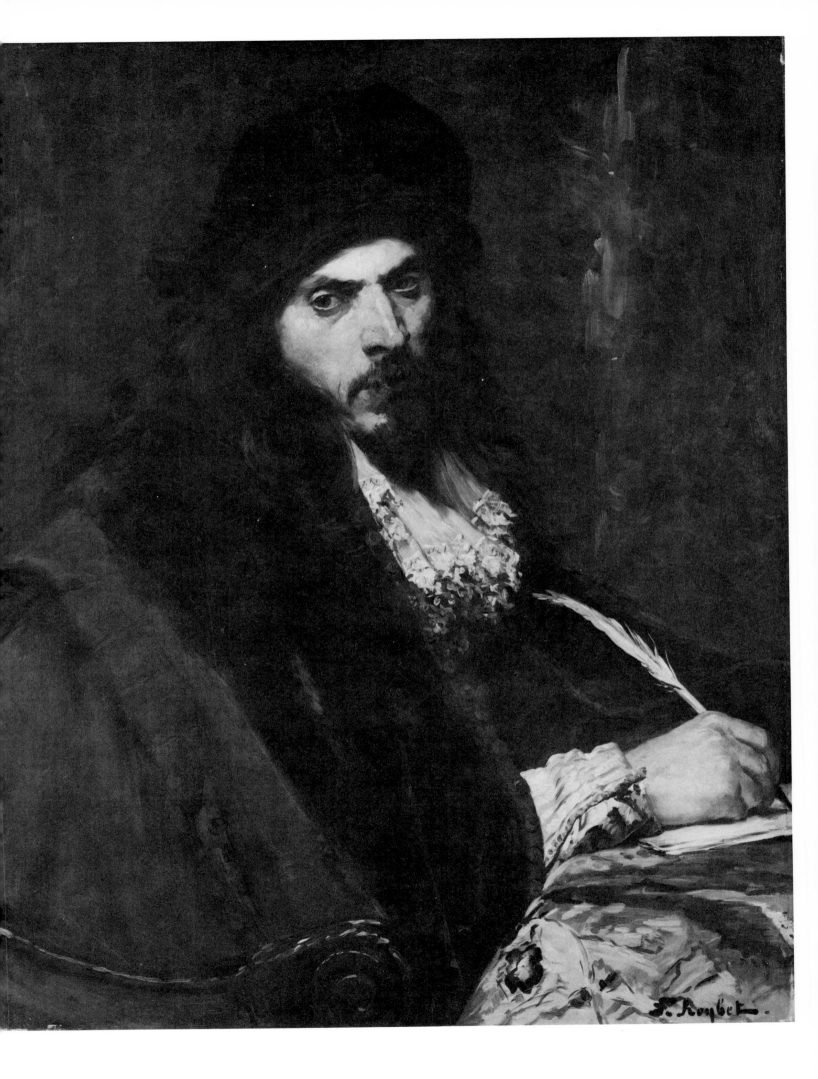

63

Profile of a Boy *c.* 1865–1870

Oil on canvas

47 x 38.5 cm

INSCRIPTION
Signed l.r., *F. Roybet.*

PROVENANCE
Shepherd Gallery, New York. Acquired
November 1969.

IN THIS PAINTING, modest in both its
subject and scale but strikingly direct in
its execution, Roybet is at his best.
Though hailed as a colourist by some
writers, he here makes abundantly clear
his principal debt to Dutch, Flemish,
and Spanish masters such as Hals, Rib-
era, and Velasquez, and to immediate
French predecessors such as Couture
(cat. nos 20–22), Ribot, and Manet
(1832–1883). With them he shares not
only the anonymous, low-life subject (in
this painting, probably a studio model),
but also the primary concern with
painting through contrast and juxtapo-
sition of tones – black, white, greys, and
beige – rather than hues. The pale
profile face is dramatically set off
against the dark background and indis-
tinct body and is modelled with a rich
range of intermediate shades. Even the
skin tints are neutralized as pure colours
by the addition of grey. Roybet refrains
from any fussy detail: the body and cap
are only schematically outlined. Avoid-
ing the gratuitous bravura sometimes
found in his more ambitious works, he
applies the almost tangible pigment
with masterful freedom. One sees the
justice of his contemporaries' praise for
his ability to *cuisiner une bonne peinture* (lit-
erally, "to cook up a good picture").

Roybet's chronology is only approx-
imate, since he left many works
undated, even among those which he
exhibited publicly. The date of this
work is more open to question than the
Standard-Bearer (cat. no. 63) or *A Poet*
(cat. no. 62), since it is a relatively pri-
vate one, more suggestive of a study
than a carefully conceived and finished
painting. Because of its affinities with
the work of the French masters of tonal
painting, it probably dates early in
Roybet's career, about 1865–1870.

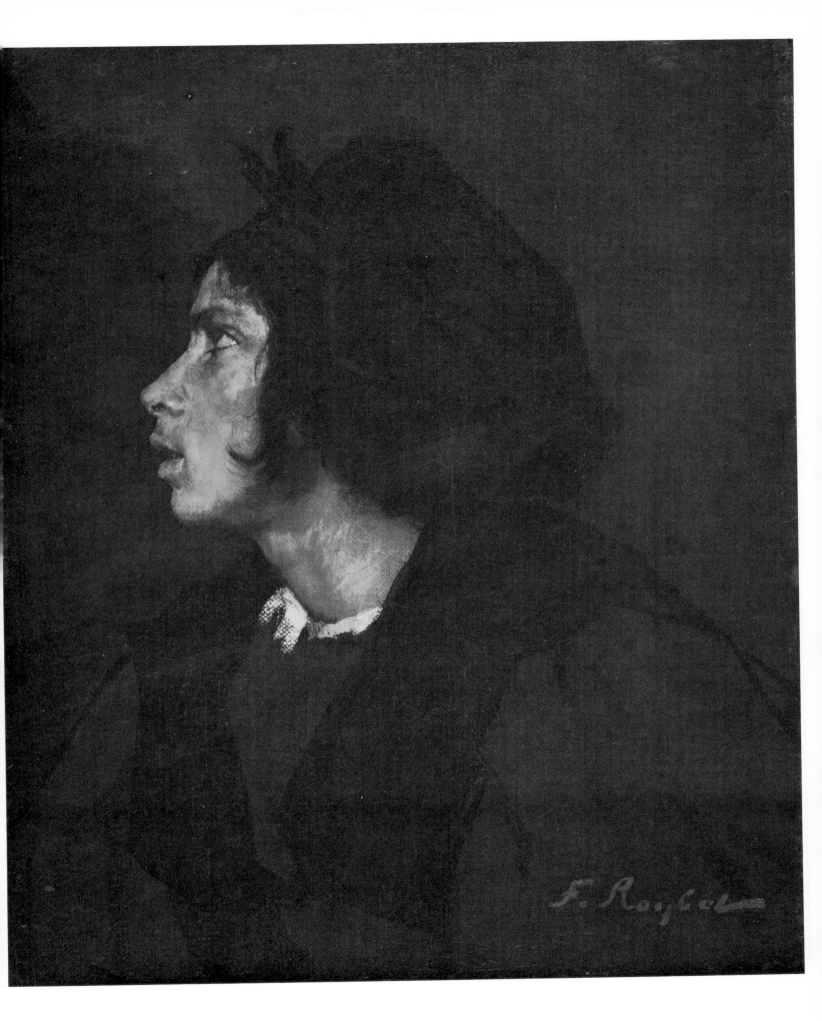

ALFRED ÉMILE LÉOPOLD VICTOR GHISLAIN STEVENS

Brussels 1823 – Paris 1906

A PUPIL OF FRANÇOIS-JOSEPH NAVEZ (1787–1869) in Brussels, Stevens went to Paris in 1844, where his family name had already been brought to public attention by his elder brother Joseph. By the 1860s he was established within his specialist genre painting and became extremely successful. He is now considered to be the most famous Belgian painter of the nineteenth century. He had notable international patrons, including King Leopold I of Belgium, and was actively supported by his younger brother Arthur, a critic and dealer. He made many friends with the artists of the pre-Impressionist generation, especially Manet, Degas, Courbet, and Boudin, and among his friends in the literary, theatrical, and social world he counted Baudelaire, Sarah Bernhardt, and Princess Mathilde (whose famous salons were attended by such well-known people as the Goncourts and Flaubert). Despite his active participation in Paris social and artistic life, Stevens was still able to enjoy a close family life with his wife and four children.

His celebrity was sufficiently enduring that, in 1900, towards the end of his career, he was accorded a one-man exhibition at the École des Beaux-Arts, the first living artist to be so honoured.

EXHIBITIONS
Brussels and Paris Salons of 1851–1884. Antwerp Salon of 1855, 1885. Brussels, Historical Exhibitions of Belgian Art, 1905.

AWARDS AND HONOURS
Medal, Paris Salon of 1853; Second-Class Medal, Paris Salon of 1855. First-Class Medal, Paris Universal Exhibition, 1867; Grand Prize, Paris Universal Exhibition 1889, 1900. Chevalier (1863), Officer (1867), Commander (by 1878) of the *Légion d'Honneur*. Grand Officer of the Order of Leopold. Commander of the Order of Franz-Joseph (Austria) and of the Order of Saint-Michael (Bavaria). Order of the Lion of the Netherlands.

BIBLIOGRAPHY
François Boucher, *Alfred Stevens*, monograph, Paris: Art Vivant, 1930. William A. Coles, *Alfred Stevens*, exhibition catalogue, Ann Arbour: University of Michigan Museum, 1977. Camille Lemonnier, *Alfred Stevens et son œuvre*, Brussels: G. Van Oest, 1906. Peter Mitchell, *Alfred Émile Léopold Stevens 1823–1906*, London: John Mitchell and Sons, 1973. François Monod, *Un peintre des Femmes du Second Empire: Alfred Stevens*, Évreux, 1909.

Retrospective Alfred Stevens, Charleroi: Palais des Beaux-Arts de Charleroi, 1975. Alfred Stevens, *Impressions sur la Peinture*, Paris: Librairie des Bibliophiles, 1886; translated by Charlotte Adams in *Impressions on Painting*, New York, 1886, and Mary White, *A Painter's Philosophy*, London, 1904. Gustave Van Zypes, *Les Frères Stevens*, Brussels: Nouvelles Sociétés d'éditions, 1936.

P.M.

64

Consolation *c.* 1875
Oil on mahogany panel
81 x 64.2 cm

INSCRIPTION
Signed l.l., *A Stevens*

PROVENANCE
James Coats, New York; Sotheby's, London, 10 December 1969, cat. no. 123, repr.; H. Shickman Gallery, New York. Acquired August 1971.

EXHIBITIONS
October 1971, New York, H. Shickman Gallery, *The Neglected 19th Century: An Exhibition of French Paintings*, Part II, n.p., repr.

THE THEME OF CONSOLATION is a familiar one in the artist's work. In his formative years, Stevens had, no doubt, made a careful study of the subject as seen in the work of Dutch and Flemish artists of the seventeenth century. Indeed, their influence prompted one critic to dub Stevens the Terborch of France. However, his range of interpretation and variation was wider than that of the earlier masters. In his paintings treating the theme of consolation, each letter brings news ranging from the frivolous to the heart-breaking. Stevens explored every nuance of the effect on the recipient, and consequently the degree of appropriate consolation. In one painting, now entitled *After the Ball* (1874; Metropolitan Museum of Art, New York), the news in the letter seems to be more serious than in *Consolation*; an affair of the heart is clearly ended, and the rejected lady leans forward in distress, supported by her companion, who endeavours to console her. Whereas in the Metropolitan painting their tightly grasped hands express perfectly the gravity of the situation, in this painting, the companion just lightly touches the hand of her friend.

It is not inappropriate to dwell upon such details as these in examining the attraction of Stevens's work. Through the fidelity of every expression, attitude, and detail, Stevens created a convincing scene from the life of the fashionable Parisian ladies. His portrayals placed him in the vanguard of the modern movement and were the basis of his success. He could confidently depict every detail of the sumptuous costumes and interiors of the period without the danger of empty, fashion-plate sterility – the fate of many of his imitators.

Stevens often indirectly suggested the theme of consolation in his paintings of single figures, where the viewer is drawn into the role of sympathiser, or invited to share a mood of introspective reverie. *Memories and Regrets* (*c.* 1875; Clark Art Institute, Williamstown) is a typical example. The setting in this painting is necessarily intimate, and no place is more appropriate than the conservatory. This typically luxurious setting includes a folding screen and bamboo furniture, recalling the artist's interest in Japanese art. The white dress of the heroine is similar to many seen in other works, but the grenadine and white dress of her friend is unusual and striking.

Based upon evidence that is now lost, *Consolation* has been dated circa 1870–1875. Judging from its execution, it could be that the panel was done later, and may date from the following decade.

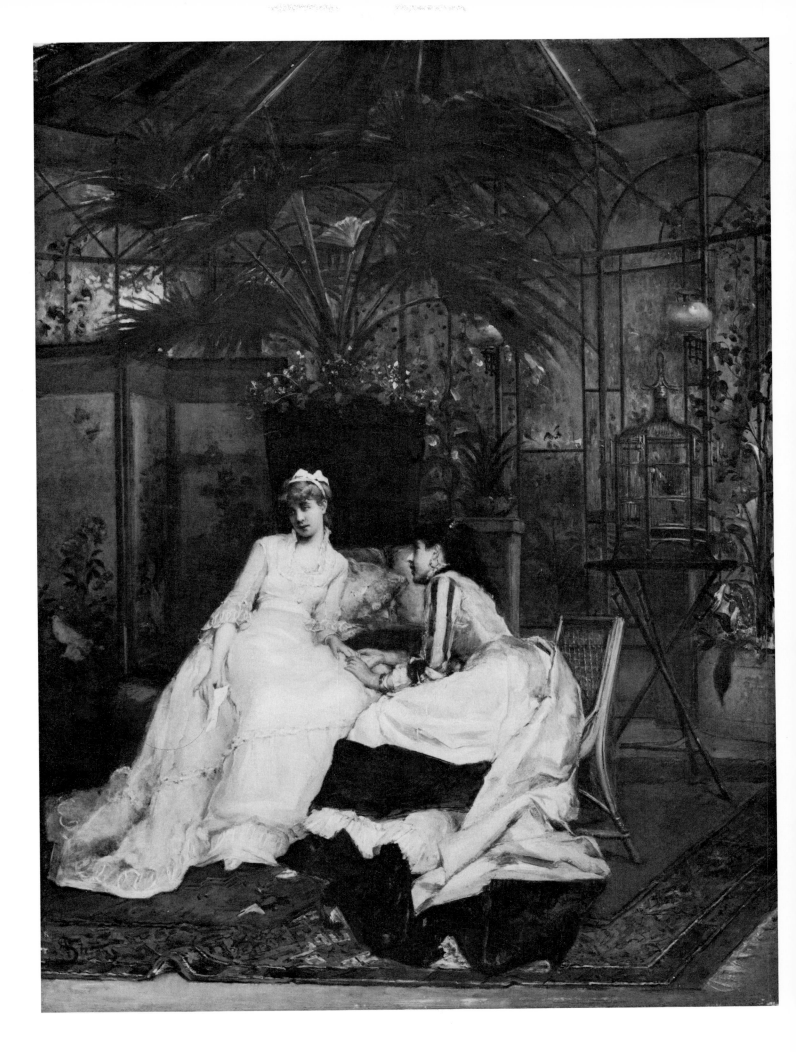

JAMES (JACQUES JOSEPH) TISSOT

Nantes 1836 – Buillon (Doubs) 1902

ARRIVING IN PARIS from Nantes in the mid-1850s, Tissot entered the École des Beaux-Arts in 1857 under the sponsorship of his teacher, Louis Lamothe (1822–1869). When he made his debut at the Paris Salon of 1859, he was already calling himself James. He exhibited regularly at the Salon until 1870. His earlier works, mediaeval costume pieces in the manner of Belgian painter Hendrik Leys (1815–1869), gradually gave way to paintings of women in contemporary dress, with occasional paintings of figures in costume of the Directoire period (1795–1799).

Tissot participated in the defence of Paris during the Franco-Prussian War; then, for political reasons unknown to us, he became involved in the Paris Commune of 1871. With the fall of the Commune, he found it necessary to leave Paris, and spent the next eleven years in London where he established a successful second career as a portraitist and a painter of genre scenes. He was a regular exhibitor, first, at the Royal Academy in London and, later, at the Grosvenor Gallery. In 1874 he took a trip to Venice with Manet and his wife. It was after this that he established a liaison with a beautiful Irish divorcee, Kathleen Newton, who appears regularly in his increasingly more idyllic genre scenes after the mid-1870s. Her death in 1882 prompted his return to Paris where he attempted to take up again the thread of his career, first with a one-man exhibition at the Palais de l'Industrie (1883) and then with the exhibition of the *The Woman of Paris (Femme à Paris)* series in 1885. While working on a painting for this series, Tissot experienced a religious reawakening which made him decide to dedicate his life to illustrating the life of Jesus. To this end he spent about two years (not ten as sometimes stated) in the Holy Land doing research and making studies. The resulting *Life of Christ* series (365 gouache paintings) was a sensation when it was shown in Paris (1894 and 1895), London (1896), and in several American and Canadian cities (1898–1900). The artist visited New York and Chicago in conjunction with the openings in those cities.

While working on improvements on the grounds of the Château de Buillon, inherited from his father in 1888, Tissot developed a fever which led to his death, thus cutting short his second series of religious works, *The Old Testament*. The château's location on the grounds of a ruined Cistercian monastery led to the pious fiction that Tissot's last years had been spent in the seclusion of a religious community. He is buried beside his mother in a chapel that she had erected on the château grounds many years earlier.

EXHIBITIONS
Paris Salons of 1859–1870. London, Royal Academy, 1864, 1872–1876, 1881. 1877–1879, London, Grosvenor Gallery.

AWARDS AND HONOURS
Honourable mention, Salon of 1861; medal, Salon of 1866. Chevalier of the *Légion d'Honneur*, 1894.

BIBLIOGRAPHY
Georges Bastard, "James Tissot," *Revue de Bretagne*, series 3, LXIV, November 1906, 253–278. David S. Brooke, Michael Wentworth, and Henri Zerner, *James Jacques Joseph Tissot: A Retrospective Exhibition*, Providence: Rhode Island School of Design, 1968. James Laver, *Vulgar Society: The Romantic Career of James Tissot*, London: Constable & Co., 1936. Willard E. Misfeldt, *James Jacques Tissot: A Bio-critical Study*, Ph.D. dissertation, Washington University, St. Louis, 1971.

W.E.M.

65

The Staircase 1869
(*L'escalier*)

Oil on canvas
56.5 x 38.8 cm

INSCRIPTION
Signed and dated l.l., *J.J. Tissot/1869*.

PROVENANCE
Christie's, 17 May 1923 (sold to Nicoll); M. Newman, 1962; James Coats, New York. Acquired February 1968.

EXHIBITIONS
1968, February–March, Providence, Rhode Island School of Design and April–May 1968; Toronto, Art Gallery of Ontario, *James Jacques Joseph Tissot: A Retrospective Exhibition*, cat. no. 11, repr.

RELATED WORKS
A drawing in the Allen Staley collection, Philadelphia (Providence – Toronto, cat. no. 43). *Melancholy*, ex-collection Charlotte Frank, 1868. *Young Ladies Looking at Japanese Articles*, 1869 (two paintings of the same title: one in a private collection in Cincinnati; the other, unlocated).

A YOUNG WOMAN IN A WHITE MORNING DRESS, a garment which also appears in three other Tissot paintings (see Related Works), stands on a stair landing, gazing wistfully through an interior leaded window into a salon below, as if in hope or anticipation. She holds some soft-bound books and a letter. In this painting, as well as in others (*The Letter*, Sir John Gielgud collection; *The Letter*, National Gallery of Canada), Tissot has used the theme of the letter, a favourite Victorian narrative device, to hint at a story which must be imagined by the viewer. Unrequited love or frustration in love is frequently the theme conveyed by this device.

The setting for this painting may be the new house that Tissot built on the fashionable Avenue de l'Impératrice (now the Avenue Foch) near the Bois de Boulogne on property acquired in 1866. This house, an *hôtel particulier*, no longer exists.

It was three-storied with a courtyard and a small garden. The studio, located on the top floor, was reached by a stairway that may be the one seen here. Even though the setting may not actually be Tissot's new house, the elegance of the setting does reflect the success and prosperity he was enjoying at this time. This success may have occasioned the shift in his thematic interests from his earlier Leysian paintings of mediaeval subjects to fashionable young women in upper-class contemporary settings.

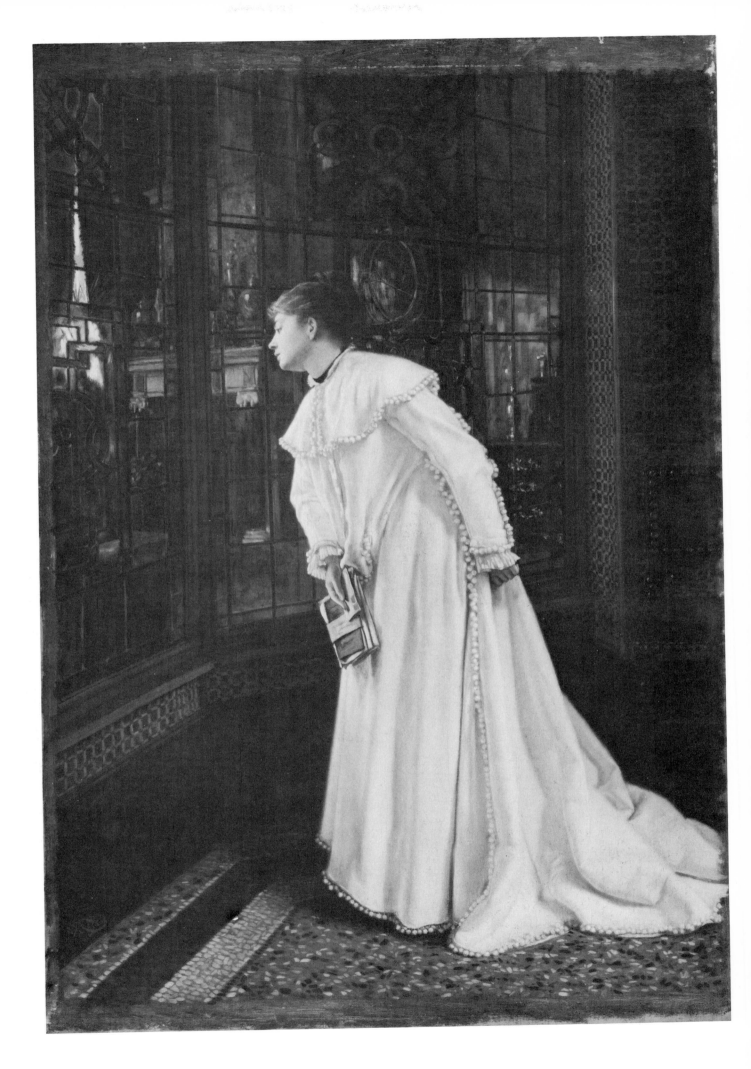

66

The Ball on Shipboard (study) 1874

Oil on canvas

94.5 x 66 cm

PROVENANCE
Paul Séguin Bertault, Paris; Count François de Vallombreuse, Paris; Sotheby's, London, 25 October 1977, cat. no. 174, repr. colour. Acquired October 1977.

EXHIBITION
February–March 1968, Providence, Rhode Island School of Design, and April–May 1968, Toronto, Art Gallery of Ontario, *James Jacques Joseph Tissot: A Retrospective Exhibition*, cat. no. 20, repr.

RELATED WORKS
The Ball on Shipboard, Tate Gallery, London.

THIS SKETCH is a preliminary study for the Tate Gallery painting exhibited at the Royal Academy in 1874 (no. 690, fig. 5). But the differences between the number and poses of figures in this sketch and the comparable section of the finished painting suggest that Tissot may have thought of the study as having the potential for an anecdotal composition complete in itself.

In the background a gentleman leaning against the railing of the poop deck is surrounded by five young ladies who seem to pay no attention to him and to whom he seems to pay no attention. Instead, his gaze seems to be directed towards the withdrawn young lady in white and yellow at the right foreground, a figure that does not appear in the finished painting.

The Tate Gallery painting is notable for the number of young ladies who wear identical gowns (the two young women in the right foreground seem to be twins) and for the colourful aspect provided by various national banners used as decoration. In the Tate painting, the American flag, which appears twice, replaces the banner of red and white squares in the background of this sketch.

As David Brooke noted in the catalogue of the 1968 Tissot retrospective exhibition (*Still on Top*, cat. no. 21), the artist used flags in several paintings circa 1873–1875. He seems to have acquired and kept a number of these large, colourful banners because a photograph of his studio in the abbey church at Buillon, taken shortly after the death of his niece Jeanne Tissot in 1964, shows one of the two large clusters of flags that flanked the large studio window. Some of those flags are identical to the ones he used in his paintings in the early 1870s.

Fig. 5
The Ball on Shipboard
(Tate Gallery, London)

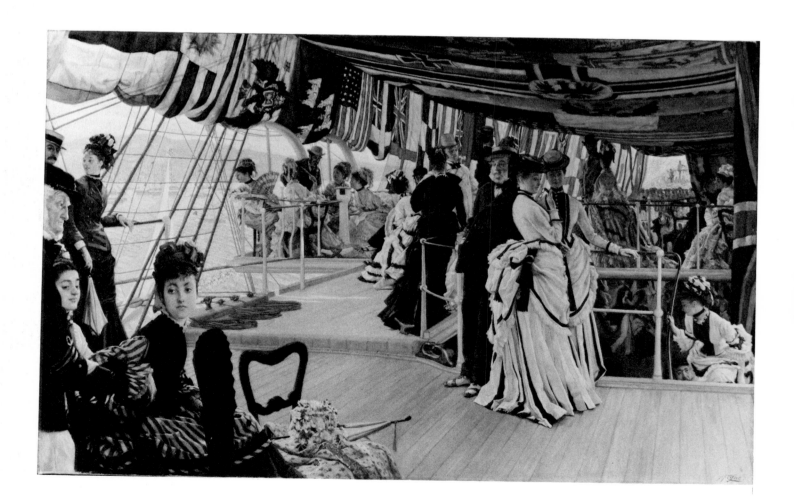

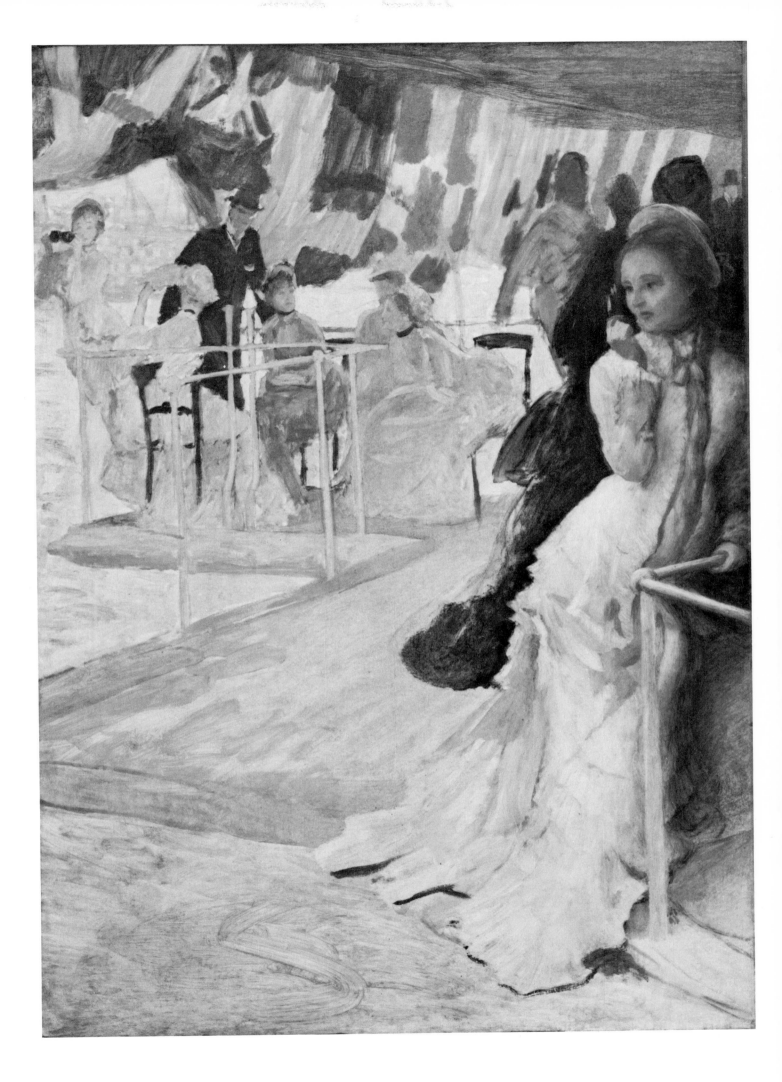

67

Without Dowry 1883–1885
(*Sans Dot*)

Oil on canvas

147.1 x 105 cm

INSCRIPTION
Signed l.l., *J.J. Tissot.*

PROVENANCE
Christie's, London, 4 October 1973, repr. (as *Sunday in the Luxembourg Gardens*, frontis. colour, cat. no. 231, opp. p. 70); H. Shickman Gallery, New York. Acquired February 1975.

EXHIBITIONS
1885, Paris, Galerie Sedelmeyer, *Exposition J.J. Tissot: Quinze Tableaux sur la Femme à Paris*, cat. no. 3. 1886, London, Arthur Tooth and Sons, *Pictures of Parisian Life by J.J. Tissot* , cat. no. 2

BIBLIOGRAPHY
Brooke, Wentworth, Zerner, *Tissot*, cat. nos 35 and 36. Colombine, "Chronique," *Gil Blas*, 20 April 1885. G. Dargenty, "Exposition de J.J. Tissot," *Courrier de l'Art*, 24 April 1885, p. 200. "Tissot's Novel Art Works: Sketches He Has Made of Women in Paris," *The New York Times*, 10 May 1885, p. 4.

RELATED WORKS
The other fourteen paintings in the *Woman of Paris (Femme à Paris)* series, 1883–1885: *Political Woman (L'Ambitieuse)*, Albright-Knox Art Gallery, Buffalo; *The Ladies of the Cars (Ces Dames des chars)*, Rhode Island School of Design, Providence; *The Mystery (La Mystérieuse)*, unlocated; *The Fashionable Beauty (La Plus Jolie Femme de Paris)*, private collection, Geneva; *The Tightrope Dancer (L'Acrobate)*, unlocated; *The Gossip (La Menteuse)*, unlocated; *The Woman of Fashion (La Mondaine)*, Tanenbaum Collection, Toronto (cat. no. 67); *The Bridesmaid (La Demoiselle d' Honneur)*, Leeds City Art Gallery; *Wifes of the Artists (Les Femmes d'Artistes)*, The Union League of Philadelphia; *Amateur Circus (Les Femmes de sport)*, Museum of Fine Arts, Boston; *Provincial Woman (Les Demoiselles de Province)*, unlocated; *The Sphinx (Le Sphinx)*, unlocated; *The "Young Lady" of the Shop (La Demoiselle de Magasin)*, Art Gallery of Ontario; and *Sacred Music (Musique sacrée)*, unlocated. (The size of each of the works is supposed to be the same.) *A Girl in an Interior* (cat. no. 68) is, in fact, a study for *The Sphinx*. Additionally, at the Sedelmeyer and Tooth exhibitions, Tissot showed two other large paintings, *Aesthetic Woman (L'Esthétique)*, Museo de Arte de Ponce, Puerto Rico, and *The Traveller (La Voyageuse)*, Koninklijk Museum voor Schone Kunsten, Antwerp, which formed part of a projected second

series on foreign woman. The series was never completed. *Return from Henley*, Newark Museum, which is nearly as large as the *Woman of Paris* paintings, may be *Sur la Tamise* of the Sedelmeyer exhibition (1885, cat. no. 23) and thus also a part of the second series.

WHEN TISSOT MOVED BACK TO PARIS in the fall of 1882, following the death of his mistress in London, he immediately set about re-establishing himself in the Paris art world. To announce his return, he arranged for an exhibition of 102 of his English works at the Palais de l'Industrie in 1883. At the same time he must have conceived the impressive series of fifteen large canvases, to be called *La Femme à Paris (The Woman of Paris)*, as an assurance to his public that he was, after all, a French artist. This series occupied his energies for two years and was ready for exhibition in the spring of 1885, along with two or three paintings from a projected series on foreign women. According to Tissot's own account, it was while he was in a Paris church working on studies for *Sacred Music*, shown in Paris but not in London, and now lost, that he expressed a religious reawakening and decided to devote his talents to illustrating the life of Christ.

The *Woman of Paris* series was divided into three sub-series, and *Without Dowry* was in the first group. Tissot made etchings after these first five paintings with the intention of etching all fifteen and issuing them with literary accompaniments provided by various writers of the time. Georges Ohnet was to have written the piece for *Without Dowry*. This combined venture in art and literature was never realized; and, as it is, the only story provided for the painting was the commentary written for the Tooth and Sons exhibition in 1886. This reads, in part:

> It is at Versailles, under the trees. The September sun is shining, but the frosty September nights have begun to nip the leaves and bring them to the ground. The summer is over, the winter is coming, to her as to the world. And so another year has gone, and she is twelve months nearer old maidenhood than she was a year ago.

Tissot has situated his subjects, a lovely young woman of good family and her aunt or perhaps her governess, both dressed in deepest mourning, under the chestnut trees of the southern quincunx at Versailles. When Christie's offered this painting for sale in 1973, they identified the setting as the Luxembourg Gardens. This is an error because in the distance, through the trees, one sees

clearly the staircase south of the Pool of Latona. In the middle distance an artilleryman (extreme left) chats with an infantryman of the line, (with his back to the viewer) while beyond them a military band entertains visitors to the palace gardens. The two young men seem to ignore the dowerless young woman. As earlier, in his portrait of the widowed Empress Eugénie and her son in exile at Camden House (1874–1875, Musée de Compiègne), Tissot has used autumn leaves to suggest the autumnal pathos of faded or vanished hopes. The young lady in *Without Dowry* is obviously without hope or prospects of a suitable marriage, the death of one or both parents having left her in such reduced circumstances that she would be fortunate to attract even a military man of the lower ranks. The older lady, absorbed in her newspaper, is blithely indifferent to the young woman's plight.

The *Woman of Paris* series is Tissot's celebration of woman, his constant and favourite theme. He aims at giving a well-rounded picture of modern woman in her various pursuits and pastimes. A critic, writing in *Gil Blas* under the name of Colombine, observed that this "incomplete collection of dolls" – omitting as it did representatives from the world of theatre and the world of love affairs and not paying enough attention to working women – could never give an idea of the real woman of Paris. Remaining impervious to the developments of Impressionism, Tissot was faulted in his own time for his insistent realism and his slick, academic style. He was considered an artist whose work was frequently interesting but always a bit on the foppish side. In this series his real originality lay not only in the concept itself but also in the inventive pictorial devices – proximity to subject, unusual points of view, inviting gestures, and direct eye contact with the viewer – with which he attempted to draw the viewer into his pictures (see also cat. no. 68) and involve him in the life of the Parisian woman of his own day.

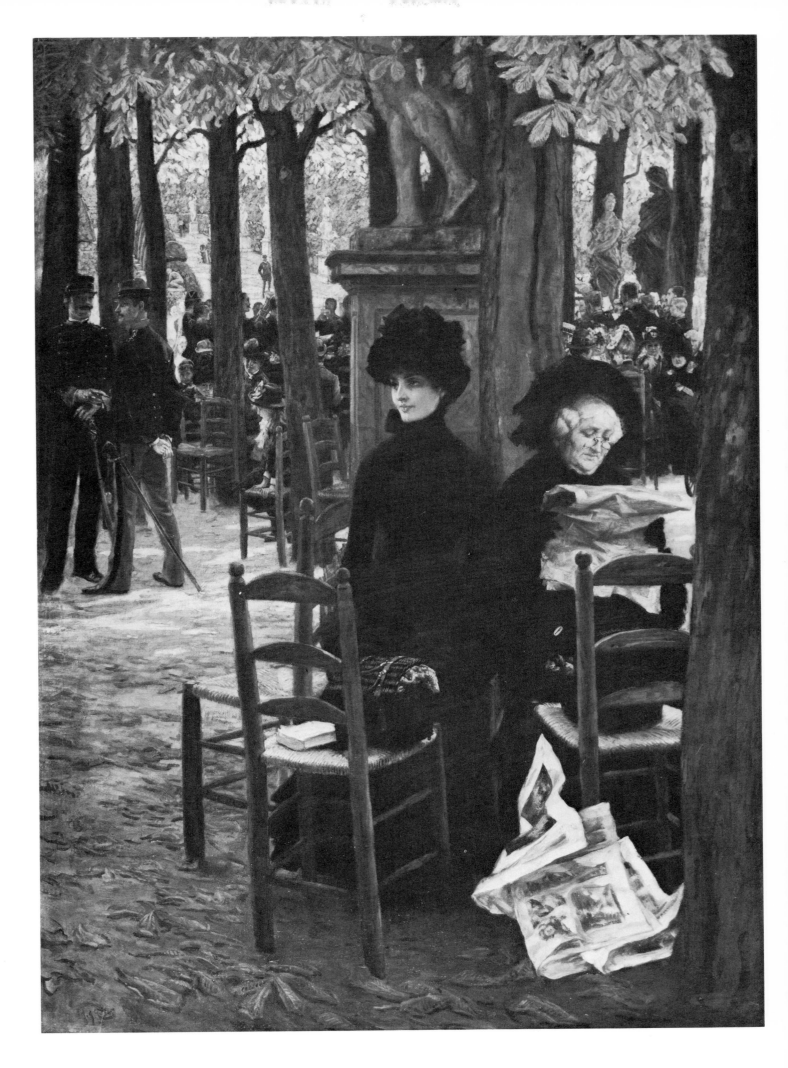

JAMES (JACQUES JOSEPH) TISSOT

68

The Woman of Fashion 1883–1885
(*La Mondaine*)

Oil on canvas

148.3 x 103 cm

INSCRIPTION
Signed l.r., *J.J. Tissot.*

PROVENANCE
H. Shickman Gallery, New York, 1970.
Acquired November 1970.

EXHIBITION
1885, Paris, Galerie Sedelmeyer, *La Femme à
Paris*, cat. no. 8. 1886, London, Arthur
Tooth and Sons, *Pictures of Parisian Life*, cat.
no. 6. February 1970, New York, H. Shick-
man Gallery, *The Neglected 19th Century: An
Exhibition of French Paintings*, cat. no. 41, repr.
b/w and colour.

BIBLIOGRAPHY
See *Without Dowry*, cat. no. 67.

RELATED WORKS
See *Without Dowry*, cat. no. 67.

THE TITLE of this painting indicates a
woman who moves in high society. This
is the second painting in the the *Woman
of Paris* series (the other is *Political
Woman* in which Tissot takes as his sub-
ject a woman who uses her beauty and
charms to best advantage to rise to the
most elevated levels). In this picture a
lovely young woman in an elegant pink
ball gown is preparing to leave a fash-
ionable social event with an elderly gen-
tleman who is probably her husband.
They are the only couple where the dis-
parity in age is so great, and the man
and woman at the left certainly seem
amused by this May-December rela-
tionship. Again, as in *Without Dowry*
(cat. no. 67), the viewer is invited to
imagine a story. Why has the young
woman allied herself with a man so
many years her senior? To whom does
she turn to look as she leaves? Has she
perhaps been engaged in a discreet
flirtation with a younger gentleman
whose position the viewer occupies?

The commentary for this painting in
the Tooth and Sons catalogue alludes to
the demands and expenses of fashion,
placing the emphasis more on *haute
couture* than on fashionable society
which the French title implies. A cer-
tain pathos is also suggested: "But it is a
hard life; can she and he endure the
wear and tear much longer? She, per-
haps, until the collapse comes suddenly;
but he, one fears, will quietly get wea-
rier and wearier, though habit and his
wife's iron determination will always be
too strong for him."

The Woman of Fashion illustrates well
the inventive devices Tissot used in the
Woman of Paris series. For the most part,
the viewer sees the backs of departing
guests moving towards the street where
carriages wait. However, the woman of
fashion turns and looks out of the pic-
ture space, towards the viewer, inviting
him into the painting. The viewer thus
becomes a participant rather than a
mere spectator.

At the Sedelmeyer exhibition in
Paris this painting was in the second
subseries (1885, cat. no. 8). But because
of the sudden religious redirection of his
work, Tissot, after the fifth etching,
abandoned the project of etching the
entire series; therefore, an etched ver-
sion of this painting was never made,
although the Sedelmeyer catalogue
advertised a subscription to the com-
plete series of fifteen. Had Tissot real-
ized this project, Sully-Prudhomme
would have written the piece telling the
story of *La Mondaine*.

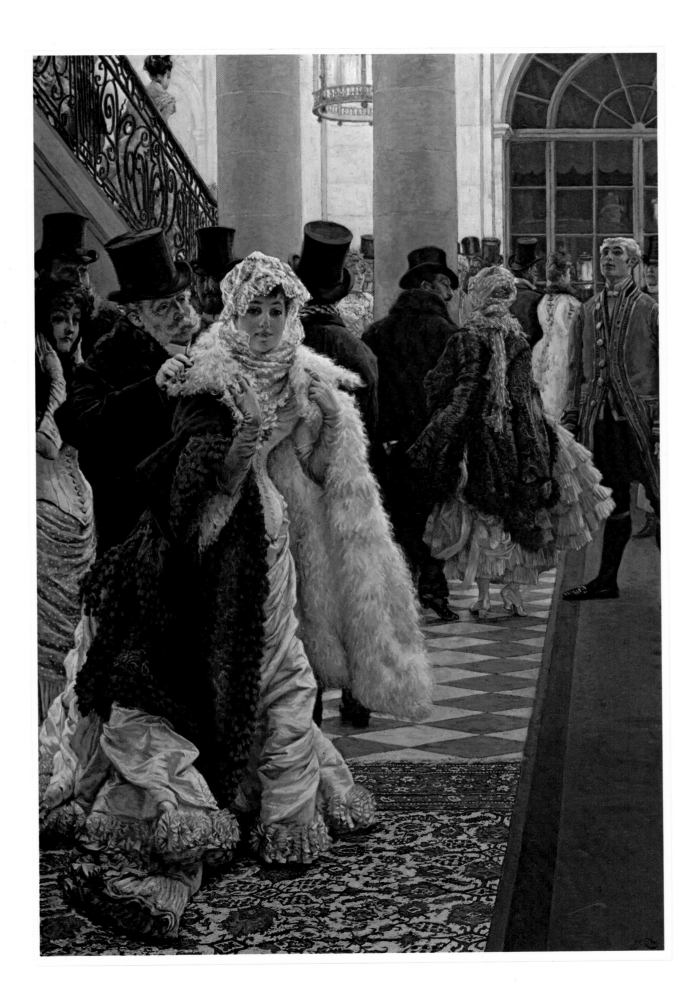

JAMES (JACQUES JOSEPH) TISSOT

69

Girl in an Interior 1883–1885
(Femme dans un intérieur)
Study for *The Sphinx*

Oil on canvas

111 x 68.5 cm

PROVENANCE
Given by the artist to Léonce Bénédite in the early 1880s; the Bénédite family; H. Shickman Gallery, New York. Acquired February 1973.

BIBLIOGRAPHY
See *Without Dowry*, cat. no. 67.

RELATED WORKS
See *Without Dowry*, cat. no. 67.

THIS PAINTING was given by Tissot to Léonce Bénédite, director of the Musée du Luxembourg in Paris in the early 1880s. According to a dealer's notation affixed to the back of the painting, "this portrait is presumed to be of Mlle Riesener to whom Tissot was engaged in 1882." The basis for this identification is uncertain, except that the timing is right. If true, this identification would certainly be tantalizing and would suggest some interesting possibilities.

The painting is obviously unfinished. Although the sofa and the woman are brought to a high degree of finish, the rest of the painting is summarily treated. The painting is, in fact, a study for another *Woman of Paris* painting, *The Sphinx* (Sedelmeyer, cat. no. 13; Tooth and Sons, cat. no. 8, fig. 6). Paul Bourget was to have written about this painting for the combined literature/graphics undertaking. Although the location of *The Sphinx* is not known, a photograph of the painting is preserved in an album of Tissot's photographs of his own paintings (private collection, France; marked vol. III, 1878–1882). In addition to being smaller and more sketchily treated than the finished version for the *Woman of Paris* series, this study differs from it in that the low round table in the foreground does not hold the small lamp and other objects seen in the completed painting.

The room in which "The Sphinx," the inscrutable woman, is seated opens into a conservatory. This is an element or a device seen in a number of other Tissot paintings, and in this case probably suggests an artificially cultivated world like the artificial world in which this unknowable woman lives. On a chair in the background rests a top hat (in the finished painting, a walking stick rests atop the hat), suggesting that the lady has received a fashionable caller. (Is it he at whom she looks with her puzzling, icy stare?) In 1876 in one of his several paintings called *The Convalescent* (Graves Art Gallery, Sheffield, England; Royal Academy, 1876, no. 530), Tissot had used this device of a man's hat and walking stick placed on an empty chair to suggest the presence of an unseen caller.

If the painting is indeed a portrait of Mlle Riesener, who is supposed to have commanded Tissot's affections at this time, this assumption gives rise to interesting speculation on the reason for Tissot's casting her in the role of the sphinx or the inscrutable woman.

According to Edmond de Goncourt's *Journal* entry in October 1885, Tissot had been planning to marry Mlle Riesener, and had even added another floor in the English style to his Paris house, when suddenly, the lady, catching a glimpse of the middle-aged artist removing his overcoat, decided against the match. In January of the same year, Goncourt had recorded that Tissot had been paying court to a tightrope dancer! Even granting that these two reports are more than mere gossip and that "The Sphinx" may be Mlle Riesener, this would make two out of the series of fifteen (the other being *The Tightrope Dancer*) that may make some allusion to Tissot's affairs of the heart. One should certainly not seek clues to Tissot's love life in the other thirteen paintings and perhaps not even in these two. The identity of "The Sphinx" remains as much a secret as does the nature of her thoughts.

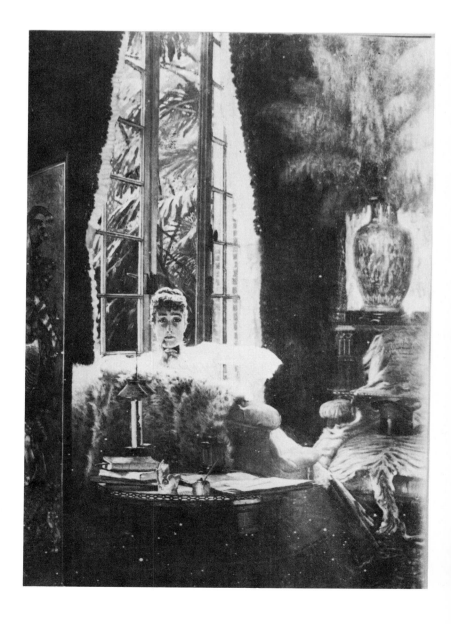

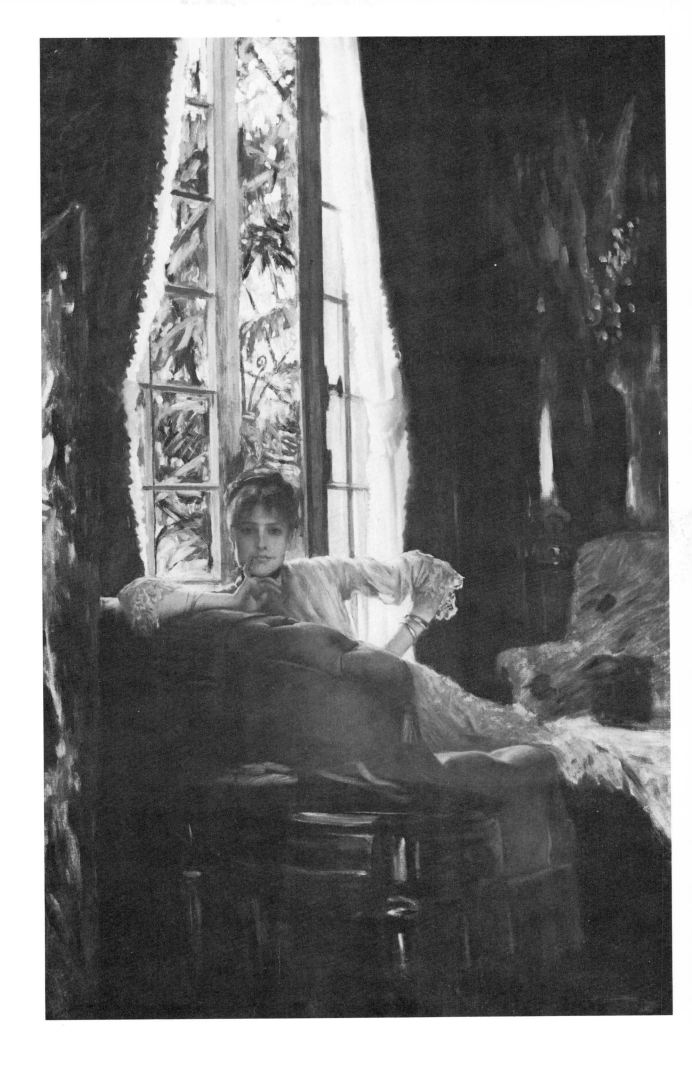

◁ **Fig. 6**
The Sphinx.
Photograph
taken by
Tissot
(location
unknown)

ANTOINE VOLLON

Lyons 1833 – Paris 1900

SON OF AN ARTIST, Vollon was born in Lyon, and enrolled in the École des Beaux-Arts de Lyon in 1850. He began to visit the Musée du Louvre in 1856, but he did not move to Paris permanently until 1859. In the capital, he lived with his friend, the painter Joseph Soumy (1831–1863), and it was at Soumy's that he made the acquaintance of Daubigny (1817–1878) and Théodule Ribot (cat. nos 52–60), whose disciple he became.

A painter of landscape, animals, and figures, Vollon was equally at home with all subjects. However, it was in still life that he distinguished himself, painting in a precious, controlled style similar to that of the great Dutch masters of the seventeenth century (Kalf, de Heem) or, at other times, in a freer, more spontaneous manner reminiscent of Manet (1832–1883). A man of remarkable talent who received numerous official honours during his life, Vollon was almost totally forgotten shortly after his death. Today there is a renewed appreciation for his subjects that reveal a familiar realism in which tradition and modernity are united in a spontaneous and original style.

EXHIBITIONS
Paris Salons from 1864 to 1900.

AWARDS AND HONOURS
Medals at the Salons of 1865, 1868, and 1869. Chevalier (1870) and Officer (1878) of the *Légion d'Honneur*. First-Class Medal at the Paris Universal Exhibition of 1878. Member of the Institut de France, 1898. Grand Prize at the Paris Universal Exhibition of 1900.

BIBLIOGRAPHY
Janine Bailly-Herzberg, *L'eau-forte de peintre au dix-neuvième siècle: la Société des aquafortistes (1862–1867)*, 2 vols., Paris: Léonce Laget, 1972 (biographical note on Vollon). *Catalogue des tableaux et études peintes par feu Antoine Vollon, et de sa collection particulière, composée de tableaux anciens et modernes, objets de curiosité et d'ameublement*, Paris: 1901. Jules Clarétie, *Peintres et sculpteurs contemporains*, second series, Paris: Librairie des Bibliophiles, 1882–1884.

L. d'A.

The Pig 1874
(*Le Cochon*)
Oil on canvas
89.5 x 67 cm

INSCRIPTION
Signed and dated, u.l., *A. Vollon 74.*

PROVENANCE
Collection of Albert Wolff, writer, art critic, and secretary to Alexandre Dumas *père*, Paris (1875); Alexandre Dumas *fils*, Paris (sales from his collection, Paris, Hôtel Drouot, 16 February 1882, no. 88, as *Intérieur de boucherie*, 88 x 65 cm and 12–13 May 1892, same title, 92 x 68 cm [*sic*]); A. Diot, Paris (sale of his collection, Paris, Hôtel Drouot, 8–9 March 1897, no. 130, as *Le cochon*, 83 x 67 cm [*sic*]; Galerie Bernheim-Jeune, Paris; Galerie André Watteau, Paris, 1967 (purchased on the New York market); H. Shickman Gallery, New York, 1969. Acquired August 1971.

EXHIBITIONS
Paris Salon of 1875 (no. 1974, as *Le cochon* and belonging to A. Wolff). October 1971, New York, H. Shickman Gallery, *The Neglected 19th Century: An Exhibition of French Paintings*, Part II, n. p., repr. (as *A Side of Beef*).

BIBLIOGRAPHY
Anatole de Montaiglon, "Salon de 1875," *Gazette des Beaux-Arts*, vol. 2 (1875), p. 32. Clarétie, *Peintres et sculpteurs contemporains*, p. 212 (as *Cochon écorché*). Mentioned in the catalogue of the exhibition *French and Dutch Loan Collection*, Edinburgh International Exhibition, 1866, David Douglas, University Press 1888, pp. 83, 85. Petra Ten Doesschate Chu, *French Realism and the Dutch Masters*, Utrecht: Haentjens Dekker & Gumbert, 1974, p. 64, fig. 127 (as *Side of Beef*).

IN HIS REVIEW of the Salon of 1866, Zola, although a defender of Naturalism in literature, accused certain painters of descending into triviality on the pretext of being faithful to reality: "For a number of people – Mr Vollon, for example – realism consists in choosing a vulgar subject" (Zola, *Mon Salon – Manet, Écrits sur l'art*, p. 76). That year, Vollon had exhibited a picture depicting a servant in her kitchen, after returning from the market. When shown at the Salon of 1875, *The Pig* was greeted by a public that was better prepared to accept such subjects which, even recently, had annoyed the critics and provoked curiosity. The reason for this is that the naturalist aesthetics proposed in literature by Zola and the Goncourts (who awaited the birth of a new art which would express their society) had been championed in painting by art critic Jules Castagnary (see his Salons of 1863 and 1868) had won respect and had begun to change modes of perception.

The subject depicted here – an eviscerated animal carcass hanging in a butcher's shop – was not new. In 1857, the Louvre's acquisition of Rembrandt's famous *Slaughtered Ox* gave rise to many copies or interpretations by artists of the era, including Delacroix, Bonvin (cat. nos 3–10), Decamps (cat. no. 23), and Daumier (see Petra Ten Doesschate Chu, *French Realism and the Dutch Masters*, pp. 42, 64, fig. 70; *Exhibition of French Drawings Post Neo-Classicism*, Colnaghi, London, 1975, no. 46 repr.). In the Salon of 1869, Vollon could also have seen the canvas by Amédée Elie Servin (1829–1885/86) entitled *My Butcher Shop* (*Le puits de mon charcutier*; Louvre, formerly Hoschedé Collection) which met with some success. This painting depicted the interior of a butcher's shop (see Paul Mantz, "Salon de 1869," *Gazette des Beaux-Arts*, vol. 1, p. 510, repr. in an etching by Servin) in which there hangs not an ox but a pig's carcass. Beside it hang the lungs and the heart. A few pieces of furniture and kitchen utensils complete the scene: table, barrel, pails, basins, broom, hook, and saw. The same subject was treated by Albert Aublet (cat. no. 3) in 1873 (1873 Salon, no. 33). His painting, entitled *Ducourroy's Butcher Shop, Tréport*, was in the collection of Alexandre Dumas *fils* at the same time as the Vollon canvas. It would seem, then, that as early as the 1870s there were those who admired these realist subjects which were beginning to establish a definite trend within the artistic currents of the second half of the nineteenth century.

In 1875, the year Vollon's *Pig* was shown at the Salon, Bonvin painted a picture with the same title (Rheims Museum, repr. in Petra Ten Doesschate Chu, *French Realism*, fig. 69) but much closer in composition to Servin's picture of 1869.

Vollon habitually painted after nature. Clarétie, in *Peintures et Sculpteurs Contemporains*, writes that, "faithful to an exact interpretation of nature, he constantly works from a model" (p. 206). He had in his possession a number of precious objects, including some of porcelain, gold and silver, faience, and stoneware, as well as musical instruments, copperware, pewter, and textiles (see catalogue for the sale of Vollon's studio, 20–23 May 1901), which he arranged for his large compositions inspired by the Dutch still lifes of the seventeenth century. It seems that when in 1868 Count Nieuwerkerke (superintendent of fine arts during the Second Empire) commissioned him to do a very large composition, he put at the painter's disposal not only his own collection of *objets d'art* and curiosities but also objects belonging to the Louvre

ANTOINE VOLLON

(Étienne Martin, quoted in the catalogue for the exhibition, *Hommage de Paul Gadala à Antoine Vollon*, Galerie M. Bénézit, Paris, 1966). But it appears that the artist disliked this kind of commission.

The Pig represents the other side of Vollon's art – coarser, more direct, and more spontaneous. Clarétie tells us that about 1874 Vollon spent several months "a step or two away from Les Halles, with the models for his still lifes in front of him" (*Peintres et Sculpteurs Contemporains*, p. 214). Regarding *A Corner of the Market* (*Coin de halle*) exhibited at the 1874 Salon, Clarétie writes that, "Vollon painted this with such passion that at one point he left his brush aside and obviously used his fingers to paint – I could say sculpt – the large screws of the cauldron handle" (p. 2). *The Pig* is a comparable work, both in its inspiration and in its treatment, in which certain accents, the colouring, and brushwork remind one of Manet. In contrast to the detailed, narrative treatments by Servin and Bonvin, Vollon's *Pig* presents an almost hallucinatory vision of the interior of a butcher's shop. The subject, unencumbered by details, is reduced to its simplest representation: suspended in full light against a dark background in an ill-defined space, the pig, its lungs and heart, create a scene whose dramatic intensity has rarely been equalled within the limitations of this genre; this depiction foreshadows the expressionism of Soutine in his various versions of the *Slaughtered Beef* (*Boeuf écorché*) – for example, that in the Minneapolis Institute of Art. A later work by Vollon, *Cut of Beef* (*Morceau de boeuf*), painted in Tréport and shown at the 1883 Salon, is done in the same spirit as this painting of 1874.

The Butte Montmartre

Oil on canvas

71 x 91 cm

INSCRIPTION
Signed, l.l., *A. Vollon.*

PROVENANCE
(?)Galerie Trotti, Paris; J.H. Van Eeghen, Amsterdam (sale of his collection, Christie's, London, 30 April 1909, cat. no. 132 (as *The Windmill*, 27 x 35 in.), purchased by M. Ellis; E.J. Van Wisselingh, Amsterdam; H. Westendorp, Amsterdam; Sotheby's, London, sale 3 June 1970, cat. no. 19 (as *Le moulin*), purchased by Roland Browse & Delbanco; H. Shickman Gallery, New York. Acquired June 1971.

EXHIBITIONS
September–October 1910; Amsterdam, Stedelijk Museum, *Tentoonstelling Van Schilderijen en Aquarellen*, cat. no. 99 (as *Le Moulin*). October 1971, New York, H. Shickman Gallery, *The Neglected 19th Century: An Exhibition of French Paintings*, Part II, n. p., repr. (as *Landscape with Windmills*).

VOLLON'S MASTERY in expressing all of the aspects of still life places him among "the most eminent followers of the French tradition of painters of reality" (Bailly-Herzberg, *L'Eau-forte de peintre au dix-neuvième siècle*, II, p. 178). The artist also distinguished himself in landscape painting, in which his style was every bit as bold and personal.

Throughout the nineteenth century, the picturesque site and windmills of the Butte Montmartre attracted the attention of many painters, including Georges Michel (cat. no. 50), Corot, Pissarro, Van Gogh, and Utrillo. A similar tradition existed in England, with the countless views of Hampstead Heath, also enhanced by the silhouette of a windmill perched on top of the hill.

Vollon is known to have painted several views of Montmartre, the earliest of which, done about 1860, depicts the Moulin de la Galette in a romantic manner (Musée Carnavalet, Paris). An etching, published in *L'Illustration nouvelle* of 1875 and entitled *The Moulin de la Galette at Montmartre*, once again explores this subject, to which the technique of etching, with its simplified effects, lends a particular, expressive power. Another canvas with two different titles, *Winter at the Foot of the Butte* and *A Part of Montmartre Covered with Snow* (sale catalogues of the Galerie Georges Petit, Paris, 19–20 May 1914 and 6 August 1924, cat. no. 63), does not depict the famous Moulin de la Galette.

As in the case of *The Pig* (cat. no. 70) and most of Vollon's pictures, it is prob-able that this canvas is the result of a study from life subsequently transformed into an image bearing all the characteristics of an idealized form of Realism.

It is difficult to date this canvas accurately. In the first place, Vollon rarely dated his paintings, and this deprives us of any reference point in attempting to establish a chronology of his work. In addition, the artist's style does not seem to have undergone any very significant changes between 1875 and the time of his death. A study of the changing appearance of the Butte Montmartre in the nineteenth century is the only means of establishing an approximate chronology of the Montmartre pictures. Until 1860, the year in which Montmartre, at the time a township on the outskirts of Paris, was annexed to the capital, its old houses, gardens, and windmills still gave it a rustic character, making it a favourite place for a Sunday stroll. Then in 1873 construction began on Sacré-Coeur, suddenly changing the character of the site, and from 1880 onward there sprang up the numerous artists' cabarets which still enliven Montmartre nightlife. By the late nineteenth century, the many windmills which for centuries had surrounded Paris had already disappeared. Only five of them were left to punctuate the skyline of the butte with their characteristic silhouettes.

The choppy, nervous style, the thin, dry application of the paint, the restrained palette, and the emptiness of the composition, in which only the elements outlined against the sky are rendered with detail (the out-of-focus effect in the foreground could indicate a photographic influence) give this work a stark effect and visibly distinguish it from the more sensuous rendering of *The Pig* of 1874. All of these factors suggest that this landscape was painted sometime between 1880 and 1890.

To those unfamiliar with nineteenth-century sculpture, it may come as something of a shock that none of the pieces in this exhibition are originals. An original, as the term is habitually used when we speak of paintings, is an object made by the artist's own hands that embodies his intentions in a uniquely individual way; it is, by definition, one of a kind. Even if the painter, as sometimes happens, makes an exact copy of his own work, this second version is never wholly like the first and remains clearly distinguishable from – and inferior to – the original.

None of this can be said of the pieces of sculpture assembled in this collection. What is more, the same would be true of almost any conceivable exhibition of nineteenth-century sculpture. They are all "multiples;" exact duplicates, in various sizes and materials, of any of them are known to exist, or to have existed, in other collections, and it often is difficult to decide which members of this family of replicas are closest to the original. With vanishingly few exceptions, the originals no longer survive. Strangely enough, they were destroyed by the artists themselves.

If we are to understand how this extraordinary situation came about, we must first visualize the nineteenth-century sculptor's standard working procedure. He begins by making some drawings, or he may produce a small, rough three-dimensional sketch, called a *maquette* or *bozzetto*, in clay, wax, or plasticine. From these he develops the full-scale final model in clay. This, clearly, is "the original," but it cannot be preserved. Unless the artist carefully guards the moisture content of the clay by keeping the model wrapped in wet rags, the clay will dry out, crack, and eventually crumble away. And firing the model in a kiln is impracticable; even if he should manage to transport the unstable mass of clay to the nearest kiln without damaging it in the process, the firing itself is likely to result in cracks and distortions. Only objects of small size lend themselves to conversion from clay to terracotta (literally, "cooked earth") without such risks. Hence the sculptor adopts a different solution: he pours plaster over his clay model, and after it has set he scrapes out the clay. He then pours plaster into this hollow mould, breaks away the mould, and thus produces an exact duplicate of the clay model in plaster.

We speak of this as "the original plaster," since it is a unique object, the mould having been destroyed in the process of making it. Actually, however, it is merely the ghost of the vanished clay model. Nor is it the end product of the sculptor's labours. He may exhibit it, but only to solicit orders for the same piece in more durable and beautiful materials. If the material is to be bronze, the original plaster is turned over to a foundry, which will produce a bronze duplicate of the plaster without destroying it in the process. Bronze casting is a highly skilled craft; the sculptor here relies on expert technicians, and his only control over the final product is the choice of casting technique

(the nineteenth century developed several besides the traditional *cire perdue* – "lost wax" – process) and surface colour (patina). In making a marble version, the original plaster is turned over to specialized carvers who, with the aid of various technical devices, translate it with a high degree of accuracy into the new material. If the sculptor is himself a trained marble carver, he may supervise the process and add the finishing touches, but in the nineteenth century this was the exception rather than the rule.

The original plaster holds further possibilities of exploitation. If it is a critical and popular success, the sculptor may decide to have duplicates made in smaller sizes for purchase by less wealthy patrons. There were machines for this purpose, and while the artist would check the final result for accuracy, he had no direct share in the process. These "reductions" were often issued in various materials – plaster, terracotta, bronze, marble – so as to appeal to every purse. The sculptor might also issue editions of "excerpts" from the original model: the principal figure from a group such as Jean-Baptiste Carpeaux's *Dance* (cat. no. 75), or only the bust or the head. Or he might issue duplicates in various materials of his maquette (see Carpeaux's *Ugolino*, cat. no. 76).

How did these practices develop? How do they differ from those of Renaissance or Baroque sculptors? In principle, none of them were wholly new, even though they were greatly facilitated by the Industrial Revolution, which affected sculpture far more profoundly than it did painting in the nineteenth century. Earlier sculptors also made maquettes and plaster models in preparing their major works in bronze or marble; they, too, utilized assistants for the more mechanical aspects of their production. But their patrons were princes of the Church or the State who commissioned monuments for specific sites and symbolic purposes, so that the work was necessarily one of a kind. Nobody could have wanted a second or third specimen. Hence the plaster models were destroyed once they had served their purpose, and most maquettes met the same fate, although the artist sometimes kept a few of them for study purposes, and a few collectors might buy them for the same reasons they collected drawings by famous artists.

What distinguishes a Renaissance bronze such as *David* by Donatello (*c.* 1387–1466) from its nineteenth-century counterpart, however, is not only the fact that it is a unique object. In those days bronze casts were so rough that they demanded a great deal of further work in finishing the surface, and this process (known as chasing) was done either by the sculptor himself or under his close supervision, so that the end result was not simply a duplicate in bronze of the original model but different enough to have the status of an original in its own right. The same is true of a marble statue by Michelangelo (1475–1564) or Gianlorenzo Bernini (1598–1680). Here, too, the master did so much of the carving that the result was an original, clearly

distinguishable from workshop pieces where the sculptor merely furnished a sketch and left the enlarging and marble carving to his assistants.

There were, to be sure, small-scale replicas in terracotta or bronze of famous masterpieces, such as Michelangelo's *Moses*, from the end of the sixteenth century on; however, these were not issued by the master himself but were the work of younger sculptors who made these reduced copies as part of their training or to sell to private collectors.

Because of the high cost of marble or bronze, sculptors before the Industrial Revolution could afford to produce major pieces only on commission, while painters, whose materials were comparatively inexpensive, worked increasingly "for the market" from the sixteenth century on. Prints, needless to say, were produced for the market from the very beginning. In sculpture, their only counterparts were small Madonna reliefs, which could be easily replicated from moulds in cheap materials such as stucco or papier mâché, often garishly painted.

It was only from the later eighteenth century on that the growing scarcity of large-scale commissions from the Church or State compelled sculptors to appeal to a wider public if they wanted to survive. They did this by producing multiples and reductions in various materials for sale to patrons of limited means. The system we have described for nineteenth-century sculpture was developed in the dawn of the Industrial Revolution, which soon began to serve it by the invention of copying machines, new casting techniques, and of production methods that greatly reduced the cost of bronze and marble. This was also the time of the first public art museums; their existence invited the sculptor to do large-scale sculpture as "museum pieces" rather than for predetermined purposes and locations, as in the past. There had, of course, been sculptural museum pieces ever since the Renaissance. But these were the works of classical antiquity such as the *Laocoön* or the *Apollo Belvedere* in the Vatican collections, and towards 1800, they became the ideal models for the modern sculptor, whose highest ambition was to produce "modern classics" similarly detached from time and circumstance and demanding to be judged by the same standards as the ancient classics. In the days of the French Revolution and the Napoleonic Wars, sculpture enjoyed greater prestige than painting. The great Italian sculptor Antonio Canova (1757–1822) became the most famous artist throughout the western world.

This state of affairs was not to endure for long, however, since Romanticism favoured all those qualities that music, literature, and painting could convey more fully and easily than sculpture. Baudelaire's famous essay of 1846, "Why Sculpture Is Boring," is perhaps the fullest expression of the low estate to which sculpture had de-

scended. The sculptor's training in the art academies of Europe and America, it must be conceded, remained conservative, that is, based on the Canovian concept of the "modern classic," until far into the nineteenth century.

Yet sculptors, from the 1830s on, found a way out of their dilemma, not only by appealing to a broad public with their multiples and reductions but also by reviving the dynamism and emotional appeal of the Baroque tradition, which they imposed on the concept of sculpture as a "museum piece" (Carpeaux's *Ugolino*, cat. no. 76, is a strikingly successful example of such a union). In addition, they explored new fields, such as animal sculpture, which had no standing in the academies, but which catered to the public's taste for realism and to the new prestige of natural science. They took advantage of the romantic appeal of the unfinished and incomplete by offering their maquettes as independent works of art complete in themselves. The latter development, already far advanced in Carpeaux, was completed by Auguste Rodin (1840–1917), whose large-scale works have all the roughness and spontaneity of maquettes and who enthroned the self-contained fragment as a sculptural ideal – his most important legacy to the twentieth century.

Nineteenth-century sculpture, then, is a complex field that demands to be understood in terms of its own dynamic development rather than – as is all too often the case – in terms of the evolution of nineteenth-century painting. Significant aspects of this development are reflected, however incompletely, in the seventeen pieces of this exhibition.

H.W. JANSON
NEW YORK UNIVERSITY

ANTOINE-LOUIS BARYE

Paris 1796 – Paris 1875

THE SON OF A GOLDSMITH, Barye was apprenticed at thirteen to a metal engraver. At sixteen, he was conscripted into Napoleon's army and served until the fall of the emperor. In 1816, he began studying under the sculptor François-Joseph Bosio (1769–1845) and the painter Antoine Gros (1771–1835). From 1818 to 1824, he studied at the École des Beaux-Arts, but left it after failing three times in a row to win the *Prix de Rome*, and went to work for the successful goldsmith, Jacques-Henri Fauconnier, where he modelled animals on a small scale.

Barye's initial Salon entries, in 1827, attracted little attention. Four years later, however, he won high praise for his *Tiger Devouring a Crocodile* (*Un tigre dévorant un crocodile*), which won him the admiration of the Duc d'Orléans who, until his death in 1842, was to remain Barye's most important patron. The life-size *Lion Crushing a Serpent* (*Le lion au serpent*) of 1833, an emblematic reference to the Revolution of 1830, was an even greater success; the State commissioned a bronze cast of it for the Tuileries Garden, and the artist was made a Chevalier of the *Légion d'Honneur*. In the mid-1830s, Barye created five elaborate hunting groups as a centrepiece (*surtout de table*) for the Duc d'Orléans. These were rejected by the Salon jury in 1837, and Barye, together with a group of other sculptors whose work had been similarly refused, ceased submitting his work. He did not return to the Salon until 1850.

During the 1840s, Barye established his own foundry and undertook to sell his work directly to the public. However, he also permitted other founders to cast his models, so that the "philology" of his casts is extremely complicated. An avid student of the animals in the Jardin des Plantes, Barye was appointed professor of drawing at the museum there in 1854, a post he retained until his death.

Barye's fame as the greatest animal sculptor of his – or any previous – time has tended to obscure his equally distinguished work involving the human figure. His greatest achievement in this domain, the four monumental groups of *War*, *Peace*, *Force*, and *Order* for the Pavillon Denon and the Pavillon Richelieu of the Louvre, are placed too high for easy visibility and are now in an advanced state of decay, but the small-scale models reveal a classic calm far closer to the spirit of Greece than the classicism of the École des Beaux-Arts. They must have been an inspiration to the Hellenist-inspired sculptor Aristide Maillol (1861–1944).

Among Barye's patrons during the later years of his life, the most enthusiastic were American. American public collections – notably The Walters Art Gallery, Baltimore – hold a richer choice of the artist's work than those of any other country.

BIBLIOGRAPHY
Roger Ballu, *L'œuvre de Barye*, Paris: Maison Quantin, 1890. Charles de Kay, *Life and Works of Antoine-Louis Barye, Sculptor*, New York: Barye Monument Association, 1889. Stanislas Lami, *Dictionnaire des sculpteurs de l'école française au dix-neuvième siècle*, Paris: Librairie Champion, 1914–1921, vol. 1, pp. 69–85. Jeanne L. Wasserman, ed., *Metamorphoses in Nineteenth-Century Sculpture*, Cambridge, Mass.: Fogg Art Museum, 1975, pp. 77–108 (Glenn F. Benge).

EXHIBITIONS
Salons of 1827, 1831–1836, 1850–1852.

AWARDS AND HONOURS
Second-Class Medal, Salon of 1831. Grand Medal of Honour, Paris Universal Exhibition, 1855; Gold Medal, Paris Universal Exhibition, 1867. Chevalier (1833) and Officer of the *Légion d'Honneur*, 1855. Member of the Institut de France, 1868.

72

Mountain Lion Attacking a Stag
(Panthère saisissant un cerf)

Bronze, dark green patina, on oval base

HEIGHT: 35.5 cm

INSCRIPTION
Signed on base, below the stag's head, A.L. BARYE.

PROVENANCE
Private Collection, Nice; A. Schweitzer Gallery, New York. Acquired May 1973.

BIBLIOGRAPHY
Stuart Pivar, *The Barye Bronzes: A Catalogue Raisonné*, Woodbridge, Suffolk: The Antique Collectors' Club, 1974, p. 148 (A70).

RELATED WORK
Panther Seizing a Stag (another cast from the same model as this *Mountain Lion*), Walters Art Gallery, Baltimore.

THE THEME OF STAGS or similar game brought down by dogs or predators had figured in Barye's work as early as 1833; for example, *Stag Brought Down by Two Greyhounds* (*Cerf terrassé par deux lévriers*). Such scenes, needless to say, are imaginative reconstructions rather than the results of direct observation. Sometimes, indeed, the combinations of wild beasts, such as in *Wild Ox Attacked by a Serpent* (*Aurochs attaqué par un serpent*), are hardly plausible; even as early as 1831, *The Tiger Devouring a Crocodile* had been criticized for this by some critics.

The titles used by Barye for these groups are not always consistent, which adds to the difficulty of identifying them in his œuvre. Barye's 1855 catalogue of bronzes, available at his gallery on the Quai des Célestins, lists a *Tiger Stalking a Stag* (*Tigre surprenant un cerf*) under no. 59 and a *Panther Seizing a Stag* (*Panthère saisissant un cerf*) under no. 64, with the remark that they are identical except for their size. In the Barbédienne catalogue of Barye bronzes (1893), the word *Tigre* has disappeared, but the word *Panthère* survives. The mountain lion, a North American animal also known as a puma or cougar, does not figure anywhere in Barye's work. It is practically certain, therefore, that the title of this piece is a misnomer and that the work corresponds to the *Panthère saisissant un cerf* on Barye's list. The sculpture the *Tiger*, less than half the size of the *Panther*, must have been a reduction of the latter.

There is, however, a troublesome problem regarding the height of *Mountain Lion*, which is 3.5 cm less than the 39 cm given for *Panther* in both the Barye and the Barbédienne catalogues. If careful measurement establishes that there really is a 10 per cent difference in height between the cast of the *Panther Seizing a Stag* (Walters Art Gallery, see Related Work) and the *Mountain Lion*, the latter would be a *surmoulage*, a cast made from a bronze cast rather than from the original plaster.

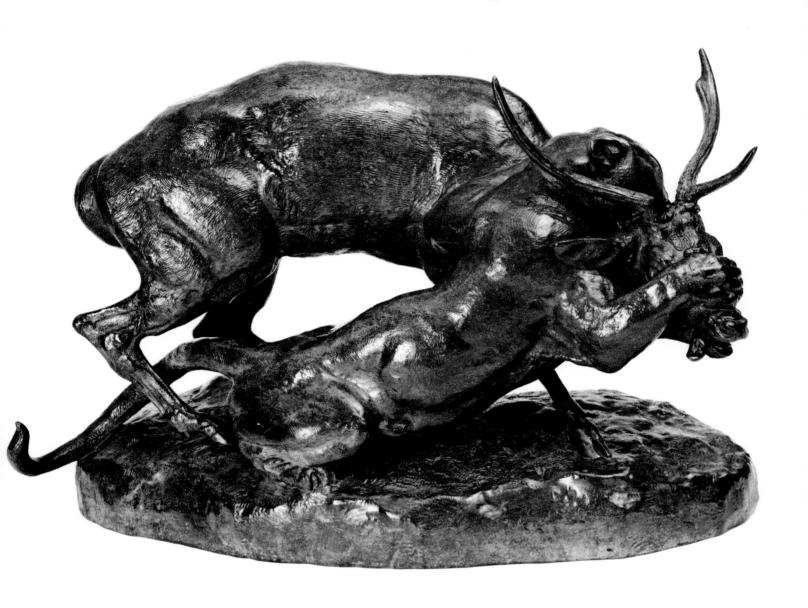

REMBRANDT BUGATTI

Milan 1883 – Paris 1916

TRAINED IN THE WORKSHOP of his sculptor father, Carlo, Bugatti showed a precocious talent for animal sculpture. He moved from Milan to Paris in 1900 and attracted the admiration of the bronze founder Hébrard, who cast and promoted Bugatti's work. His animals, based on close study of those in the Jardin des Plantes, place Bugatti in the line of succession of the great nineteenth-century *animaliers*, from whom he is distinguished, however, by a summary treatment of detail, a freer and more individual handling of surfaces, and by his feeling for the grace and power of his models. From 1904 on, he had a number of successful exhibitions in the Salon of the Société Nationale and the Salon d'Automne. In its flowing, simplified contours and smooth surfaces, the work of Bugatti anticipates the Art Deco style of the 1920s.

EXHIBITIONS
Venice, International Exhibition of Art, 1903. Salon de la Société Nationale des Beaux-Arts, 1904, 1905, and 1910. Salon des artistes italiens, 1907. Salon d'Automne, 1910.

AWARDS AND HONOURS
Chevalier of the *Légion d'Honneur*, 1911.

BIBLIOGRAPHY
Marcel Horteloup, "An Italian Sculptor Rembrandt Bugatti," *The Studio*, vol. XXXVIII (1906), pp. 23–26. Jérôme Peignot, "Bugatti. Qui est exactement ce sculpteur auquel certains collectionneurs s'intéressent tant aujourd'hui?" *Connaissance des arts*, no. 185 (July 1967), pp. 83–85. V. Rossi-Sacchetti, *Rembrandt Bugatti sculpteur. Carlo Bugatti et son art*, Paris, 1907. André Salmon, "Rembrandt Bugatti," *L'Art et Décoration*, vol. XXXIV (1913), pp. 157–164. Marcel Schiltz, *Rembrandt Bugatti, 1885–1916*. Royal Society of Zoology, Antwerp, 1955.

Panther Walking c. 1910
(*La Panthère*)

Bronze, on rectangular base

HEIGHT: 24.6 cm

INSCRIPTION
Signed and marked no. *1* on base.

PROVENANCE
Collection of Jean Désy, Montreal; Dominion Gallery, Montreal. Acquired April 1974.

THE NUMBERING OF BRONZE CASTS did not become a general practice until the end of the nineteenth century. Hébrard was a pioneer in this respect. His editions of Bugatti's work were issued in either six or twelve specimens. The appeal of the *Panther Walking* rests upon the studied contrast of the spontaneous, sketch-like treatment of the surfaces and the smooth contours, which stress the elegance of the animal's rhythmic movement rather than its ferocity.

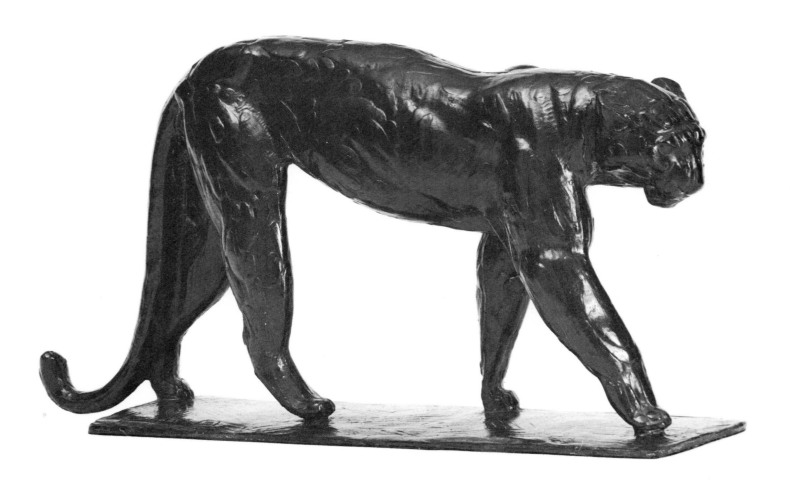

JEAN-BAPTISTE CARPEAUX

Valenciennes 1827 – Paris 1875

CARPEAUX'S FATHER, a stonemason, was too poor to further his son's education. With the financial aid of a cousin, the boy entered the Petite École in 1842, and made friends with two of his fellow students, the architect Charles Garnier (1825–1898), the future architect of the Opéra, and Ernest-Albert Carrier-Belleuse (1824–1887). Two years later he was admitted to the École des Beaux-Arts, where he studied with François Rude (1784–1855). However, for the purpose of increasing his chances to win the *Prix de Rome*, he later switched to the more orthodox Francisque Duret (1804–1865). Having won the coveted prize at last in 1855, Carpeaux spent six productive years in Italy. Instead of copying the antique as he was expected to do, he became an ardent admirer of Michelangelo, whose influence is paramount in Carpeaux's major work of this period, the *Ugolino* (cat. no. 76).

On his return to Paris, Carpeaux sent three pieces to the Salon of 1863; of these *Ugolino* received a medal, although it was attacked by the conservatives. A second work, the *Neapolitan Fisherboy*, was a tribute to Rude (who had treated the same subject as early as 1833), filtered through the graceful Rococo revival style at that time being launched by Carpeaux and Carrier-Belleuse. The third entry, a portrait bust of Princess Mathilde, established Carpeaux as a master portraitist and gained him entrée to the court of Napoleon III. This success led to the ambitious commission for the sculptural décor of the Pavillon de Flore at the Louvre, and another in 1865 for the monumental group, *The Dance,* one of four such groups for the façade of Garnier's Opéra. *The Dance* caused something of a scandal because of the sensuous nudity of the figures. Nevertheless, shortly before the outbreak of the Franco-Prussian war, Carpeaux received yet another monumental commission, the *Fountain of the Four Continents* for the Place de l'Observatoire in Paris, which he completed in 1874 shortly before his death.

An ardent admirer of Napoleon III, Carpeaux sought refuge in London after the Emperor's fall; he returned to Paris in 1872, only to find his studio badly damaged. The artist's last two years were dominated by his illness – he had cancer of the stomach – and grave difficulties with his family, which pre-vented him from carrying out any major artistic projects. Carpeaux's career thus spans no more than about fifteen years, from the late 1850s to the early 1870s. Yet during this brief period he succeeded in decisively influencing the future course of French sculpture. Both Aimé-Jules Dalou (cat. nos 78, 79) and Rodin were greatly indebted to him.

EXHIBITIONS
Salons of 1853, 1859, 1863, 1864, 1866, 1867, 1870, 1872, 1874. Paris Universal Exhibition, 1867. London, Royal Academy, and London International Exhibition, 1871.

AWARDS AND HONOURS
Prix de Rome, 1855. First-Class Medal, Salon of 1863. First-Class Medal, Paris Universal Exhibition, 1867. Chevalier (1867) and Officer (1875) of the *Légion d'Honneur.*

BIBLIOGRAPHY
Annie Braunwald, *Carpeaux,* exhibition catalogue, Paris, Grand Palais, 1975. Ernest Chesneau, *Le statuaire J.B. Carpeaux, sa vie, son œuvre,* Paris: A. Quantin, 1880. Louise Clément-Carpeaux, *La Vérité sur l'œuvre et la vie de Carpeaux,* Paris: Doussett and Bigerelle, 1934.

74

Defence of the Fatherland c. 1870
(Défense de la patrie)

Terracotta, on base in the shape of a segmental pediment

HEIGHT: 51.5 cm

INSCRIPTION
Signed on front of base, under left foot, *J.B^{te} Carpeaux*; oval stamp with eagle, above the signature, *Atelier Carpeaux.*

PROVENANCE
Heim Gallery, London. Acquired April 1971.

EXHIBITION
Winter 1969, London, Heim Gallery.

BIBLIOGRAPHY
Stanislas Lami, *Dictionnaire des sculpteurs de l'école française au dix-neuvième siècle,* Paris: Librairie Champion, 1914–1921, vol. 1, p. 271.

DEFENCE OF THE FATHERLAND, intended for the sculptural decoration of the city hall at Valenciennes, shows the personification of the city – note her mural crown – defending the arts and sciences, industry and agriculture symbolized by the objects on her left. The broken sword in her right hand suggests that the design was conceived at a time when France's defeat in the war of 1870–1871 was already certain. It is thus the earliest of a long series of monuments to the lost war conceived by younger sculptors in the years to come.

This piece was part of an edition made from the original plaster in Carpeaux's studio, probably not long before his death. There also exist examples in plaster.

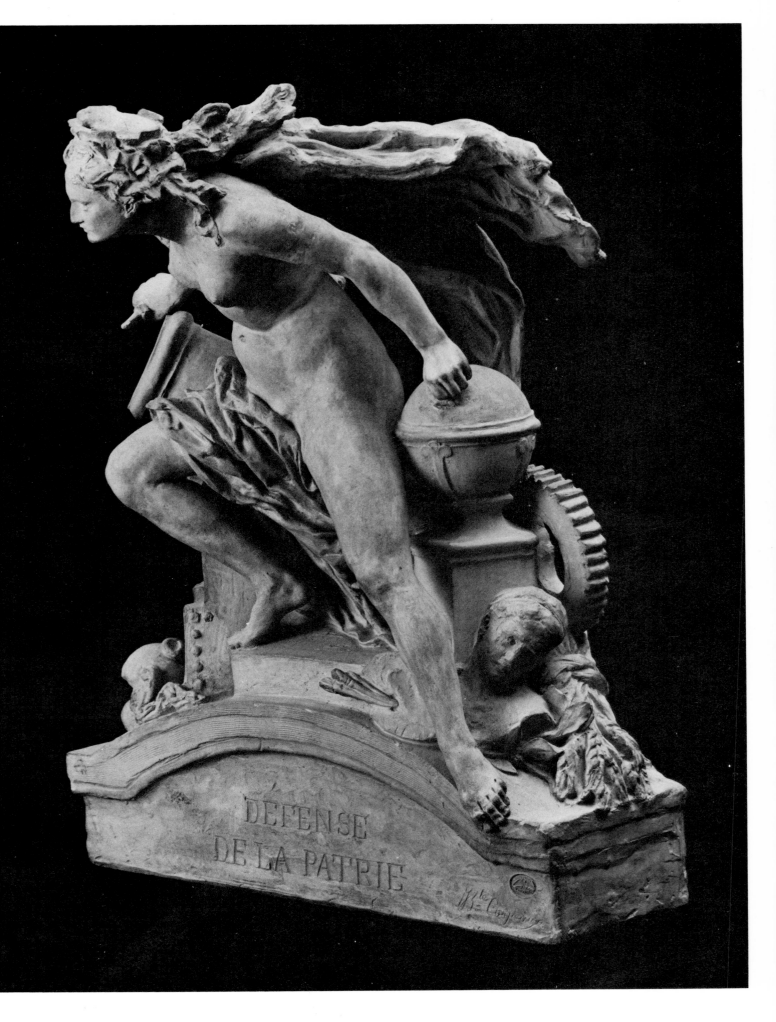

DEFENSE
DE LA PATRIE

75

Spirit of the Dance
(Génie de la danse)

Bronze with pitted greenish-brown patina,
on square bake-o-lite base

HEIGHT: 32 cm

PROVENANCE
Shepherd Gallery, New York. Acquired
May 1971.

EXHIBITION
1973, New York, Shepherd Gallery, *Western
European Bronzes of the Nineteenth Century: A
Survey* (unpaginated), cat. no. 43, repr.

RELATED WORKS
The Dance, Louvre (the original group from
the Opéra).

THE HEAD CORRESPONDS to that of the
figure on the extreme right of *The Dance.*
This is evidently a trial cast based on a
study for that head, perhaps in prepara-
tion for issuing an edition of it as a sepa-
rate piece. The title, *Génie de la danse,*
properly applies only to the central
figure of the group, which was issued in
various sizes and materials (see Jeanne
L. Wasserman, ed., *Metamorphoses in
Nineteenth-Century Sculpture*, Cambridge,
Mass.: Fogg Art Museum, 1975, pp.
128–133). Grapes and vine leaves in her
hair clearly mark the figure as a Bac-
chante. The study which this bronze
records probably dates from about
1868, while the cast may be of the years
1873–1875.

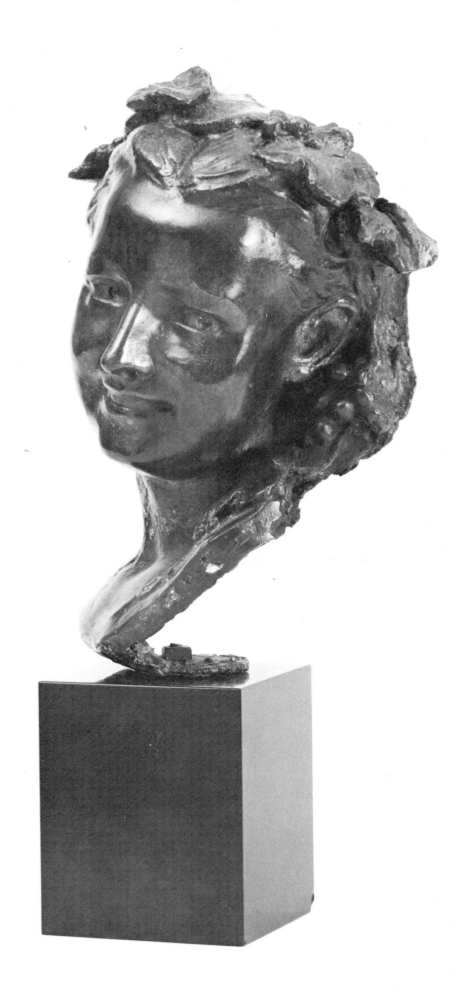

76

Ugolino and His Sons *c.* 1860
(Ugolin et ses enfants)

Plaster with dark brown patina, on base

HEIGHT: 54 cm

INSCRIPTION
Signed on base, right rear, *B. Carpeaux.*

PROVENANCE
Barnet Fine, New York; Heim Gallery,
London. Acquired May 1972.

EXHIBITION
1975, Cambridge, Mass., Fogg Art Museum,
Jeanne L. Wasserman, ed., *Metamorphoses in
Nineteenth-Century Sculpture*, pp. 113-123, cat.
no. 5a.

RELATED WORKS
Ugolino and His Sons, terracotta maquette;
Louvre, Paris. *Ugolino and His Sons*, marble;
Metropolitan Museum of Art, New York.

THE THEME OF UGOLINO, the starving
count who devoured his dead children,
is taken from Dante's *Inferno.* It had
been repeatedly treated by French
Romantic artists but had never before
been the subject of a monumental
sculptural group. Carpeaux's choice
violated the rules of the Academy and
he had to battle for permission to carry
it out. The original maquette – or, rath-
er, the "original plaster" made from the
clay model – is preserved in the Acad-
émie de France in Rome, Villa Medici.
This example was made from a piece
mould taken from the original plaster.
The catalogue of the *Metamorphoses* exhi-
bition (see Exhibition) designates it as
"type A" and notes that at least five
specimens are known. There also exist
specimens in bronze, plaster, and clay
based on other piece moulds, taken
from the Rome original. This first
maquette is distinguished from the ter-
racotta maquette in the Louvre and the
final, large-scale version of the work by
the fact that it has only three children
and a more compact grouping.

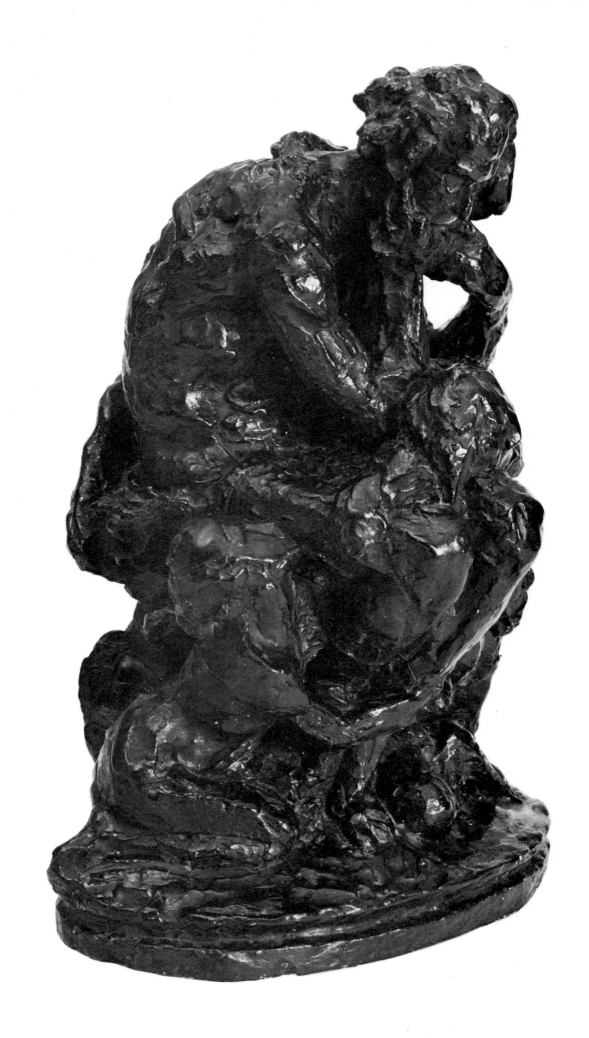

77

The Fisherwoman of Vignots
Model, 1874; *cast, c.* 1880–1890
(La Pêcheuse de Vignots)

Bronze with brown patina on oval base

HEIGHT: 71.7 cm

INSCRIPTION
Signed, engraved on base, by right foot, *JB
Carpeaux.* Engraved on vertical front of base,
PUYS.

PROVENANCE
Shepherd Gallery, New York. Acquired
March 1973.

EXHIBITION
1971, Louisville, Kentucky, J.B. Speed Art
Museum, *Nineteenth-Century French Sculpture:
Monuments for the Middle Class*, cat. no. 48,
repr. 1973, New York, Shepherd Gallery,
*Western European Bronzes of the Nineteenth Centu-
ry: A Survey* (unpaginated), cat. no. 48.

IN JULY 1874 CARPEAUX, already very ill,
was staying at Puys near Dieppe with
his old friend, Alexandre Dumas *fils.*
According to a letter he wrote to his
wife, he encountered a young fisher-
woman on the road and was so charmed
by her that he arranged for her to pose
for him. *The Fisherwoman* is thus one of
Carpeaux's last works, yet its freshness
of conception shows that his powers
were undiminished. His earlier genre
pieces, such as the *Neapolitan Fisherboy*
and its female counterpart, had been
nude and "exotic;" *The Fisherwoman* for
the first and only time shows him
exploring a contemporary French
"woman of the people" whom he invests
with grace and dignity.

Carpeaux, in this work, inevitably
evokes comparison with the various
Boulonnaises which Dalou was turning
out so successfully in London. He might
have seen one or the other of these dur-
ing his own London sojourn in 1872,
and such an experience could have
alerted him to the possibilities of this
novel kind of genre sculpture.

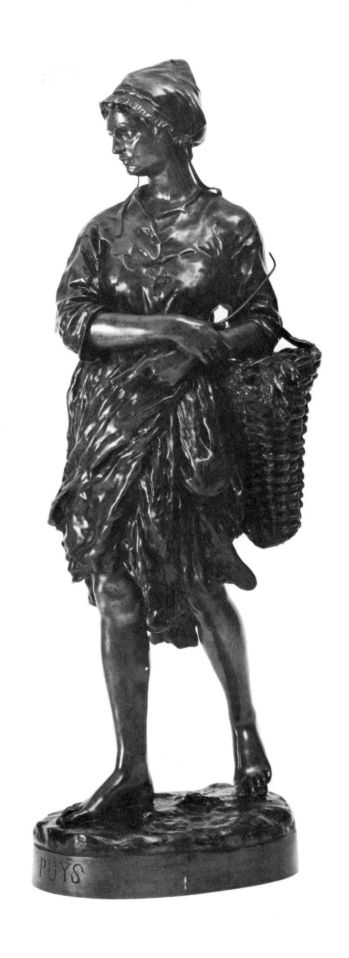

AIMÉ-JULES DALOU

Paris 1838 – Paris 1902

OF HUMBLE ORIGIN – his father was a glovemaker – Dalou first studied at the Petite École d'art decoratif. In 1854 he gained admission to the École des Beaux-Arts, where he studied under the sculptor Francisque-Joseph Duret (1804–1865). He never succeeded in winning the *Prix de Rome*, however, and like Rodin had to turn to decorative sculpture for a living. His earliest known works, a large mantelpiece and several reliefs, were done in 1864 (Hôtel Païva, Paris). In 1869 and 1870, he had his first successes at the Salon, with a group of two sculptures, *Daphnis and Chloë* and *Embroiderer* (*Brodeuse*), both of which were acquired by the State. During the Franco-Prussian war Dalou, a life-long Socialist, welcomed the Commune and joined the revolutionary Fédération des Artistes led by Gustave Courbet (1819–1877). After the collapse of the Commune, Dalou and his family fled to London. Three years later he was condemned in absentia to hard labour for life. Meanwhile, however, Dalou, aided by his friend Alphonse Legros (1837–1911) had successfully established himself in London, where he regularly exhibited portraits and genre pieces at the Royal Academy. Queen Victoria commissioned him to do a monument to her grandchildren who had died in infancy for the family chapel at Windsor. Nevertheless, Dalou returned to Paris as soon as he could after the general amnesty of 1879, where he entered a competition for a monument to the Republic destined for the Place de la République. Although he failed to win the contest, his model won such praise that it became the basis for a second monument to the Republic, unveiled twenty years later at the Place de la Nation.

Dalou's success was now assured; in 1883 he was made a chevalier of the *Légion d'Honneur* and won the *Grand Prix* at the Paris Universal Exhibition of 1889. Among the most impressive of his numerous public monuments to individuals are those to Delacroix, Victor Noir, Léon Gambetta, and Scheurer-Kestner, the defender of Dreyfus. His favourite project, however, never grew beyond the preparatory stage: it was a huge monument to labour, for which he produced countless sketches during the last decade of his life. After his death, the contents of his studio went to a charitable institution in exchange for the care of the artist's retarded daughter for the duration of her life. The institution retained reproduction rights but sold the originals to the city of Paris; they are now in the Petit Palais.

Next to Rodin, his lifelong friend, Dalou was the most important sculptor in his time. A frank admirer of Bernini – the first French sculptor who dared to acclaim the great Italian without reservation – Dalou combined the dynamism of the High Baroque with an intimate realism based on keen and sympathetic observation. His studies for the monument to labour have all the grandeur of the best of Millet's peasants but without the latter's sentimental pathos.

EXHIBITIONS
Salons of 1861, 1864, 1867, 1869, 1870. London, Royal Academy, 1872–1877, 1879. Salons of 1883–1889. Paris Universal Exhibitions, 1889, 1900. Salon, Société Nationale des Beaux-Arts, 1890–1892, 1894, 1897, 1901–1902.

AWARDS AND HONOURS
Grand Prize, Paris Universal Exhibition, 1889. Chevalier (1883); Officer (1889); Commander (1899) of the *Légion d'Honneur*.

BIBLIOGRAPHY
Henriette Cailleux, *Dalou (1838–1902): L'Homme, l'œuvre*, Paris: Librairie Delagrave, 1935. John M. Hunisak, *The Sculptor Jules Dalou: Studies in His Style and Imagery*, New York: Garland Publishing, 1977.

78

Boulogne Peasant Woman With Palm
1871–1872
(*Boulonnaise au Rameau*)
Terracotta, on circular base
HEIGHT: 59.9 cm

INSCRIPTION
Signed on base, *DALOU.*

PROVENANCE
James Coats, New York; Stephen Spector, New York; Peridot Gallery, New York. Acquired November 1971.

EXHIBITION
1872, London, Royal Academy, cat. no. 1461 (as *Le Jour des Rameaux à Boulogne*).

BIBLIOGRAPHY
Cailleux, *Dalou*, p. 126.

RELATED WORK
Palm Sunday in Boulogne (*Le Jour des Rameaux à Boulogne*), terracotta, 1872; Bethnal Green Museum, London.

DURING HIS YEARS IN LONDON (1871–1879), Dalou produced and exhibited a number of Boulogne peasant women, of which this piece seems to have been the earliest. The works all share an interest in the picturesque costume of the region and emphasize the simple piety and maternal tenderness of peasant women, sometimes – as in this example – not without a touch of self-conscious idealization and sentiment. The example in the Bethnal Green Museum (see Related Work) appears to be an exact duplicate of this one; presumably the artist worked from a plaster mould, producing an unknown number of terracotta replicas on demand. This *Boulogne Peasant Woman*, however, is not a mechanical reproduction, for it gives evidence of careful finishing by hand.

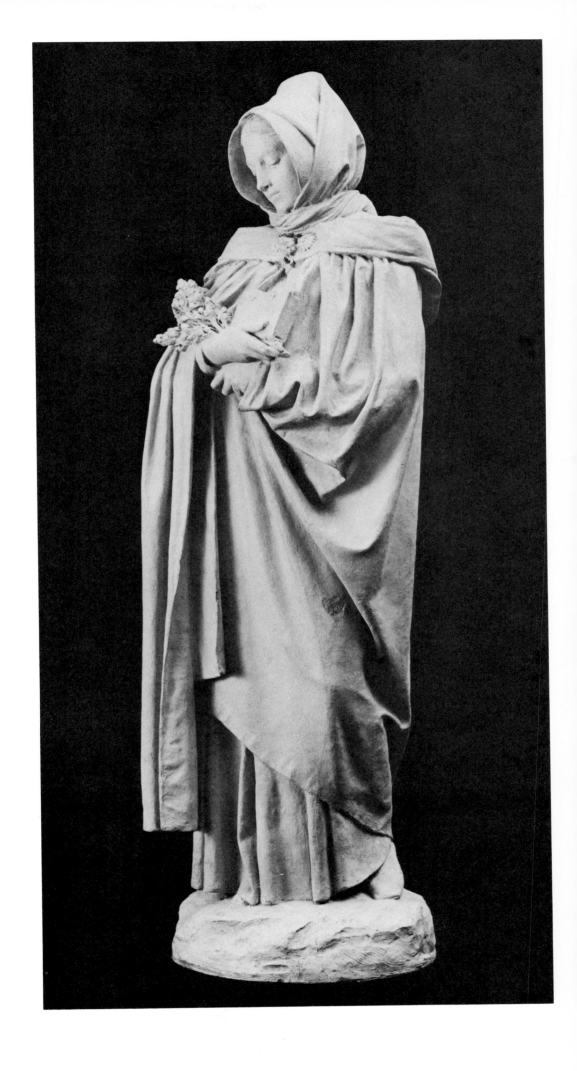

79

The Bather
Model, c. 1890; *cast, c.* 1905

Bronze, black patina, on octagonal base

HEIGHT: 54.6 cm

INSCRIPTION
Signed on vertical edge of base, below the
left buttock, *DALOU*; foundry mark *Hébrard
11 fondeur.*

PROVENANCE
Mario Amaya Collection, New York.
Acquired February 1971.

BIBILIOGRAPHY
Cailleux, *Dalou,* pl. XII.

RELATED WORK
The Bather (Baigneuse), original plaster; Petit
Palais, Paris (repr. in Cailleux, *Dalou,* pl.
XII).

THE CHRONOLOGY of Dalou's numerous
female bathers is difficult to establish.
They seem to be concentrated in two
groups: an early one, made during his
London sojourn, and a late one, dating
from the 1890s. The bathers of the latter
group are distinguished by their heavier
bodies, compact poses, and realistic
expressions. This example clearly
belongs to this late type.

The plaster reproduced by Cailleux
(see Related Work) is presumably
among the artist's works in the Petit
Palais, but the author does not identify
it further, nor does she correlate it with
her list of the artist's works. The excel-
lent cast by Hébrard (see Inscription) is
surely posthumous; presumably, there
was a limited edition made about 1905,
as there was of so many other pieces in
plaster or terracotta from the artist's
estate.

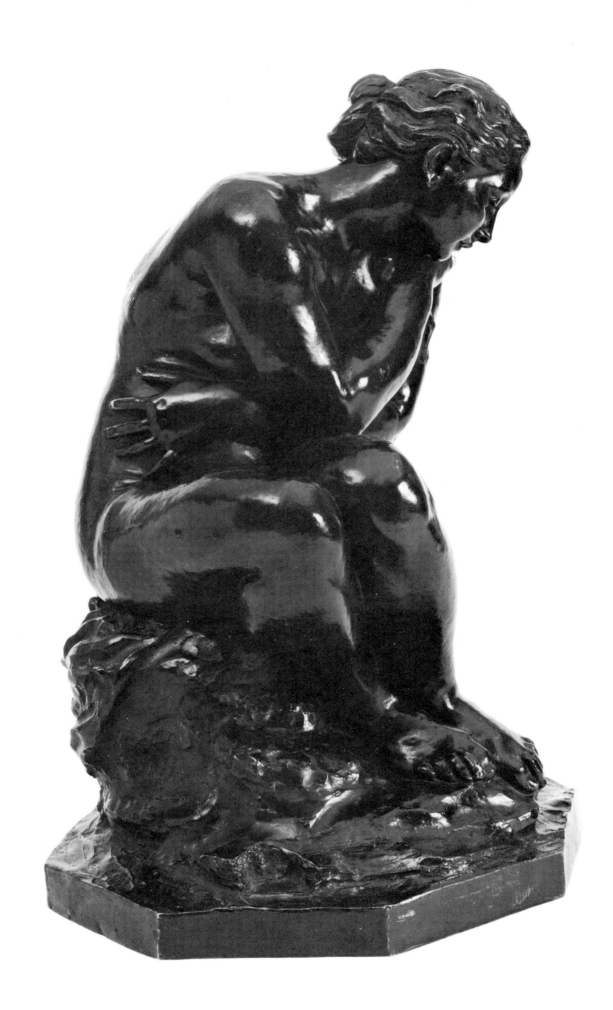

80

Truth Unrecognized
(La vérité méconnue)

Terracotta,
on irregularly shaped oval base

HEIGHT: 21 cm

INSCRIPTION
Signed on base, below left buttock, *Dalou.*

PROVENANCE
Mario Amaya Collection, New York.
Acquired May 1971.

BIBLIOGRAPHY
Cailleux, *Dalou*, p. 156.

RELATED WORK
Truth Unrecognized (La vérité méconnue), pati-
nated plaster, height: 34 cm; Petit Palais,
Paris. Reproduced in porcelain by the Man-
ufacture de Sèvres and in bronze by Susse
Frères.

THE MIRROR ON THE GROUND beside
the left foot characterizes the figure as
the mourning "Truth Abandoned."
This specimen corresponds exactly to a
terracotta, evidently a study for the
larger plaster model, in the Petit Palais
(see Related Work). Cailleux plausibly
suggests that the subject reflects Dalou's
distress with the implications of the
Dreyfus affair. There must have been
an edition of this terracotta, perhaps for
the benefit of the defenders of Dreyfus.
In style and conception, the figure
appears closely related to *The Bather*
(cat. no. 79).

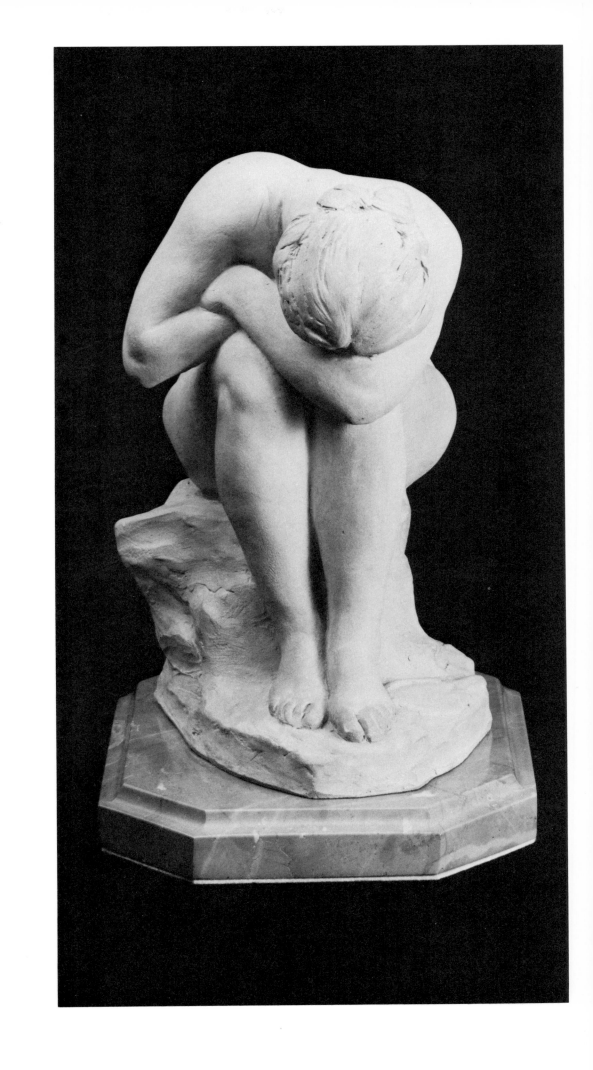

JEAN-ALEXANDRE-JOSEPH FALGUIÈRE

Toulouse 1831 – Paris 1900

THE SON OF A STONEMASON, Falguière received a fellowship from the city of Toulouse that enabled him to go to Paris, where he studied under François Jouffroy (1806–1882) at the École des Beaux-Arts. He made his Salon debut in 1857 with a plaster statue, *Theseus as a Child* (*Thésée Enfant*) and won the *Prix de Rome* two years later. In Italy, which enchanted him, he was befriended by the slightly older Jean-Baptiste Carpeaux (cat. nos 74–77). Falguière's first public success came in 1864, when he sent a bronze, *Winner of the Cockfight* (*Un vainquer au combat de coqs*), to the Salon. It won critical acclaim for its elegance and grace, was bought by the State, and shown again at the Paris Universal Exhibition of 1867. The marble figure of the dying boy-martyr *Tarcisius* (1868) further helped to establish his reputation. In 1870, he became a Chevalier of the *Legion d'Honneur* and advanced to higher ranks in 1878 and 1889.

During the Franco-Prussian war, Falguière served with the National Guard. In the winter of 1870–1871, while Paris was under siege, he created a gigantic statue, *La Résistance*, of snow; its appearance is preserved in a maquette done later (bronze cast; Los Angeles County Museum of Art).

From 1873 on, Falguière was also active as a painter, but sculpture remained the basis of his successful career, which brought him numerous commissions for public monuments to "culture heroes." It was he who carried out the Balzac monument (1889), after Rodin's statue had been rejected by the Société des Gens de Lettres. His most popular works were the female nudes he sent to the Salon during the 1880s, including *Eve*, *Diana*, and *Juno*, yet he failed with his most ambitious project, a monumental group for the top of the Arc de Triomphe de l'Étoile; the model he mounted on the arch aroused general criticism.

Despite his conventional success – in 1882 he became a professor at the École des Beaux-Arts and a member of the Académie Française – Falguière was no mere academic sculptor. His spirited maquettes and intimate portraits reveal a measure of sympathy with Rodin. This is not surprising, since they were friends and made portrait busts of each other.

EXHIBITIONS
Paris Salons of 1857, 1864. Paris Universal Exhibition, 1867. Salons of 1868, 1872, 1875–1878, 1880, 1883, 1886, 1890, 1892, 1896.

AWARDS AND HONOURS
First-Class Medal, Paris Universal Exhibition, 1867. Chevalier (1870); Officer (1878); Commander (1889) of the *Légion d'Honneur*.

BIBLIOGRAPHY
Léonce Bénédite, *Alexandre Falguière*, Paris: Librairie de l'art ancien et moderne, 1902. Stanislas Lami, *Dictionnaire des sculpteurs de l'école française au dix-neuvième siècle*, Paris: Librairie Champion, 1914–1921, vol. 2, pp. 324–335.

81

Bust of Diana *c.* 1885–1890

Bronze, dark brown patina, on marble base

HEIGHT: 43.5 cm

INSCRIPTION
Signed on left shoulder, *A. Falguière*; foundry mark, *Thiébaut Frères*.

PROVENANCE
David Daniels Collection, New York. Acquired June 1971.

EXHIBITION
1971, Louisville, Kentucky, J.B. Speed Art Museum, *Nineteenth-Century French Sculpture: Monuments for the Middle Class*, cat. no. 64, repr.

RELATED WORK
Diana, marble, life-size (Salon, 1887); Musée de Toulouse.

THE MOST POPULAR of the various Dianas and "Nymphs Hunting" Falguière produced during the 1880s was a standing figure. Her weight rests on her left leg, and she pulls an imaginary bow. The subject exists in reduced marble and bronze versions, and as a bust such as this *Diana*, which presumably is an elaborated study for the life-size statue. The summary handling of details and the ragged and irregular edge of the bust suggest the influence of Rodin, as does the austere expression, unusual for Falguière.

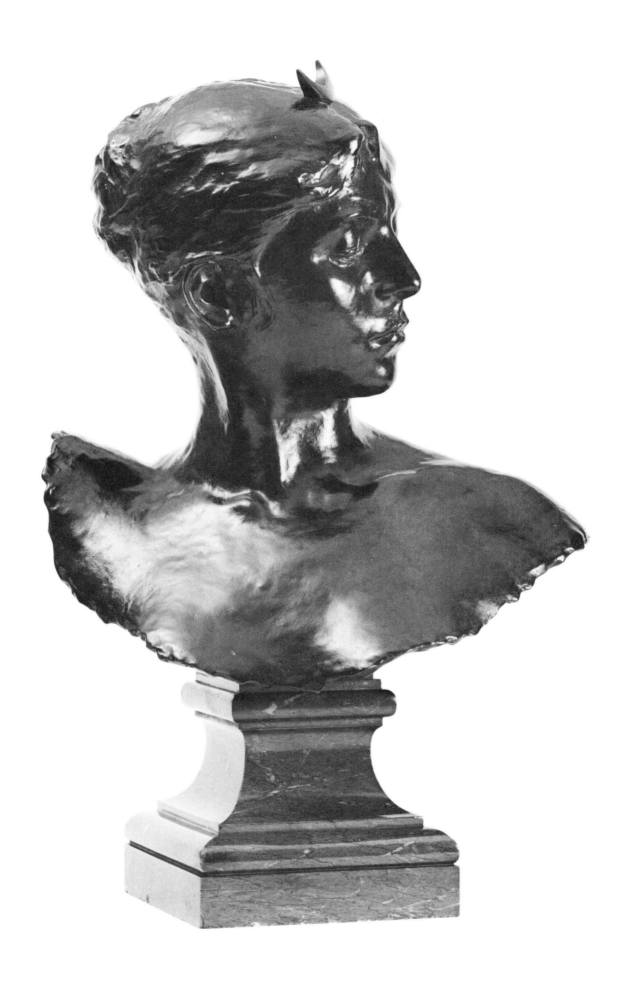

EMMANUEL FRÉMIET

Paris 1824 – Paris 1910

FRÉMIET'S AUNT, Sophie Frémiet, who had married the sculptor François Rude (1784–1855), awakened the boy's interest in art. He studied briefly with another relative, the natural history painter Jacques Christophe Werner (1798–1856), at the Petite École d'art décoratif and at the Museum of the Jardin des Plantes, until he became a pupil of Rude. Frémiet made his Salon debut in 1843 with the plaster study of a gazelle; six years later, he was awarded a Third-Class Medal for animal sculpture, and received his first State commission for a bronze *Wounded Dog* (*Le chien blessé*; Louvre). He soon gained the favour of Napoleon III with *The Basset Hounds Ravageot and Ravageole* (Salon of 1853; Guard Room, Château de Compiègne). Between 1855 and 1860, he produced for the emperor fifty-five statuettes of soldiers wearing the various uniforms of the French army. These were lost in the burning of the Tuileries in 1871, but reproductions of a number of them exist today at Compiègne.

Frémiet's most ambitious work before the Franco-Prussian war, *Gorilla Dragging the Body of a Woman* (*Gorille*; 1859), was rejected by the Salon jury of 1859, a decision praised by Baudelaire. A second version, which he submitted to the Salon of 1887, was eminently successful (it was shown at the Paris Universal Exhibitions of 1889 and 1900). Although he became a chevalier of the *Légion d'Honneur* as early as 1860, public success eluded him until the 1870s. Then, in 1875, he took the place of Antoine-Louis Barye (cat. no. 72) as professor of drawing at the museum of the Jardin des Plantes. Thereafter he received more promotions (see Awards and Honours) and in 1892 he was elected a member of the Académie des Beaux-Arts.

Of his numerous equestrian monuments, the best known is the gilt-bronze *Joan of Arc* (Place des Pyramides, Paris). Throughout his career, he turned out a steady stream of small animal bronzes which established him as the most accomplished *animalier* of the last third of the century. His most ambitious works, however, stem from the ill-fated *Gorilla* of 1859: *Man of the Stone Age* (*Homme de l'âge de pierre*), *Bear-Cub Hunter* (*Dénicheur d'oursons*), and *Orang-outrang and Savage of Borneo* (*Orang-outrang et sauvage de Bornéo*). Their full implications, reflecting the impact of Darwinism on the anthropology of the late nineteenth century, remain to be explored.

EXHIBITIONS
Exhibited regularly at Salons of 1843–1903. Paris Universal Exhibitions, 1855, 1867, 1889, 1900.

AWARDS AND HONOURS
Second-Class Medal, Salon of 1851. Second-Class Medal, Paris Universal Exhibition, 1867. Medal of Honour, 1887. *Hors concours*, Paris Universal Exhibition, 1889. Grand Prize, Paris Universal Exhibition, 1900. Chevalier (1860); Officer (1878); Commander (1896); and Grand Officer (1900) of the *Légion d'Honneur*.

BIBLIOGRAPHY
Etienne Bricon, "Frémiet," *Gazette des Beaux-Arts*, 1895, vol. 19, pp. 494–507; vol. 20, pp. 17–31. Jacques de Biez, *Un maître imagier: E. Frémiet*, Paris, Jouve, 1896. Stanislas Lami, *Dictionnaire des sculpteurs de l'école française au dix-neuvième siècle*, Paris: Librairie Champion, 1914–1921, vol. 2, pp. 405–419.

82

Bear and Gladiator *c.* 1890
(*Ourse et rétiaire*)

Cast terracotta, on oval base

HEIGHT: 28 cm

INSCRIPTION
Signed top of base, *E. FREMIET.*

PROVENANCE
Shepherd Gallery, New York. Acquired April 1972.

EXHIBITIONS
1971, Louisville, Kentucky, J.B. Speed Art Museum, *Nineteenth-Century French Sculpture: Monuments for the Middle Class*, p. 178ff, cat. no. 70, repr. 1973, New York, Shepherd Gallery, *Western European Bronzes of the Nineteenth Century: A Survey* (unpaginated), cat. no. 35b, repr.

RELATED WORK
Bear and Man of the Stone Age (*Ours et homme de l'âge de pierre*), 1885; Jardin des Plantes, Paris (another cast belongs to the University of Illinois, Urbana-Champaign).

THIS WORK IS A VARIANT of Frémiet's life-size bronze of a Stone Age hunter being crushed by a bear whose cub he has snared. The same model also exists in bronze (David Daniels Collection, New York; Shepherd Gallery Exhibtion, 1973, cat. no. 35a). In the small-scale version, intended for private collectors, the Stone Age hunter has been turned into a *retiarius*, a Roman gladiator who fought wild beasts or other gladiators almost naked, equipped only with a net and a trident. The net is clearly visible, but Frémiet has omitted the trident; the gladiator's knife, corresponding to that of his Stone Age predecessor, is plunged into the bear's left shoulder. The cub is not snared, but clings to his mother's left leg.

Frémiet had modelled a wounded bear as early as 1850, and a *retiarius* in 1876 (*Gladiator and Gorilla* [*Rétiaire et Gorille*], terracotta). The change of scene from the Stone Age to the Roman arena entails a new emphasis on the animal: unlike the Stone Age hunter, who is still struggling, although vainly, against the deadly embrace of the bear, the gladiator has lost consciousness, so that the animal is both crushing and supporting him with its paws. The work may be dated soon after the success of the large group at both the Salon of 1885 and the Paris Universal Exhibition of 1889.

To the public, gladiatorial combats (frequently depicted by painters such as Gérôme) were more familiar than was the anthropological context of Frémiet's original version, suited to the special environment of the Jardin des Plantes.

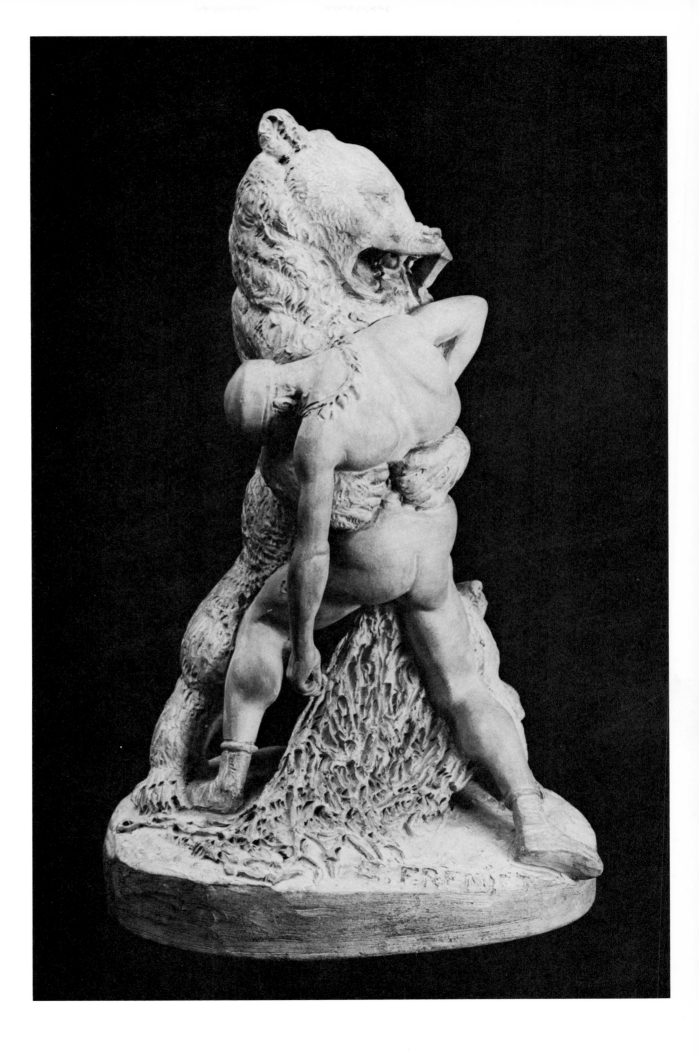

JEAN-LÉON GÉRÔME

Vesoul (Haute-Saône) 1824 – Paris 1904

HAVING ACHIEVED BOTH FAME AND HONOUR as a painter (see cat. nos 30–38), Gérôme, at the age of fifty-four, began to devote himself increasingly to sculpture. This rather astonishing change resulted in works which included classical and oriental subjects, equestrian figures, and portrait busts and he exhibited a sculpture for the first time in a Salon in 1878.

Gérôme's works in marble are distinguished by his pioneering use of polychromy. He often combined a variety of materials – bronze, ivory, marble, semiprecious stones – to achieve novel effects of extraordinary richness (see *Bellona*, 1892, and *Corinth*, 1904). Most of his large pieces were issued in smaller sizes, usually in gilt-bronze, by the foundry Siot-Decauville. In his exploration of coloured materials and surfaces, Gérôme followed a tradition which can be traced to ancient Egypt and which had been widely practised in western art until the Neo-classic era. This tradition was revived in the mid-nineteenth century by such French sculptors as Charles Cordier (1827–1905), who provided the immediate precedents for Gérôme. Yet it was in the work of Gérôme that the techniques involved reached their greatest refinement, and his example was followed by younger sculptors in France and abroad (see Louis-Ernest Barrias, 1841–1905, and Max Klinger, cat. no. 84). Gérôme's influence was felt as late as the 1920s in the coloured "multimedia" sculpture of Art Deco.

EXHIBITIONS
Paris Universal Exhibition, 1878. Salons (sculpture) of 1881, 1890–1892, 1896–1899, 1901, 1904. 1900, Paris Exhibition of French Art (centennial).

AWARDS AND HONOURS
Second-Class Medal, Salon of 1878 and First-Class Medal, Salon of 1881 (sculpture).

BIBLIOGRAPHY
Charles Moreau-Vauthier, *Gérôme, peintre et sculpteur, l'homme et l'artiste, d'aprés sa correspondance, ses notes, les souvenirs de ses élèves et de ses amies*, Paris: Hachette, 1906.

Sarah Bernhardt *c.* 1890 – 1895
Patinated plaster
HEIGHT: 67.7 cm

INSCRIPTION
Signed on base, left of centre, *A SARAH BERNHARDT/J.L. GEROME.*

PROVENANCE
H. Schickman Gallery, New York. Acquired September 1972.

BIBLIOGRAPHY
Stanislas Lami, *Dictionnaire des sculpteurs de l'école française au dix-neuvième siècle*, Paris: Librairie Champion, 1914–1921, vol. 3, p. 56. Maurice Rheims, *19th Century Sculpture*, translated by Robert E. Wolfe, New York: Harry N. Abrams, 1977, pp. 392, 398 (fig. 12).

RELATED WORK
Bust of the same subject in tinted marble, bequeathed by the artist to Musée du Luxembourg, now in the Musée du Louvre.

━━━━━━━━━━━━━━━━━━━━

SARAH BERNHARDT (1844–1923), besides being the most famous actress of her day, was a sculptor and painter of talent, who made her Salon debut in 1875 and continued to exhibit until the end of her life. The dedicatory inscription of Gérôme's bust, as well as the allegorical figures attached to it (a swarm of winged genii on the left, a classical actor wearing a tragic mask on the right) attest that the artist intended it as a homage to the "Divine Sarah."

Judging by the sitter's age and costume, the marble version must date from the 1890s. Patinated plaster casts of the original, such as this work, were probably produced under the artist's supervision in considerable numbers for sale to the general public. The odd combination of a life-size portrait bust with allegorical figures on a much smaller scale may have been suggested by Sarah Bernhardt's well-known *Self-Portrait as a Chimera* (1880).

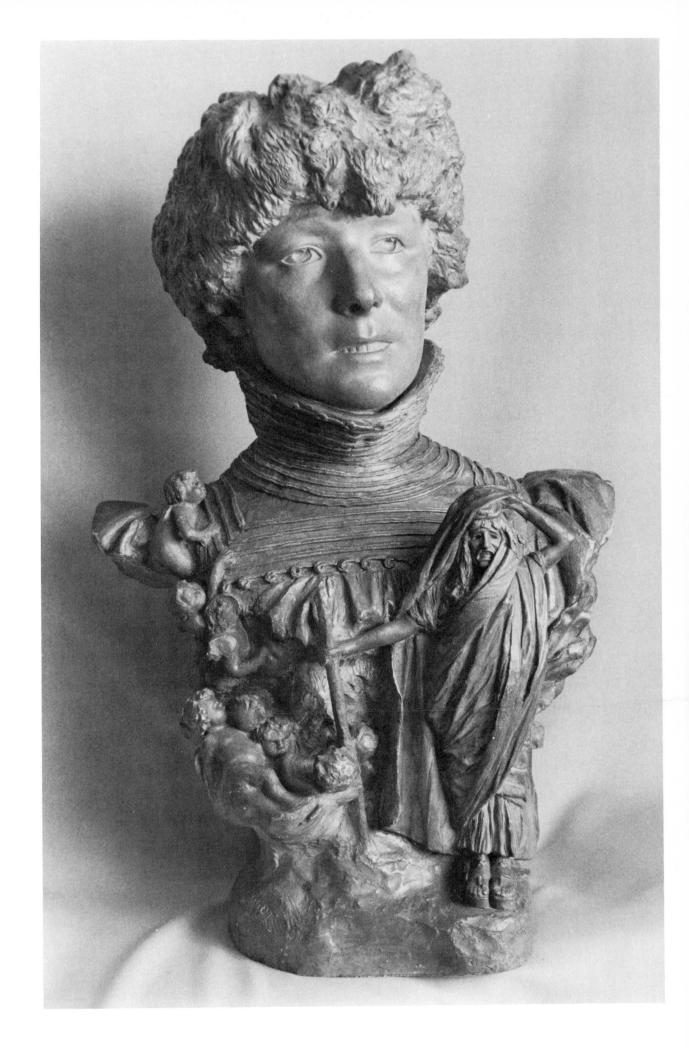

MAX KLINGER

Leipzig 1857 – Grossjena 1920

KLINGER'S FATHER, a soap manufacturer who was also an amateur painter and musician, encouraged his son's artistic ambitions.

In 1874, Klinger began to study painting with Karl Gussow (1843–1907) at the Karlsruhe Academy, Leipzig (among his fellow students was the painter Ferdinand Hodler [1853–1918] and followed him to Berlin a year later, when Gussow was called to the academy there). After a year's military service, Klinger returned to Berlin, where he had his first public success in 1878 at the exhibition of the Royal Academy. In 1875 he spent six months in Brussels as a student of Émile Charles Wauters (1846–1933) and produced a series of erotic drawings under the influence of Félicien Rops (1833–1898). Another important source of inspiration for the youthful Klinger was Arnold Böcklin; having trained himself to become an accomplished graphic artist, Klinger produced etchings after several of Böcklin's paintings. In 1883 he settled in Paris for six months, and returned to that city for a year and a half in early 1885. According to his own testimony, it was at this time that he began his earliest sculptures in the round. In the years 1888–1893 Klinger travelled extensively in Italy. In 1894 he spent several weeks in Greece. Meanwhile, in 1892, he had helped to found the anti-academic artists' group "XI" in Berlin to protest the closing of an exhibition of Edvard Munch (1863–1944).

By now, Klinger had become the most famous artist in Germany. Notwithstanding the attacks of the conservatives, he was appointed professor at the Leipzig Academy in 1897 and during the next decade received a large number of official honours and distinctions. The year 1902, when his Beethoven monument was triumphantly displayed at the Vienna Secession and subsequently acquired by the Leipzig Museum, to be housed in a specially built annex, represents the climax of Klinger's career, although his most fruitful years were the 1880s and early 1890s.

His work, with its often startling mixture of realism and symbolism; its striving for a *Gesamtkunstwerk* concept, which combines not only a variety of media but various arts; and his preoccupation with eroticism, religion, and death, make Klinger the most striking *fin-de-siècle* artist in central Europe. After half a century of neglect, there has been a notable revival of interest in him since the centennary of his birth in 1957.

EXHIBITIONS
Royal Academies of Art: Berlin, 1878, 1887; Breslau, 1888; Dresden, 1893; Leipzig, Paris, and Dresden, 1895; Vienna, 1898; Leipzig, 1907, 1917.

AWARDS AND HONOURS
Medal (engravings), Munich, 1891.
Member of the Royal Academy of Art, Berlin, 1894.

BIBLIOGRAPHY
Giorgio de Chirico, "Max Klinger," *Il Convegno*, vol. 1 (1920), pp. 32–44. Museum der bildenden Münste, *Max Klinger*, exhibition catalogue, Leipzig, 1970. Stella Vega Mathieu, *Max Klinger, Leben und Werk in Paten und Bildern*, Frankfurt: Insel-Verlag, 1976.

84

Beethoven 1897–1902
Bronze with black patina
on green marble base

HEIGHT: 52 cm

INSCRIPTION
Signed on truncation of left leg, *MK*; foundry mark on truncation of right buttock, *AKTIENGESELLSCHAFT. GLADENBECK/BERLIN-FRIEDRICHSHAGEN.* Directly above foundry mark, number *1*.

PROVENANCE
Shepherd Gallery, New York. Acquired August 1971.

EXHIBITION
1973, New York, Shepherd Gallery, *Western European Bronzes of the Nineteenth Century: A Survey* (unpaginated), cat. no. 89, repr.

RELATED WORKS
Beethoven, marble; Museum of Fine Arts, Boston. *Beethoven Monument*, marble, bronze, and ivory; Museum der bildenden Künste, Leipzig.

KLINGER CLAIMED that he conceived the Beethoven monument in Paris in 1885 and carried out the project in coloured plaster, but that he set it aside when it was rejected a few years later by the Berlin Academy. This first version, for which the artist claimed priority over Rodin's *The Thinker* and *Victor Hugo*, has not survived, and its size and appearance are not known, even from photographs or drawings.

This monument incorporates many reminiscences of the Paris sojourns of Klinger – not only of Auguste Rodin (whose studio he visited in 1900) but also of Jean-Léon Gérôme (cat. nos 30–38, 83), and even of François Rude (1784–1855). Surprisingly enough, Klinger himself seems to have sensed that the monument was something of an anachronism; in 1904, having just seen a Rodin exhibition, he wrote to a friend that, in comparison, "my Beethoven looks like a ghastly plaything."

Aside from the marble replica of the Beethoven torso now in the Museum of Fine Arts, Boston, Klinger issued a limited edition of bronze reductions of the torso, including this one.

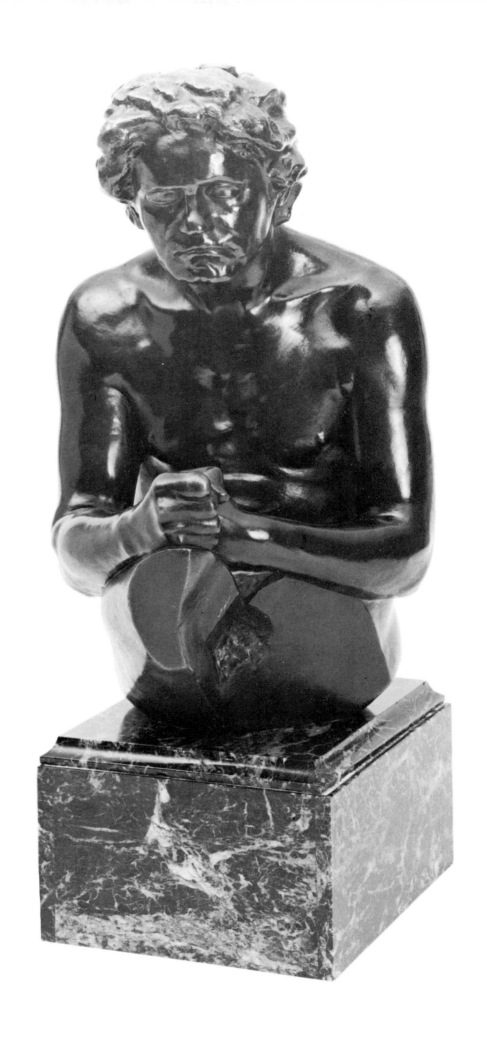

CONSTANTIN MEUNIER

*Etterbeek (near Brussels) 1831 –
Exelles 1905*

MEUNIER STUDIED SCULPTURE under
Charles Auguste Fraikin (1817–1893)
and painting under F.J. Navez
(1787–1869) at the Brussels Academy.
From 1857 on, he turned to social and
religious themes under the influence of
Charles de Groux (1825–1870) and
achieved modest success as a painter. It
was not until 1885 that he resumed his
early activity as a sculptor, exhibiting
five pieces with *Les "XX"* in Brussels.
These sculptures reflected the deep
impressions he had received during a
visit in 1878 to the coal-mining district
near Mons known as Le Borinage,
which inspired his desire to celebrate
"the heroism of labour" in his work.
Meanwhile Meunier also had made
contact with the Impressionists and
with Auguste Rodin (1840–1917), who
influenced him profoundly. His monu-
mental worker types established the
artist's international fame as a sculptor
which, about 1900, rivalled that of
Rodin. His bronzes, shown in Paris at
Siegfried Bing's Salon de l'Art Nouveau
and Julius Meier-Graefe's Maison
Moderne, greatly influenced younger
sculptors, especially those in Germany.
Even Rodin's *Thinker* came to be inter-
preted as a "heroic worker" about to
explode into action, although nothing of
the sort could have been intended when
the figure was still a part of the huge
commissioned work, *The Gates of Hell*.

The close link between art and
social reform during the 1890s is further
attested to by the fact that in those
years Rodin as well as Aimé-Jules
Dalou (cat. nos 78–80) planned a
"Monument to Labour," and that the
Belgian Workers' Party established a
section d'art at its headquarters where
Meunier and others showed their work.
Meunier's fame began to diminish soon
after his death; today, his sculpture is
suffering from undeserved neglect. A
rational evaluation of his achievement
is long overdue.

EXHIBITIONS
Brussels Salons of 1851, 1869. Paris Salons of
1868, 1872, 1873, 1876–1881, 1884–1886.
Brussels, Exhibition of "XX" of 1885, 1887.
Paris Universal Exhibition of 1889, 1900.

AWARDS AND HONOURS
Gold Medal, Brussels Salon of 1869. Knight
of the Order of Leopold, 1875. Chevalier of
the *Légion d'Honneur*, 1889. Grand Prize,
Paris Universal Exhibition, 1889, 1900.

BIBLIOGRAPHY
Lucien Christophe, *Constantin Meunier*, Mon-
ographies de l'art belge, Antwerp: De Sik-
kel, for the Ministry of Education, 1947. A.
Thiery and E. Van Dievot, *Catalogue complet
des œuvres . . . de Constantin Meunier*, Louvain:
Imprimerie Nova et Vetera, 1909. A. Thiery
and G. Hendrickx, *Le Monument au Travail de
Constantin Meunier*, Brussels, 1912.

85

Bust of a Puddler

Bronze with brown patina,
on grey marble base

HEIGHT: 48.2 cm

INSCRIPTION
Signed, back right, *C. Meunier*; foundry
mark, back left, FONDU PAR VERBEIST POUR
L'ATELIER CONSTANTIN MEUNIER BRUXELLES.

PROVENANCE
Shepherd Gallery, New York. Acquired
October 1971.

EXHIBITION
1973, New York, Shepherd Gallery, *Western
European Bronzes of the Nineteenth Century: A
Survey* (unpaginated), cat. no. 80, repr.

BIBLIOGRAPHY
Albert Alhadeff, "Meunier's *Puddleur*:
'Heroic Grandeur' or 'Heroic Afflatus'?",
The University of New Mexico Art Muse-
um, Bulletin no. 10, 1977, pp. 12–14.

A WAX FIGURE of a seated puddler (a
foundryman), apparently of fairly small
size like his other entries, was among
the five pieces Meunier sent to the exhi-
bition of *Les "XX"* in 1885. A life-size
bronze version dates from 1889. The
bust exhibited here agrees with the cor-
responding portion of the full-length
statue, but not in detail; it may be an
elaborated study for the statue, cast in
an edition of unknown size for private
collectors. Such "excerpts" of full-length
statues are known from the late eight-
eenth century on and enjoyed great
popularity among sculptors of the late
nineteenth (Carpeaux, cat. nos 74–77;
Dalou, cat. nos 78–80; Falguière, cat.
no. 81; and Rodin). The rough surfaces,
powerful anatomy, and dramatic
expression of this bust are eloquent tes-
timony to the influence of Rodin, whose
work Meunier had come to know dur-
ing his frequent trips to Paris in the
later 1880s.

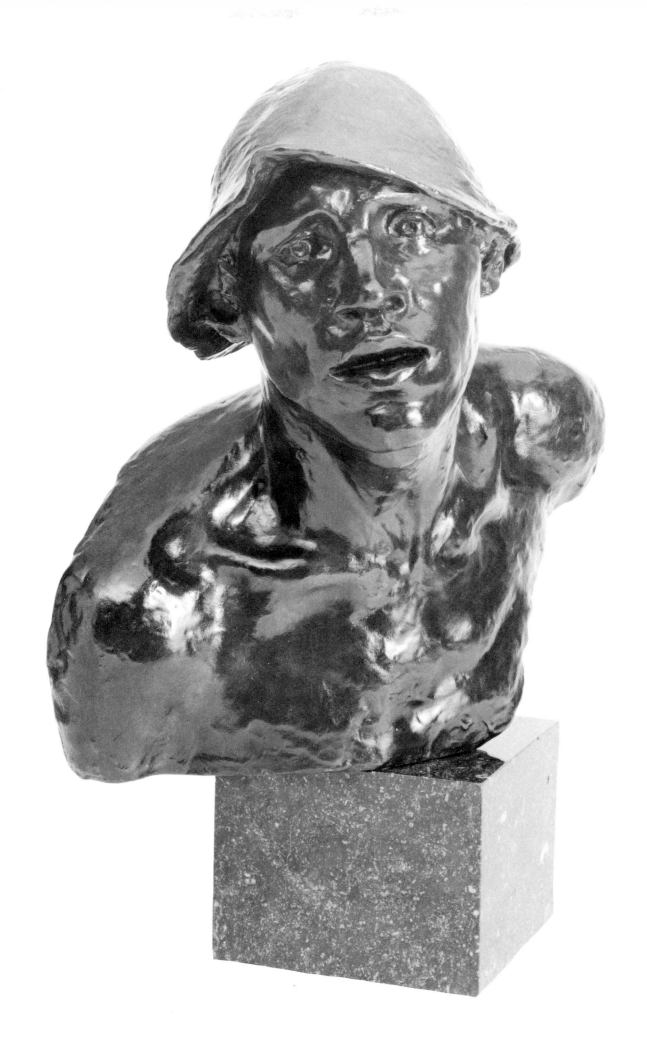

GEORGE MINNE

Ghent 1866 – Laethem-Saint-Martin 1941

THE SON OF AN ARCHITECT, Minne was expected to follow in his father's footsteps. While studying at the Ghent Academy, however, he began sculpting on his own, without formal training. Early works such as the *Christ on the Cross* (1885; destroyed) and *Mother Mourning Her Dead Child* (1886; Musée royal d'Art moderne, Brussels) show his awareness of Auguste Rodin (1840–1917), who praised his work when Minne visited Paris in 1890; but from the late 1880s on, under the influence of Émile Verhaeren (1855–1916) and Maurice Maeterlinck (1862–1949), he became the leading sculptor of the Symbolist movement.

The 1890s was the artist's most productive decade. His elongated, motionless figures, his sharp-edged, block-like forms betray his kinship, not only with the Symbolist painters of the time but with Gothic sculpture, which he must have studied intensively. His best-known and most ambitious work, the *Fountain of Kneeling Youths* (1898), was shown at the Vienna Secession in 1900 and acquired by the Folkwang Museum, Essen. Minne had a decisive influence on two leading German sculptors of the twentieth century, Wilhelm Lehmbruck (1881–1919), a follower of Rodin, and Ernst Barlach (1870–1938), a German Expressionist sculptor. Minne's later works, from about 1910 on, are disappointingly conservative.

EXHIBITIONS
Brussels, Exhibition of "xx" of 1890, 1892. Vienna Secession, 1900. Retrospective (Brussels), 1929.

AWARDS AND HONOURS
Created baron in 1931.

BIBLIOGRAPHY
Leo van Puyvelde, *George Minne*, Brussels: Les Cahiers de Belgique, 1930. André de Ridder, *George Minne*, Monographies de l'art belge, Antwerp: De Sikkel for the Ministry of Education, 1947.

Fellowship 1898
(Solidarité)

Bronze with brown patina

HEIGHT: 68.5 cm

INSCRIPTION
Signed, engraved on corner of base, l.f., G. *MINNE*, followed by the number *2/6*.

PROVENANCE
Shepherd Gallery, New York. Acquired September 1971.

EXHIBITION
1973, New York, Shepherd Gallery, *Western European Bronzes of the Nineteenth Century: A Survey* (unpaginated), cat. no. 86, repr.

RELATED WORK
Fellowship (Solidarité), 1933, cut stone, height: 117 cm; Royal Palace of Laken, Belgium.

FELLOWSHIP WAS MODELLED as a project for the monument to Jean Volders. The plaster remained in the Minne estate, and the bronze casts were executed posthumously under the supervision of the artist's son. The two figures, almost identical in pose, are closely related to the kneeling youths of Minne's *Fountain*, executed the same year. The late variant at the Royal Palace of Laken (see Related Work) does not have the emaciated forms and emotional intensity of the model.

Minne's *Man with a Waterskin* (*L'homme à l'outre*, 1897; Musée royal d'Art moderne, Brussels) anticipates the stance of the two boys, while the grouping of figures in nearly identical poses occurs in the artist's works from the late 1880s on (*Adam and Eve*, 1889; *The Three Marys at the Tomb*, 1896).

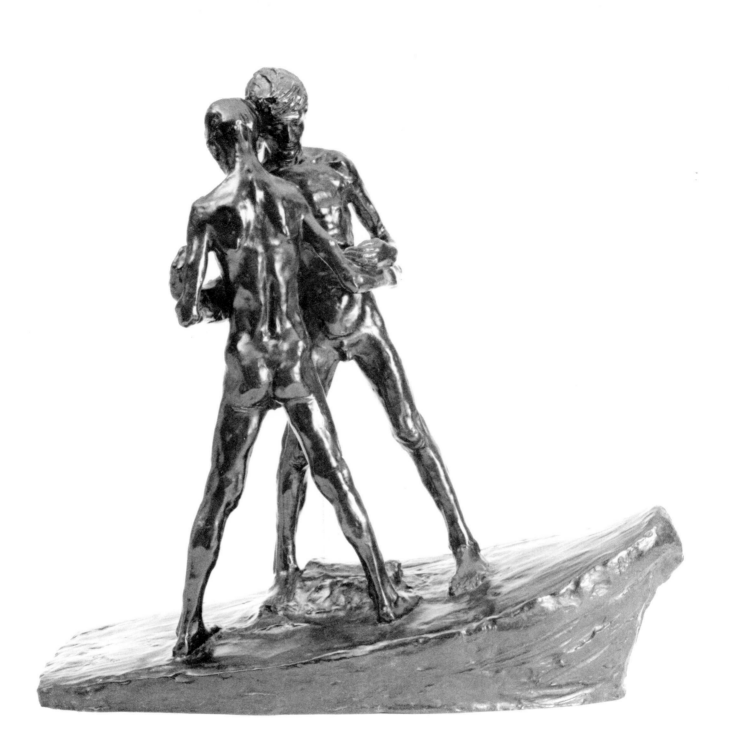

AIMÉ-NICOLAS MOROT

Nancy 1850 – Dinard 1913

MOROT, a pupil of Cabanel and son-in-law of Jean-Léon Gérôme (cat. nos 30-38, 83), won the *Prix de Rome* in 1873, became a member of the Institut de France in 1898, and from 1900 until his death taught at the École des Beaux-Arts. He was a successful academic painter of portraits and battle scenes, but with the single notable exception of the piece here exhibited, his work as a sculptor remains unknown.

EXHIBITIONS
Salons of 1873, 1879, 1880, 1886, 1887. Paris Universal Exhibition, 1900.

AWARDS AND HONOURS
Medal of Honour, Salon of 1880. Grand Prize, Paris Universal Exhibition, 1900. Chevalier (1883); Officer (1900); Commander (1910) of the *Légion d'Honneur*.

BIBLIOGRAPHY
Charles Moreau-Vauthier, *L'œuvre de Aimé Morot*, Paris: Hachette, 1906.

Portrait of Jean-Léon Gérôme
Model, 1880s; *cast*, 1904

Bronze, with dark green patina, on rectangular base

HEIGHT: 31 cm

INSCRIPTION
Signed and dated on the vertical edge of the base, below sitter's left arm, *Aimé Morot 1904*.

PROVENANCE
Shepherd Gallery, New York. Acquired April 1973.

RELATED WORKS
Large bronze version, after this statuette, dedicated as a memorial to Gérôme in the Tuileries in 1909. Present location unknown.

GÉRÔME DIED SUDDENLY at the age of eighty on 10 January 1904. Morot's statuette shows him as a man of mature years but surely not as an octogenarian. It must be assumed, therefore, that Morot did this portrait of his father-in-law a good many years before 1904, perhaps as early as the 1880s, without any thought of designing a memorial. In the year of Gérôme's death, he had the model cast in bronze, probably in a sizeable number of specimens.

The prototype for informal, seated portraits of this kind in sculpture is found in statuettes of the Romantic era, such as *Ludwig Tieck* (1836) by David D'Angers (1788–1856). The addition of the cat in the Gérôme portrait further emphasizes the domestic, intimate quality of the work. That a design as clearly "anti-monumental" as this could be chosen for the commemorative statue of 1909 indicates a growing reaction against the self-consciously heroic postures of earlier monuments to individual genius that had been gathering force since the 1890s.

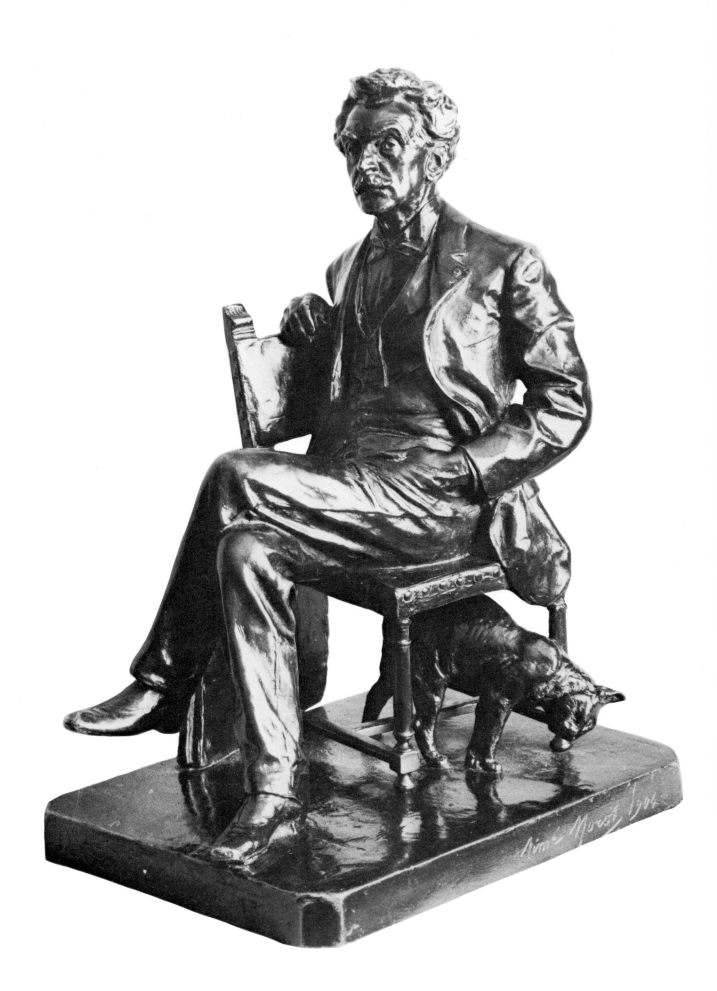

MEDARDO ROSSO

Turin 1858 – Milan 1928

ROSSO'S FATHER, a stationmaster, expected Medardo to follow a career in railroading and opposed his artistic leanings. Nevertheless, when the family moved to Milan in 1870, the boy spent much of his time in the workshop of a stone-cutter and, after service in the Italian army (1879–1882), Rosso enrolled in the Accademia di Brera in Milan, but was expelled within a year for undisciplined behaviour. His earliest known works, three heads and a statuette, all of 1882, were shown in Rome in the spring of 1883 at the Esposizione di Belle Arti. Their rough surfaces and acute observation of everyday types betray Rosso's indebtedness to the most important Milanese sculptor of these years, Giuseppe Grandi (1843–1891). In 1884, Rosso spent some months in Paris, where he found temporary employment in the studio of Jules Dalou (cat. nos 78–80) and met Auguste Rodin (1840–1917). He returned to Milan because of the death of his mother, to whom he was deeply attached.

It was between the end of 1883 and 1886 that Rosso arrived at his personal style, a true counterpart in sculpture to Impressionism; the forms emerge softly (and only partially) from their surrounding envelope of light and atmosphere. Rosso also discovered a technique uniquely well suited to his aesthetic goal: he modelled in clay, prepared a plaster replica, and added a final surface coating of wax.

Between 1886 and 1889 he showed several pieces at the Paris Salon, the Indépendants, and the Paris Universal Exhibition. Another trip to Paris in 1889 stretched into a sojourn of eight years. In 1894, Rodin visited Rosso's studio and wrote him an enthusiastic note of praise. When Rodin's final plaster for the Balzac monument was first exhibited four years later, Rosso claimed to have influenced its conception. Some of the salient features of the Balzac had indeed been anticipated, though on a small scale, in Rosso's works of 1893 and 1894, but the exact degree of their influence on the older artist is hard to assess.

After 1897, Rosso was widely known and exhibited in France, England, Germany, and Austria. Success in his native country was somewhat slower in coming (by 1914, the Galleria d'Arte Moderna in Rome owned seven of his works). Artistically, Rosso entered a fallow period shortly before 1900 that was to last the rest of his life. Often ill, and mainly concerned with furthering his public career, the aging artist confined himself almost entirely to producing repetitions and variants of his pieces of 1886–1896, which by now had become famous. His influence on early twentieth-century sculpture was pervasive, reaching from such artists as Brancusi, Picasso, and Matisse, to Lehmbruck and Boccioni.

EXHIBITIONS
Salon des Indépendants and Paris Universal Exhibition, 1889.

BIBLIOGRAPHY
Ardengo Soffici, *Medardo Rosso*, Florence: Vallechi, 1929. Mino Borghi, *Medardo Rosso*, Milan: Edizioni del Milione, 1950. Margaret Scolari Barr, *Medardo Rosso*, New York: Museum of Modern Art, 1963.

88

The Golden Age 1886
(*L'Età d'oro*)

Wax on plaster

HEIGHT: 48.4 cm

INSCRIPTION
Signed *Rosso*; inscribed below the mother's arm, *a Talboom*.

PROVENANCE
Leon Talboom, Paris (bought from the artist in 1889; Sotheby Parke-Bernet, New York, sale 11 March 1971, cat. no. 140. Acquired March 1971.

BIBLIOGRAPHY
Borghi, *Medardo Rosso*, pp. 64ff.; Barr, *Medardo Rosso*, pp. 27ff.

RELATED WORKS
Mother and Child Sleeping, 1883, Collection Cesare Fasola, Florence (illus. in Barr, *Medardo Rosso*, p. 19).

THE GOLDEN AGE, executed in Milan, is among Rosso's most famous works. The poetic title, as Barr observes, recalls Rodin's *The Age of Brass*. Borghi lists the original model as in the Rosso Museum, Barzio. Wax versions closely related to this piece are in the Petit Palais, Paris; the Galleria d'Arte Moderna, Rome; the Hirshhorn Museum, Washington; and several private collections. The total number is not known, nor can it be determined which of these were executed in 1886 and which are later replicas by the artist's own hand. There also exist several bronze casts. *The Golden Age* is in many respects Rosso's earliest fully mature work; the contrast with the much smaller and more realistic bronze of 1883 is instructive. The subject is said to represent the artist's wife Giuditta, whom he had married in 1885, and their son Francesco.

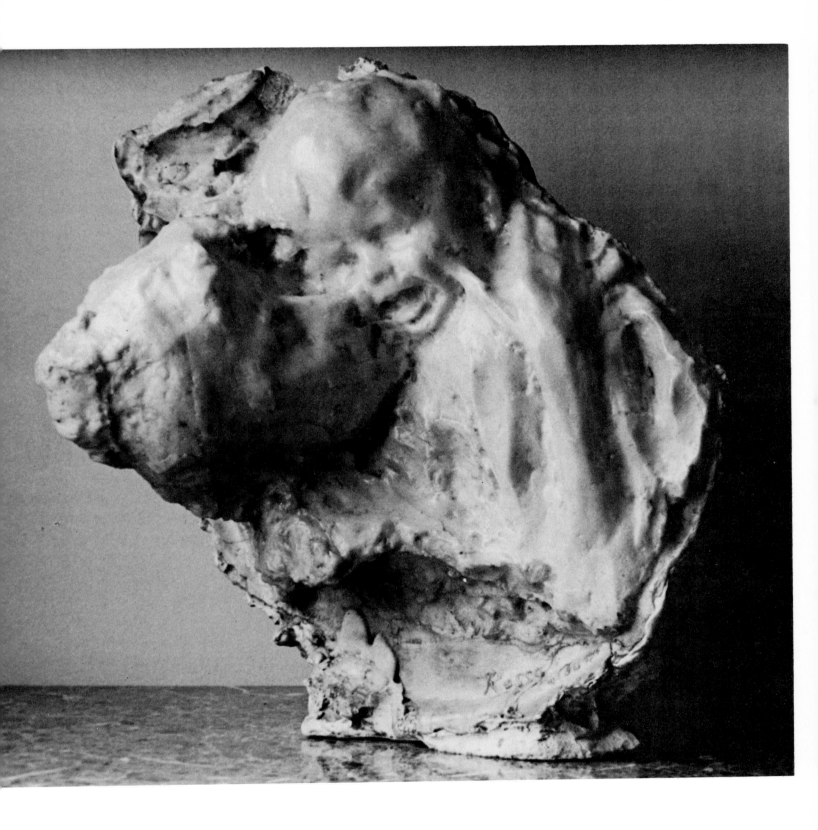

INDEX OF ARTISTS

Albers, Josef, 154
Alma-Tadema, Sir Lawrence, 21, 23, 24, 27, 33-37, 156
Angers, David D', 232
Antigna, Alexandre, 166, 172
Aublet, Albert, 38-39, 194

Banti, Cristiano, 44
Bargue, Charles, 40-43, 112
Barlach, Ernst, 230
Barrias, Louis-Ernest, 224
Bartholdi, Frédéric Auguste, 106, 123
Barye, Antoine-Louis, 202-203, 222
Bastien-Lepage, Jules, 123, 157
Bernasconi, Ugo, 66
Bernhardt, Sarah, 44, 244
Bernini, Gianlorenzo, 199, 214
Boccioni, Umberto, 234
Böcklin, Arnold, 226
Boisbaudran, Horace Lecoq de, 90, 92, 93
Bol, Ferdinand, 46
Boldini, Antonio, 44
Boldini, Giovanni, 44-47
Boldini, Giuseppe, 44
Boldini, Pietro, 44
Bonington, Richard Parkes, 128
Bonvin, François Saint, 48-53, 90, 157, 158, 160, 164, 168, 194, 196
Borrani, Odoardo, 44
Bosio, François-Joseph, 202
Boudin, Eugène, 130, 182
Bouguereau, William Adolphe, 23, 24, 25, 54-59, 102, 130
Bouhot, Étienne, 82
Bourdelle, Émile, 63
Bracquemond, Félix, 23, 25, 60-62
Brancusi, Constantin, 234
Breton, Jules, 84
Bronzino, Il, 102
Bruandet, Lazare, 151
Bugatti, Carlo, 204
Bugatti, Rembrandt, 204-205

Cabanel, Alexandre, 63, 232
Cabianca, Vincenzo, 44
Caillebotte, Gustave, 44
Canova, Antonio, 200, 201
Caravaggio, Michelangelo da, 166
Carnielo, Rinaldo, 46
Carpaccio, Vittore, 136
Carpeaux, Jean-Baptiste, 97, 199, 201, 206-213, 220, 228
Carrier-Belleuse, Ernest Albert, 82, 206
Carrière, Ernest, 63
Carrière, Eugène, 21, 23, 25, 63-71, 123, 172
Cassat, Mary, 24
Cazin, Jean-Charles, 157
Cézanne, Paul, 75, 170
Chardin, Jean-Baptiste, 48, 52, 148, 164
Chassériau, Théodore, 23, 24, 72-74
Chéret, Jules, 63
Chevreuse, Jacquesson de la, 97, 98
Cimabue, Giovanni, 136
Cogniet, Léon, 148
Constable, John, 145
Coques, Gonzales, 46
Cordier, Charles, 224
Cornelius, Peter, 136
Corot, Jean-Baptiste, 44, 60, 90, 123, 130, 196
Correggio, Antonio, 123
Cosmati, the, 56
Costoli, Aristodesno, 46
Couder, Auguste, 124

Courbet, Gustave, 44, 48, 76, 84, 90, 93, 94, 148, 164, 182, 214
Couture, Thomas, 75-81, 123, 130, 180

Dalou, Aimé-Jules, 206, 212, 214-219, 228, 234
Daubigny, Charles, 50, 194
Daumier, Honoré, 75, 78, 85, 112, 164, 194
David, Jacques-Louis, 108, 142
Decamps, Alexandre Gabriel, 22, 23, 24, 25, 82-84, 164, 194
Degas, Edgar, 44, 50, 62, 97, 123, 182
Delacroix, Eugène, 40, 46, 60, 72, 82, 90, 127, 128, 194, 214
Delaroche, Paul, 75, 102
Demarne, Jean-Louis, 152
Desboutin, Marcelin Gilbert, 75
Dolci, Carlo, 123
Donatello, 199
Doré, Gustave, 23, 24, 85-89, 123
Dou, Gerard, 46
Drölling, Martin, 123
Duccio di Buoninsegna, 136
Dürer, Albrecht, 80
Duret, Francisque-Joseph, 206, 214
Dyckmans, Joseph Laurent, 33

Eakins, Thomas, 110
Eyck, Jan Van, 50

Fabre, François, 142
Falguière, Jean Alexandre Joseph, 220-221, 228
Fantin-Latour, Ignace Henri Jean Théodore, 23, 24, 25, 48, 90-96, 123, 157
Fattori, Giovanni, 44
Fauconnier, Jacques-Henri, 202
Ferdinandi, Francesco, 142
Feuerbach, Anselm, 75
Firenze, Andreada, 136
Flandrin, Hippolyte, 126
Forain, Jean-Louis, 23, 24, 97-101
Fortuny y Garbo, Mariano, 114
Fosse, Charles de la, 142
Fraikin, Charles Auguste, 228
Frère, Édouard, 50
Frémiet, Emmanuel, 222-223
Fromentin, Eugène, 22, 23, 40
Fuseli, Henri, 138

Garnier, Charles, 206
Gauguin, Paul, 60, 68, 70
Gentz, Wilhelm, 75
Géricault, Théodore, 46, 82, 126
Germain, Théodule, 162
Gérôme, Jean-Léon, 23, 24, 25, 27, 28, 30, 38, 40, 44, 50, 56, 97, 102-119, 123, 222, 224-225, 226, 232
Gill, André, 97
Giorgione, Il, 123
Giotto di Bondone, 54, 136
Giovanni da Bologna, 82
Glaize, Auguste-Barthélémy, 157, 166
Gleyre, Charles, 102
Gogh, Théodore Van, 97
Gogh, Vincent Van, 120, 196
Gordigiani, Michele, 44
Goutzwiller, Charles, 123, 124
Goya y Lucientes, Francisco José de, 160
Grandi, Giuseppe, 234
Granet, François-Marius, 48
Greco, El, 80
Gregory, Edward John, 120-122
Greuze, Jean-Baptiste, 148
Gros, Antoine, 75, 202
Groux, Charles de, 228
Grünewald, Mathias, 124, 126
Guérin, Gabriel, 123
Guichard, Joseph, 60, 62
Guillemet, Antoine, 176
Gussow, Karl, 226

Hall, Sydney, 120
Hals, Frans, 44, 46, 157, 176, 180

Healy, George, 78, 80
Heem, Jan Davidsz de, 194
Helleu, Paul, 44, 120
Henneberg, Rudolph Frederich August, 75
Henner, Jean-Jacques, 23, 25, 28, 30, 44, 63, 123-126
Herkomer, Hubert von, 120
Hodler, Ferdinand, 226
Hoet, Gerard, 140
Holbein, Hans, 62, 126
Holiday, Henry, 154
Hunt, William Morris, 75, 76

Ingres, Jean Auguste Dominique, 44, 58, 60, 62, 72, 82, 102, 104, 108
Isabey, Jean-Baptiste, 127
Isabey, Louis Gabriel Eugène, 23, 24, 25, 88, 127-129, 130

Jacquand, Claude, 38
Jadin, Louis-Godefroy, 82
Johnson, Eastman, 75
Jongkind, Johan Barthold, 23, 25, 130-132
Jordaens, Jacob, 176
Jouffroy, François, 220
Julien, Bernard, 123

Kalf, Willem, 194
Kauffman, Angela, 142
Keyser, Hendrik De, 46
Klimt, Gustav, 29
Klinger, Max, 224, 226-227

Lamothe, Louis, 184
Lastman, Peter, 140
Laurens, Jean-Paul, 23, 133-135, 176
Lefebvre, Jules, 126, 176
Legros, Alphonse, 48, 90, 92, 93, 214
Lehmann, Henri, 104
Lehmbruck, Wilhelm, 230, 234
Leighton, Frederic Lord, 23, 28, 33, 136-144, 154
Leleux, Adolphe, 50
Leslie, George Dunlop, 140
Leys, Hendrick, 33, 184
Loutherbourg, Philippe Jacques de, 128

Maeterlinck, Maurice, 230
Maillol, Aristide, 202
Manet, Édouard, 44, 50, 60, 62, 75, 90, 97, 123, 130, 157, 158, 166, 174, 180, 182, 184, 194, 196
Martin, John, 145-147
Massaccio, 136
Matisse, Henri, 234
Meissonier, Jean-Louis Ernest, 22, 24, 25, 40, 44, 102, 108, 148-150, 176, 178
Menzel, Adolphe, 44
Meryon, Charles, 60
Metsu, Gabriel, 148
Meunier, Constantin, 228-229
Michel, Georges, 21, 22, 24, 151-152, 196
Michelangelo, 138, 148, 199, 220, 206
Mieris, Frans van, 46
Millais, Sir John Everett, 122, 140
Millet, Jean-François, 54, 60, 90, 214
Minne, George, 230
Monet, Claude, 130, 157
Moore, Albert Joseph, 25, 154-156
Moreau, Gustave, 60, 64, 123, 126
Morot, Aimé-Nicolas, 232-233
Morris, William, 140
Munch, Edvard, 226
Murillo, Bartolomé Esteban, 158
Musso, Boniface, 145

Navez, François-Joseph, 182, 228
Neer, Aert van der, 130
Newman, Allen George, 75
Nittis, Joseph de, 157

Orchardson, William, 122
Ottin, Léon, 90

Pasini, Alberto, 38
Picasso, Pablo, Ruiz y, 234
Picot, François Édouard, 54, 58, 123
Pissarro, Camille, 60, 196
Pollastrini, Enric , 44
Poussin, Nicolas, 82
Poynter, Sir Edward John, 33, 140
Prud'hon, Pierre-Paul, 123, 126
Pujol, Alexandre Denis Abel de, 82
Puvis de Chavannes, Pierre, 44, 64, 75, 126, 148

Raffaelli, Jean-François, 157
Raphael, 54, 56, 82
Rappard, Anthon Van, 120
Redon, Odilon, 64
Regamey, Guillaume, 90, 92
Regnault, Jean-Baptiste, 123
Rembrandt, Harmensz van Rijn, 82, 92, 94, 98, 157, 174, 176, 194
Reni, Guido, 140
Renoir, Pierre Auguste, 24
Rethel, Alfred, 136
Ribera, José, 157, 180
Ribot, Germain, 170
Ribot, Louise, 170, 172
Ribot, Théodule Augustin, 23, 24, 25, 30, 48, 52, 90, 157-175, 176, 186, 194
Ricard, Gustave, 76
Richmond, William Blake, 154
Robert, Léopold, 82
Rochegrosse, Georges-Antoine, 134
Rodin, Auguste, 60, 63, 201, 206, 214, 220, 226, 228, 230, 234
Romney, George, 142

Rops, Félicien, 226
Rosa, Salvator, 128
Rosso, Medardo, 234-235
Rothko, Mark, 154
Rousseau, Philippe, 168
Rousseau, Théodore, 130
Roybet, Ferdinand, 23, 176-181
Rubens, Peter Paul, 63, 140, 176
Rude, François, 206, 222, 226
Ruisdael, Jacob, 128, 152
Ryder, Albert Pinkham, 75

Sage, Auguste Jules, 58
Sargent, John Singer, 44, 120
Sarto, Andrea del, 56
Schelfhout, Andreas, 130
Scholderer, Otto, 90, 92, 93
Schwind, Mortiz von, 136
Servin, Amédée Élie, 194, 196
Seurat, Georges, 75
Signorini, Telemaco, 44
Sinet, Louis, 90, 92
Sisley, Alfred, 44
Solomon, Abraham, 26, 27, 29
Solon, Marc, 90
Soumy, Joseph, 194
Soutine, Chaim, 196
Steinle, Edward, 136, 138
Stevens, Alfred Émile Léopold Victor Ghislain, 25, 44, 157, 182-183
Stone, Marcus, 154

Terborch, Gerard, 112, 148, 182
Timbal, Charles, 102

Tissot, James (Jacques Joseph), 23, 27, 29, 30, 122, 184-193
Titian, Vecelli, 82, 126
Toulouse-Lautrec, Henri Marie Raymond de, 160
Troili, Uno, 76
Turner, James Mallard William, 63, 128, 138

Ussi, Stefano, 44
Utrillo, Maurice, 196

Van Dyck, Sir Anthony, 102
Vasari, Giorgio, 136
Velasquez, Diego de Silva y, 126, 158, 160, 162, 176, 180
Verhaeren, Émile, 230
Vermeer, Jan, 50
Vernet, Joseph, 128
Veronese, Paul, 136
Verspronck, 46
Vibert, Victor, 176
Villemsens, 133
Vinci, Leonardo da, 56, 123
Vollon, Antoine, 23, 25, 48, 50, 90, 157, 158, 160, 164, 166, 168, 170, 176, 194-197

Walker, Frederick, 154
Waltner, Albert, 176
Watteau, Jean-Antoine, 44, 157
Wauters, Émile Charles, 226
Werner, Jacques Christophe, 222
West, Benjamin, 142, 146
Whistler, James McNeill, 25, 48, 50, 90, 92, 93, 94, 120, 122, 130, 154, 157, 158, 160
Wilkie, Sir David, 146

INDEX OF TITLES

The Acquittal (Solomon), 26
Adam and Eve (Minne), 230
Adam and Eve Finding the Body of Abel
 (Henner), 123, 124
The Adulteress (Forain), 98
After the Ball (Stevens), 182
After the Dance (Alma-Tadema), 34
After the Interrogation (Laurens), 134
The Age of Augustus, The Birth of Christ
 (Gérôme), 106
The Age of Brass (Rodin), 234
The Agitator (Forain), 100
The Agitator of Languedoc (Laurens), 134
Alcestis (Leighton), 138, 140
The Algerian Guard (Bargue), 40
Alms (Doré), 86
Alsace (Henner), 123, 124
Andromeda (Henner), 124
Andromeda Bound to the Rock (Chassériau), 74
An Apodyterium (Alma-Tadema), 27, 34
Apollo Belvedere, 200
Apollo and Daphne (Chassériau), 74
Apples (Moore), 154
Arabian House (Decamps), 82
Arnaut Officer (Gérôme), 106
Arnaut Smoking (Gérôme), 27, 110, 112, 114
Art Dealer (Ribot), 162
The Arts of Industry as Applied to War
 (Leighton), 142
The Astronomer (Roybet), 176
Atelier of Batignolles (Fantin), 92
Autumn Leaves (Millais), 122
Awaiting the Verdict (Solomon), 26
Azaleas (Moore), 154

The Ball on Shipboard (Tissot), 186
Baptism of the Prince Imperial (Couture), 75
Bara (Henner), 126
The Basset Hounds Ravageot and Ravageole
 (Frémiet), 222
The Bather (Dalou), 216, 218
Bather Sleeping beside a Spring (Chassériau),
 74
Battledore (Moore), 154
Beads (Moore), 154
Bear-Cub Hunter (Frémiet), 222
Bear and Gladiator (Frémiet), 222
Beethoven (Klinger), 226
Beggars in the Cloister of the Barcelona Cathedral
 (Doré), 86
Bellona (Gérôme), 224
Belshazzar's Feast (Martin), 145, 146
The Bird-Catcher (Couture), 75
Birds (Moore), 154
The Blacksmiths (Bonvin), 48
Blossoms (Moore), 154
Borghese Warrior (Leighton), 138
Boulogne Peasant Woman with Palm (Dalou),
 214
Boulonnaises (Dalou), 212
Boulter's Lock: Sunday Afternoon (Gregory),
 120
Boy Singing (Ribot), 166
Brotherly Love (Bouguereau), 54, 56
Bunch of Grapes (Bouguereau), 54
Bust of Diana (Falguière), 220
Bust of a Puddler (Meunier), 228
My Butcher Shop (Servin), 194
The Butte Montmartre (Vollon), 196

Calvary (Forain), 98
Canonico Bosio (El Greco), 80
Captive Andromache (Leighton), 142, 144
Ceremony of the Howling Dervishes of Scutari
 (Aublet), 38
Charity (Bouguereau), 56
Charles the Bold at Nesles (Roybet), 176
The Chess Game (Bargue), 40
Child with Dog (Carrière), 63
Christ (Velasquez), 126
Christ Carrying His Cross (Forain), 98
Christ on the Cross (Minne), 230
Christ on the Cross (Prud'hon), 126
Christ with Donors (Henner), 126
Christ in Gethsemane – Self-Portrait (Gauguin),
 70
Christ with the Shroud (Henner), 126
Christ in the Tomb (Holbein), 126
Cimabue Finding Giotto in the Fields of Florence
 (Leighton), 136
Cimabue's Celebrated Madonna is Carried
 through the Streets of Florence (Leighton),
 136, 138
The Cock Fight (Gérôme), 102, 104, 116
Consolation (Stevens), 182
The Convalescent (Tissot), 192
The Convict (Laurens), 134
The Cook (Bonvin), 48, 50
Corinth (Gérôme), 224
A Corner of the Market (Vollon), 196
The Cottage (Michel), 152
Count Paris (Leighton), 138
A Court Jester of Henry III (Roybet), 176
Crowning of the Empress Josephine by Napoleon
 (David), 108
Crucifixion (Grünewald), 126
Cut of Beef (Vollon), 196

Daedalus and Icarus (Leighton), 138
Dance (Carpeaux), 199, 206, 208
Daphnephoria (Leighton), 140, 144
Daphnis and Chloë (Dalou), 214
David (Donatello), 199
Dawn (Gregory), 120, 122
Dead Christ (Henner), 126
Death of Atala (Henner), 126
The Death of Brunelleschi (Leighton), 136
The Death of the Duc d'Enghien (Laurens), 133
Defeat of the Cimbrians (Decamps), 82
Defence of the Fatherland (Carpeaux), 206
Defence of Gaul (Chassériau), 72
Deluge (Martin), 29
Diana (Falguière), 220
The Display of Enchantment (Fantin), 94
Drummer Boy (Couture), 75
Duc d'Orbieno (Roybet), 178
Ducourroy's Butcher Shop (Aublet), 194

The Effect of Waves (Isabey), 128
The Egyptian Recruiter (Gérôme), 104
The Egyptian Recruits Crossing the Desert
 (Gérôme), 104, 106, 114
1814 The Campaign of France (Meissonier),
 148
1807 Friedland (Meissonier), 148
Electra at the Tomb of Agamemnon (Leighton),
 138
Elijah's Sacrifice (Moore), 154
Embroiderer (Dalou), 214
The End of the Story (Moore), 154, 156
Enlistment of the Volunteers of 1792 (Couture),
 75, 76
Esther (Chassériau), 74
Eve (Falguière), 220
An Evening in the Granada Countryside (Doré),
 86
Evening Landscape (Decamps), 82, 84
The Excommunication of Robert the Pious
 (Laurens), 134

Fabiola (Henner), 123
The Fall of Babylon (Martin), 145
The Fall of Nineveh (Martin), 145
A Favourite Custom (Alma-Tadema), 34
Fellowship (Minne), 230

Fifer (Manet), 160
Fire on the Steamer "Austria" (Isabey), 128
The Fisherwoman of Vignots (Carpeaux), 212
Flemish Cabaret (Bonvin), 50
Force (Barye), 202
Fortune-telling at Sacro-Monte (Doré), 86
Fountain of the Four Continents (Carpeaux),
 206
Fountain of Kneeling Youths (Minne), 230

Gate of the Sala de Justicia (Doré), 86
The Gates of Hell (Rodin), 228
The Geographer (Roybet), 176
Georges Sand (Couture), 76
Girl in an Interior (Tissot), 192
Gladiator and Gorilla (Frémiet), 222
Goatherder of the Abruzzi (Decamps), 82
The Golden Age (Rosso), 234
Gorilla Dragging the Body of a Woman
 (Frémiet), 222
The Great Day of His Wrath (Martin), 145
Grief (Carrière), 70

Hand Leafing through Pages of a Book
 (Couture), 80
Hercules Wrestling with Death for the Body of
 Alcestis (Leighton), 138
The Holy Family (Bouguereau), 54, 56
Homage to Eugène Delacroix (Fantin), 92
Hope I (Klimt), 29
The Hostages (Laurens), 134

The Indiscreet Servant (Bonvin), 50, 52
The Interrogation before the Court of the
 Inquisition (Laurens), 134
Intruders (Gregory), 120

Joan of Arc (Frémiet), 222
Job and His Friends (Decamps), 82
Joshua Commanding the Sun to Stand Still
 (Martin), 145
Judgement of Pierrot (Couture), 78
Juno (Falguière), 220

"Kearsarge" and the "Alabama" (Manet), 160
Kitchen Scene (Ribot), 162

Ladies and Gentlemen on the Shore at
 Scheveningen (Isabey), 128
Ladies of Granada Listening to Dwarf Musicians
 (Doré), 86
Landscape (Carrière), 68
Laocoön, 200
The Last Judgement (Martin), 145
Lawyer Pleading His Case (Couture), 78, 80
The Lazy Schoolboy (Couture), 75
The Letter (Tissot), 184
Levite of Ephraim (Couder), 124
The Levite of Ephraim and His Dead Wife
 (Henner), 124, 126
Life of Christ (Tissot), 184
Lion Crushing a Serpent (Barye), 202
The Little Chimney Sweep (Ribot), 158
Little Milkmaid (Ribot), 158
Love of Gold (Couture), 75
The Loves of the Winds and the Seasons
 (Moore), 154
Low Tide (Isabey), 128
Ludwig Tieck (D'Angers), 232

Mme Carrière (Carrière), 64
Madame Moitessier (Ingres), 102
The Madonna and Child, with the Infant St John
 (Bouguereau), 56
Man of the Stone Age (Frémiet), 222
Man with a Waterskin (Minne), 230
The Mandolin Player (Ribot), 160, 164
Marine Venus (Chassériau), 74
Marooning (Gregory), 120
The Martyr (Henner), 126
Mater Dolorosa (Carrière), 70
Mater Dolorosa (Dolci), 123
A Meeting (Decamps), 82
Memories and Regrets (Stevens), 182
Men of the Holy Office (Laurens), 134

The Milkmaid's Payment (Germain), 162
Mill in Holland (Jongkind), 132
Monument to Decamps (Carrier-Belleuse), 82
Moonlight Scene (Jongkind), 130
Moses (Michelangelo), 200
Moses (Millais), 140
Mother Mourning Her Dead Child (Minne), 230
The Moulin de la Galette at Montmartre (Vollon), 196
Mountain Lion Attacking a Stag (Barye), 202
Music Lesson (Leighton), 142
The Musicians (Ribot), 164
Nausicaa (Leighton), 140, 142
Neapolitan Fisherboy (Carpeaux), 206, 212
Nobility (Couture), 80

Old Man Reading (Manet), 174
Old Man Reading (Ribot), 174
The Old Rooster (Bracquemond), 60
The Old Testament (Tissot), 184
Old Woman Cooking Eggs (Velasquez), 162
The Oleander (Alma-Tadema), 34
Orang-outang and Savage of Borneo (Frémiet), 222
Order (Barye), 202
Orpheus and Eurydice (Leighton), 138
Painting (Carrière), 66
Panther Seizing a Stag (Barye), 202
Panther Walking (Bugatti), 204
Paris, under the Red Flag (Gregory), 120
A Part of Montmartre Covered with Snow (Vollon), 196
The Parting Kiss (Alma-Tadema), 34
Peace (Barye), 202
The Philosopher (Meissonier), 148, 150, 178
The Philosopher (Roybet), 176
Phryné (Gérôme), 108
Piccadilly (Gregory), 120
Pietà (Bouguereau), 56
Pietà (Carrière), 70
Pietà (Flandrin), 126
Pietà (Forain), 98
The Pig (Bonvin), 194
The Pig (Vollon), 194, 196
The Plains of Heaven (Martin), 145
A Poet (Roybet), 178, 180
Political Woman (Tissot), 190
Pope Formosus and Stephen VII (Laurens), 133
Portrait of Alphonse Legros (Fantin), 90, 92, 93, 94
Portrait of the English Painter Ridley (Fantin), 92
Portrait of Erasmus (Holbein), 62
Portrait of Fantin (Fantin), 93, 94, 96
Portrait of Goncourt (Bracquemond), 60
Portrait of Jean-Léon Gérôme (Morot), 232
Portrait of a Lady (Gérôme), 102, 104
Portrait of Madame Calmas (Bracquemond), 60, 62
Portrait of a Man (Couture), 76
Portrait of Manet (Fantin), 92
Portrait of Meryon (Bracquemond), 60
Portrait of M and Mme Auguste Manet (Manet), 160
Portrait of My Grandmother (Bracquemond), 60
Portrait of Pedro and Luis Subercaseaux (Boldini), 44
Portrait of Pho Xai (Gérôme), 108
Portrait of a Young Man (Boldini), 46
Portrait of a Young Man (Rembrandt), 92
Portrait of a Young Woman (Ribot), 172
Prayer in a Mosque (Bargue), 42

Prayer in the Mosque of Quat Bey, Cairo (Gérôme), 118
Praying Hands (Dürer), 80
Prince Alonso (Couture), 76
La Princesse du Pays de la Porcelaine (Whistler), 122
Prodigal Son (Couture), 75
Prodigal Son's Return (Forain), 98
Profile of a Boy (Roybet), 180

Raft of the Medusa (Géricault), 126
A Reader (Moore), 154
The Reception of the Siamese Ambassadors at Fontainebleau (Gérôme), 108
The Release of the Prisoners of Carcassonne (Laurens), 134
In Remembrance of the Civil War (Meissonier), 148
A Remembrance of Treport (Bonvin), 48
La Résistance (Falguière), 220
Returning from Trial (Couture), 78
Romans of the Decadence (Couture), 75, 76

Sacred Music (Tissot), 188
Sadak in Search of the Waters of Oblivion (Martin), 145
Saint Jerome as Cardinal (El Greco), 80
Saint Philip (El Greco), 80
Saint Philip Baptizing the Eunuch of the Queen of Ethiopia (Chassériau), 72
Saint Sebastian (Ribot), 157
Sapphires (Moore), 154
Sappho (Chassériau), 74
Sarah Bernhardt (Gérôme), 224
The Scholars (Roybet), 178
The School for Orphan Girls (Bonvin), 48
Scotch Landscape (Doré), 88
The Sculptor's Model (Alma-Tadema), 34
Seated Bashi-Bouzouk (Bargue), 40, 42
Self-Portrait (Bouguereau), 58
Self-Portrait as a Chimera (Bernhardt), 224
Self-Portrait (Whistler in the Big Hat) (Whistler), 93
The Shipwreck (Isabey), 128
Shuttlecock (Moore), 154
The Siesta, A Recollection of Spain (Doré), 86
The Singers (Ribot), 160, 164, 166
Sketch Made in Alicante (Doré), 86
Slaughtered Beef (Soutine), 196
Slaughtered Ox (Rembrandt), 194
Slumber (Bouguereau), 54, 56
Soap Bubbles (Couture), 75
A Sofa (Moore), 154
The Song (Meissonier), 148
A Spanish Gypsy Woman (Doré), 86
The Spanish Singer (Manet), 160
Spanish Street Scene (Doré), 86
The Sphinx (Tissot), 192
Spirit of the Dance (Carpeaux), 208
Spring in the Garden of the Villa Borghese (Alma-Tadema), 36
Stag Brought Down by Two Greyhounds (Barye), 202
On the Staircase (Meissonier), 148
The Staircase (Tissot), 184
A Standard-Bearer (Roybet), 176, 180
Still Life (Ribot), 170
Still Life with Ceramic Jug, Eggs, and Knife (Ribot), 168
Still Life with Game (Bonvin), 50
Still Life with Jar of Cherries (Bonvin), 52
Still Life with Lemon and Oysters (Bonvin), 48, 50
A Street Scene in Cairo (Gérôme), 114

Study: at a Reading Desk (Leighton), 142
Sunshine and Storm (Michel), 152
Supper at Emmaus (Forain), 98
Suzanne at the Bath (Chassériau), 74
Swamp (Michel), 152
The Syracusan Bride (Leighton), 138

The Tambourine Player (Ribot), 158
Tannhauser lithograph (Fantin), 94, 96
Tarcisius (Falguière), 220
In the Tepidarium (Alma-Tadema), 34
Tepidarium (Chassériau), 72
Teresina (Leighton), 142
Theseus as a Child (Falguière), 220
The Thinker (Rodin), 226, 228
Thirst (Gérôme), 116, 118
The Three Marys at the Tomb (Minne), 230
Tiger Devouring a Crocodile (Barye), 202
Tiger Stalking a Stag (Barye), 202
The Tightrope Dancer (Tissot), 192
The Toast: Homage to Truth (Fantin), 92
Too Early (Tissot), 122
Tow-Horse (Decamps), 82
Town and Port of Dieppe (Isabey), 128
Truth Unrecognized (Dalou), 218
Turkish Butcher in Jerusalem (Gérôme), 110
The Two Sisters (Fantin), 90, 93, 94
The Two Sisters of the Artist (Chassériau), 72

Ugolino and His Sons (Carpeaux), 199, 201, 206, 210
Unconscious Rivals (Alma-Tadema), 36
Under the Roof of Blue Ionian Weather (Alma-Tadema), 34
Upper Part of a Swinging Door (Bracquemond), 60

The Vale of Rest (Millais), 122
A Valley near Braemar, Scotland (Doré), 88
Victor Hugo (Rodin), 226
View Taken in the Middle East (Decamps), 82
The Village (Michel), 152
Virgin as Consoler (Bouguereau), 56
The Virgin, the Infant Jesus, and Saint John (Bouguereau), 54, 56, 58
The Vito, A Gypsy Dance at Granada (Doré), 86
The Voice of Spring (Alma-Tadema), 34, 36

War (Barye), 202
Water Carrier of Seville (Velasquez), 168
The Way to the Temple (Alma-Tadema), 34
Welcome Footsteps (Alma-Tadema), 34
The White Girl Symphony in White, No. 1 (Whistler), 122
The Wife of the Levite of Ephraim (Henner), 126
Wild Ox Attacked by a Serpent (Barye), 202
Winding the Skein (Leighton), 142
Winner of the Cockfight (Falguière), 220
Winter at the Foot of the Butte (Vollon), 196
Without Dowry (Tissot), 188, 190
Woman of Fashion (Tissot), 190
The Woman of Paris (Tissot), 184, 188, 190, 192
Woman Reading (Fantin), 93
Wounded Dog (Frémiet), 222

The Year's at the Spring: All's Right with the World (Alma-Tadema), 36

Zenobia Found by the Shepherds on the Shores of the Araxes (Bouguereau), 54

PHOTOGRAPHS

COLOUR: Brian Merrett and Jennifer Harper, Montreal: frontispiece, cat. nos 12, 31, 45, 68; The National Gallery of Canada, Ottawa: Cover, cat. nos 8, 18, 27, 40, 42, 70.

BLACK-AND-WHITE: Horst W. Janson, New York: cat. nos 87, 88; Brian Merrett and Jennifer Harper, Montreal: cat. nos 1–5, 7, 11–14, 16, 17, 19–22, 24–26, 30–35, 37, 38, 41, 42, 45–47, 51, 57, 58, 67–69, 71–86; The National Gallery of Canada, Ottawa: cat. nos 6, 8–10, 15, 18, 23, 27–29, 36, 39, 40, 43, 44, 48–50, 52–56, 59–66, 70. Sotheby Parke-Bernet, New York: fig. 4; Tate Galley, London: fig. 5.

DESIGN: Frank Newfeld

PRINTING: Thorn Press Limited